SPIRITS SPEAK

A CELEBRATION
OF AFRICAN MASKS

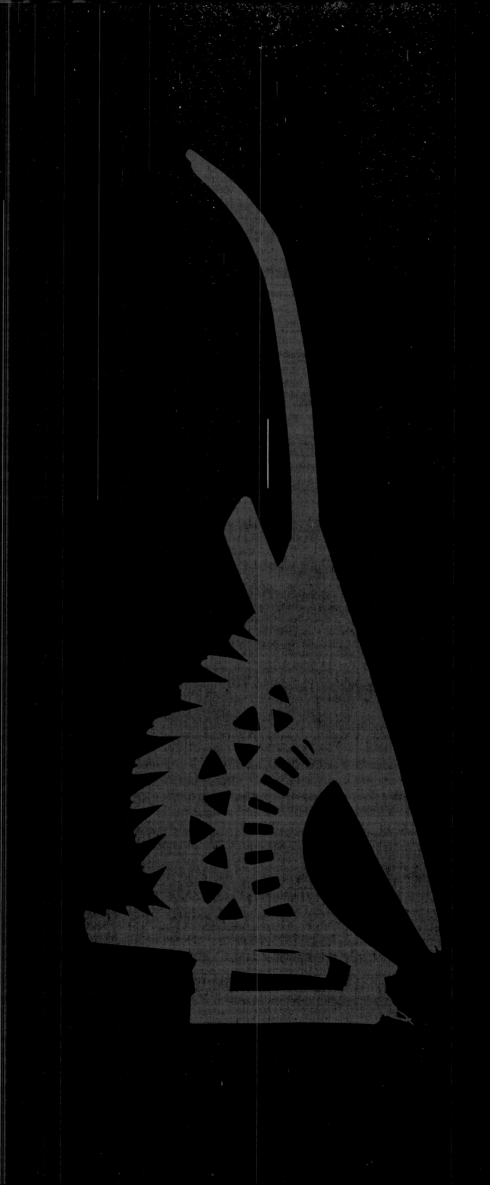

SPIRITS SPEAK

A CELEBRATION
OF AFRICAN MASKS

PETER STEPAN
CATALOGUE ENTRIES BY IRIS HAHNER

PRESTEL
MUNICH | BERLIN | LONDON | NEW YORK

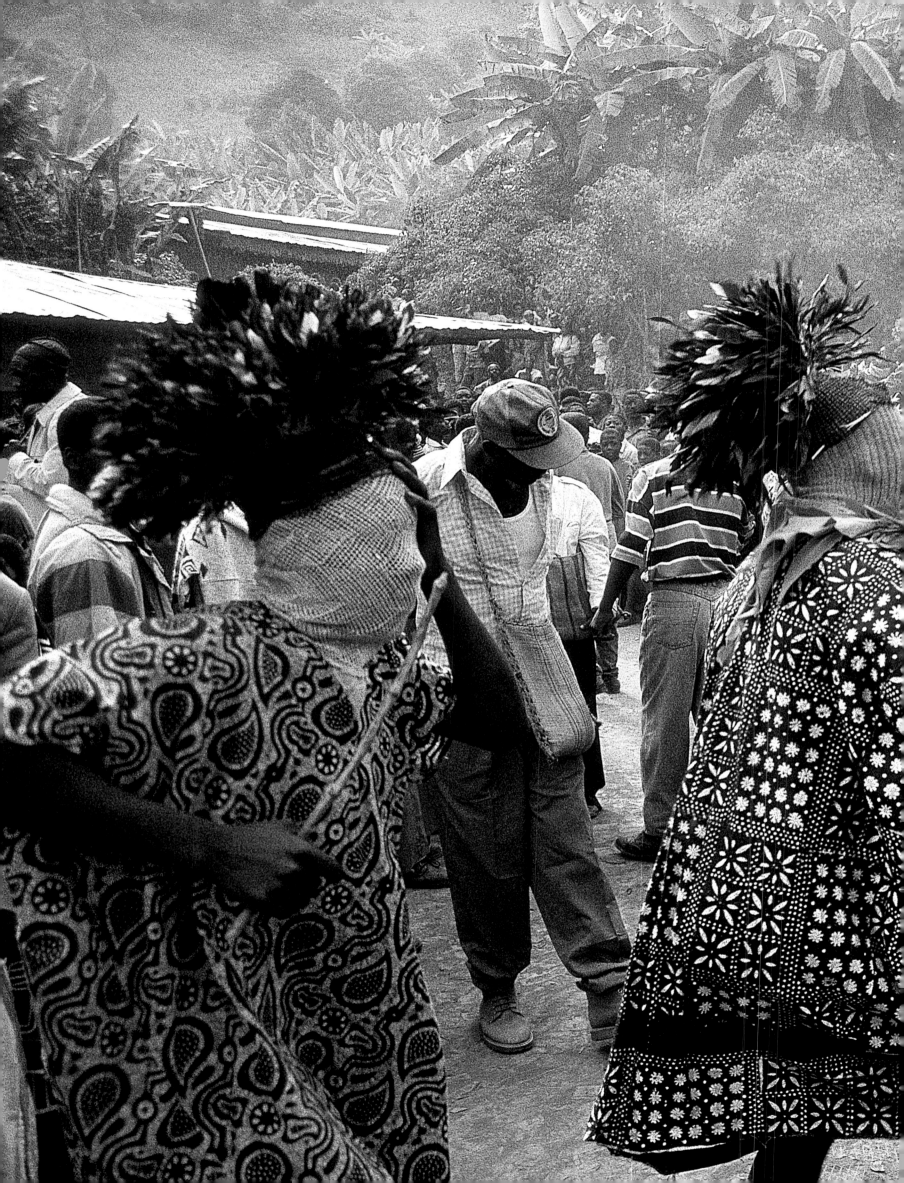

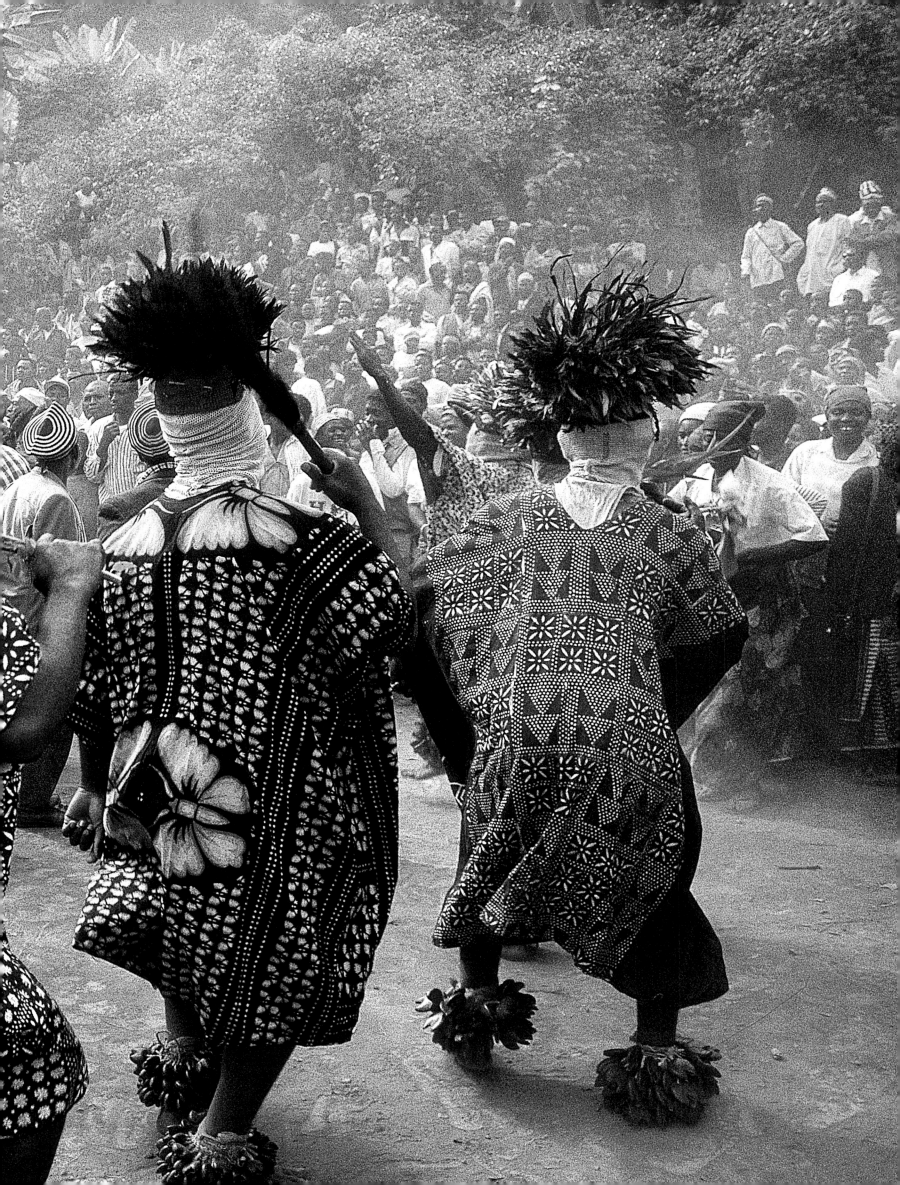

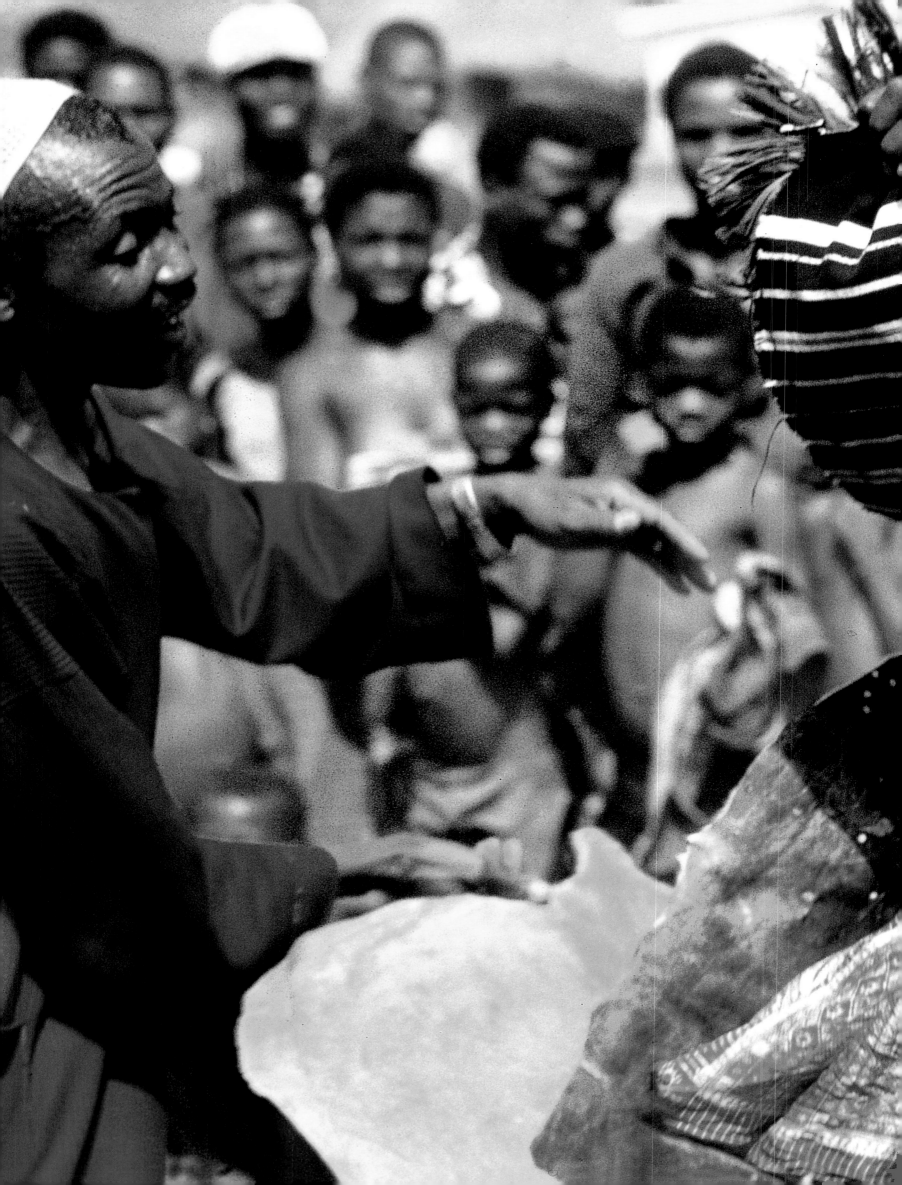

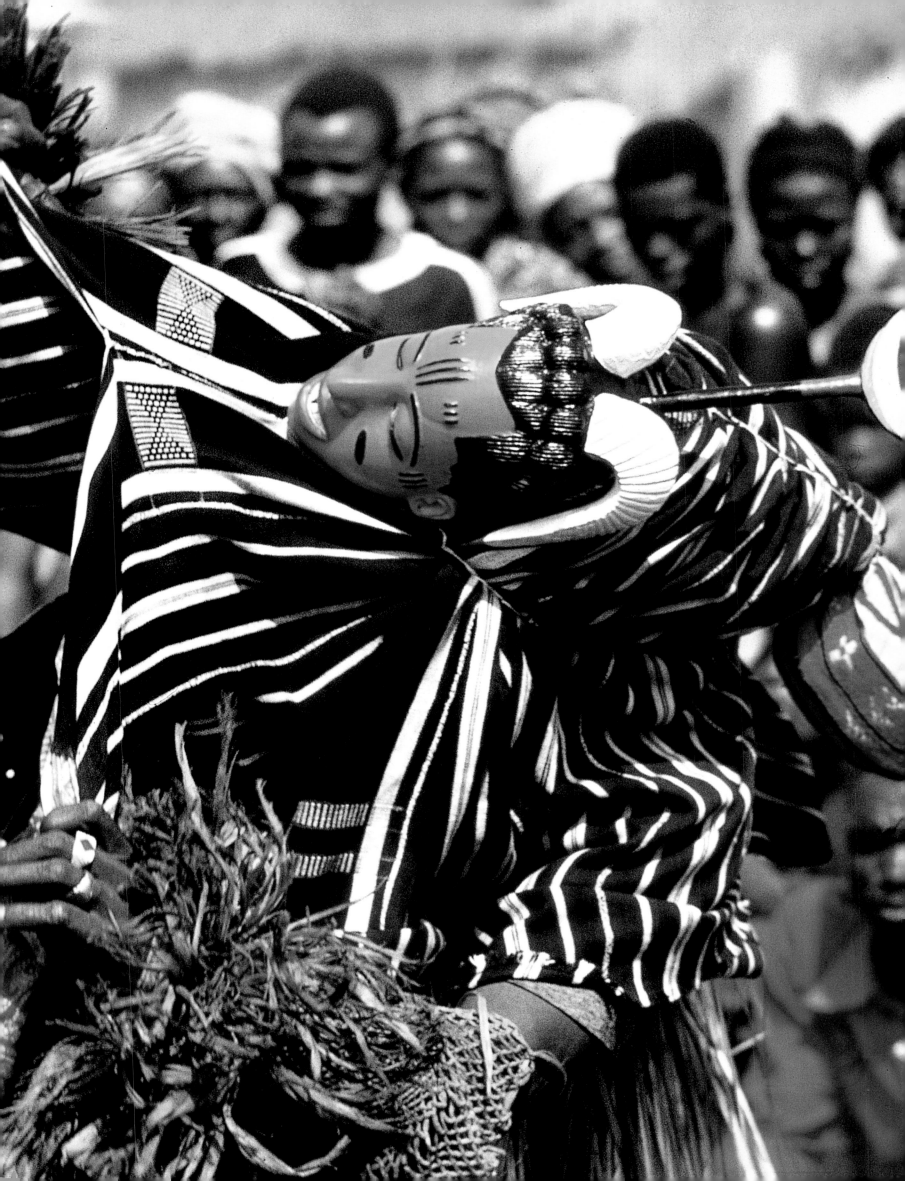

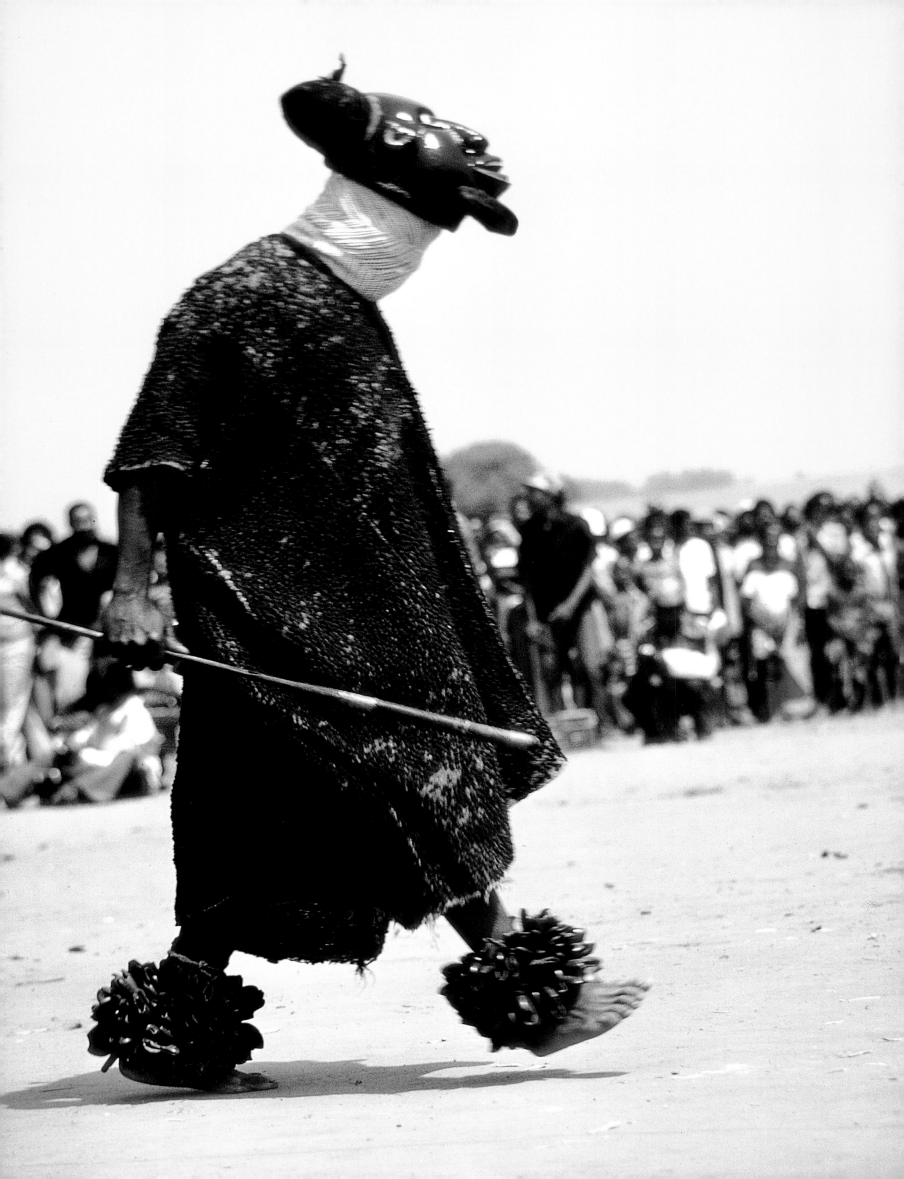

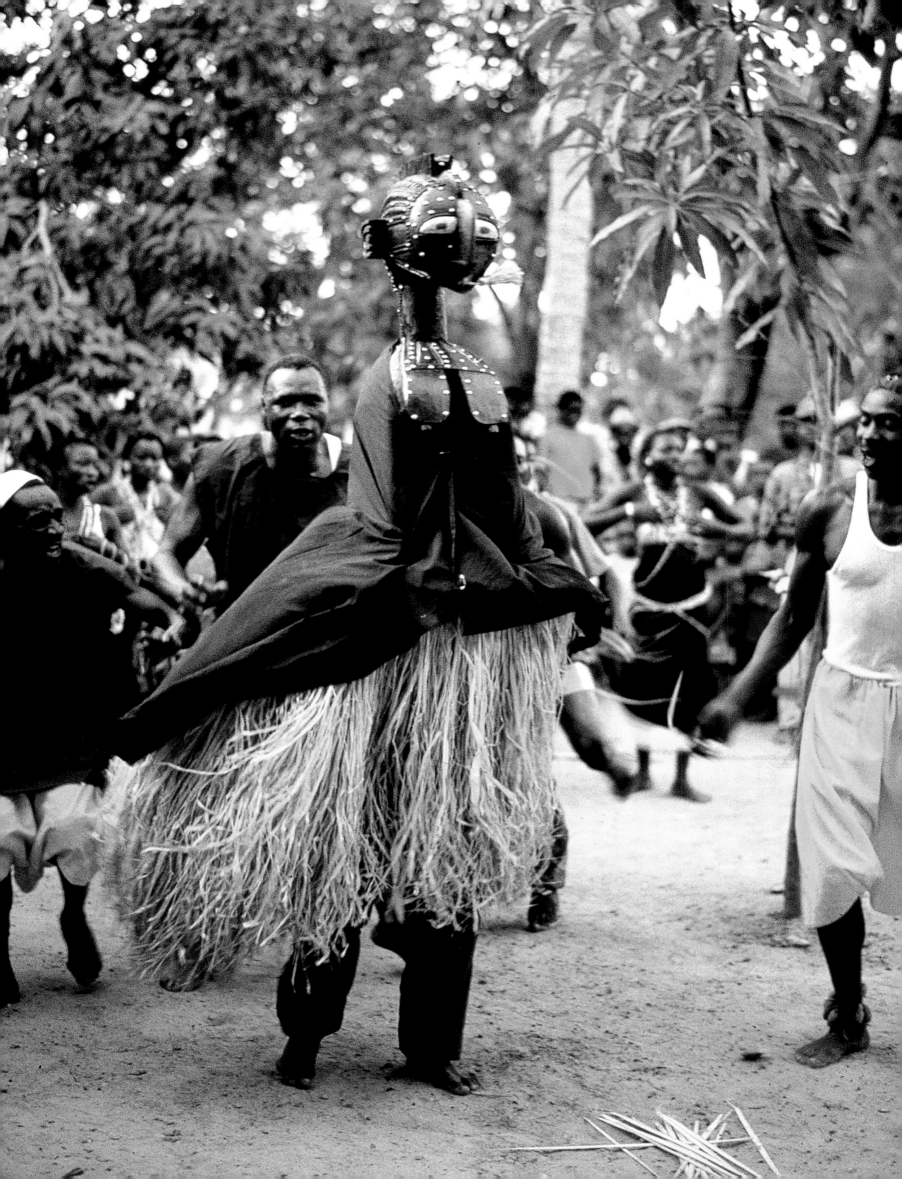

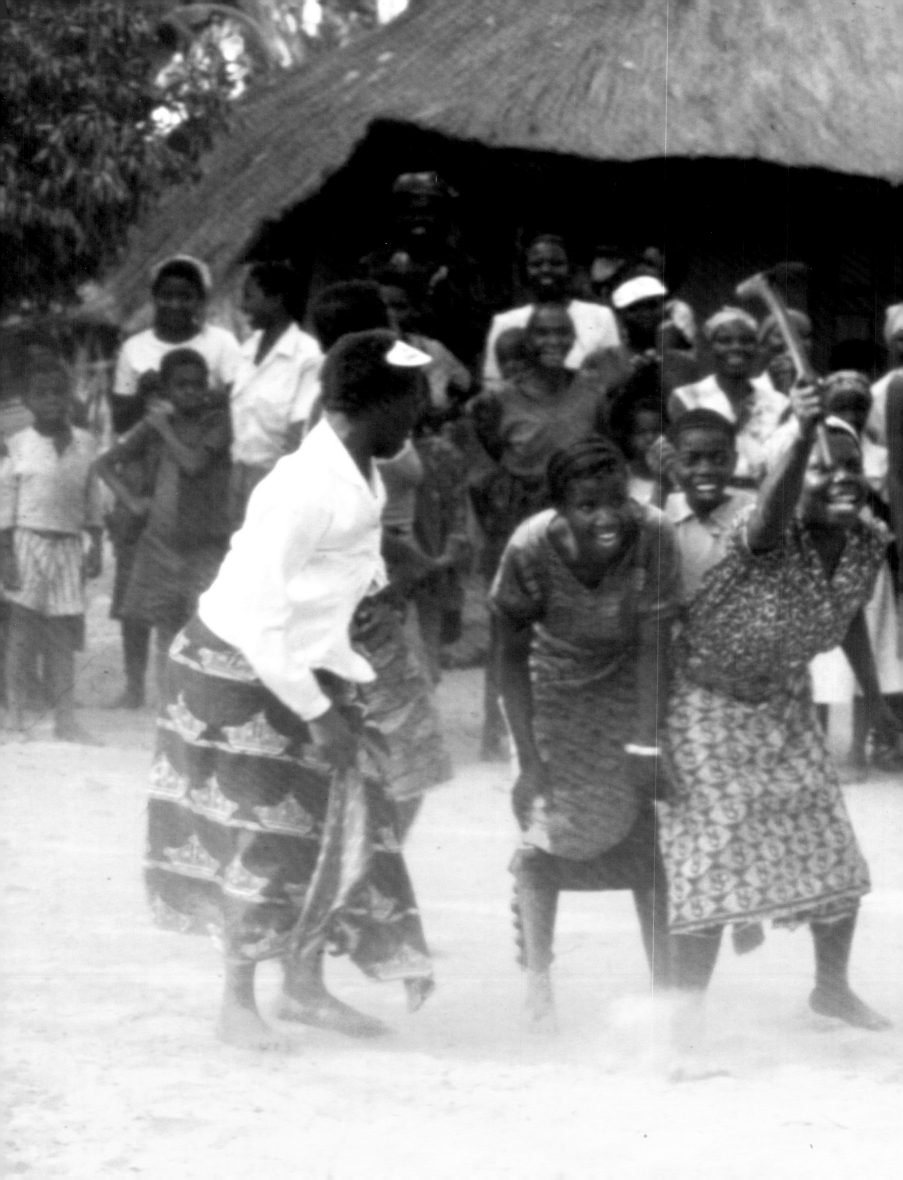

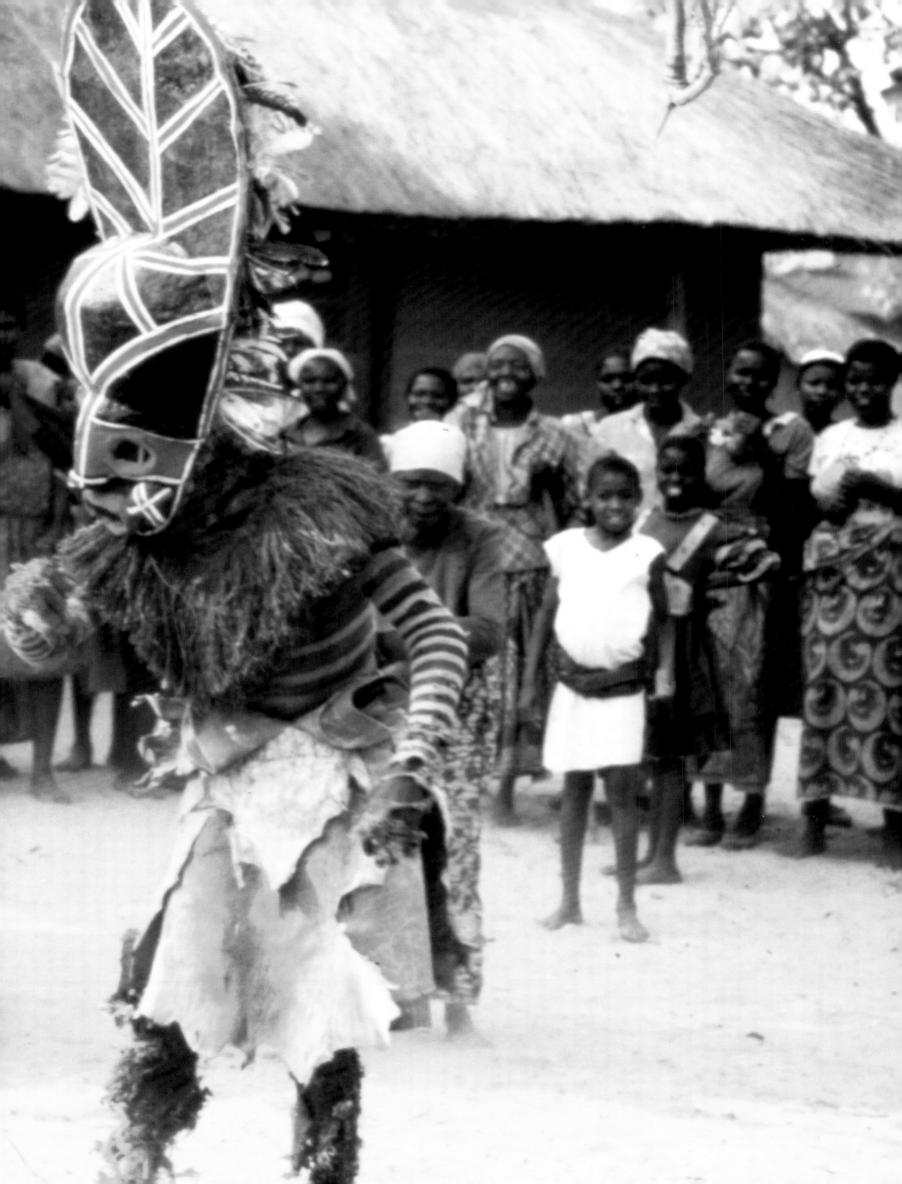

CONTENTS

PREFACE

THE AIM OF THIS BOOK is admittedly not a modest one. It is to provide a comprehensive overview of the finest African masks—the most compelling in terms of beauty or sculptural concept, the most awesome, and perhaps most magical, masks ever created by African artists. For much too long now, masks have been treated as mere tokens of the "style" of certain ethnic groups or regions, and their artistic quality has frequently been neglected. The present selection is different, having purposely been made on the basis of the aesthetic rank of these creations.

As most people are now aware, the masks in Western museums and collections represent mere fragments, and that in two respects. As face, cap or helmet masks, they were originally part of often voluminous masquerade costumes, usually made by a whole team of artisans, of raffia and other materials. These whole-body costumes, in turn, were simply the visual components of a complex performance in which music and percussion rhythms, gestures and dancing came together to form a grand unity. The African wooden masks as we know them today are merely the "remnants" of an all-inclusive work of art. Yet what splendid remnants they are!

Making a virtue of necessity, we can feel grateful that, if nothing else, these wooden fragments of such masquerades have been preserved. In fact, the ancient masquerade traditions of Africa have since died out to a certain extent, and where masks are still enthusiastically danced today, the performances often make concessions to entertainment and tourists' expectations. Only a few African communities have managed to keep their masquerade performances hidden from the inquisitive eyes of white visitors.

APART FROM FAMOUS ICONS OF the African mask-making art, this book includes masks that seem well on the way to becoming such. Its selection of "Mona Lisas" or "master masks" is supplemented by an outline of the broad range of key mask types. With this in mind, the celebration of African masks can begin.

THE MAJORITY OF AFRICAN
MASK FACES HAVE CLOSED EYES—
CLOSED TO THIS WORLD, BUT OPEN
INWARDLY, TO ANOTHER

SPIRITS SPEAK

PETER STEPAN

THE SURREALISTS WERE QUITE MISTAKEN. They one-sidedly associated African art with "the earth, the tilled soil, maternity," and saw its opposite pole in the art of the South Seas, which to André Breton evoked "the bird, the skies, the dream."[1] Africa became a metaphor for earthiness and fertility; Oceania an ideal projection of lightness and etherial spirituality. On the one hand, a culture of tillers laboring in the sweat of their brow; on the other, an *espace d'esprit* in which a dreamworld unfolded.[2] The continent of the archipelagoes was viewed as harboring the bizarre, an imagination unleashed and readied for an oceanic plunge into the depths of the unconscious mind.

For all its appeal as a literary fiction, Breton's strophe contributed little to a useful characterization of the art of these two cultural realms. Projecting his peasant ideal on Africa rendered him blind to the continent's social and cultural diversity. Africa has always been home to nomadic herdsmen like the Fulbe and Massai in the savannahs, to fishing peoples along the endless coastlines and the shores of the great rivers, to hunters and gatherers like the Pygmies. The continent nurtured urban cultures with a flourishing trade and highly developed crafts. Artists at the royal courts of the Ashanti and Kuba, or in the Kingdom of Benin, refined the arts of casting in metal or the weaving of textiles to a point that astonished travellers even centuries ago.

Carl Einstein's book *Negerplastik* (Negro Sculpture), published in 1915, has always been extolled as the first description of African art. Despite its undoubted significance for the reception of African art in the Western World (the author explicitly speaking, for instance, of *art* rather than of tribal artifacts), a dissenting opinion may be in order here. This book in fact had a lasting, and dire, effect on our conception of African art. Einstein saw Africa through the distorting lenses of Cubism.[3] The illustrations in his book showed works that demonstrated sculptural solidity, statues hewn in wood. It was here that the long-standing association of Africa with the art of woodcraft began. This misconception was no coincidence: monoxylic (single-block) masks, shorn of their raffia and textile adornment, cleaned and polished to a high sheen like a Stradivarius, fairly invited being misconceived as pure *sculptures*. Their original appearance had in fact much more of a *plastically* conceptualised character than a sculpted one, more closely related to Melanesian masks. The plastic masks of this region are composite in nature, being assembled of various materials, a combination of separate, previously carved wooden parts with elements made of other materials.[4] A process of this kind naturally encourages the emergence of "surrealist" effects.

Einstein's scholastic formalism (based on such terms as "cubic spatial concept") obstructed a perception of the free imagination that informs African art: The fluent movements in the

THE DANCING OF MASKS IS SURROUNDED BY AN ENTIRE LITURGY, DESIGNED TO ENCOURAGE THE ENTRY OF THE SUPERNATURAL INTO THE MUNDANE WORLD

rock drawings of the Sahara, the fantasy in the metal sculptures of the Yoruba and Fon, the charm of textile creations in silk (Ashanti) and raffia plushes (Congo/Kuba). East African sculptures with their basically planar pattern are prime examples of a non-tectonic, plastic approach. Shamanistic trance experiences, such as those embodied in the rock art of the San in southern Africa, would have excited Breton, Max Ernst and their friends, had these records of a hunter-gatherer culture been known at the time. The Africa of plastic density, compactness and material concentration indeed exists, but there also exists the Africa of fluctuation and phantasmagoria, of visual puzzles and metamorphoses. By claiming Africa for Cubism, Einstein forced a subsequent generation to search for a new continent of yearning: Oceania. Einstein threw open the door for Breton's fundamental misunderstanding.

THE AFRICAN IMAGINATION REACHES its climax in the mask dance. Out of a collaboration of carvers, costume makers, specialists in ritual, musicians and dancers a *gesamtkunstwerk* emerges whose complex structure of ritually defined choreography, noises, rhythms and music achieve a considerable degree of fantasy and intensity. In the old masquerade traditions, the urgency of each dancer's performance derived from the conviction, "I am not myself." It was not *he* who danced; he *was danced*. A being or spirit entered

his body, thus assuming outward form and communicating in this physical embodiment with the circle of living and visible onlookers.[5] States of possession and trance, still an everyday occurrence in the voodoo religions of the Republic of Benin or the Caribbean, suggest the nature of this mental transgression of borderlines. In other words, dancing a mask was ideally not an expression of individual skill but a veritably religious act, of devotion to a supernatural power. In many regions, this devotion was and still is expedited by ritual regulations governing the carving of masks and the preparation of dancers for their performance. The dancing of masks is surrounded by an entire liturgy, designed to encourage the entry of the supernatural into the mundane world.

This mystical interpretation may not be to everyone's taste, and the extent to which a mask dancer in fact identifies with some transcendent being (or could still identify in pre-colonial times) is controversially discussed in the literature. For this reason it would be helpful to admit a range of variations, extending from complete embodiment through various degrees of inspiration to an "actor's portrayal" of a supernatural mask spirit.

In contrast to the institutionalized world religions that dominate today, African religious beliefs often differed from one region to the next. The uniformity of these official churches in both the East and the West, has always been foreign to the strongly regionally or locally colored African forms of faith. The

lack of a written language proved an advantage when it came to the individual religious imagination, since it worked against the emergence of any form of bibliolatry or dogmatic rigor. African oral traditions left great leeway for personal interpretation. In many cases, Africans have even succeeded in integrating imported Western religions into their older cults, expanding the spectrum of religious forms of expression.

Instead of a supreme being or a canonically established pantheon of divinities, the African heavens are populated by innumerable spirits and beings. This so-called animism, fought by Christian missionaries and Moslem marabouts, is rich in transcendental forms of existence that populate the continuum between this life and the life beyond. The continent of ancestors alone is enormous, and savannah, woodlands and waters abound with nature entities and spirits. These are augmented by more clearly defined notions of gods, as with the Yoruba, whose beliefs recall the polytheism of European antiquity.

THE RICHNESS OF PHYSIOGNOMIES in African art can be explained by the need to capture the appearance of beings that belong to other worlds or stand between the two. This is the source of the ambivalence, indeed the multiple levels of meaning that are fundamental to African image making. Figuration in European art prior to modernism was veritably barren by comparison. The Western struggle against heathenism, iconoclasm, even the Enlightenment and the triumph of academic art, dessicated the biotope of visages and visions. African art, in contrast, never subject to the Western dictate of naturalism, for centuries cultivated a latent "modernism" and created a universe of physiognomic diversity. Oscillating between realistic illustration and abstraction, while retaining its ties with the human, animal and spirit realms, metamorphosis became Africa's great speciality. Nature spirits came on the scene and demanded their right to embodiment: "Spirits of wildlife and the bush; lords of the animal kingdom or of individual species; earth, tree, river, mountain, rain, and storm spirits, as well as spirits that cause fertility or illness; spirits of possession."[6]

In many depictions of animals—more precisely, depictions of spirits in animal form—not only actual species of the bush or savannah may be represented but mythical animal beings as well. This superb capacity of polymorphic expression is a key trait of African art and underlies, like a matrix, all artistic creation on the continent. No dividing line is drawn between the spirit realm and that of human beings and animals; every sphere plays a latent part in the flux and continuum of forms. Many configurations include

references to the most diverse levels of existence. Beyond this, a large proportion of figures and masks are conceived as embodiments or representations of beings that are truly hybrid.

This multifarity of visual form reveals a multidimensional reality in which different worlds literally interpenetrate. The truth of the one world is the illusion of the next. The borderlines between these realms, to the cognoscenti, are as permeable as membranes. In states of ecstasy and trance, clairvoyants and persons possessed by a spirit overcome the barriers of physical perception. Drum beats and dance rhythms form the score that leads to an expansion of consciousness. When a mask comes on the scene in a village community, it marks the culmination of a rite in which the local spirits or villagers' ancestors are revealed. And even if these were merely figments of the human imagination, how much stronger must the belief in their reality be.

MANY STANDARD TEXTS ON AFRICAN MASKS from the early twentieth century raise their character as objects to an absolute. In fact, it was primarily art historians like Carl Einstein or art dealers like André Level, Paul Guillaume, Charles Ratton, and Carl Kjersmeier[7] who wrote on African art, arranged exhibitions or contributed loans to them. Almost no references to the appearance of masks in the context of rites or celebrations are found in their writings, and, obviously, dealers in particular would tend to consider the aesthetic autonomy of masks beyond doubt. We should recall that in the early modern period, the work of art emancipated itself from all traditional ties, claimed absolute status. There were also other reasons why it was still too early for a contextual view of the maskmaking art. Who at that period would have been interested in raffia, fur, leaves or simple textiles? Who had an eye for such "artsy-craftsy" accessories of masks as staffs, whips and fly whisks, rattles and knives?

It was not until the post-colonial era that observers attempted and became equipped to do justice to the variety of African art making. A differentiated perception of African art, combined with an abolishment of the hierarchy of genres, an appreciation of mundane materials and objects of daily use, were achievements that came in the wake of Dada, Arte Povera, Land Art, *Spurensicherung* and other, more recent directions. It was the performance artists of the 1970s who at long last opened Western eyes to the complexity of the mask dance as an all-encompassing work of art. As the West entered unexplored artistic territory with each new avant-garde and—in the case just mentioned—discovered multimedia techniques, a readiness grew to see the contexts in which masks appeared in a new light.

Process as the "content" of many recent currents in art, along with the multimedia character of contemporary art forms, finally encouraged ethnologists of art to focus "on human acts and creative processes rather than material products." Recently Frederick J. Lamp encouraged that "a series of contextual elements" be brought into the foreground: "audience, timing, light, serendipity, costuming, dance, movement, gesture, music, narrative, associated objects, staging, smells, taste, and touch." These factors would "enliven the material object in its original artistic context."[8] Not that Lamp intends to revive an anthropological interest in the general social or cultural context. Rather, he encourages us to envision the rich, multisensory orchestration of masquerade performances, of which the wooden face-coverings in museum display cases are nothing but mute remnants.

There are numerous examples of carved masks that, while unchanged in appearance, had various names and were correspondingly danced in different ways. In such cases it was solely the type of dance movements and the unmistakable air of the mask dancer that revealed what spirit was involved to local audiences. Torn from their context and isolated in a museum, such masks can no longer reflect their true identity.

WHEN NON-AFRICANS THINK OF "drums, dancing, and masks," they tend to imagine colorful masquerade festivals. In fact, masks appear on occasions of the most diverse kind. For instance, one of the most prominent masks we know from Africa used to appear mostly at night, and its presence was conducive to anything but a party mood (plate 78f.). The detached dignity of this large, awe-inspiring mask—about twice as high as a human head—its pronounced aesthetic abstraction underscored by a finish of white, kaolin clay, seem diametrically opposed to its executive function.[9] The men's association of the Fang, known as *ngil,* evidently used such masks in the persecution of sorcerers and criminals. They reputedly appeared in villages by torchlight in the middle of the night, an apparition whose drama was heightened by their white finish—fear and trembling were spread by these masks with a small mouth, often only suggested by a slit. The spirit they embodied needed no great eloquence to communicate its meaning, and even its eyes were nearly gazeless—indicators of the superior metaphysical power of the spirit effective in them.[10]

By comparison to the deadly earnest and power embodied in such masks, others give the impression of a cheerful kindergarten. Hugo A. Bernatzik once described a masquerade he saw in 1930–31 on Orango Grande (Bissagos Islands). It was accompanied by girls beating skin drums and loudly singing in statement and reply (plate 3ff.): "A female dancer with a cow's mask on her head appeared Affixed to the mask were long, narrow horns carved of wood, and in her hand the girl waved a ceremonial staff, whose grip had the form of a carved wooden figure. The staff itself was fitted with numerous small brass bells, which, along with the dancer's foot rattles, underscored the rhythm of the drum beats. The dancer bent her upper body forward, set the bells ringing, and began to stamp her feet on the ground. A few older women began, one after another, to move toward the young dancer in time with the drums and singing, and anointed her body with palm oil. Then, in the same posture as before, she broke into a loud song The orchestra and audience joined in. The dancer, still singing and kicking her legs aside and back, rushed back and forth across the clearing between the trees and houses, until finally she returned, weary, to the women drummers Suddenly there was a press of bodies. A horde of about twenty boys rushed pell-mell into the clearing, raising a cloud of dust. In their midst, on a long lead, they led a boy wearing a large, carved wooden bull mask with inlaid eyes and natural horns. Bells jingled on his ankles. The little mask dancer deported himself like an angry bull, attacking the girls and the boys around him with his horns until they all scattered screaming. One of the boys managed to leap up on the mask dancer's back, as he was accustomed to doing with real cattle. After they had set the crowd in a commotion, the boys soon vanished again, yelling and laughing, among the houses of the village. What we had just witnessed was the dance of adolescent girls who were to participate in the next initiation."[11]

As we can gather from this report, the dance included spontaneous elements, and surprises were welcome. Although such performances with animal masks had a firm place in initiation rites, the field researcher apparently had no access to these. According to several elderly men, these mask dances "were taught to the young people who were to be admitted into the tribe during their seclusion in bush schools, where they were also introduced to the mysteries of love."[12] The bull, symbol of physical and sexual prowess, was invoked in such performances by imitating its movements, all the way down to mock copulation. Yet there are also reports of sawfish and hippopotamus masks, even of cock or rooster dances performed by four young fellows "who were dressed as cocks, in costumes made of palm leaf strips. They imitated these birds by bending forward from the hips and mincing around with short steps in time to the music. Occasionally they interrupted their tripping steps with a few dust-raising stamps, then resumed fluttering around, chirping and crowing the while"[13]

THIS MULTIFARITY OF VISUAL FORM REVEALS A MULTIDIMENSIONAL REALITY IN WHICH DIFFERENT WORLDS LITERALLY INTERPENETRATE

As the same observer relates, the Bidjogo used to teach their adolescents such dances in the secluded domain of a bush camp, yet animal masks nonetheless remained a feature of public village celebrations as well. Earnest choreographic imitations of animal behavior, frank sexual allusions in grotesque form, and the repeated appearance of female clowns who caricatured the men's lust, all lubricated with plenty of palm wine, maintained a balance between cult and play, sacred and profane.

MASK PERFORMANCES ARE NOT necessarily associated with village dance spectacles alone. There are many and diverse occasions for them, and their range of meaning is broad. In many traditional communities, rites of passage and initiations are virtually unthinkable without the presence of masks. Their essential task was fulfilled especially in bush camps, where male and female adolescents were initiated. The highly sensitive phase of transition from childhood to adulthood, with its pitfalls and uncertainties, stands under the protection of masks, which, among other things, keep evil spirits at bay. Such bush camps, which usually last several weeks, are not only the place where boys and teenagers are circumcised but the site of instruction in dancing and crafts skills, in the community's proverbs and basic rules. Here youths are taught the use of medicinal herbs and the fabrication of costumes. A sacred, primeval forest is the preferred site for a bush camp,

the habitat that represents the true home of the mask spirits. These, we remember, included forest, bush and water spirits, and when girls and boys (in different camps) are separated from their mothers and families to spend a key phase in their lives in a forest clearing with teachers and wise men, sorcerer hunters and medical caretakers, the adolescents are received by and given into the care of masks. Among the Dan in Ivory Coast, for instance, their care begins with the masks' daily entry into the village to collect food for their pupils from the women—not silently or seriously but with earthy wit and charming insistence. The wearers disguise their voices to conform with the mask, uttering animal-like sounds that transform them into "spirit voices"—a kind of "acoustic masking," as it were.[14] When the children return from the camp to the sleeping hut in the village every day at twilight, they are accompanied by a protective escort of masks. And the maskers expect their wards to greet them with all due respect the next morning (plates 17f.).

Hans Himmelheber, who in 1976 had the privilege of participating, as a white man, in an initiation camp of the Dan in Liberia, reported on a ritual welcome of the arriving boys on the part of an invisible forest spirit by the name of Nana, who functioned as spiritual supervisor from a concealed shelter in the sacred woods. The greeting included questions about the language of birds and chickens. "This, then, is how *gle* are greeted, i.e., spirit beings like

DURING THEIR GREETING THE SPIRITS TEST THE NOVICES' KNOWLEDGE OF THE FOREST REALM—THE VOICES OF ANIMALS

Nana and masks This is another indication of the forest nature of these spirit entities, like the fiber and fur cloaks and forked-stick weapons of the mask figures, and above all the mask faces, which often have animal features (a crocodile's snout) or animal attributes (small horns, feathers). During their greeting the spirits test the novices' knowledge of the forest realm—the voices of animals."[15]

It is part of the psychological profile of such masks that they frequently move awkwardly and give the impression of being visitors from another realm who are unfamiliar with the human way of life. The adolescents, through their initiation, likewise become "children of the forest," and it is no wonder that when they return to their families at the end of the seclusion period, the forest-spirit masks do not relinquish them without a tearful farewell.

The decision to don a certain mask—among the Dan, a kindly *deagle* mask, a chimpanzee mask, or one of the numerous dancing, singing and entertaining masks—is not a matter of personal preference. Himmelheber reports that certain masks appeared to men in a dream—a sign that the spirits desired them to wear their mask. Often, the author continues, masks were not danced for a considerable time after the death of their former wearer, until someone experienced a vision that made him feel called as a successor. "During the initiation camp, new masks can be born People are overjoyed at such mask births, because they show that the

forest spirits are satisfied with the course of the camp. They therefore feel a desire to participate in it, embodied in masks."[16]

MENTION WAS MADE OF THE UNDOGMATIC variety of African art making. In the present context we can observe the way mask forms sometimes multiply at an astonishing rate, when in addition to the simpler youth initiation rites a people possesses a complex hierarchy of initiation and secret societies, which in turn frequently have a great number of different internal degrees of initiation. Every rite of passage offers an opportunity for celebration with mask performances, and every region, every village branch of one of the many secret societies may be distinguished by special forms of mask. The Bamana, in the landlocked West African nation of Mali, have developed a rich humus of this kind from which an abundance of mask types have sprouted (plates 31ff.). Their social life was, and in places still is, marked by initiation societies known as *jow,* which were once so great in number that rivalries sometimes arose between them in the towns and villages. Especially well-known societies are the *ntomo* and *koré,* the *jo* and *gwan,* as well as the *komo, kono, tyi wara, nama* and *nya,* to name just a few. In view of their masks, the formula "one style, one tribe" appears quite absurd. If we review the stylistic and typological variety of Bamana masks, we cannot help but conclude that they might have originated from more than the carvers of one single ethnic group. And if, moreover, we

relinquish this notion and notice how they often spread far beyond linguistic and national borders, we begin to sense the intriguing appearance of additional "stylistic" transitions.[17]

The *ntomo (ndomo)* association, responsible for the age-group of uncircumcised minors, is divided into several classes, each associated with certain animals: lions *(jaraw),* toads *(ntoriw),* birds *(kònòw),* Guinea hens *(kamiw)* and dogs *(wuluw).* Novices, who traditionally wander through the villages begging for alms and food, may be accompanied by the *ntomo* mask with its comb-like row of horns above the forehead (plate 34), which announces imminent puppet plays *(sogow).*[18] *Ntomo* masks correspondingly allude to animal physiognomies, especially those of birds. Adolescents, when they enter the *korè* association, are accepted into the adult world, an initiation accompanied by a test of maturity that includes experiencing a symbolic death. The *korè* association, too, has various classes, each associated with certain masks and animals: hyenas *(surukuw),* lions *(jaraw),* and monkeys *(sulaw).*[19] The masks are identified by corresponding facial features.

Those of the *ci wara* association are legendary. They include artful stylizations and interlockings of the traits of aardvarks, pangolins and antelopes. Although the ancestor Tyi Wara was the son of a snake, the roan antelope became central to the configuration of the society's masks. Extremely quick and sturdy, and hard to hunt, antelopes possessed ideal traits with which farmers could identify. The fact that the antelope masks appear in pairs, like a small family—a male roan antelope and a female oryx with a calf on her back—links the tilling of the fields with marriage and reproduction. The *tyi wara* carvers skilfully exploit the different appearance of the two antelope species to underscore the contrast between the genders.

No people who invoke the proximity of animal spirits in their rites and masks would be surprised when their political chiefs, *griots* (singers of epics), or religious leaders ally themselves with spirits of the bush to bolster their power, receive musical inspiration, or heighten their charisma. With the Bamana, this merger of human and animal souls takes place not only visually, in art. Such hybrid beings are also part and parcel of practical, everyday life.

Many Bamana masks have an unusually thick encrustation of patina, and their appearance—especially the masks of the *komo* (plates 31f.)—recalls that of "fetishes" which have been "charged" with magic substances. In fact the members of ritual brotherhoods bring many of their masks offerings of beverages, blood and food, adding layer after layer to their surface. If this alone augments their magical power, the attachment of pouches filled with special substances, animal horns with magic-working contents, bunches

of hair from feared animals, etc. transform them into veritable *boliw*—objects of extreme power which are at the focus of many rites. Furnished with "nourishment" by the offerings, these masks gradually experience an accrual of the magic force known as *nyama,* around which the occult thinking of the Bamana revolves.[20] A loss of "aesthetic appeal" does not matter, so long as the spiritual effectiveness of the mask is heightened. The appearance of such large, horizontally worn *komo* helmet crest masks with their antelope horns, bunches of pig bristles and raffia, thickly packed with amulettes, is occasionally disquieting, even terrifying. They seem true incarnations of wild spirits of the bush. In earlier periods they used to appear freshly anointed with sorghum beer or blood, making their effect even more dramatic—they seemed like walking *boli* altars charged to bursting point with magic powers. The contrast to the *deangle* face masks of the Dan (plate 17), incessantly joking and laughing, could hardly be greater—the charm of ideal female beauty in the service of boys' initiation versus an accumulation from the accoutrement boxes of medicine men who know their occult business.

Like their neighbors on the east, the Dogon, the Bamana have one of the richest mask traditions in Africa. Although the continuing waves of Islamization and Christianization have buried many customs, here, unlike several other regions of Africa, many traditions are still honored. Occasionally a recourse to animistic religion can even be observed. The habitat of the Bamana in the hinterlands, which led to a very belated colonialization and submission to European rule, has proved advantageous for the survival of their customs. Then, too, this agricultural people continued to observe the faith of their fathers even after their leaders had converted to Islam. As a comparison with a coastal country like Senegal indicates, in Mali mask traditions still flourish, while in the immediate hinterland of Senegalese harbor towns such practices are now seldom to be found.

THESE FEW EXAMPLES MAY suffice to indicate how risky it is to speak of *the* African mask tradition. Masks not only continually change their appearance but fulfill entirely different functions, depending on who ordered them and for what audience and for what purpose they were made and performed. After having gained an idea of the mask traditions of a fishing people, the Bidjogo, and farmers, the Dan and Bamana, let us go on to those of the Cameroon Grasslands, a region that is dominated by kingdoms. It is surprising to hear that there, masks take on another identity altogether (plates 72–77). Hans-Joachim Koloss, who intensively studied the world view of the Kingdom of Oku, comes to the

conclusion that "masks are an entity of their own and do not represent ancestors or particular spirits."[21] If here the axiom "masks are masks"[22] and nothing else holds true, one suspects the presence of a largely secularized definition of masks, whose animistic sources have been forgotten or are no longer of much significance for people's everyday religious lives. The common appearance of animal masks in the Grasslands might suggest a link with nature spirits. Yet, according to Koloss, more important than spirits or ancestors is masks' connection with medicine (juju), that is, the charging of masks with magic powers. "The general conviction," he writes, "is that owing to the medicine, the masks are capable of everything conceivable, according to their type. For example, the wearer of one specific mask has the ability to carry enormous burdens, to destroy houses and trees, to cover great distances in a moment or to consume large cala-bashes full of palm wine in a second. Some masks can disclose all hostile intentions, especially hostile medicines."[23] The magic powers of the masks, the author concludes, are therefore indis-pensable to pursue and punish workers of witchcraft or evil magic, or to guarantee the success of an armed campaign.[24] A similar charging of masks was already seen in the case of the Bamana, whose komo masks bear an amazing similarity to 'fetish' altars (plates 31f.). In contrast, in the Grasslands the gris-gris are not directly attached to the wooden part of the mask but to the dancer's costume, nor are offerings made to masks in this region. While the variety of masks among the Bamana may be partially explained by a hierarchy of intitiations, these seem to play no special role in the Grasslands of Cameroon.

There, masks are owned by secret societies, war, medicine and special mask societies, and by the most important association of all, the kwifon, whose prime task is to control the power of the king. Masks serve to legitimate these societies and are used, for instance, to enhance the protocol of their public appearances. An official announcement on the marketplace, for instance, is given additional weight by the presence of a mask. Finally, funerals become superb masquerade festivals, especially when the local societies are reinforced by delegations of maskers from surrounding areas. Renowned are the great mask groups of the Grasslands, "families" of up to twenty masks, whereas a regular troupe usually averages twelve. Such groups are composed of a great variety of masks in human and animal form. Towards the end of the 1970s, for instance, the fifteen-mask group of the mukong society of Ngashie (a branch of a royal clan by the name of Mbele) had, in addition to six anthropomorphic masks, nine zoomorphic ones: two buffaloes, a dog, a monkey, a bird, a bat, a ram, an antelope,

and an elephant.[25] Indispensable even for the smallest mask group is the leader's mask, kam (along with its female counterpart, ngon), which appear with a human face, as a bird or buffalo. These masks enter the dancing area first and leave it last. The end of the train is brought up by a second leader's mask in the shape of an elephant, if a royal mask society is involved, or of a buffalo. Although all of these masks have a face, they are usually worn horizontally or at a slight angle on top of the dancer's head, that is, with the eyes looking skywards. A stylistic feature of these masks is the impression they give of being cheerful and well-fed, conveyed by their goggling eyes and fleshy mouths. Although "baroquely" exaggerated, the human faces are quite realistically rendered, as are the animal masks, which are only slightly stylized and their original models easily recognizable. Transitions between the species tend to remain the exception.

Although the Grasslands masks with their full, rounded, soft features have become a veritable symbol of the art of Cameroon, mask costumes without wooden face or headpieces are considerably more common and often associated with greater authority. The effectiveness of these masks does not depend on artistic adornment, since it is already assured by their association with magic medicine, one reason why Grasslands masks have maintained their significance down to this day. Masks without wooden face portions consist of an artfully woven or crocheted material that is pulled over the head like a large stocking, and a textile cloak or garment. Feather costumes—like the color red— are reserved for the kwifon.[26] In former days, people went bare to the waist, and only maskers wore costumes, a distinction between everyday life and ceremony that has since become blurred.

WITH THE MASK TRADITION OF THE CHOKWE and relat-ed ethnic groups who inhabit the inmost regions of Central Africa (where Congo, Sambia and Angola border on one another), we come to an area with a solidly rooted ancestor worship (plates 97–100). There the masks are called makishi, and they appear principally in connection with the circumcision and initiation of adolescent boys (mukanda). They protect the bush camp from undesirable groups of persons, shield the novices, or augment the authority of the instruction by their presence. "Makishi represent the spirits of deceased individuals (áfu) that return to the world of the living to guide, assist, protect, and even educate members of a community on important occasions," explains Manuel Jordán.[27] In this region, a net garment forms the basic component of a mask, which is fully effective even in the absence of a wooden headpiece. Traditionally such garments are fabricated laboriously

CERTAIN MASKS APPEARED TO MEN IN A DREAM—A SIGN THAT THE SPIRITS DESIRED THEM TO WEAR THEIR MASK

of root raffia, a material that likewise invokes the sphere of the ancestors—the earth in which they are buried. According to Jordán, the masks also appear at annual confirmatory ceremonies for chiefs, or even at modern political campaign events. Especially striking mask characters are *pwo*—symbol of feminine charm (plates 97f.)—which, similarly to the *deagle* masks of the Dan mentioned above (plate 17), serve as mediators between the bush camp and the villagers, especially the mothers of the circumcised boys. *Chihongo* is a male ancestor spirit who embodies power and wealth, and accordingly is danced only by a king or his sons. The likewise male mask figure *chisaluke* appears at the conclusion of the initiation, which lasts several months. In many cases a kind of "godfather mask" for each participant in the bush camp, *chisaluke* determines whether they have in fact mastered the dances they have practiced. This mask concludes the bush camp with occasionally eccentric performances on house roofs or termite mounds, behaving like a trickster: "In his performances chisaluke incites the crowd by running around the village recklessly, climbing on houses, granaries, and trees, and dancing suggestively with his phallic appendage, called a *fwifwi*, with which he 'impregnates' everything and everybody."[28]

The Chokwe and their neighbors have a good hundred mask figures, which are viewed as embodiments of ancestors even when they bear European features (including abundances of facial hair)

or the traits of animals such as pangolins, baboons, hornbills, or pigs. The Chokwe masks with an aristocratic air signify personalities from the dynastic past. "The masks of the East Angolan cultural region form an hierarchic order, and some of them represent historical personalities, members of the household of the ancient *vamyene* (rulers, kings, chiefs), their officials and retinue. The memory of an epoch of mighty rulers in East Angola ... finds an expression in the mask traditions. Sometimes, it would appear, earlier rulers themselves are commemorated in mask form, for instance in the Chokwe masks cikunza ... and Kalelwa In these two masks, Chokwe kings of earlier centuries are depicted."[29]

A CLOSER SCRUTINY OF VARIOUS MASK traditions compells us to revise our notions of what the term "mask" signifies in Africa. The results may surprise especially those who have become accustomed to a uniform picture of African culture. This picture reflects the colonial viewpoint of "forced collectivization," when blanket judgements were passed on Africans and *art nègre*. In the appearance of masks, representatives of the colonial powers tended to see an unleashing of elemental instincts and superstitions rather than expressions of a highly complex cultural system, everchanging and full of nuances from region to region.

According to a more recent ethnological interpretation of these cultural systems, the performance of masks is also a means

to counterbalance the discrepancies and social asymmetries—especially in the relationship of the sexes—that exist in every society. By seismographically reacting to shifts in the social status quo and group dynamics, mask culture is reputedly capable of exerting, as it were, a group-therapeutic effect, by inventing new masks and strategies or revising the meaning of the existing range of masks: mask typology as a form of "family constellation therapy" for a community. Even the emergence of masks has been associated with this process of social compensation.[30] Yet isn't it universally true that art, music, and rhythm are capable of having beneficial, healing effects? And that social therapy comes into play when these art forms suffuse the entire social fabric? Without the basic artistic impulse to produce something three-dimensional to move in space, without this plastic and physical will to expression, even the most sophisticated group-therapy concept would remain a paper tiger.

AS AN ARTIFACT OF MATERIAL CULTURE, a carved wooden mask has a massive, substantial presence, while the multi-media web of arts in which it is incorporated is ephemeral, diaphanous—it represents exactly that field of associations which André Breton, quoted at the outset, metaphorically described with an eye to Oceania: "The bird, the skies, the dream." The immobile, as if petrified facial expression of a mask contrasts sharply with the dynamic character of its dance. It is this sculptural immobility of feature that defines a mask as such, and is capable of triggering disquiet, fear, even panic. Tranquillity and action are both simultaneously present. Out of this dialectic—a stasis of mimicry and an ecstasy of dance movements—the mask dance as an art form derives its evocativeness and aesthetic attraction.

It may be part of the aesthetic logic of this polar tension that carved masks must not be dynamic in any respect. Their facial features usually remain profoundly earnest, and reflect no everyday expressions or states of mind, such as laughter, anger, sulking, anxiety, aggressiveness, etc. We find neither speech mimicry, caricatural exaggeration, nor pathos of expression. If one or the other African mask type appears grotesque or monstrous to Western eyes, it is worth asking whether it strikes Africans in the same way. The expressive art of Africa has nothing in any way whatsoever in common with Western Expressionism. No demons, sorcerers, witches, or evildoers stand at the center of interest (unlike, say, Alpine or some Far Eastern masks). Grimaces, as a rule, are foreign to African masks. And it is comparatively rare for mask dances to take the form of an illustrative, historical "theater" in the sense of staged history.[31] At the same time, a

realistic rendering of the human face is the exception in Africa, and when such realism does appear, it likely can be traced back to European influences (plate 86). Nothing could be further from an African mask carver's mind than to capture a certain individual's appearance in the sense of a Western portrait.[32] Masks form a conscious contrast to experiences of the physical world. They reveal a different reality. The majority of African mask faces have closed eyes—closed to this world, but open inwardly, to another.

THE QUESTION ARISES AS TO WHAT position masks occupy within the larger context of African fields of art. The present volume attests to the outstanding mastery of mask carvers. Still, mask making is a utilitarian art—in an even broader sense than the functionally oriented art of Africa in general. The West has lifted these sculpted wooden elements of complex masquerade costumes from their original context, accorded them aesthetic autonomy, and relegated them to the museum. In Africa, in contrast, the mask dance is an ephemeral art form which is cyclically manifested—masks unfold in the process of a performance, and outside this context, their trappings remain relatively insignificant. Even though masks—in the entirety of their dance appearance—may embody or represent ancestors or nature spirits, they are not comparable to cultic images of the kind to which sacrifices were once made. Such sculptures for sacred groves, altars and ancestors' houses demanded still greater mastery on the sculptor's part, whereas masks could, and can, be carved by amateurs. This is why the plastic genius of Africa unfolds to a greater degree in cultic imagery than in masks. The formula for success "Africa = masks," as a synonym for the Dark Continent of the colonial period, is misleading and one-sided, not only when seen in this light. Nevertheless, the mask dance as a unique synthesis of the arts, an all-encompassing plastic, choreographic and musical work of art with a profound religious meaning, still remains one of the most marvellous contributions Africa has made to world art.

NOTES

1 "African art, / this is the earth, the tilled soil, maternity. / Oceanic art, / this is the bird, the skies, the dream" (André Breton).

2 It is worth recalling one of the Surrealists' bibles—Freud's *Interpretation of Dreams*—in order to grasp the extremely positive connotation of dreams in their thinking.

3 This despite the fact that he illustrated a few works from Oceania as well.

4 One is put in mind of the masks used in celebrations in memory of the dead in New Ireland (*malanggan*), especially the *tatanua* masks. These, consisting of wood, red seaweed, cloth, rind raffia, rush pith, plant fibers, etc., are true composite, plastic sculptures. These stand in strong contrast to the massive, tectonic character of the great female figures from the Caroline Islands (Micronesia), the *tikis* of the Marquesas Islands, or the sculptures of Easter Island (Polynesia).

5 In the Ngangela language region of East Angola, as Gerhard Kubik has pointed out, there is no equivalent for our Western concept of mask. Instead, people speak directly of "beings from the transcendental world"—*likisi*. Gerhard Kubik, *Makisi, nyau mapiko. Maskentraditionen im bantu-sprachigen Afrika*, Munich (Trickster), 1993, p. 22. See also the detailed discussion of the mask concept there, p. 20ff. Based on investigations conducted from the 1960s onwards, Kubik doubts that mystical experiences are involved in mask performances: "The wearers of masks in the cultures mentioned are not possessed by any 'spirit,' nor do they fall into a 'trance.' Such expectations on the part of Western observers are frequently based on a projection of occult and spiritualist tendencies onto the African data" (p. 77).

6 Iris Hahner-Herzog, Maria Kecskési and László Vajda, *African Masks from the Barbier-Mueller Collection, Geneva,* Munich and New York (Prestel), 1998, p. 24.

7 Level co-authored, with H. Clouzot, the 1919 volume *L'art nègre et l'art océanien*, followed by *Sculptures africaines et océaniennes, colonies françaises et Congo belge,* and in 1925 by *Sculptures africaines et océaniennes.* Paul Guillaume, in 1917, published *Sculptures nègres* (repr. 1931 in the catalogue of the Breton/Eluard auction) and, with Thomas Munro, *Primitive Negro Sculpture,* dealing with the Barnes Collection. Charles Ratton was the author of *Masques africains* (1931) and exerted a great influence on the exhibition "African Negro Art" at the Museum of Modern Art, New York (1935). Carl Kjersmeier, a Dane, authored the four-volume *Centres de style de la sculpture nègre africaine* (1935–38).

8 Frederick J. Lamp, prologue to *See the Music, Hear the Dance. Rethinking African Art at The Baltimore Museum of Art,* ed. by Frederick John Lamp, Munich, Berlin, London and New York, 2004, p. 14f. Robert Farris Thompson was the pioneer of this point of view: *African Art in Motion: Icon and Art in the Collection of Katherine Coryton White,* Berkeley (University of California Press), 1974. This branch of research has been expanded by Simon Ottenberg and others; cf. Lamp, ibid., p. 27, note 12.

9 It is not rare for masks to function as the executive arm of the judiciary. Hans-Joachim Koloss reports from the Cameroon Grasslands on a mask known as *mabuh,* whose tasks included pushing condemned men off a cliff. See *World-View and Society in Oku (Cameroon),* Baessler-Archiv, Beiträge zur Ethnologie, New Series, Supplement 10, Berlin (Verlag von Dietrich Reimer), 2000, p. 265. Examples of an institutionalized state terror that utilizes masks are cited by Gerhard Kubik (see note 5), p. 63ff.

10 See Peter Stepan, *World Art—AFRICA,* Munich, London and New York (Prestel), p. 20 (includes bibliography).

11 Hugo A. Bernatzik, *Im Reich der Bidjogo. Geheimnisvolle Inseln in West Afrika,* Alfeld/Leine (Alpha-Verlag), 6th rev. ed., 1950, p. 67f.

12 Ibid., p. 117.

13 Ibid., p. 153f.

14 Recalling an expression introduced by Elias Canetti, the phrase is Hugo Zemps'; cf. Kubik (see note 5), p. 35f.

15 Hans Himmelheber, *Masken und Beschneidung. Ein Feldbericht über das Initiationslager der Knaben im Dorf Nyor Diaple der liberianischen Dan,* Zurich (Museum Rietberg), 1979, p. 37.

16 Ibid.

17 "In this way the entire western half of Africa became the domain of the *kòmò* and closely related societies." Transl., for original see Patrick McNaughton, "Die Geheimbünde—*Kòmò,*" in Jean-Paul Colleyn, *Bamana. Afrikanische Kunst aus Mali,* exh. cat. Museum Rietberg, Zurich, and Museum for African Art, New York, 2001, p. 182.

18 Jean-Paul Colleyn, ibid., p. 95.

19 Ibid., p. 98.

20 Cf. McNaughton, "Die Geheimbünde – Einführung" (see note 17), p. 169.

21 Hans-Joachim Koloss (see note 9), p. 223.

22 Ibid., p. 239.

23 Ibid., p. 99.

24 As embodiments of the *juju,* an at least indirect link between masks and god and the ancestors is established, since it was they who gave men *juju* to help protect them from evil.

25 Koloss, op. cit., pp. 242–44.

26 Whereas cowrie shells, the royal textile *kelanglang,* and the use of the lizard as a symbolic animal are privileges of the royal clan, according to Koloss.

27 Manuel Jordán, "Engaging the Ancestors: Makishi Masquerades and the Transmission of Knowledge Among Chokwe and Related Peoples," in Jordán, *CHOKWE! Art and Initiation Among Chokwe and Related Peoples,* exh. cat. Birmingham Museum of Art, Baltimore Museum of Art, and The Minneapolis Institute of Arts, 1998-2000, Munich, London and New York (Prestel), 1998, p. 67. See also the essays by Elisabeth L. Cameron and Niang Batulukisi in the same volume.

28 Jordán, ibid., p. 72.

29 Kubik (see note 5), p. 110f.

30 Ibid., p. 67ff.

31 Although William Fagg saw masks at an Ife *edi* celebration which acted out an historical event—intruders from the bush being driven away with the aid of fire. "Il est vrai que certaines mascarades africaines présentent des caractéristiques narratives, surtout certains rituels de royauté du type 'cérémonies de reconstitution'." William Fagg, *Masques d'Afrique dans les collections du Musée Barbier-Müller,* Paris (Editions Fernand Nathan), 1980, p. 17. 'Historical performances' are most likely to be found in the royal courts of the Kuba or Chokwe peoples who especially value their genealogy.

32 A certain person may be "characterized" at the most by the representation of attributes, such as cosmetic scarifications or coiffure. Regarding individual personification, see Kubik (see note 5), pp. 70f., 130.

PLATES

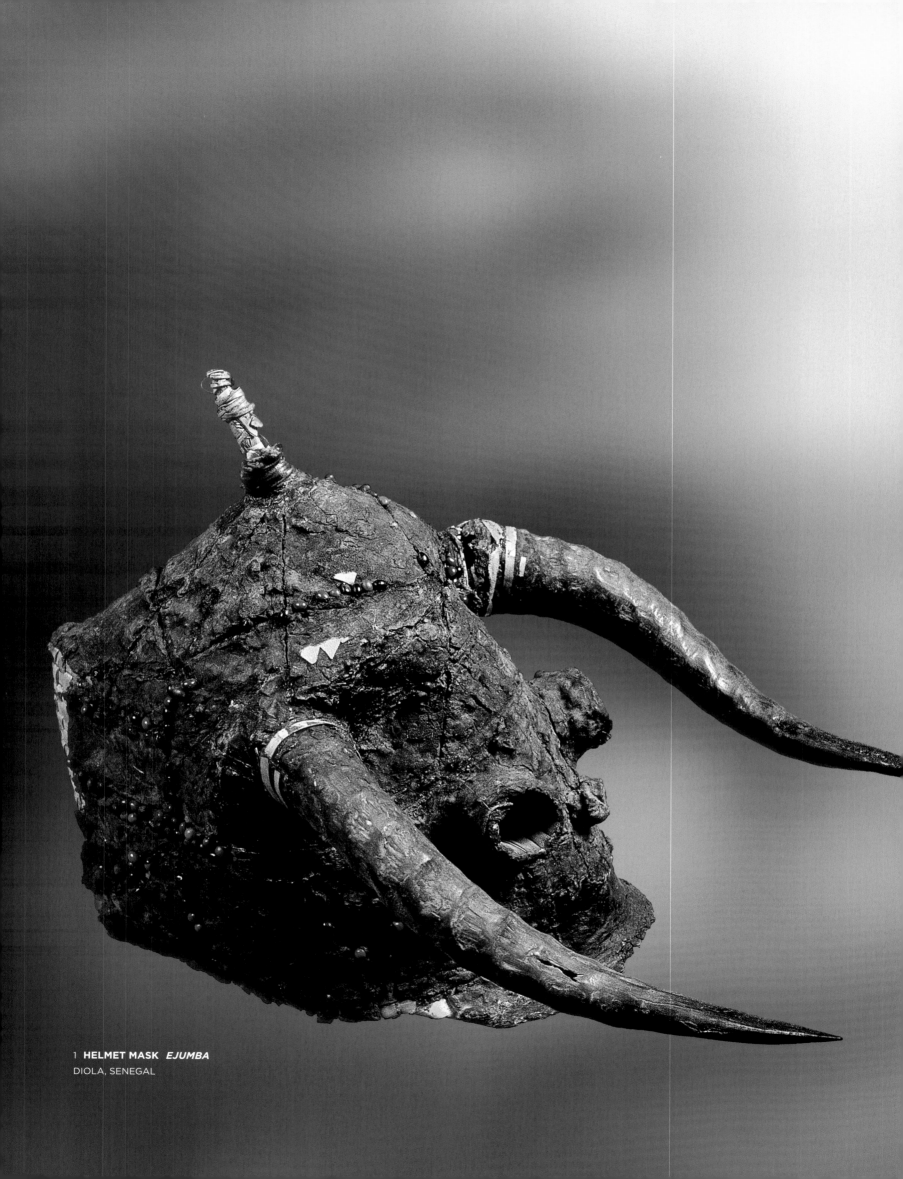

1 **HELMET MASK** *EJUMBA*
DIOLA, SENEGAL

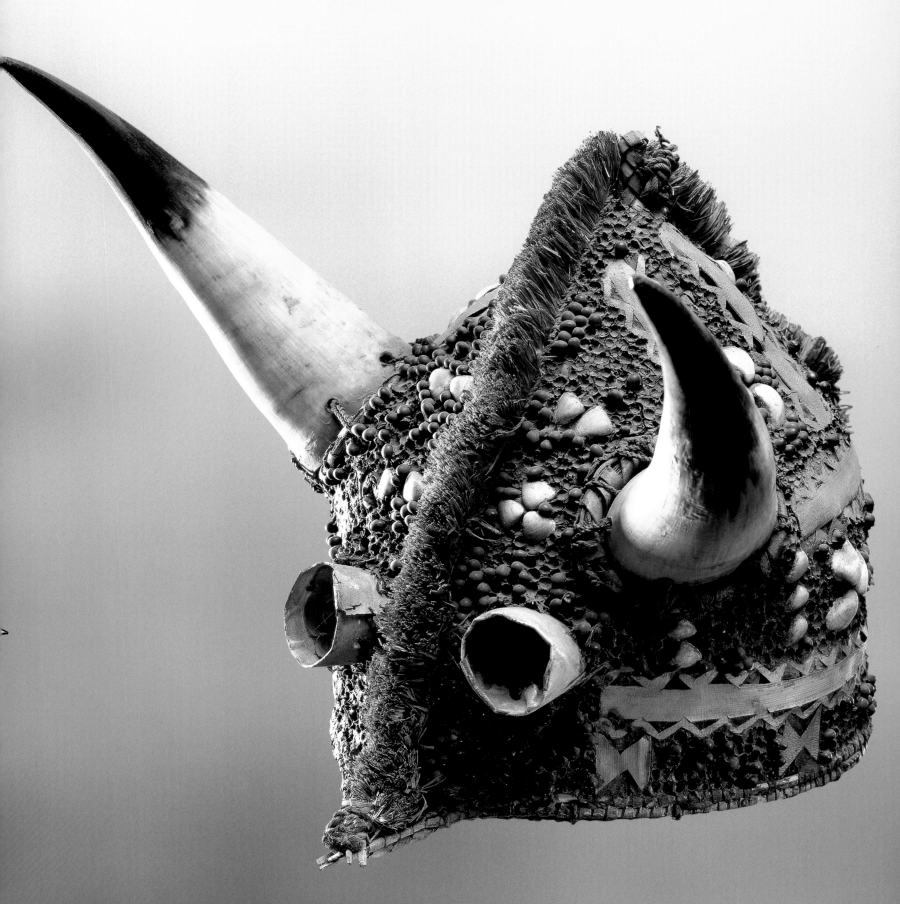

2 **HELMET MASK** *EJUMBA*
DIOLA, SENEGAL

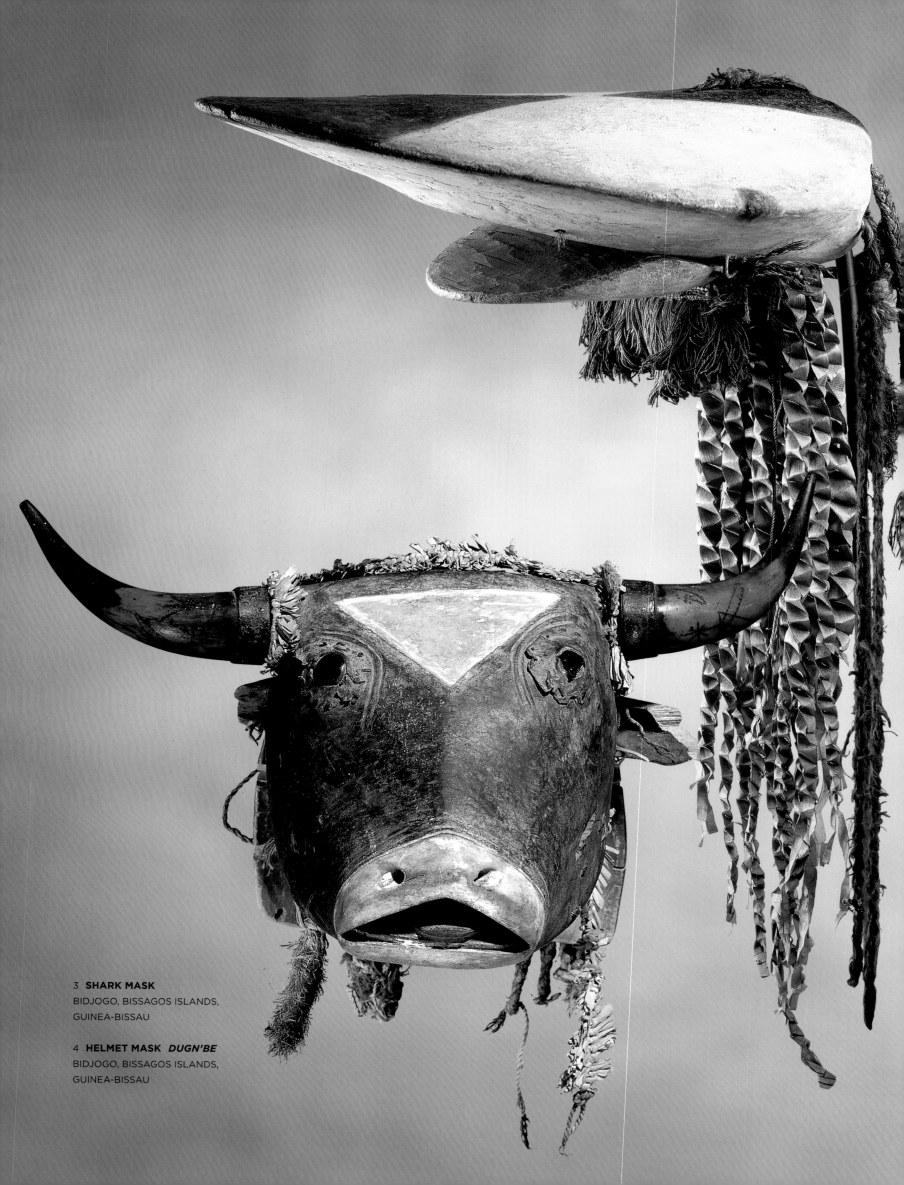

3 **SHARK MASK**
BIDJOGO, BISSAGOS ISLANDS,
GUINEA-BISSAU

4 **HELMET MASK** *DUGN'BE*
BIDJOGO, BISSAGOS ISLANDS,
GUINEA-BISSAU

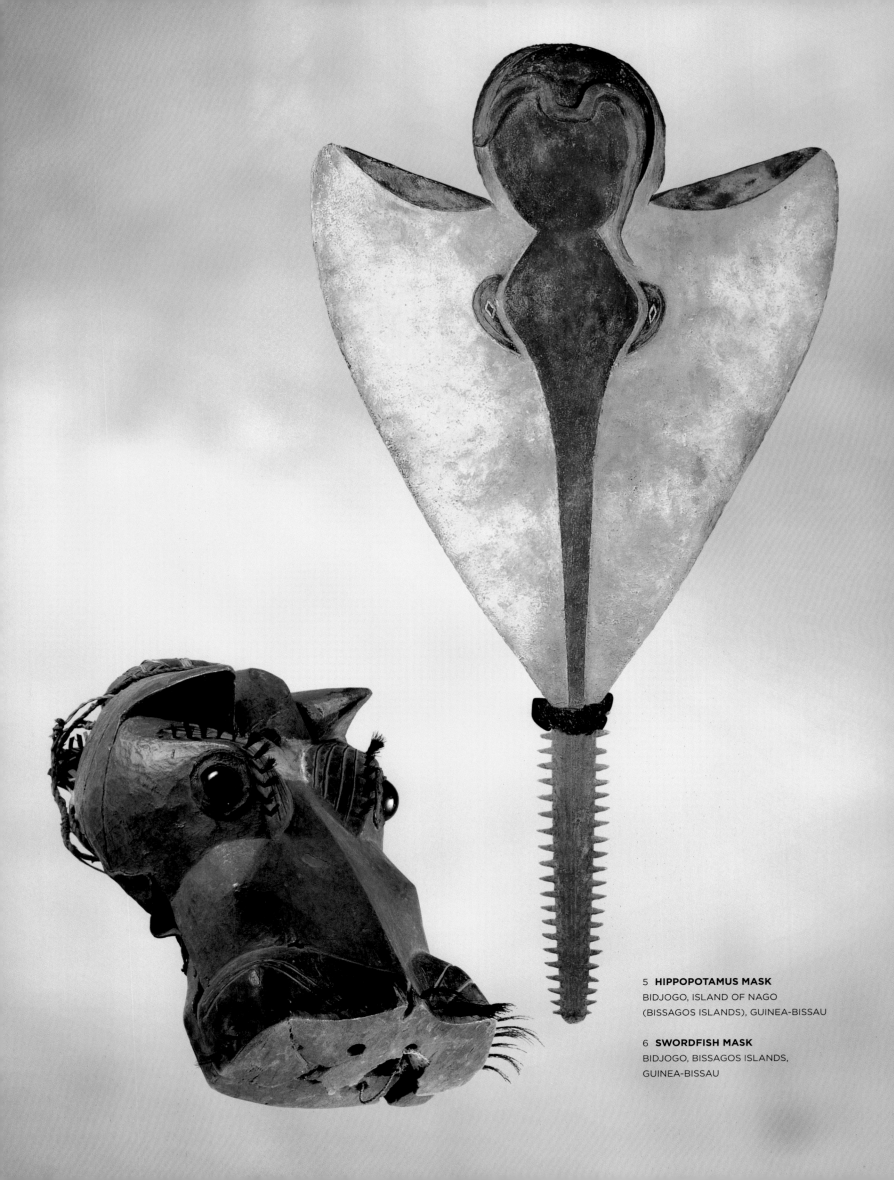

5 **HIPPOPOTAMUS MASK**
BIDJOGO, ISLAND OF NAGO
(BISSAGOS ISLANDS), GUINEA-BISSAU

6 **SWORDFISH MASK**
BIDJOGO, BISSAGOS ISLANDS,
GUINEA-BISSAU

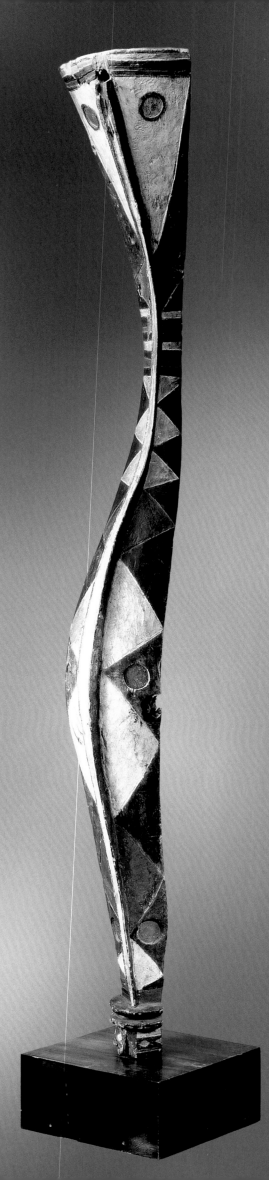

7 FACE MASK
BAGA, BULUÑITS ?, GUINEA

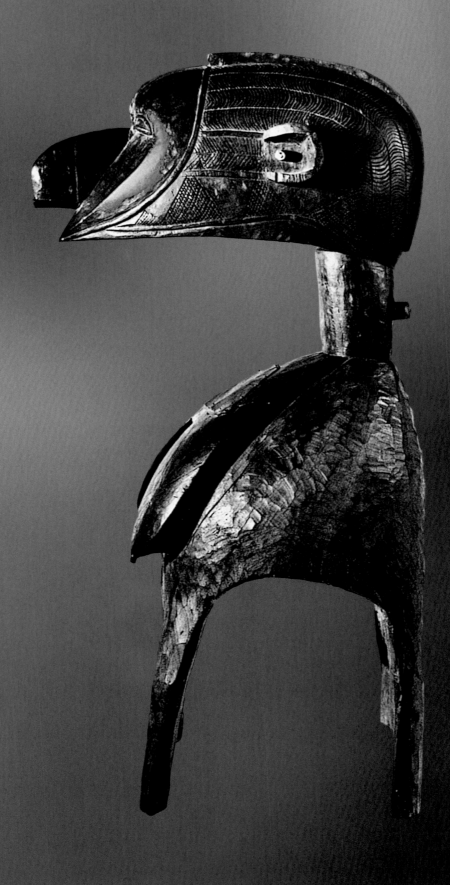

8 **STELE MASK** *MBANCHONG*
NALU, GUINEA

9 **HEADDRESS** *D'MBA*
BAGA, GUINEA

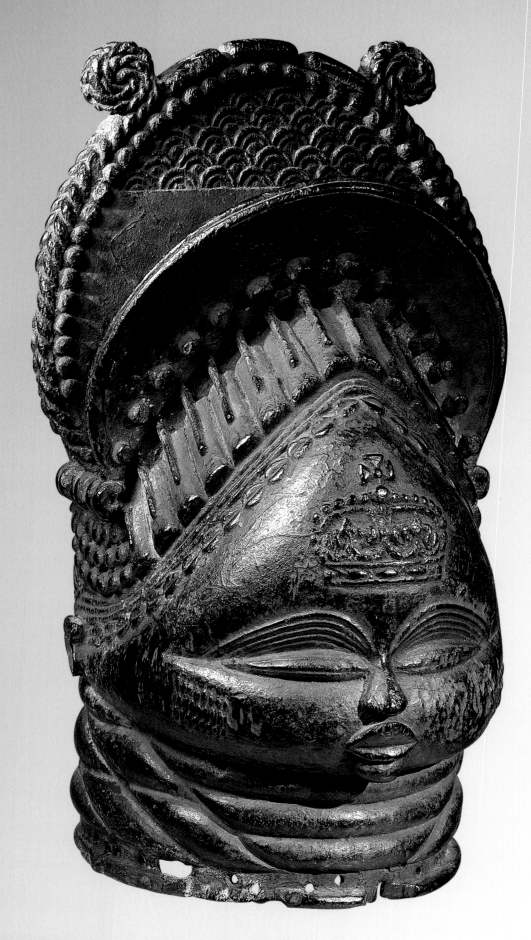

10 HELMET MASK *SOWEI*
MENDE, SIERRA LEONE/LIBERIA

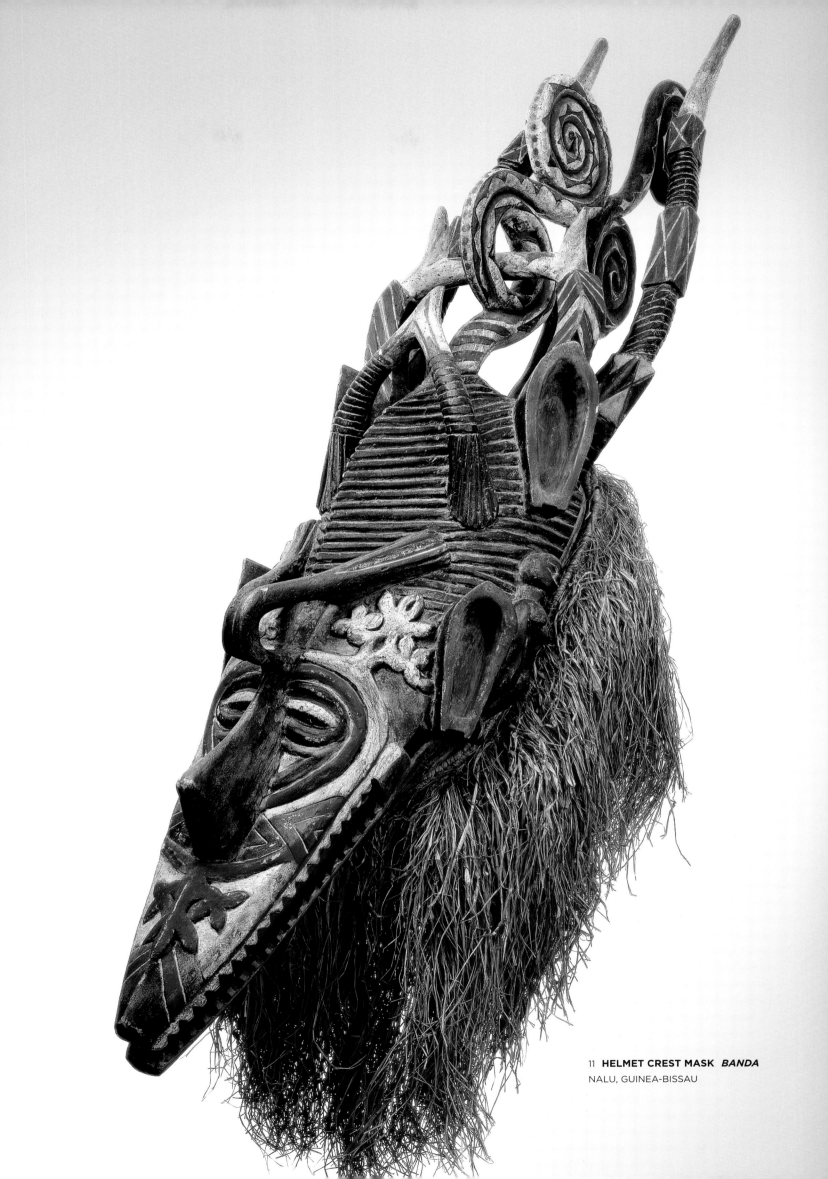

11 HELMET CREST MASK *BANDA*

NALU, GUINEA-BISSAU

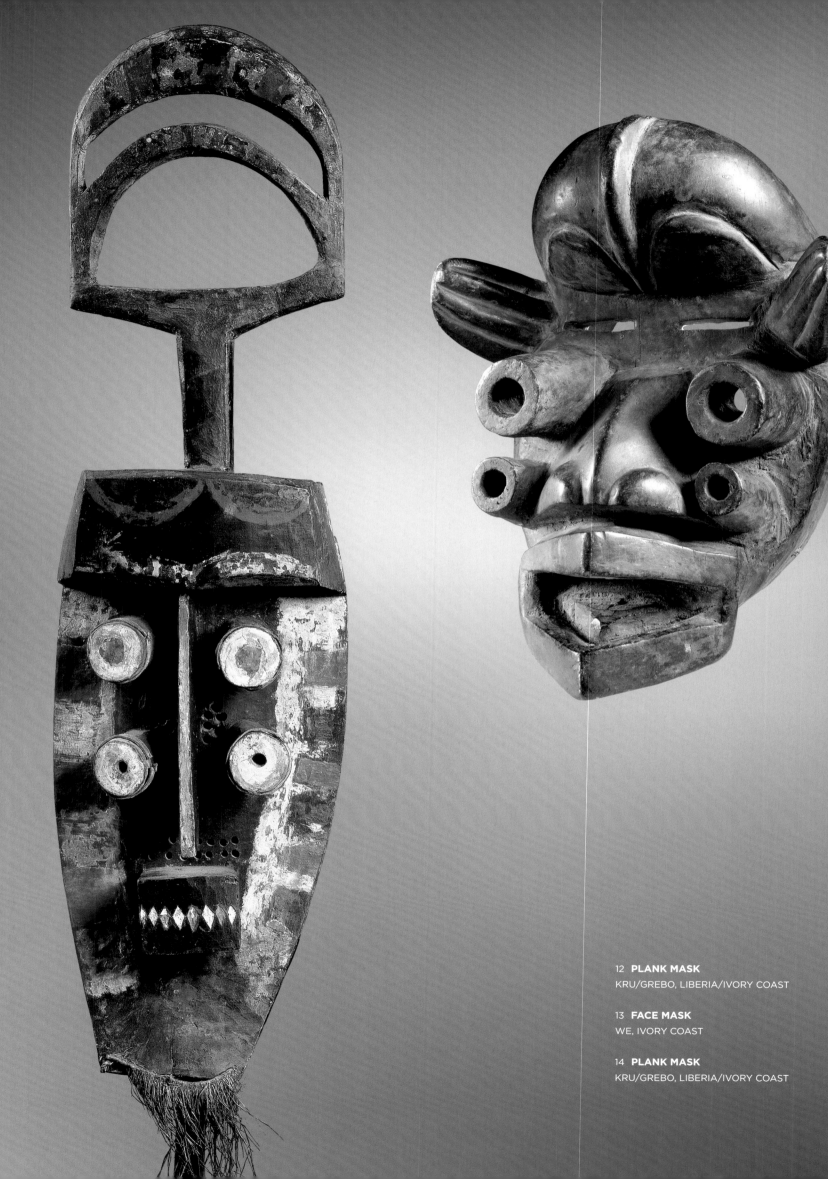

12 **PLANK MASK**
KRU/GREBO, LIBERIA/IVORY COAST

13 **FACE MASK**
WE, IVORY COAST

14 **PLANK MASK**
KRU/GREBO, LIBERIA/IVORY COAST

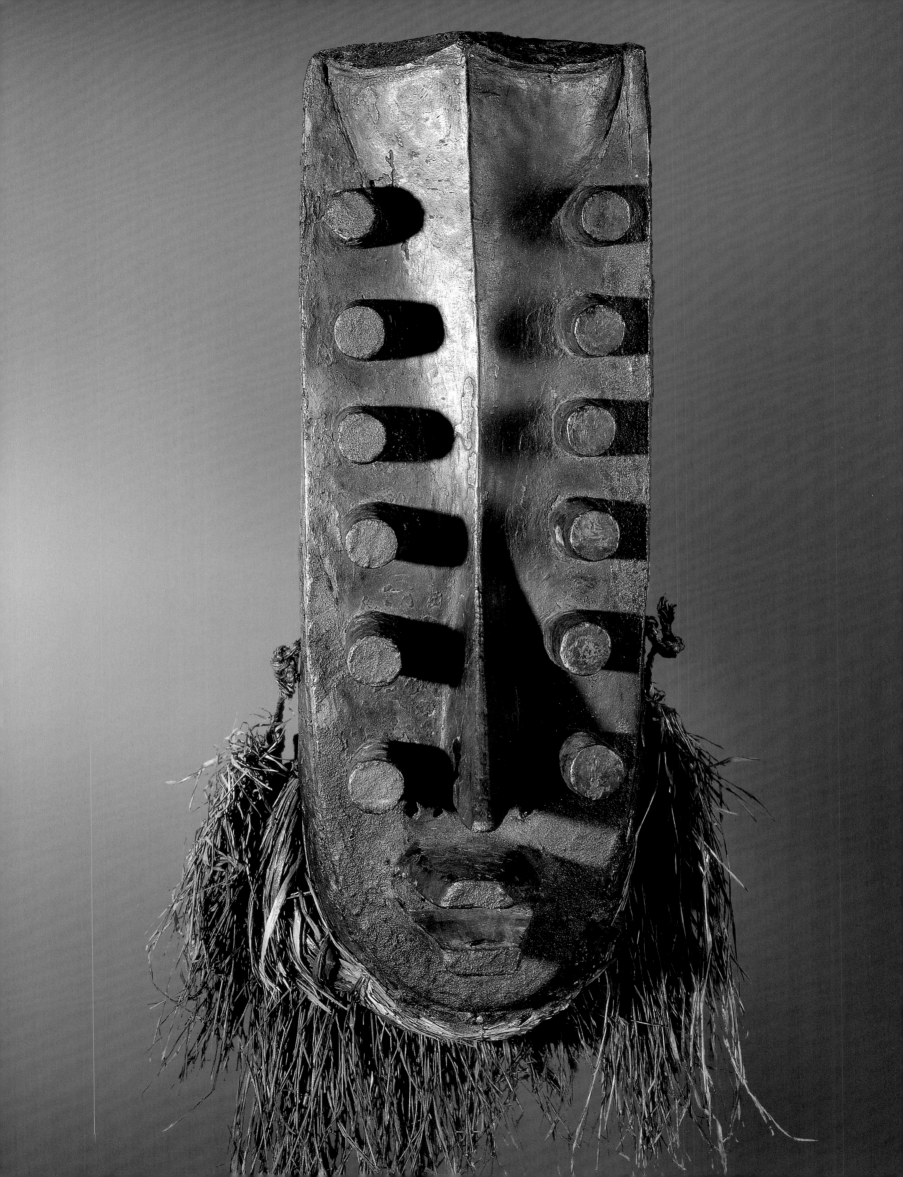

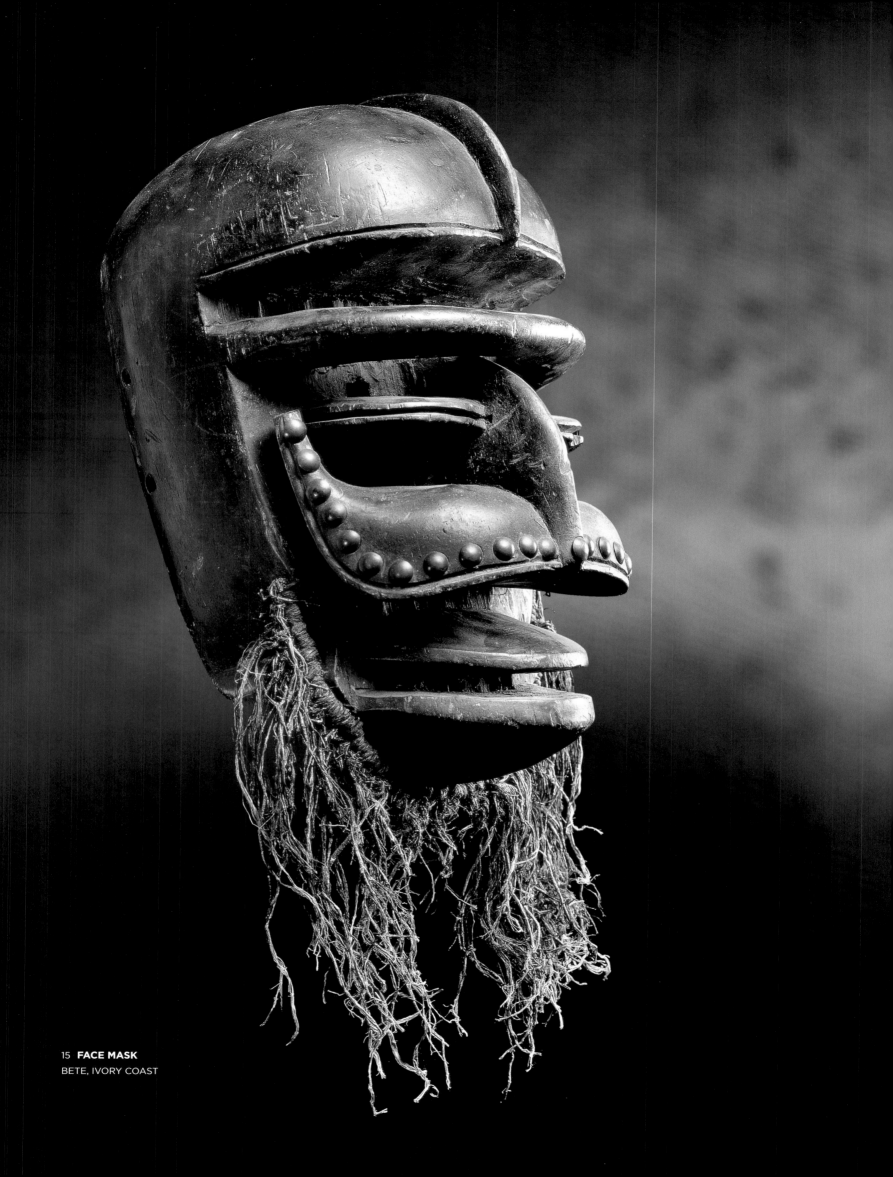

15 **FACE MASK**
BETE, IVORY COAST

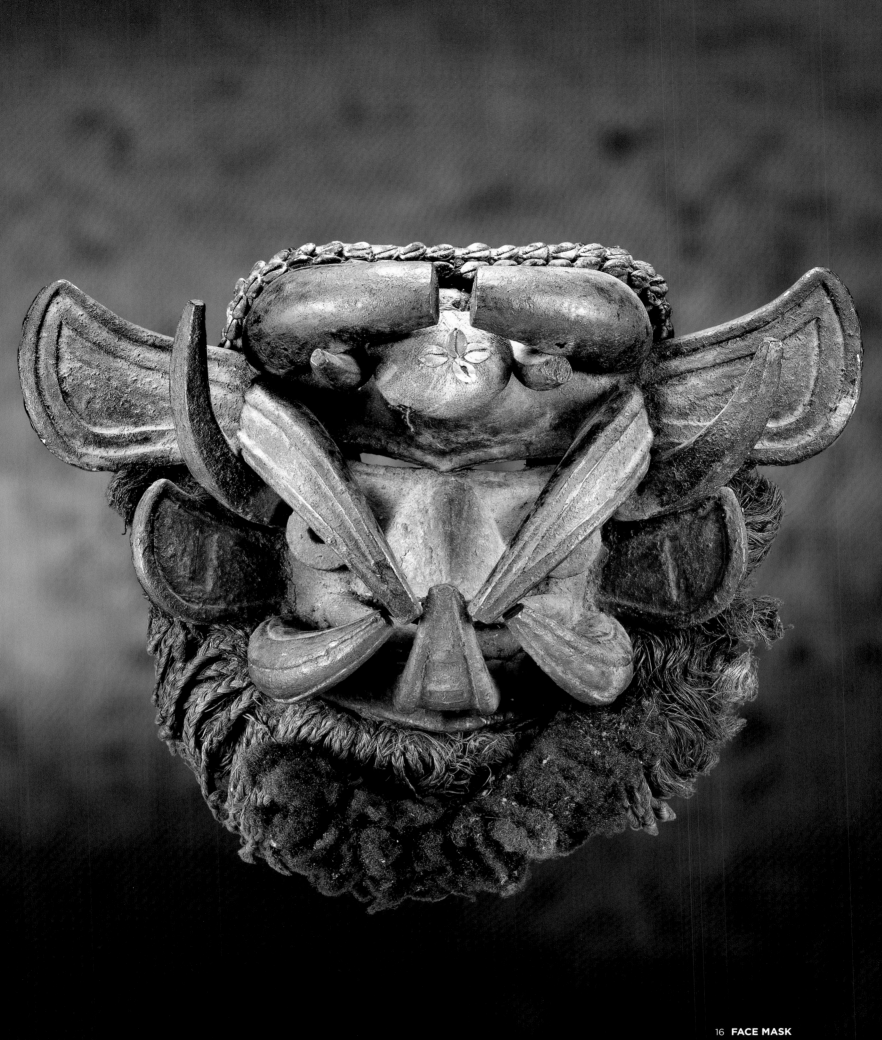

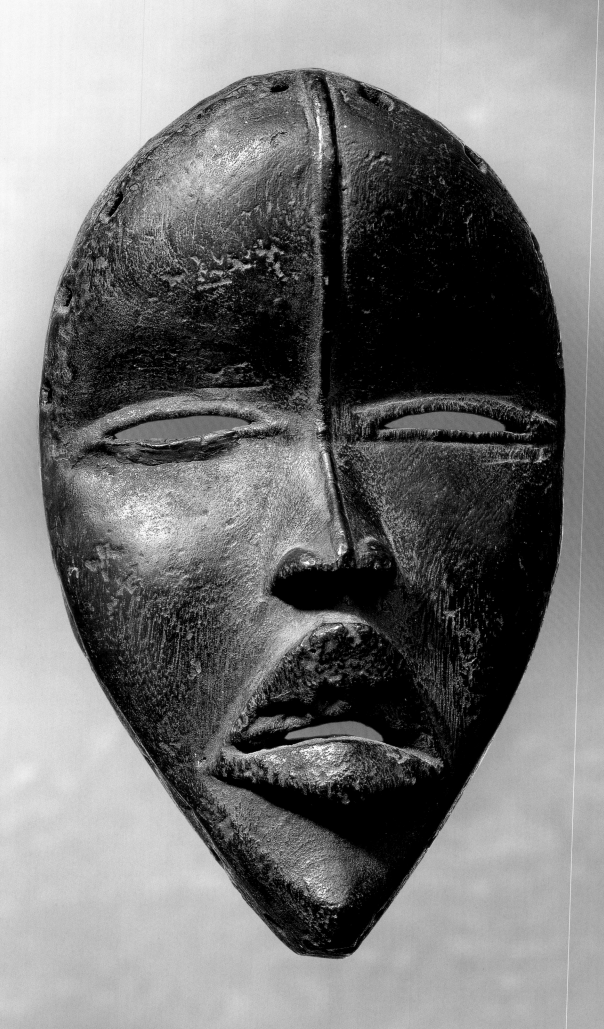

17 FACE MASK *DEANGLE* **OR** *TANKAGLE*
DAN, IVORY COAST/LIBERIA

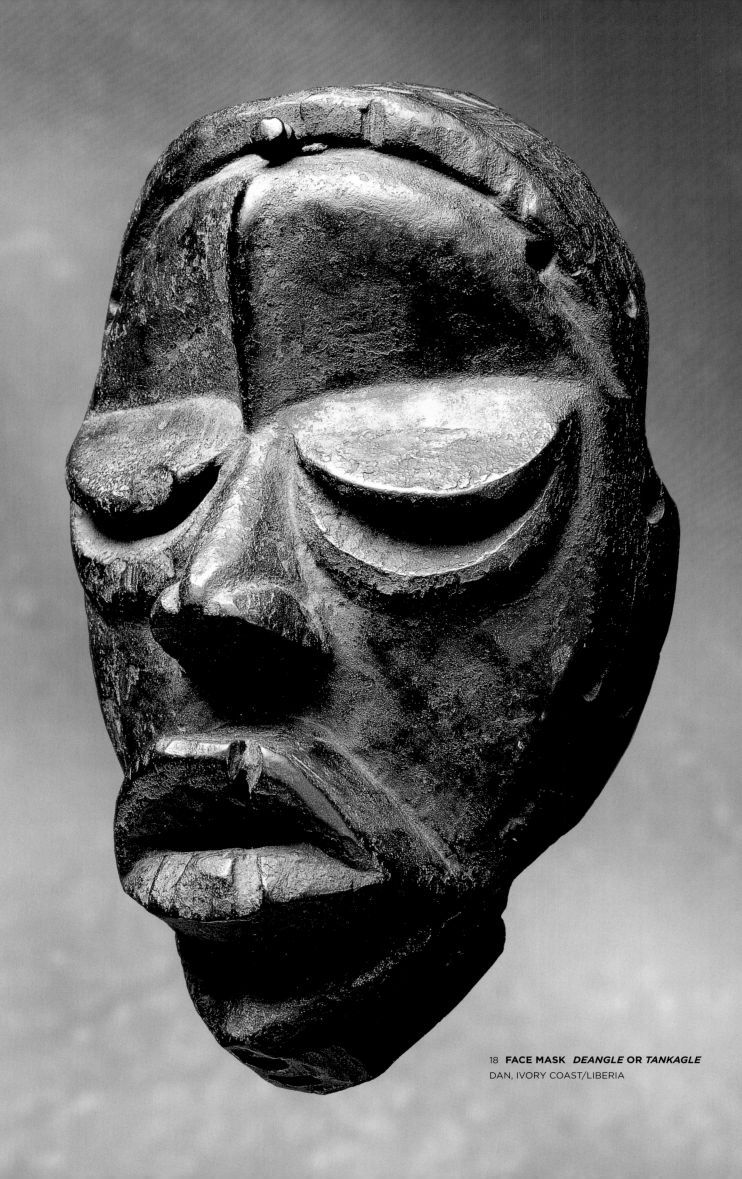

18 **FACE MASK** *DEANGLE* **OR** *TANKAGLE*
DAN, IVORY COAST/LIBERIA

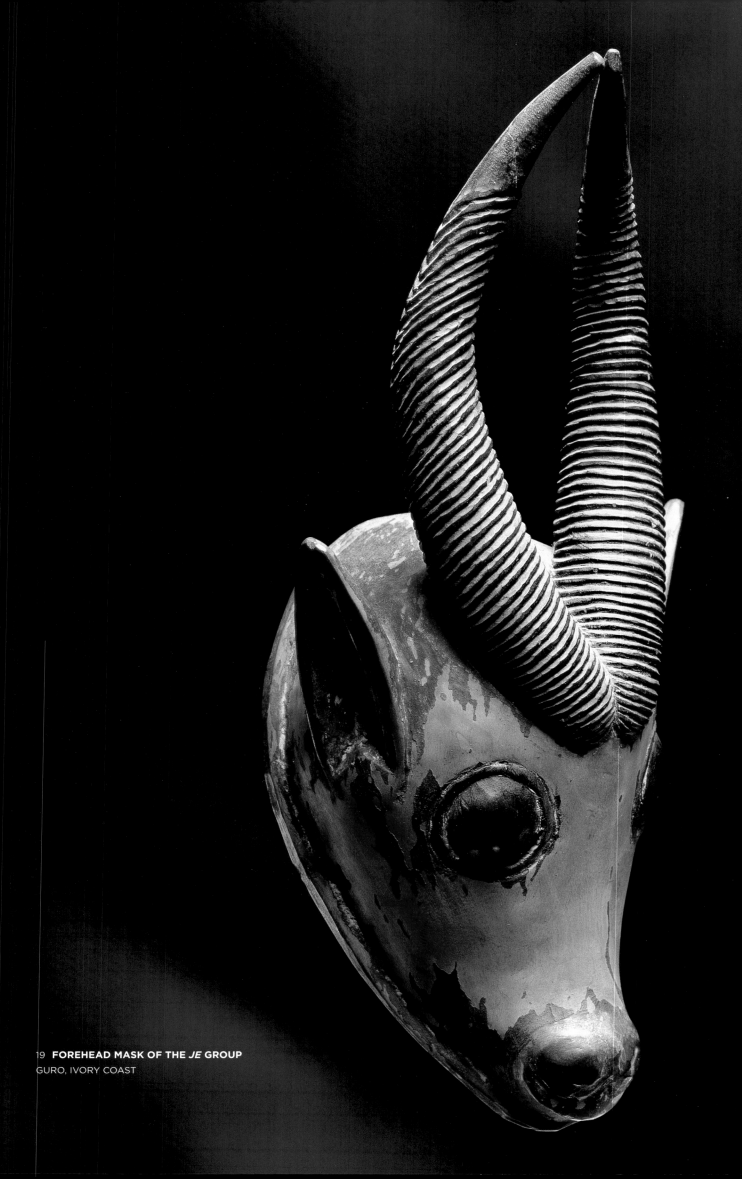

19 FOREHEAD MASK OF THE *JE* GROUP
GURO, IVORY COAST

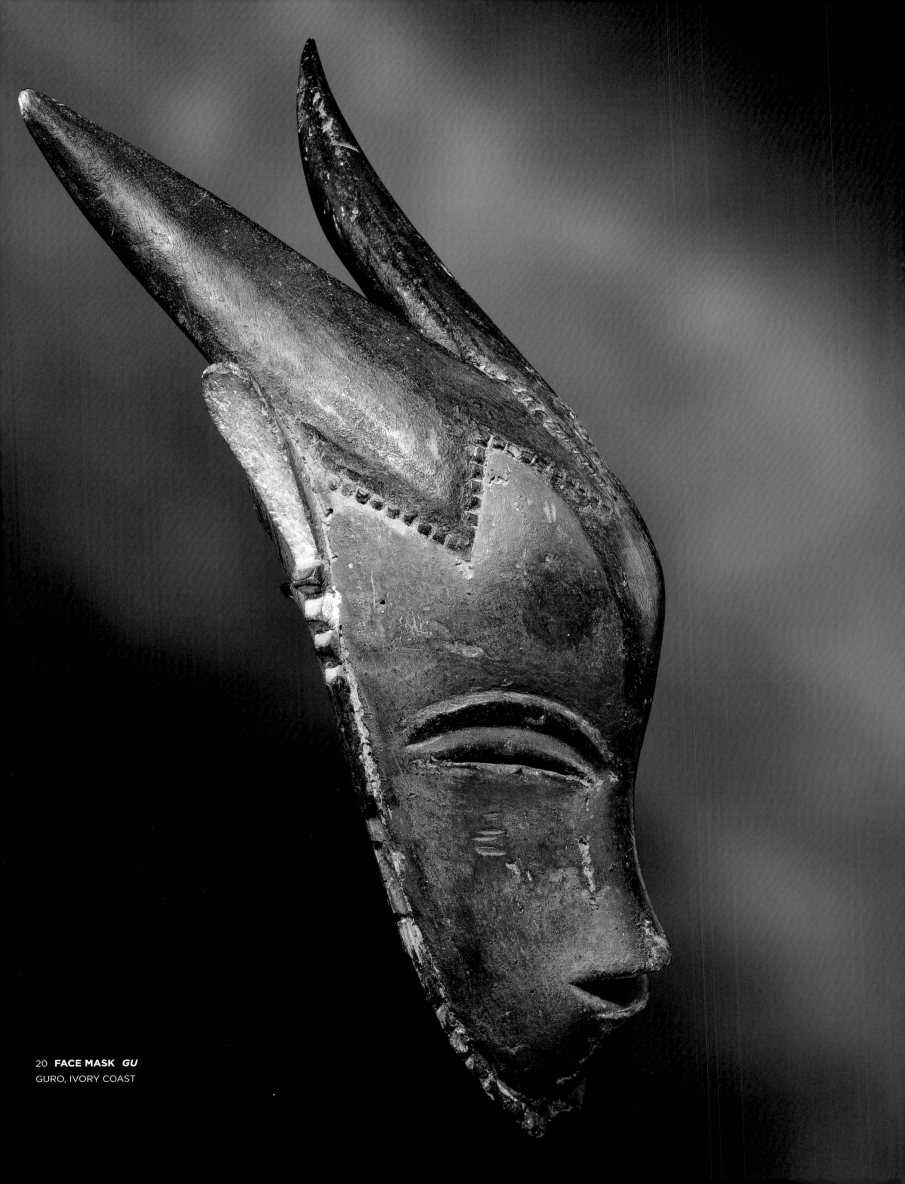

20 **FACE MASK** *GU*
GURO, IVORY COAST

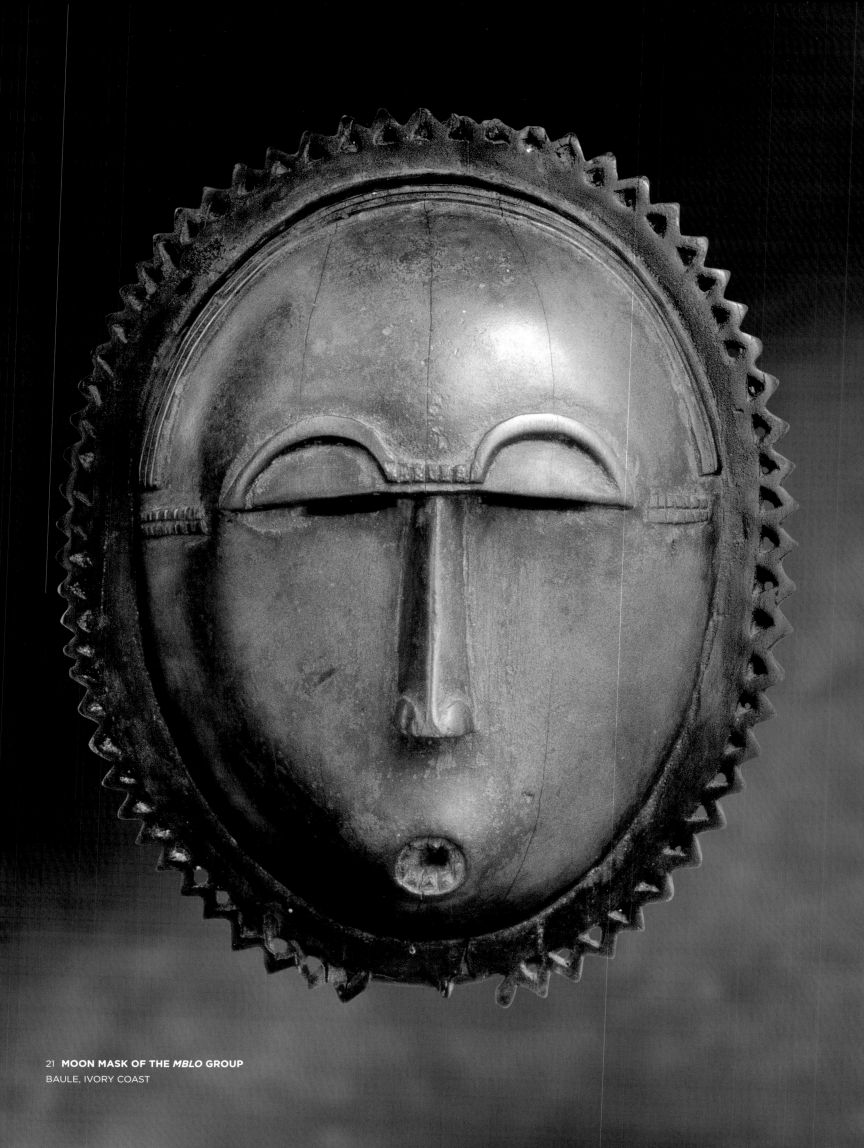

21 **MOON MASK OF THE *MBLO* GROUP**
BAULE, IVORY COAST

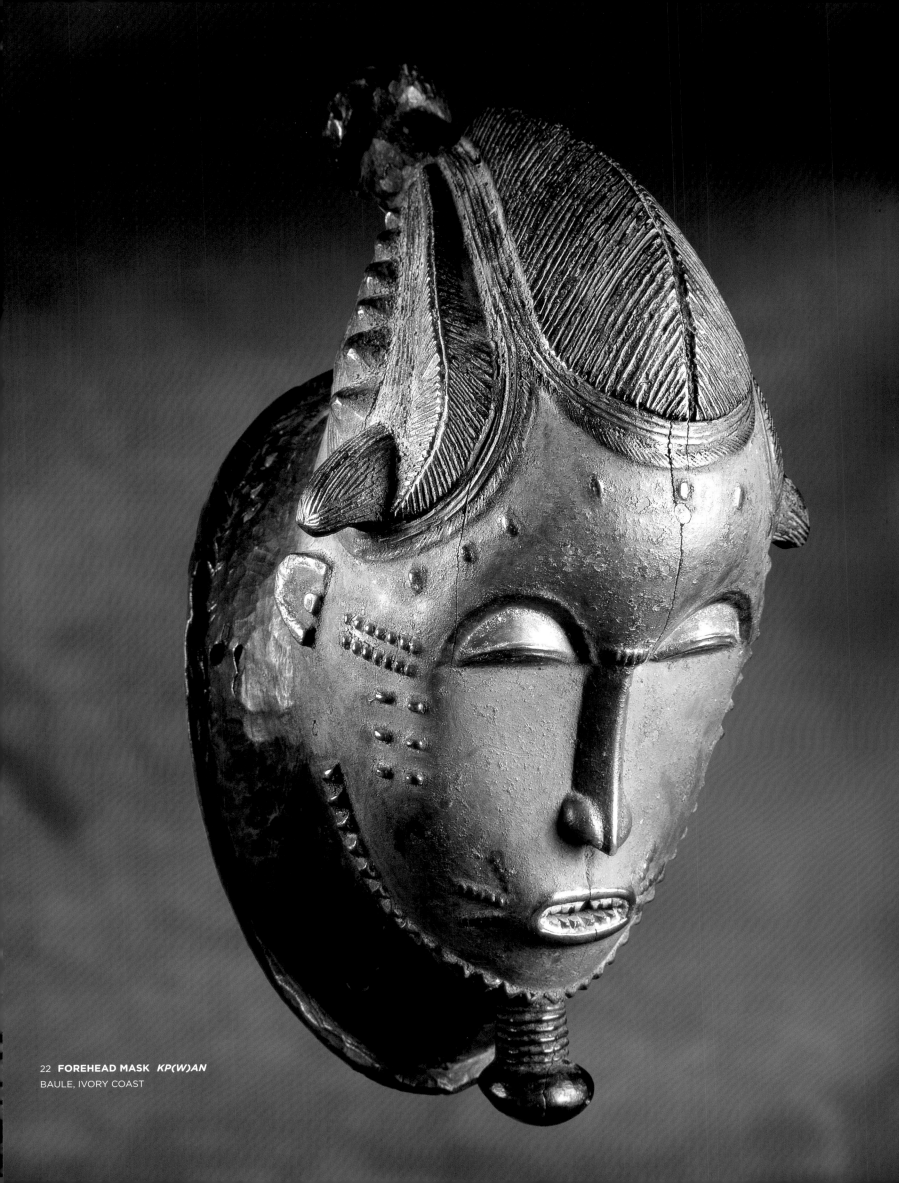

22 **FOREHEAD MASK** *KP(W)AN*
BAULE, IVORY COAST

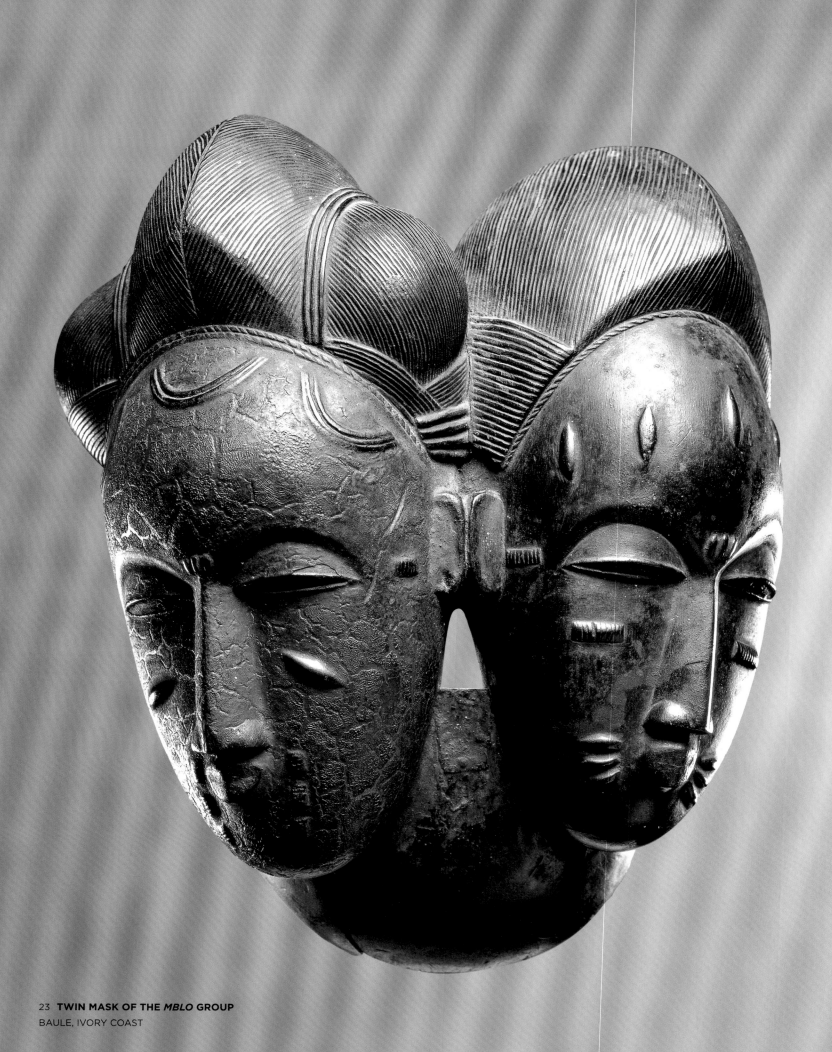

23 **TWIN MASK OF THE *MBLO* GROUP**
BAULE, IVORY COAST

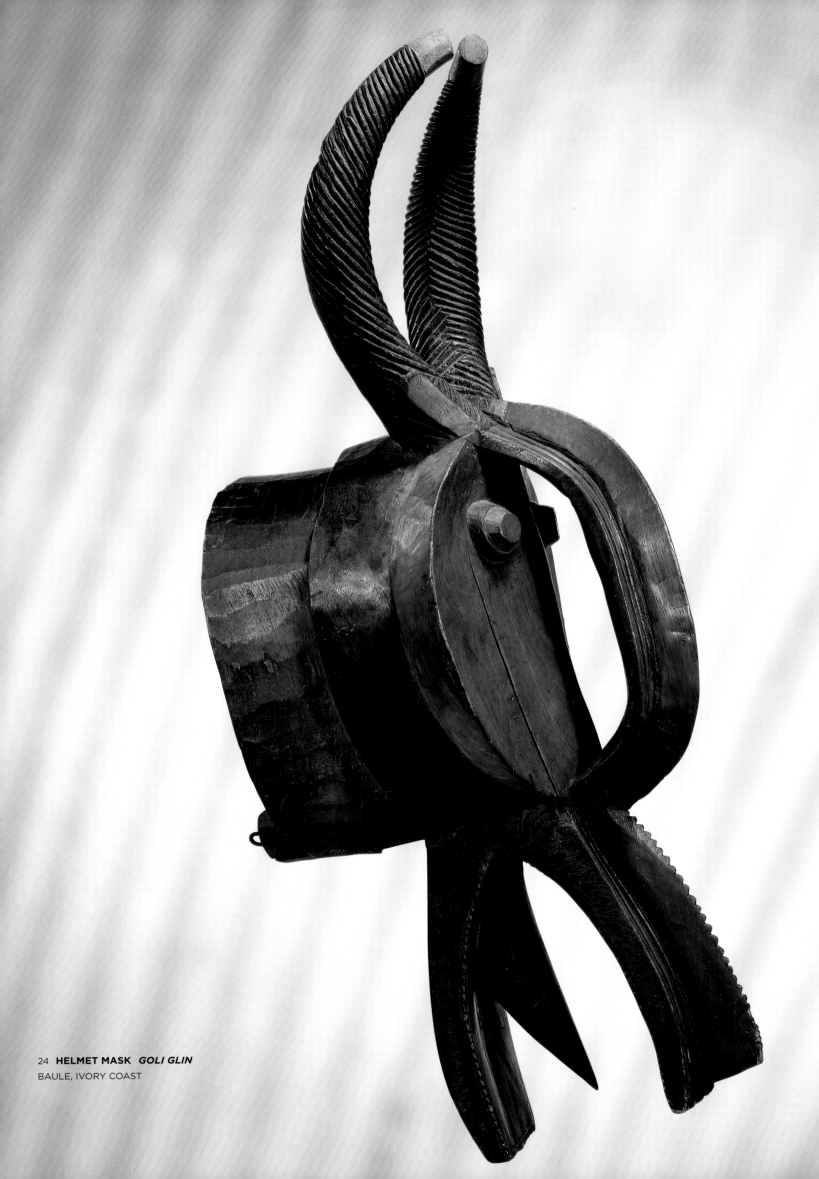

24　**HELMET MASK** *GOLI GLIN*
BAULE, IVORY COAST

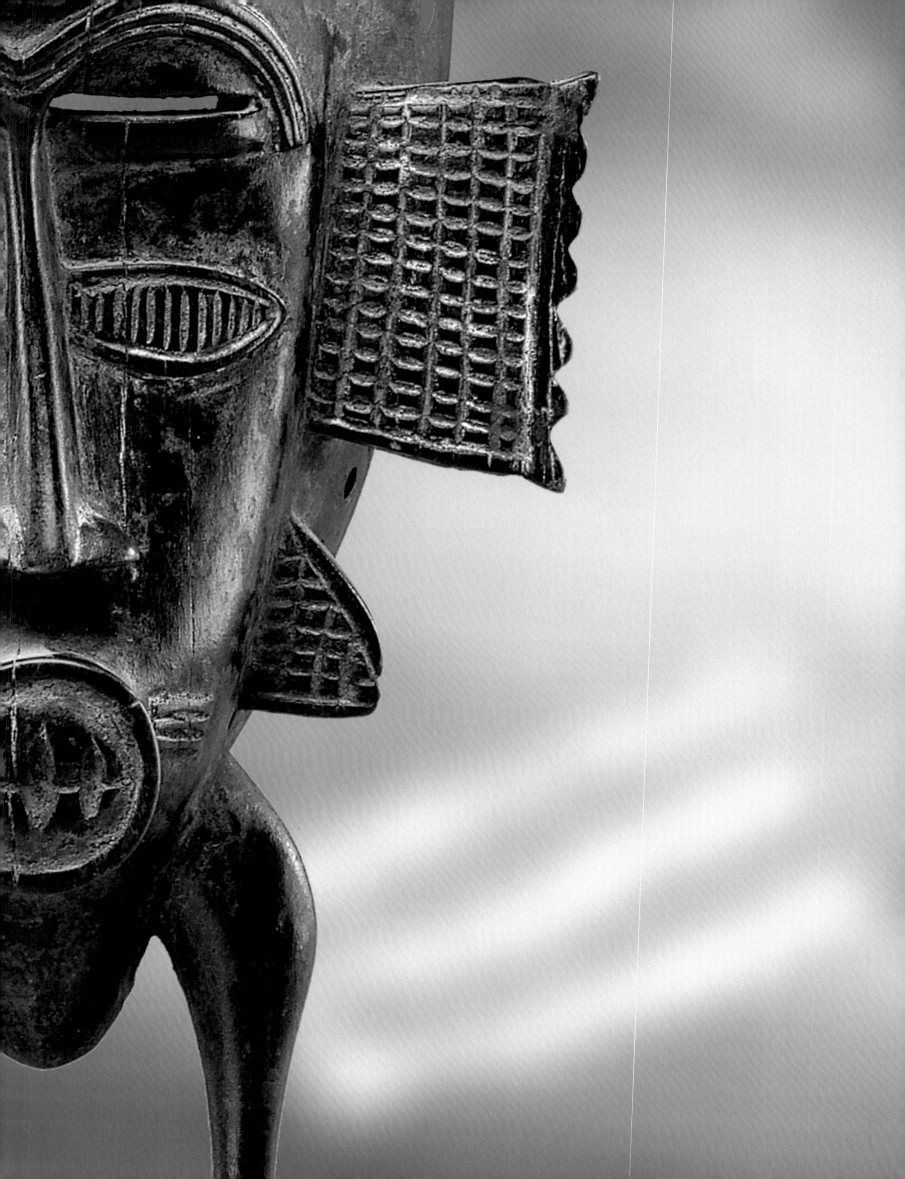

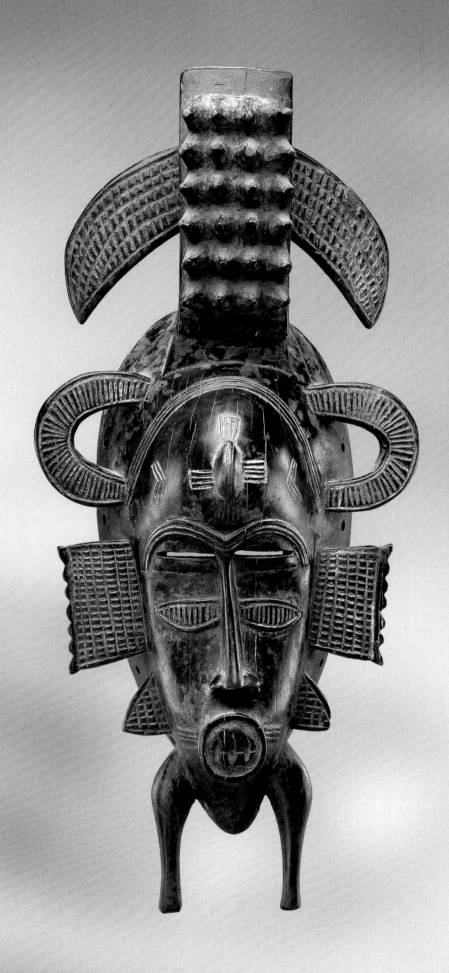

25 FACE MASK *KPELIYE'E*
SENUFO, IVORY COAST

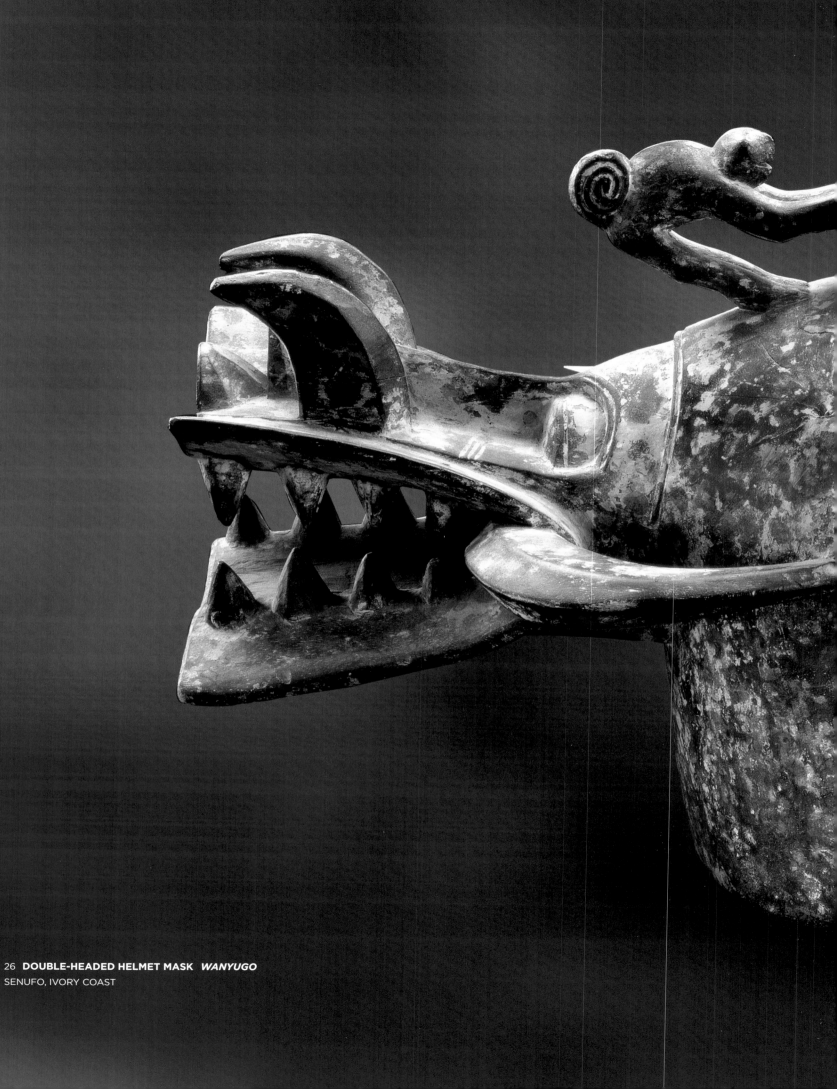

26 **DOUBLE-HEADED HELMET MASK** *WANYUGO*
SENUFO, IVORY COAST

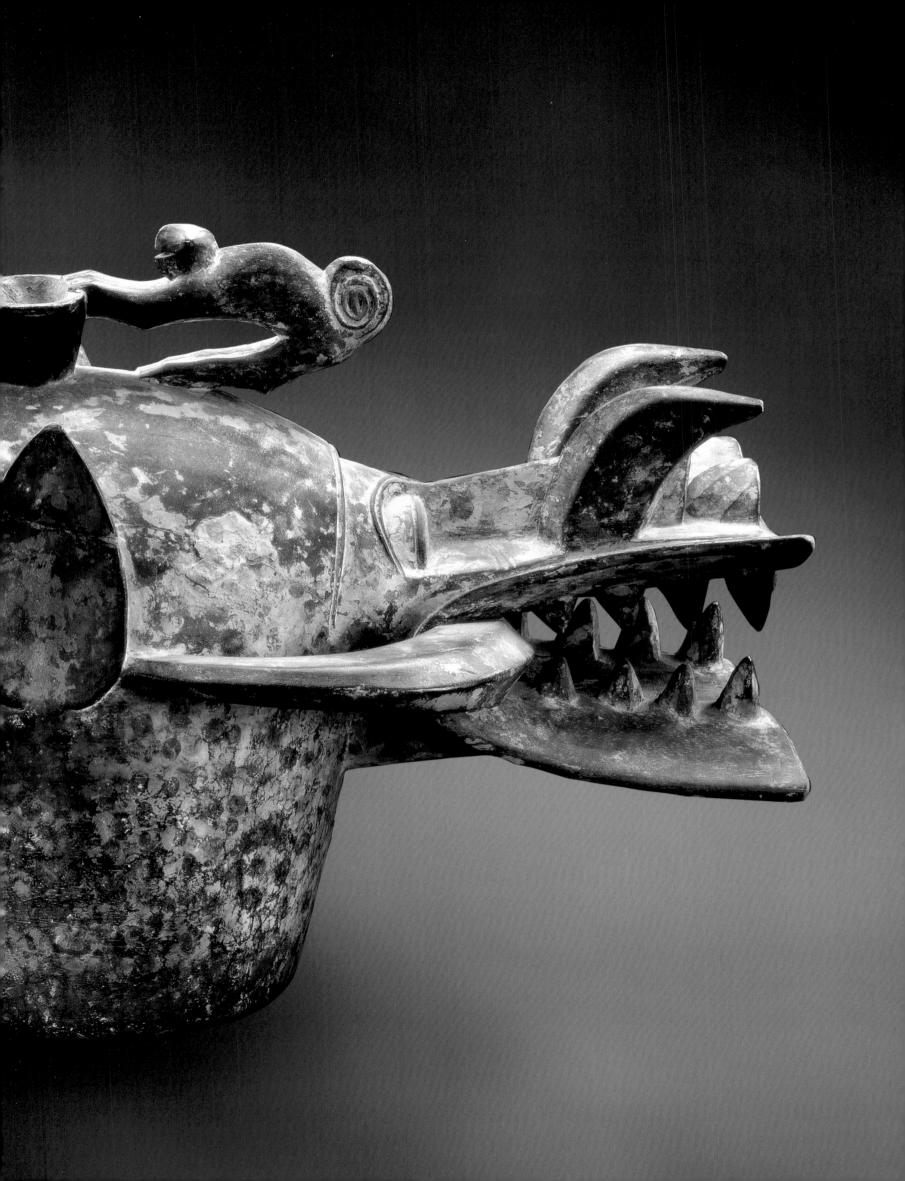

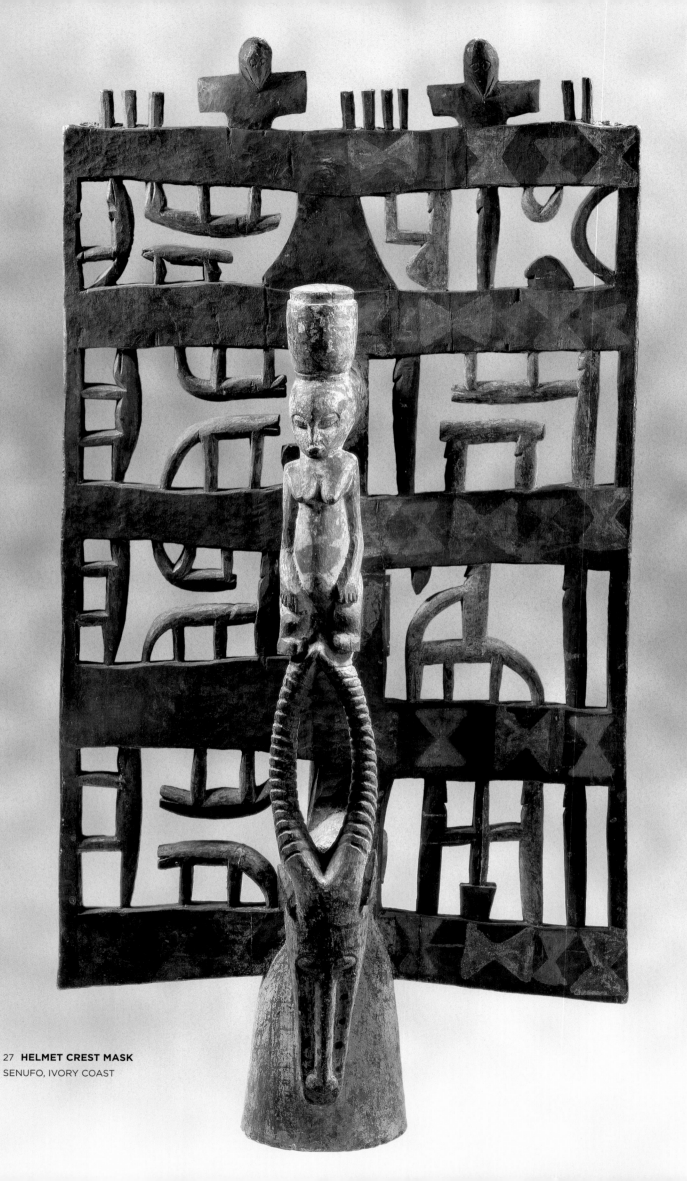

27 **HELMET CREST MASK**
SENUFO, IVORY COAST

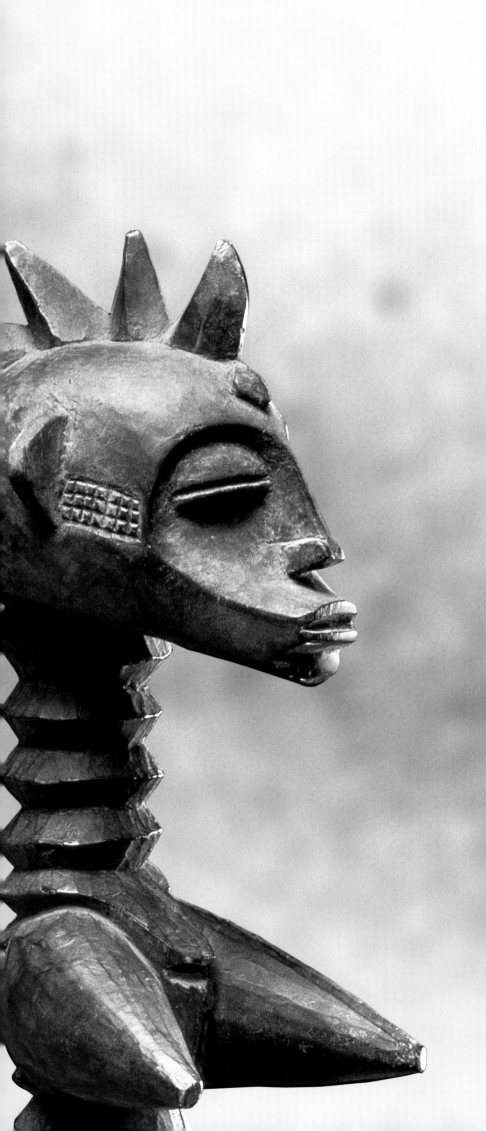
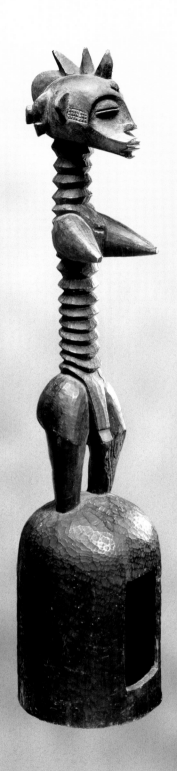

28 **HELMET MASK WITH FEMALE FIGURE** *DEGELE*
SENUFO, IVORY COAST

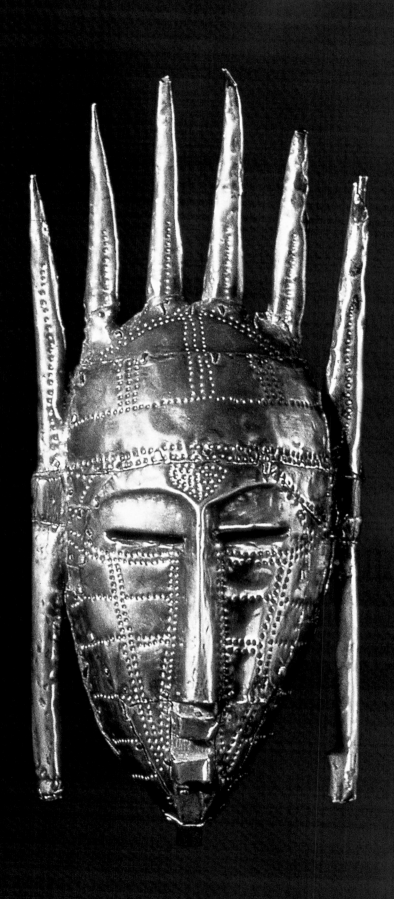

29 FACE MASK *N'DOMO*
MARKA, BURKINA FASO/MALI

30 FACE MASK OF THE *DO* SOCIETY
DYULA, IVORY COAST

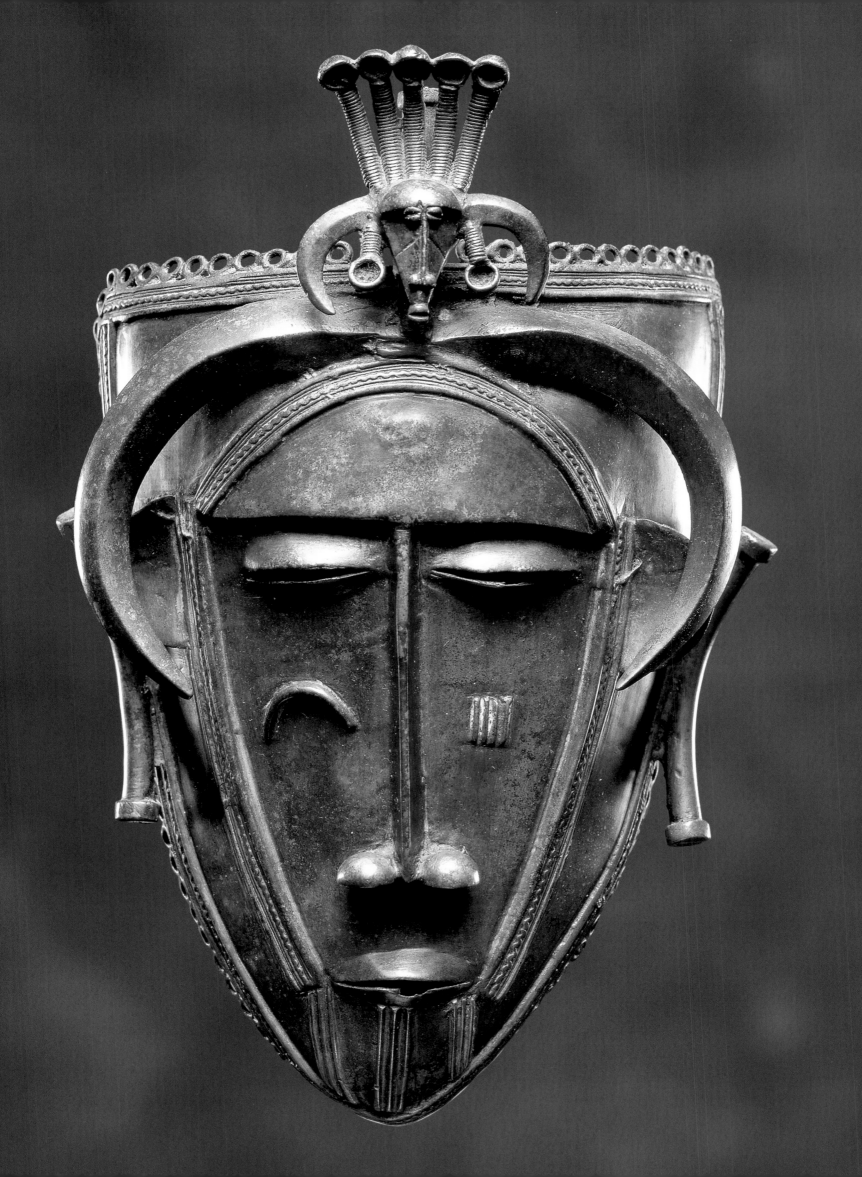

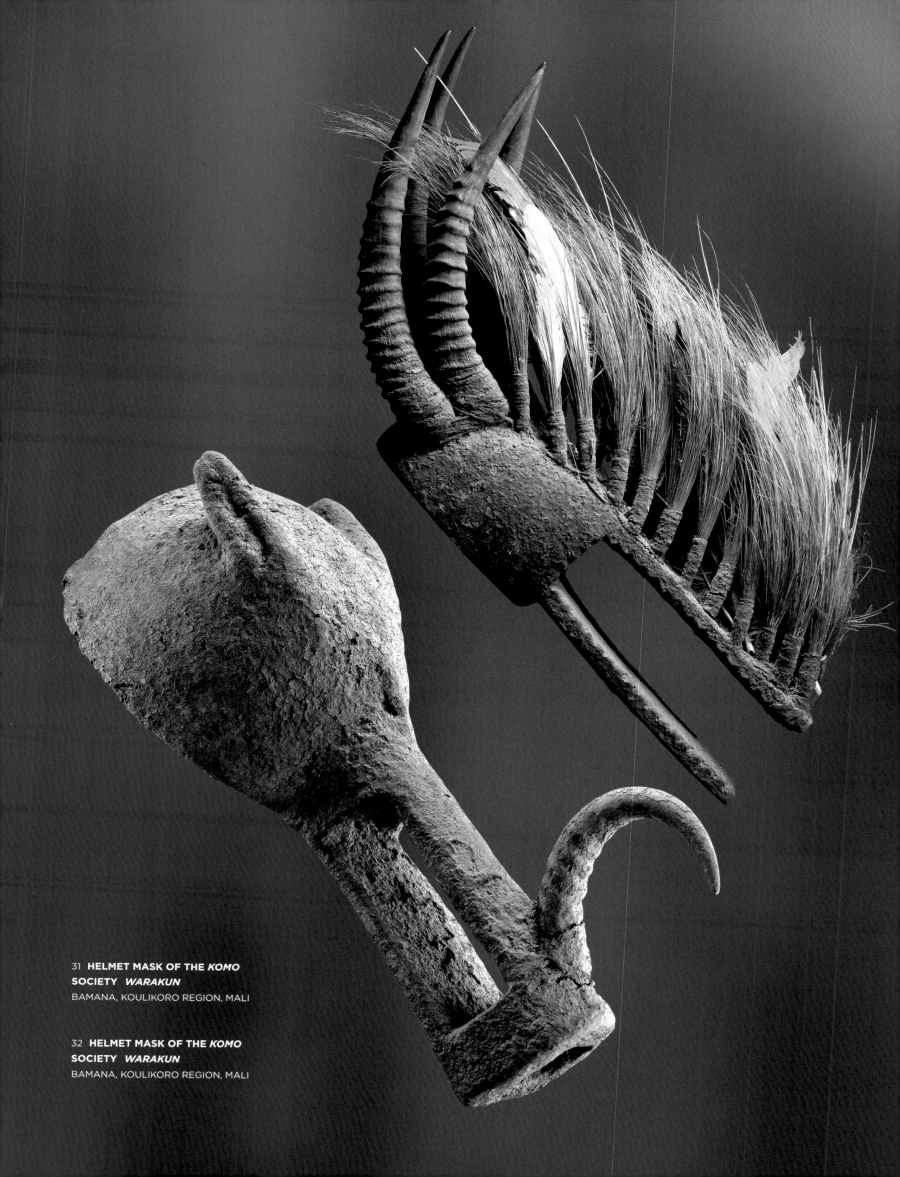

31 **HELMET MASK OF THE** *KOMO*
SOCIETY *WARAKUN*
BAMANA, KOULIKORO REGION, MALI

32 **HELMET MASK OF THE** *KOMO*
SOCIETY *WARAKUN*
BAMANA, KOULIKORO REGION, MALI

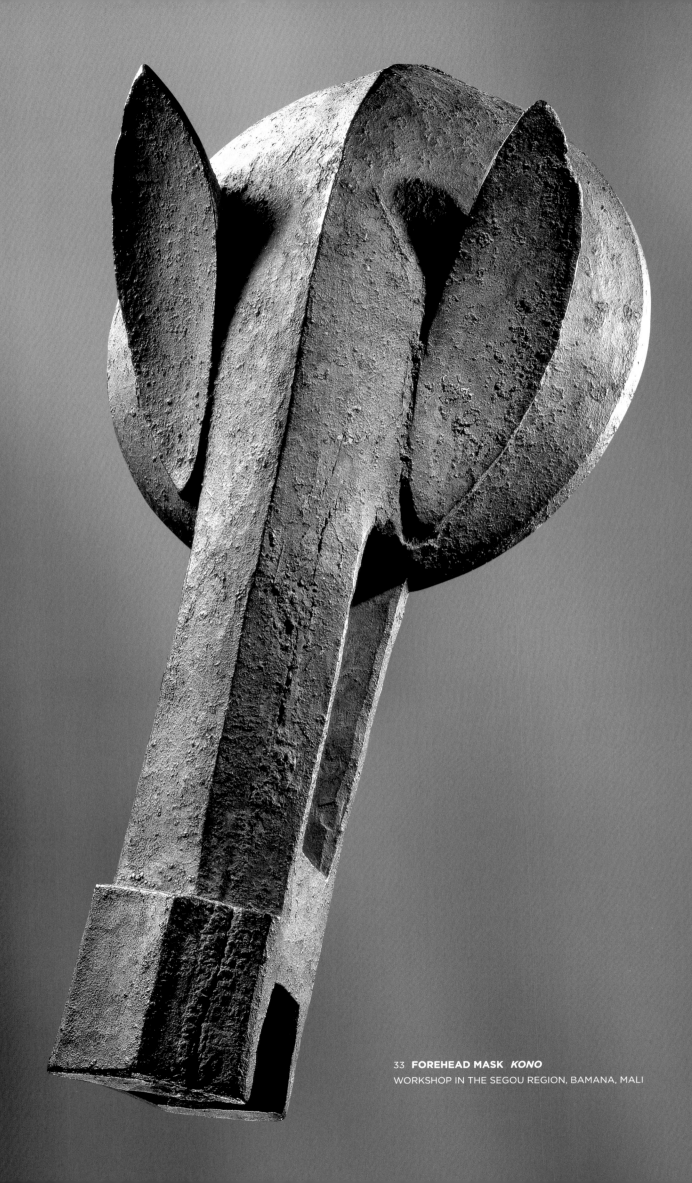

33 **FOREHEAD MASK** *KONO*
WORKSHOP IN THE SEGOU REGION, BAMANA, MALI

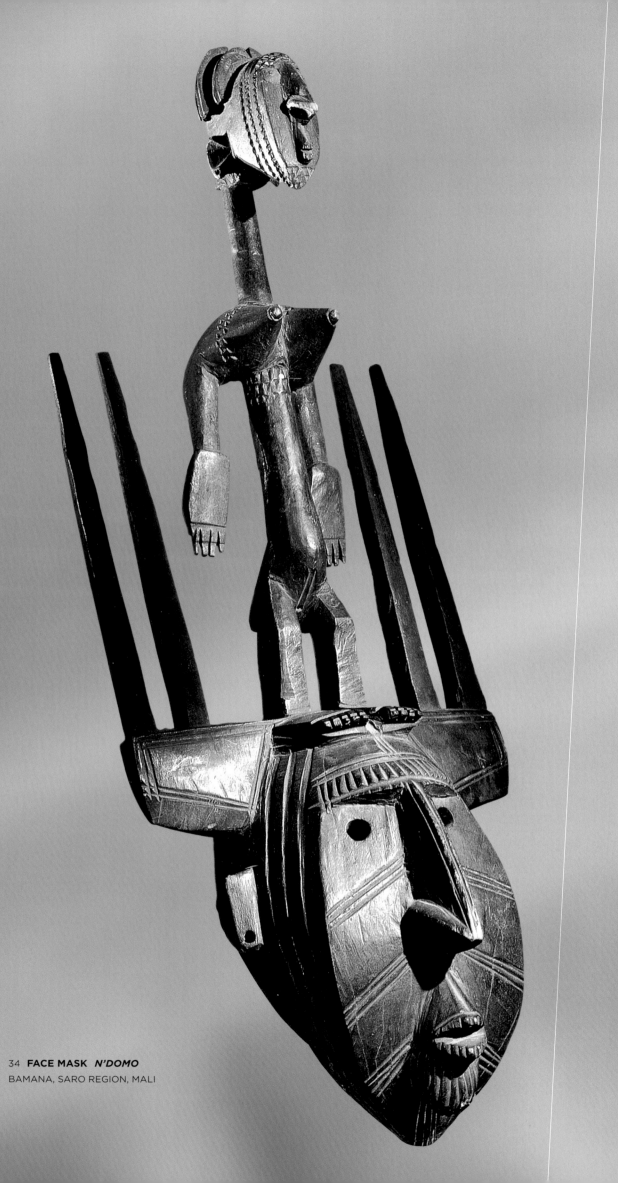

34 **FACE MASK** *N'DOMO*
BAMANA, SARO REGION, MALI

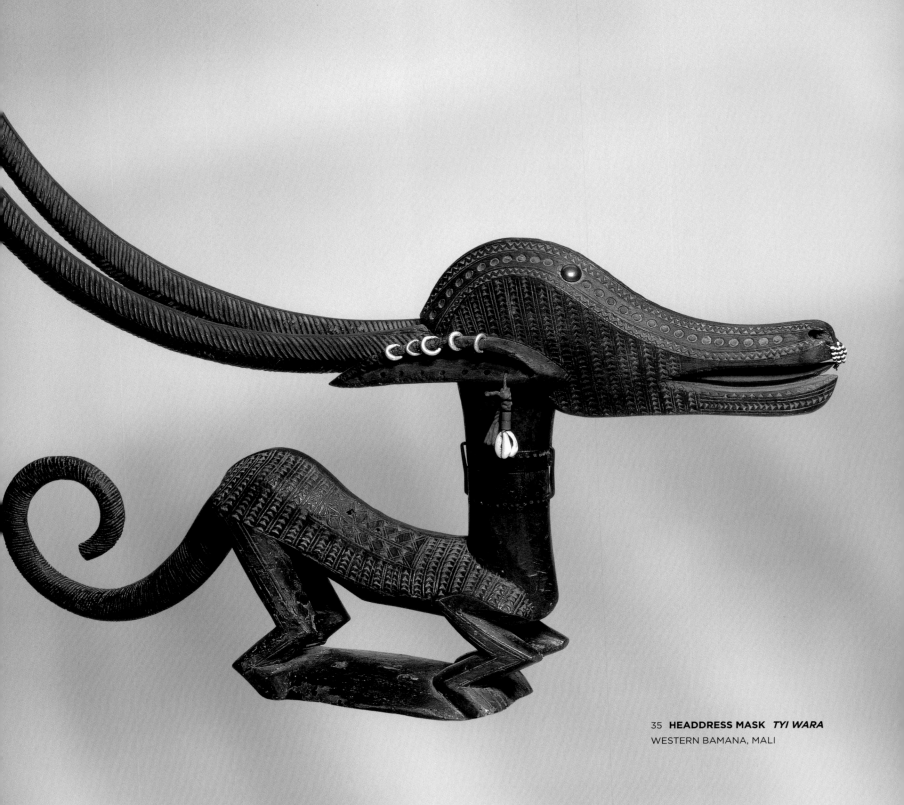

35 **HEADDRESS MASK** *TYI WARA*
WESTERN BAMANA, MALI

36/37 **HEADDRESS MASKS** *TYI WARA*
BAMANA, SEGOU REGION, MALI

38 **HEADDRESS MASK WITH KID** *TYI WARA*
BAMANA, SEGOU REGION, MALI

39 **HEADDRESS MASK** *TYI WARA*
SOUTH-WESTERN BAMANA REGION, MALI

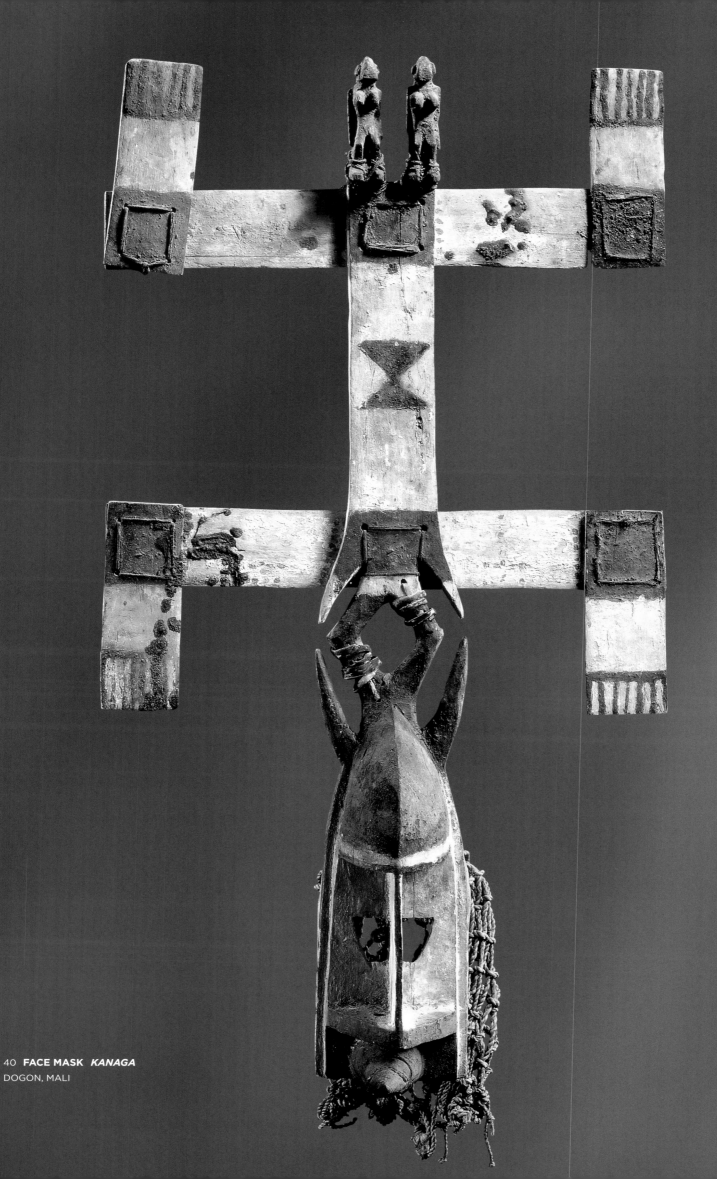

40 **FACE MASK** *KANAGA*
DOGON, MALI

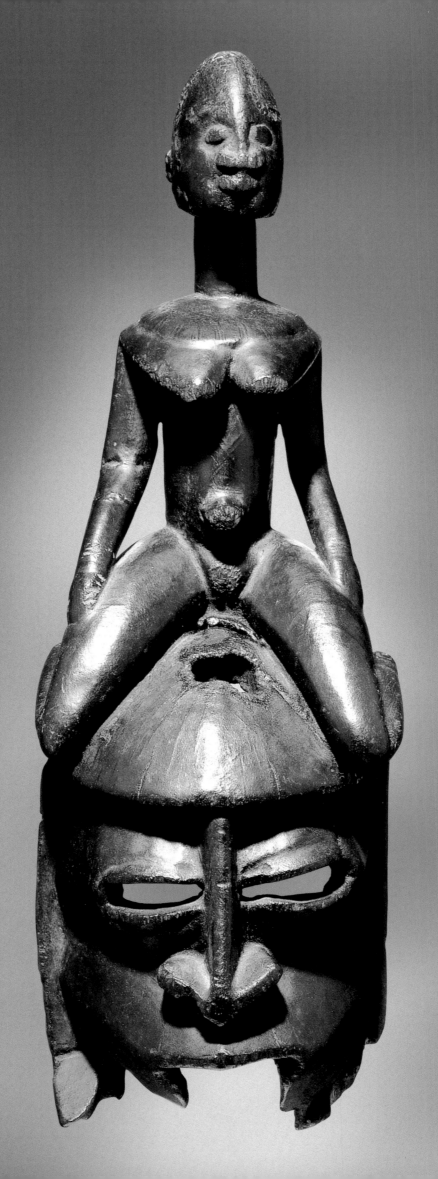

41 FACE MASK *SATIMBE* **(?)**
DOGON, MALI

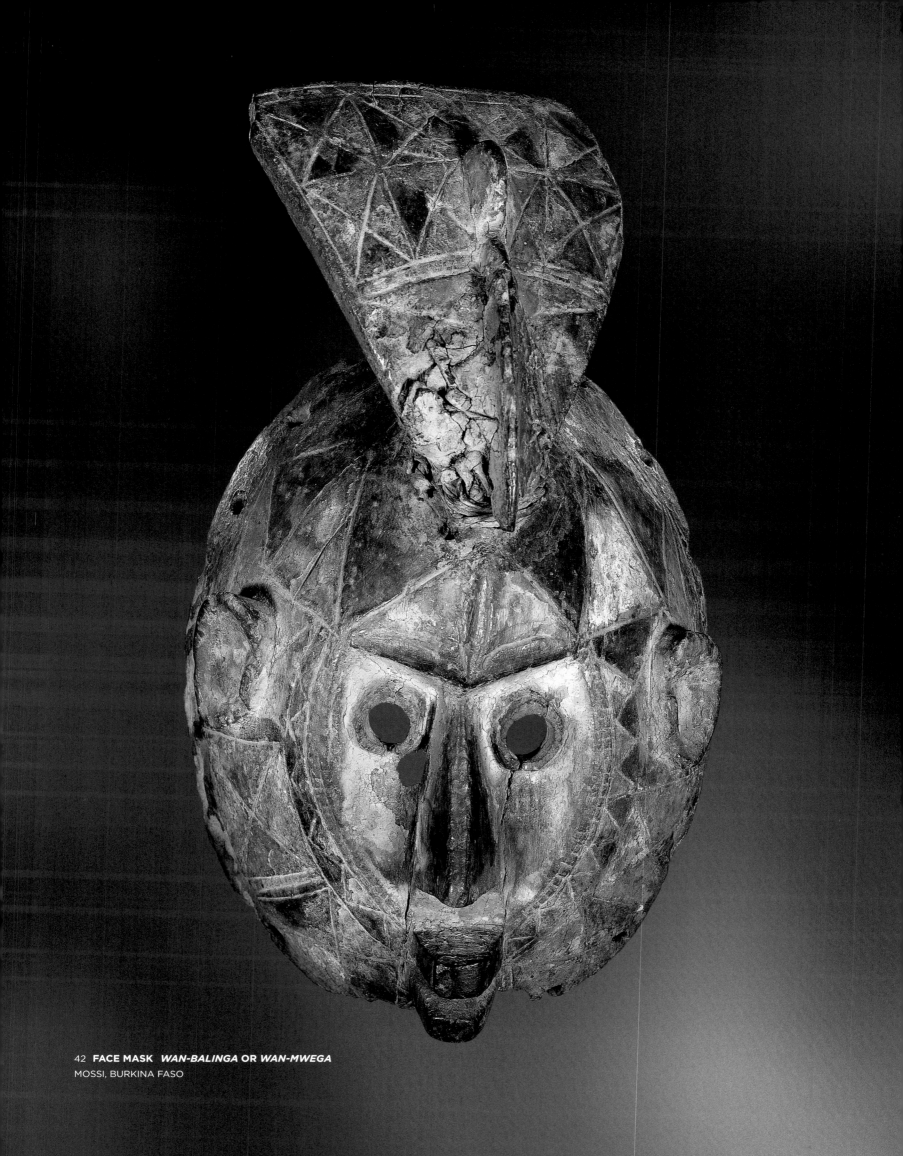

42 **FACE MASK** *WAN-BALINGA* **OR** *WAN-MWEGA*
MOSSI, BURKINA FASO

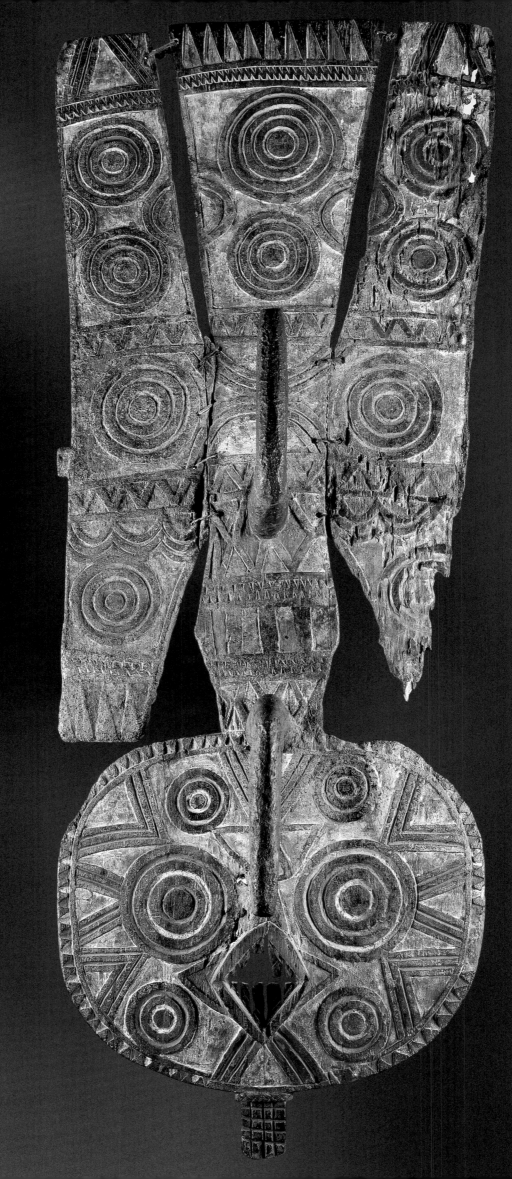

43 **FACE MASK**
NUNUMA (GURUNSI), BURKINA FASO

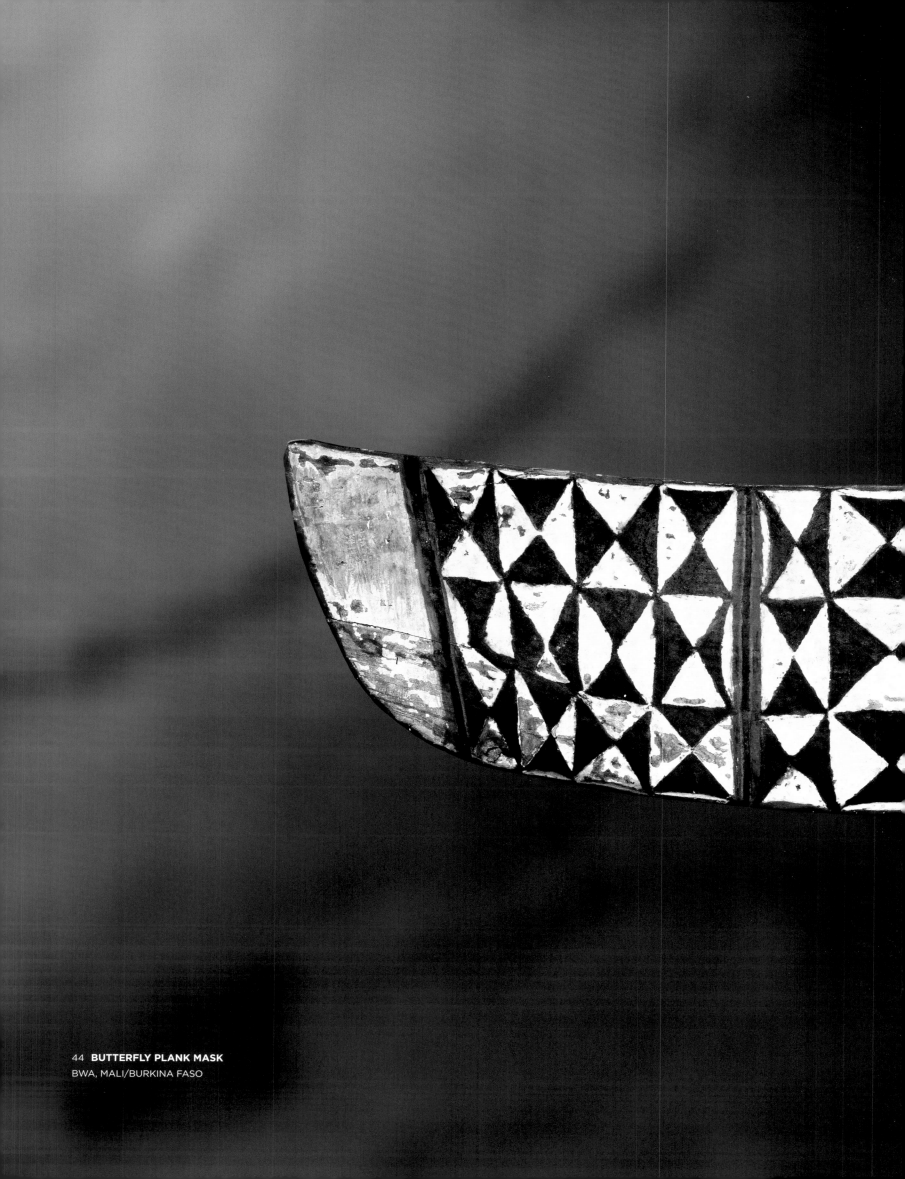

44 **BUTTERFLY PLANK MASK**
BWA, MALI/BURKINA FASO

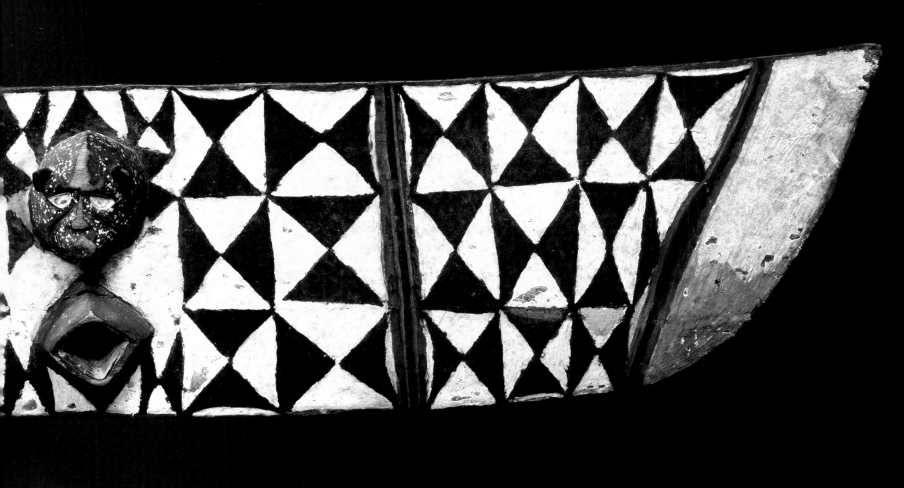

45 **PLANK MASK** *LONIAKEN*
TUSYAN, BURKINA FASO

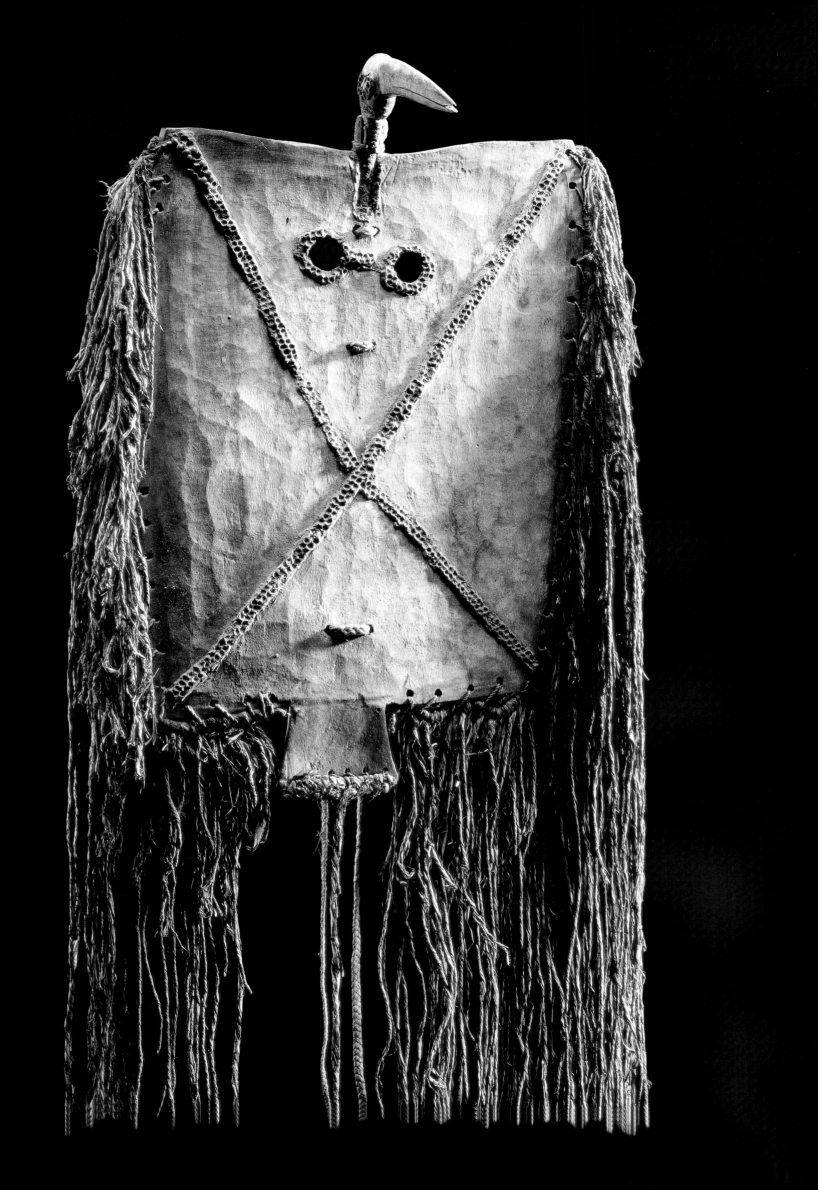

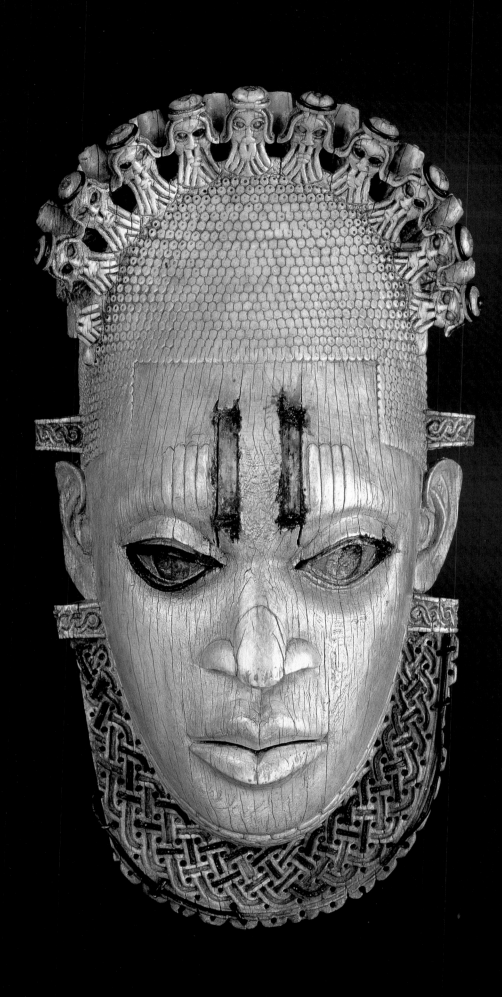

46 **PENDANT IN MASK FORM**
BENIN KINGDOM, NIGERIA

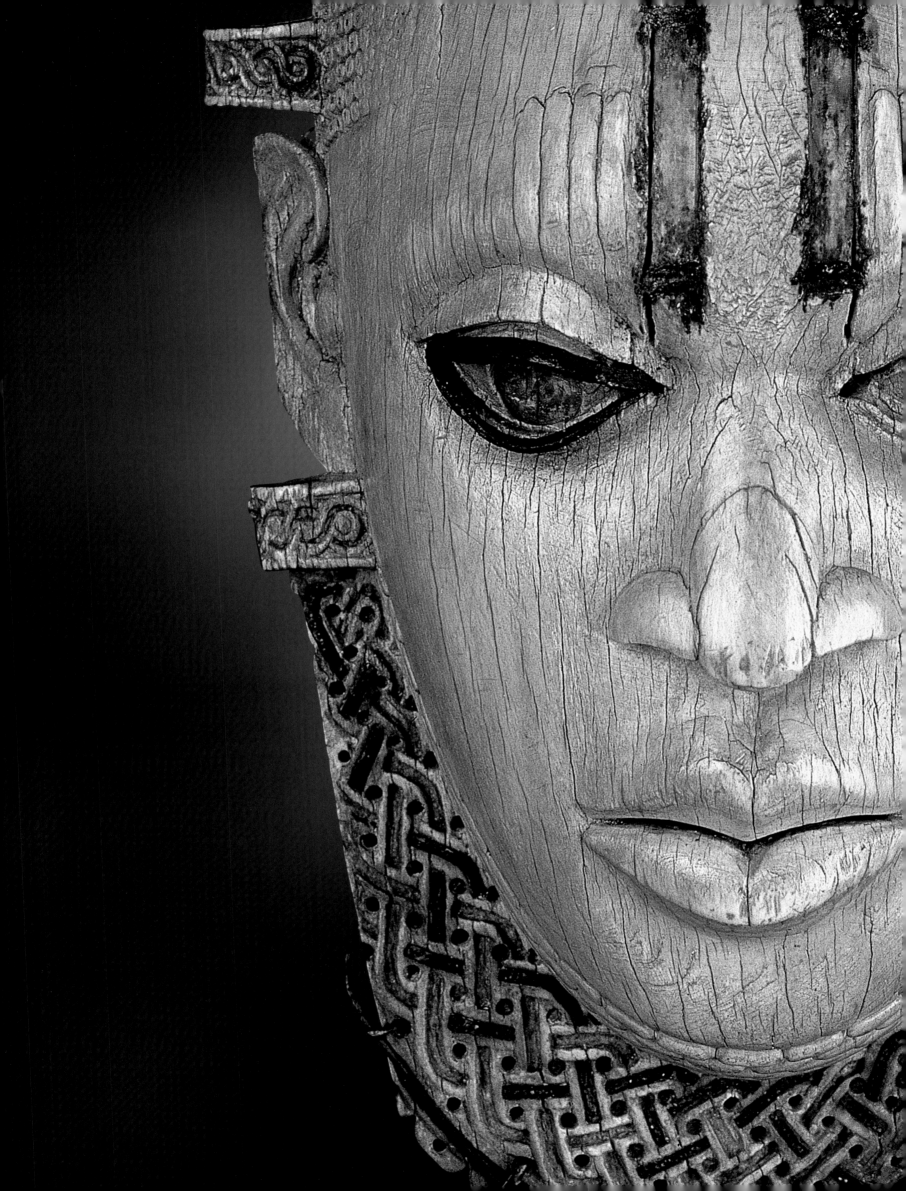

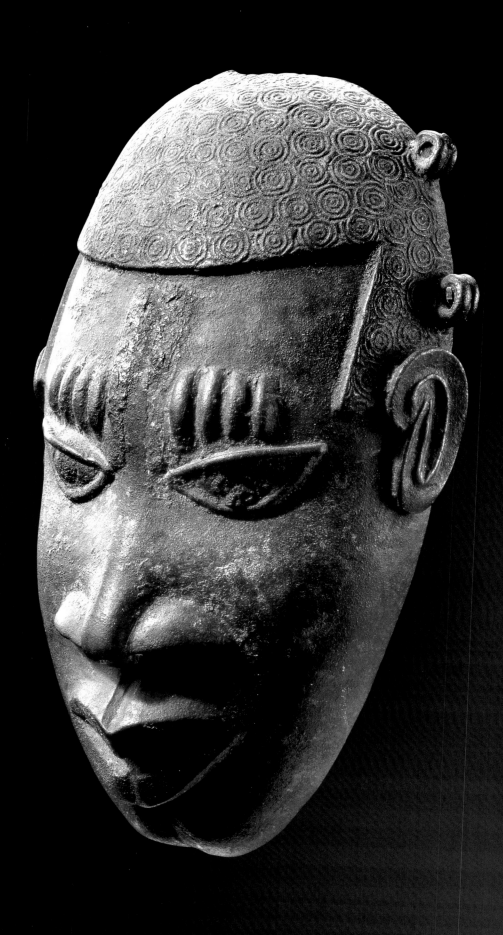

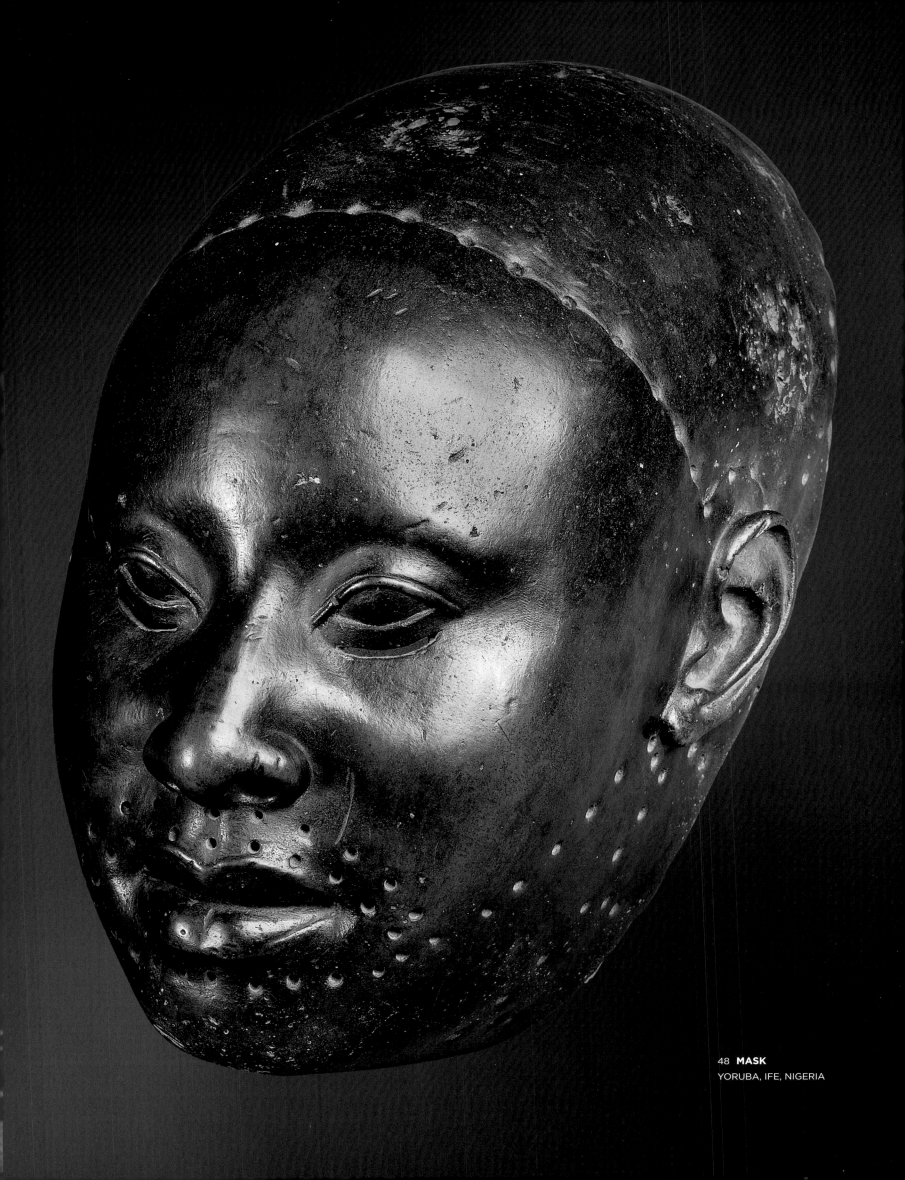

48 **MASK**
YORUBA, IFE, NIGERIA

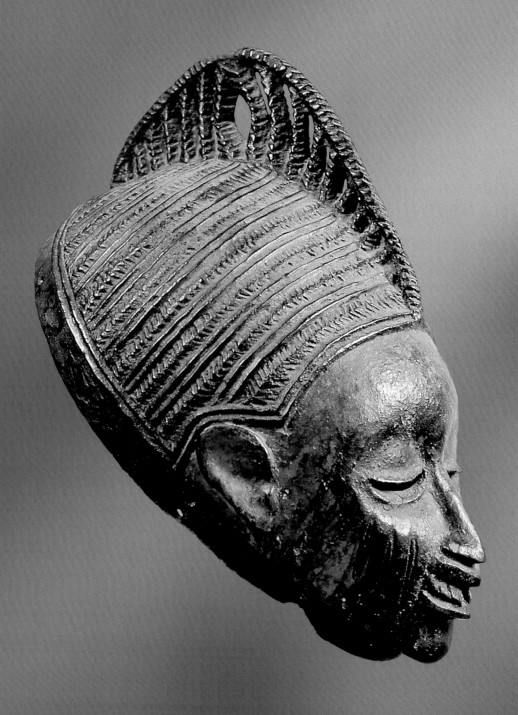

49 **HELMET MASK** *EGUNGUN*
OLOWE OF ISE, YORUBA, NIGERIA

50 **HELMET MASK**
EKITI (YORUBA), NIGERIA

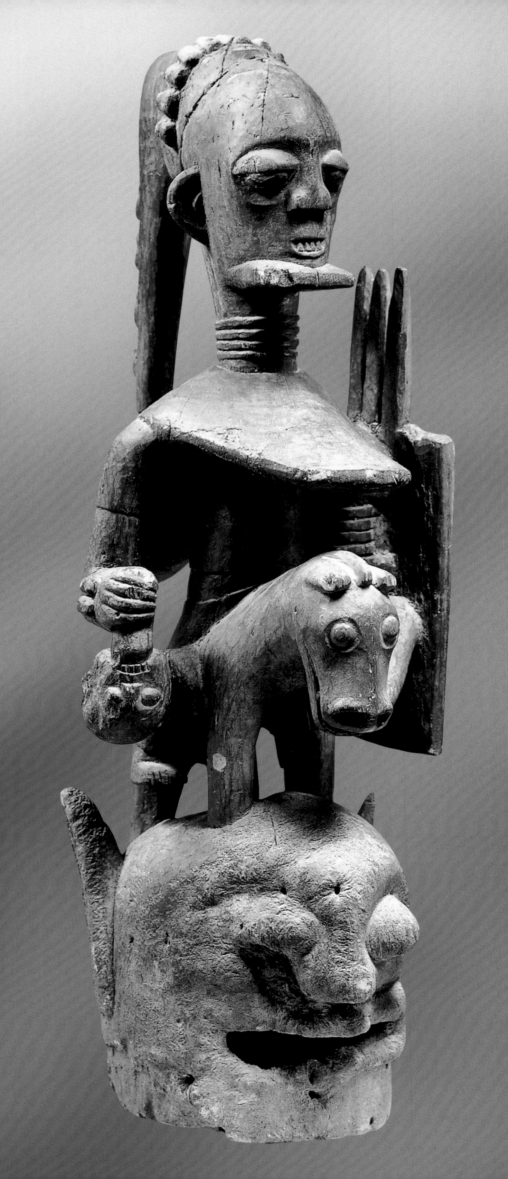

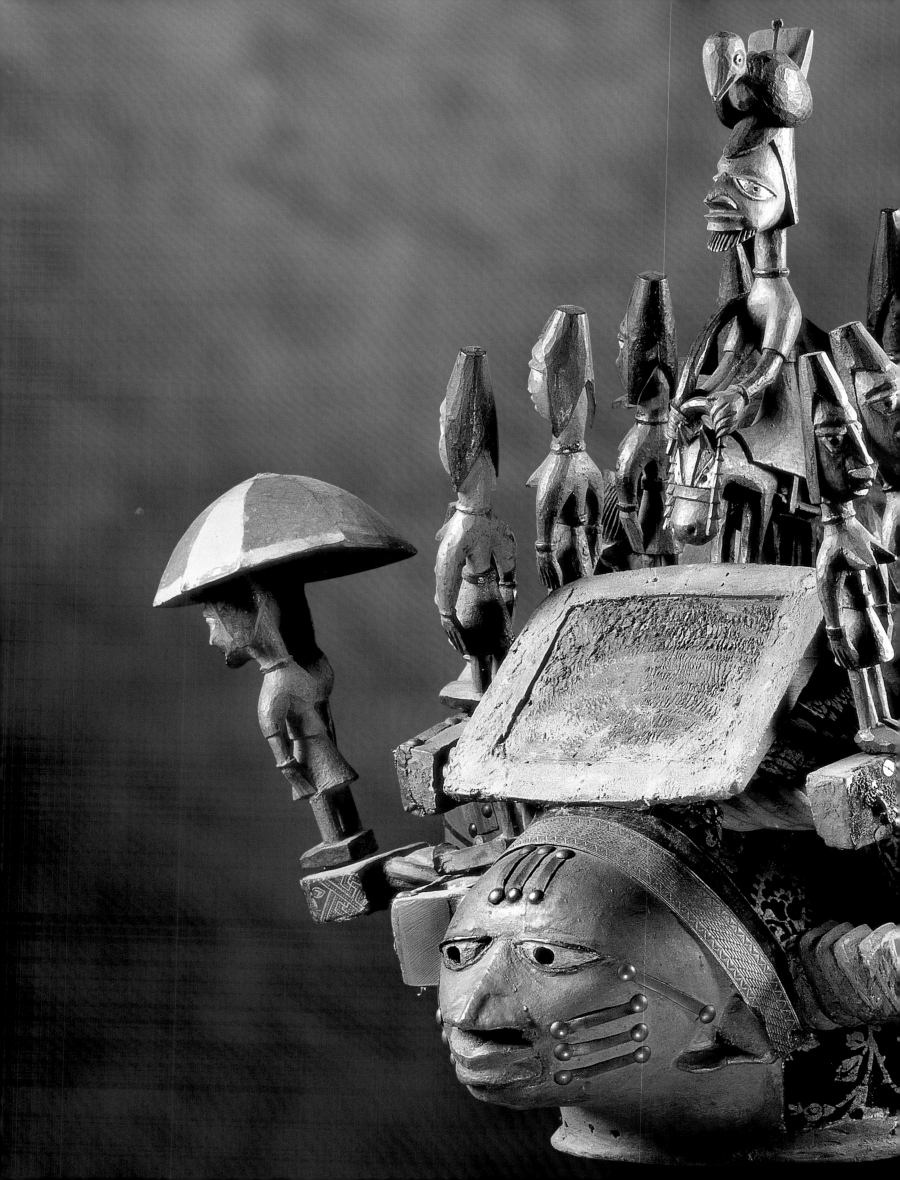

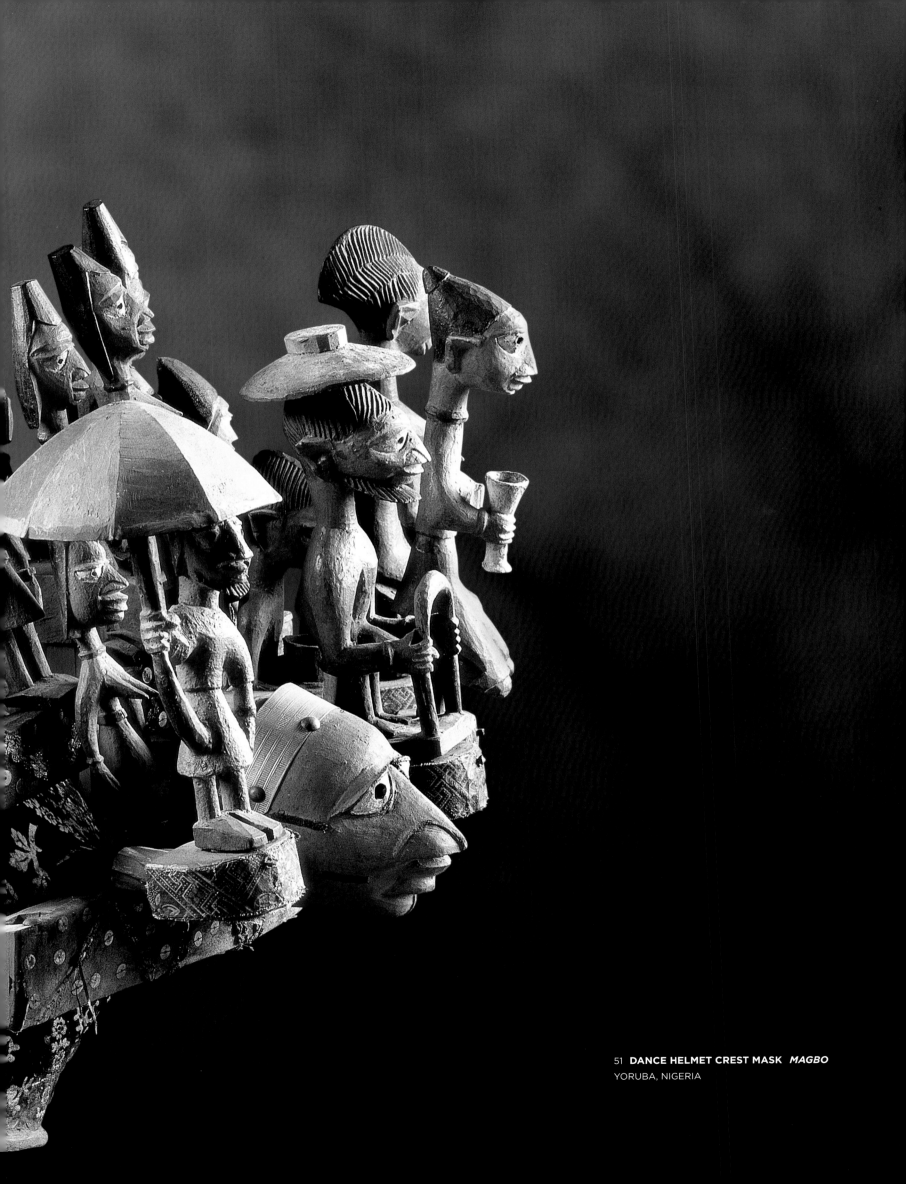

51 **DANCE HELMET CREST MASK** *MAGBO*
YORUBA, NIGERIA

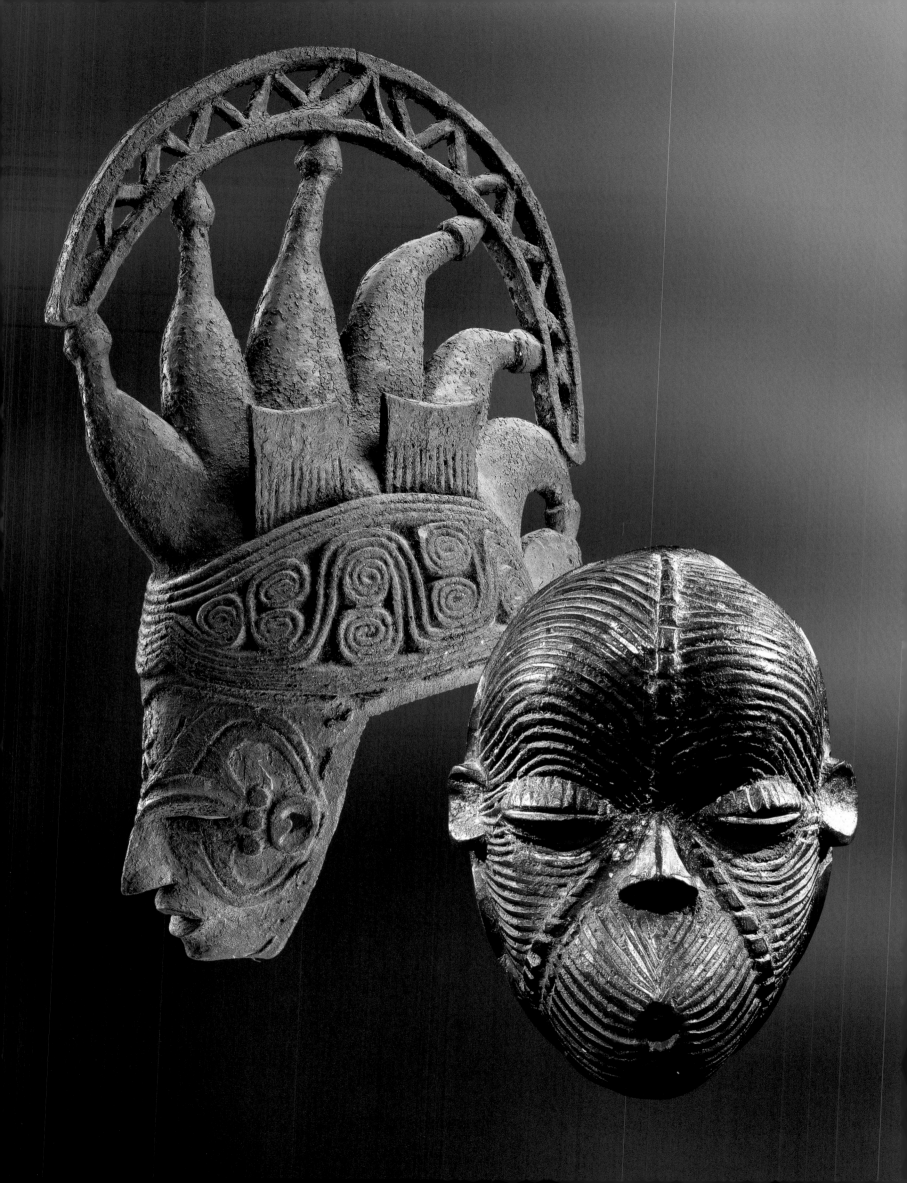

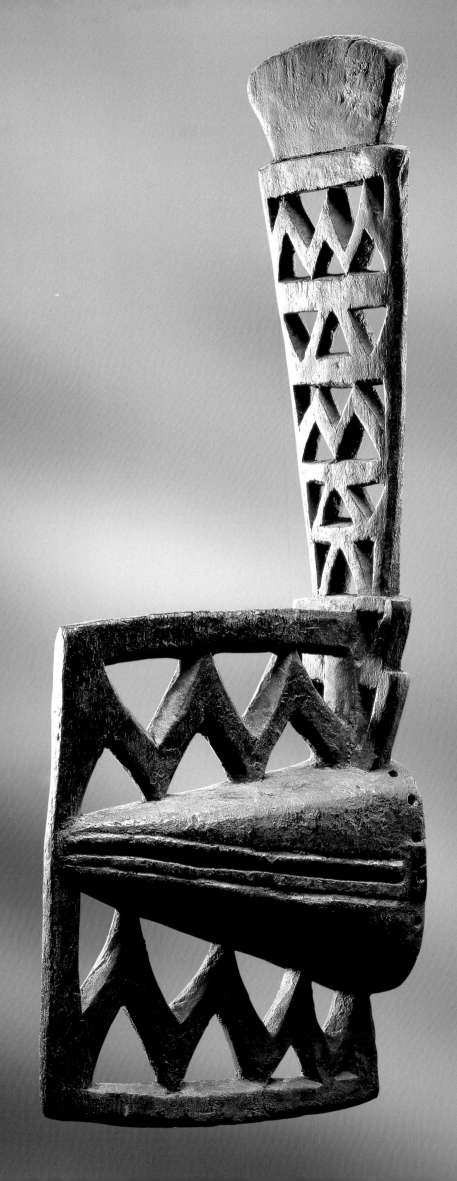

52 HELMET MASK *AGBOGHO MMUO*
IGBO, NIGERIA

53 FACE MASK
ADA-IGBO, NIGERIA

54 FACE MASK
IGBO, NIGERIA

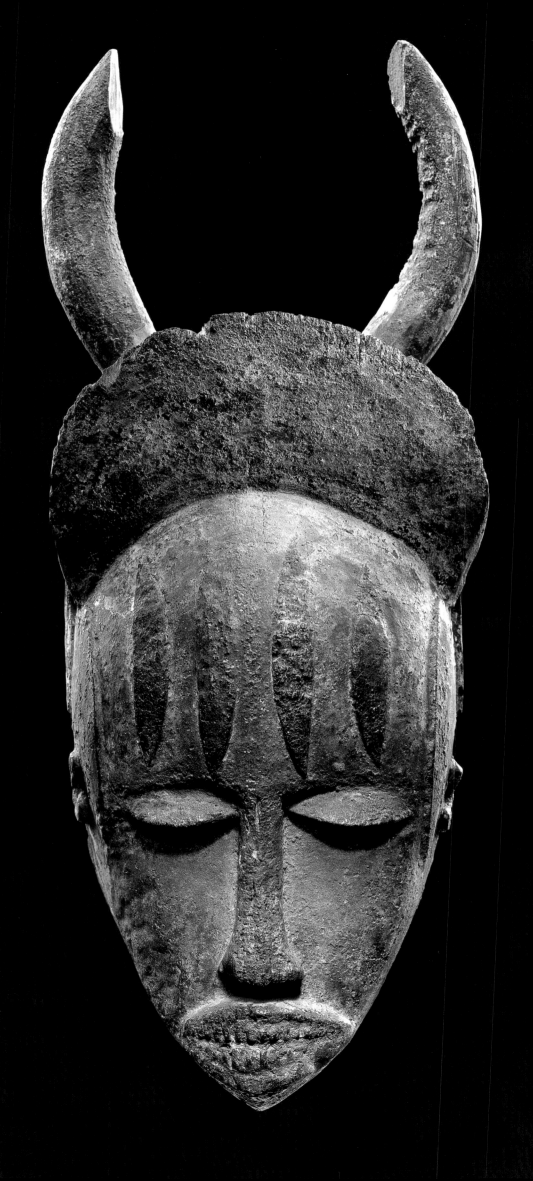

55 **FACE MASK**
URHOBO, NIGERIA

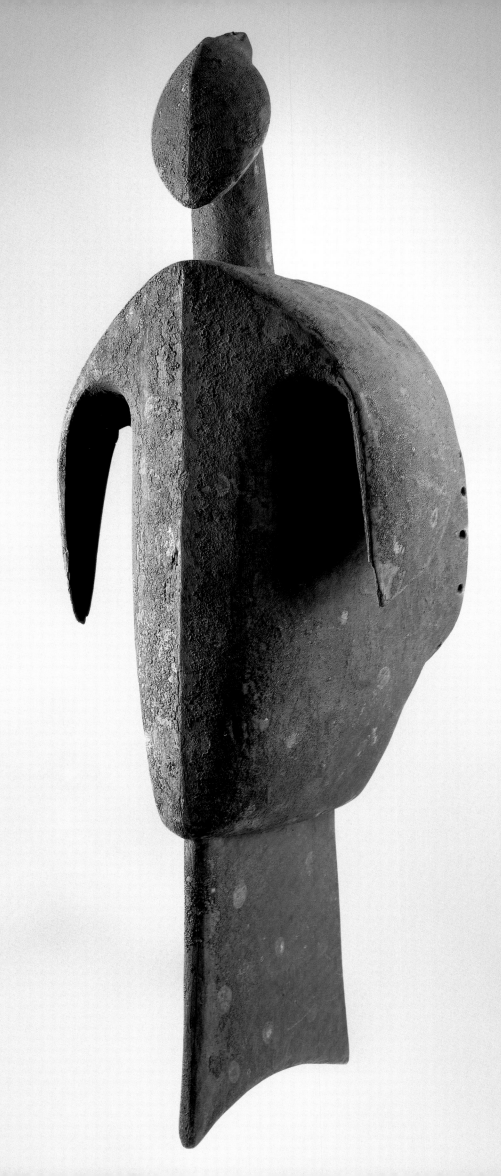

56 HELMET CREST MASK
IJO, NIGERIA

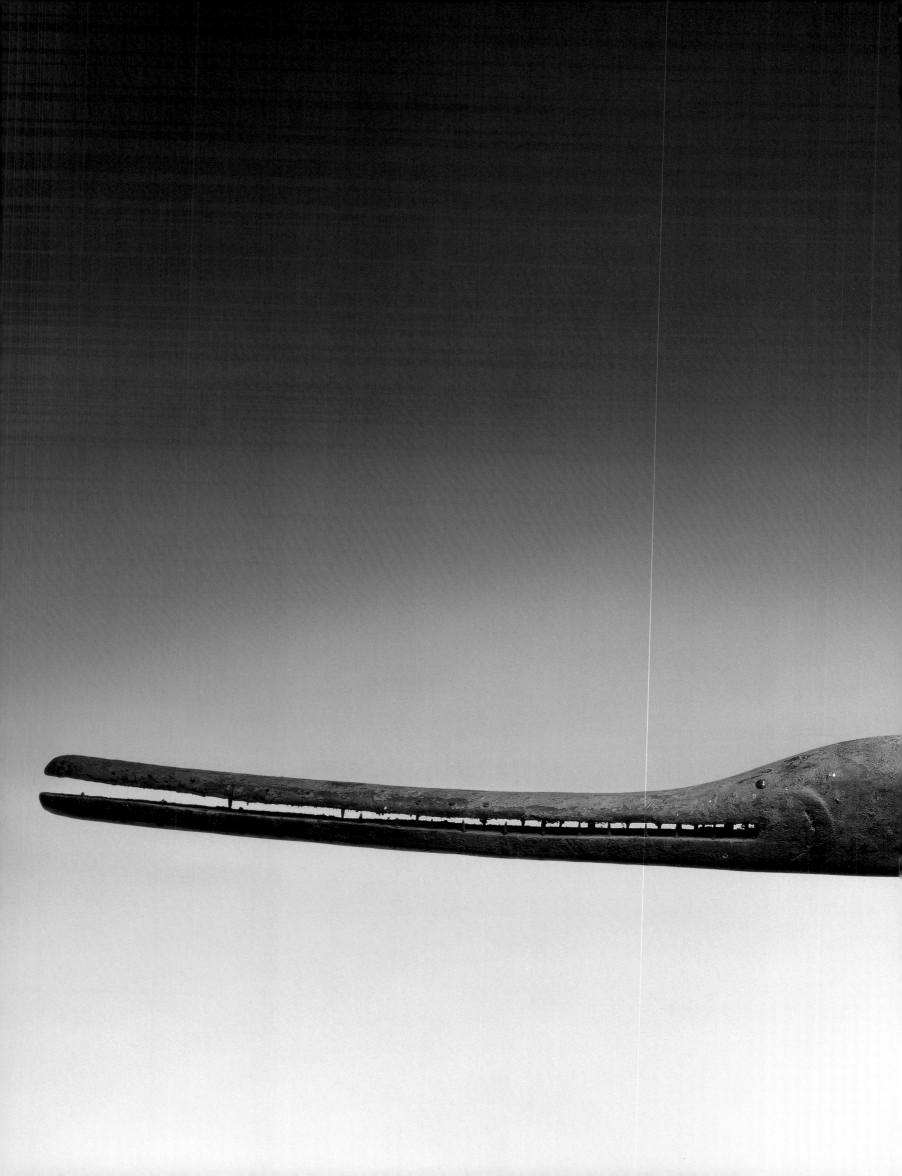

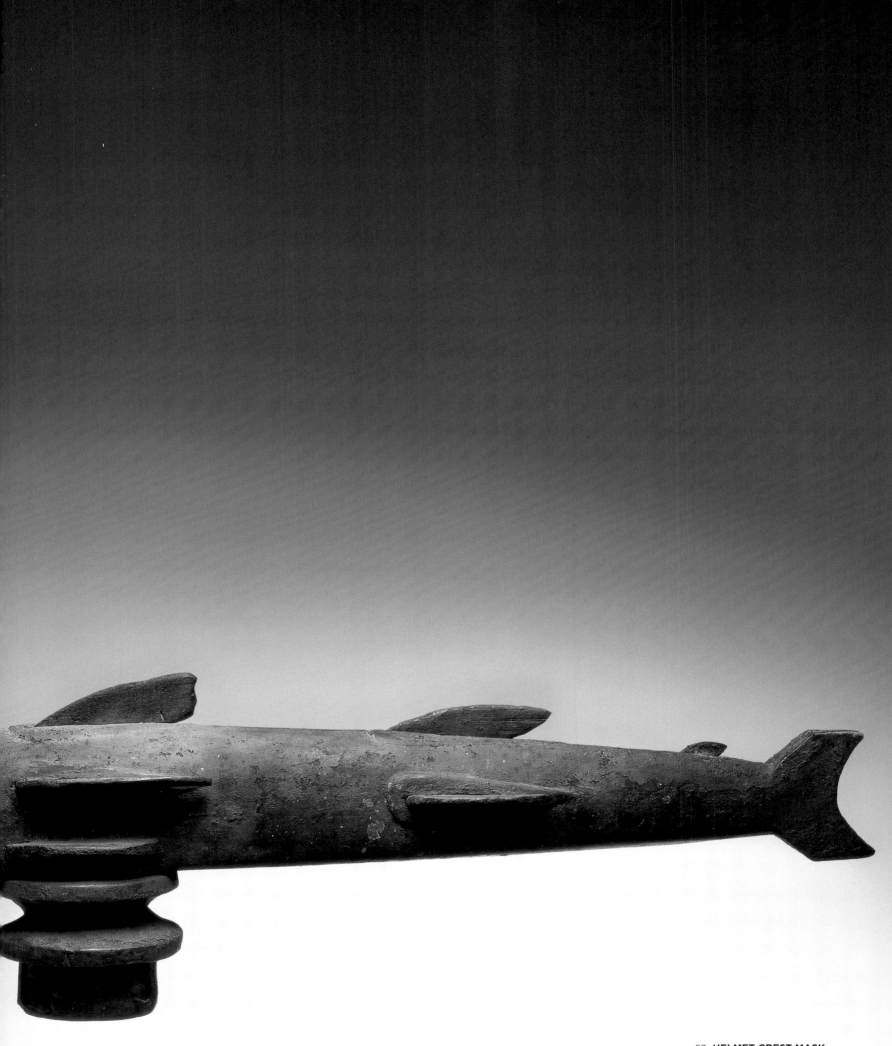

57 **HELMET CREST MASK**
IJO, NIGERIA

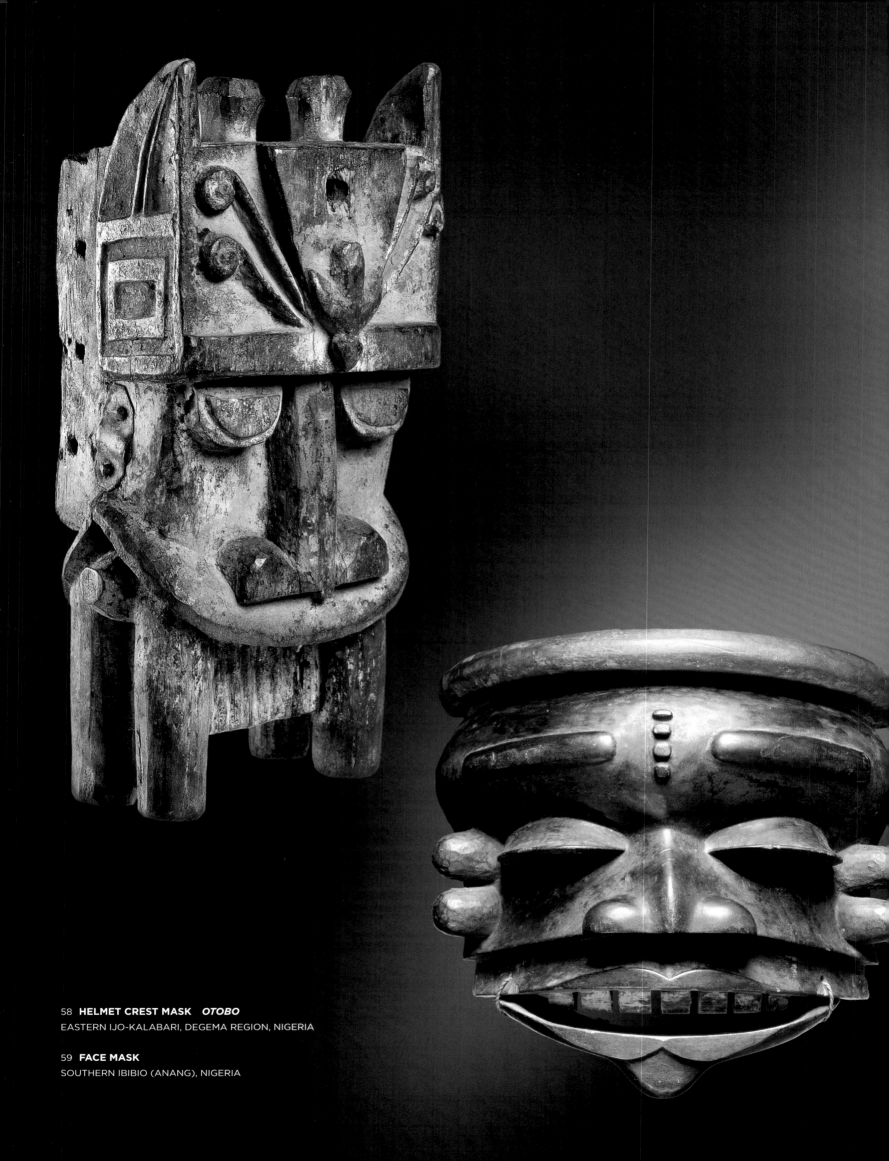

58 **HELMET CREST MASK** *OTOBO*
EASTERN IJO-KALABARI, DEGEMA REGION, NIGERIA

59 **FACE MASK**
SOUTHERN IBIBIO (ANANG), NIGERIA

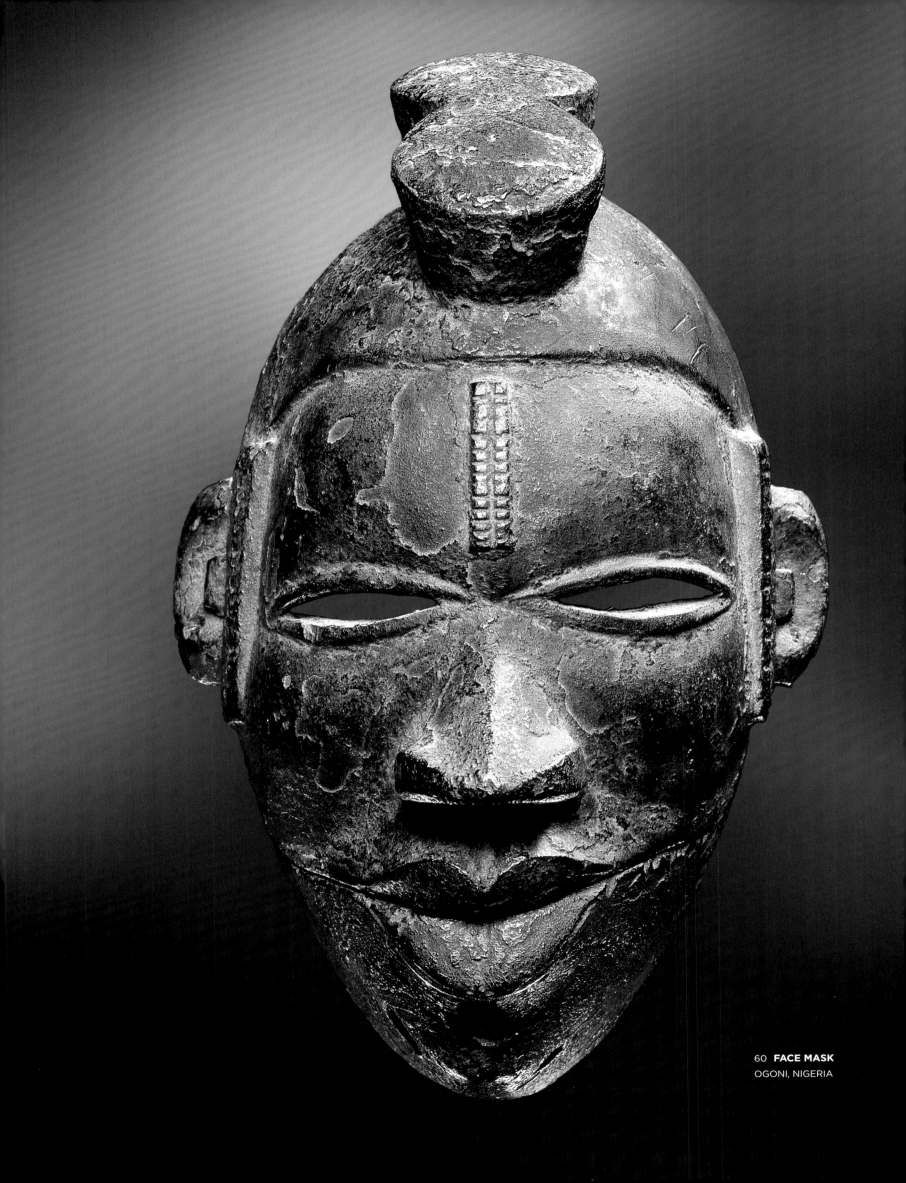

61 **HELMET CREST**
EJAGHAM, NIGERIA

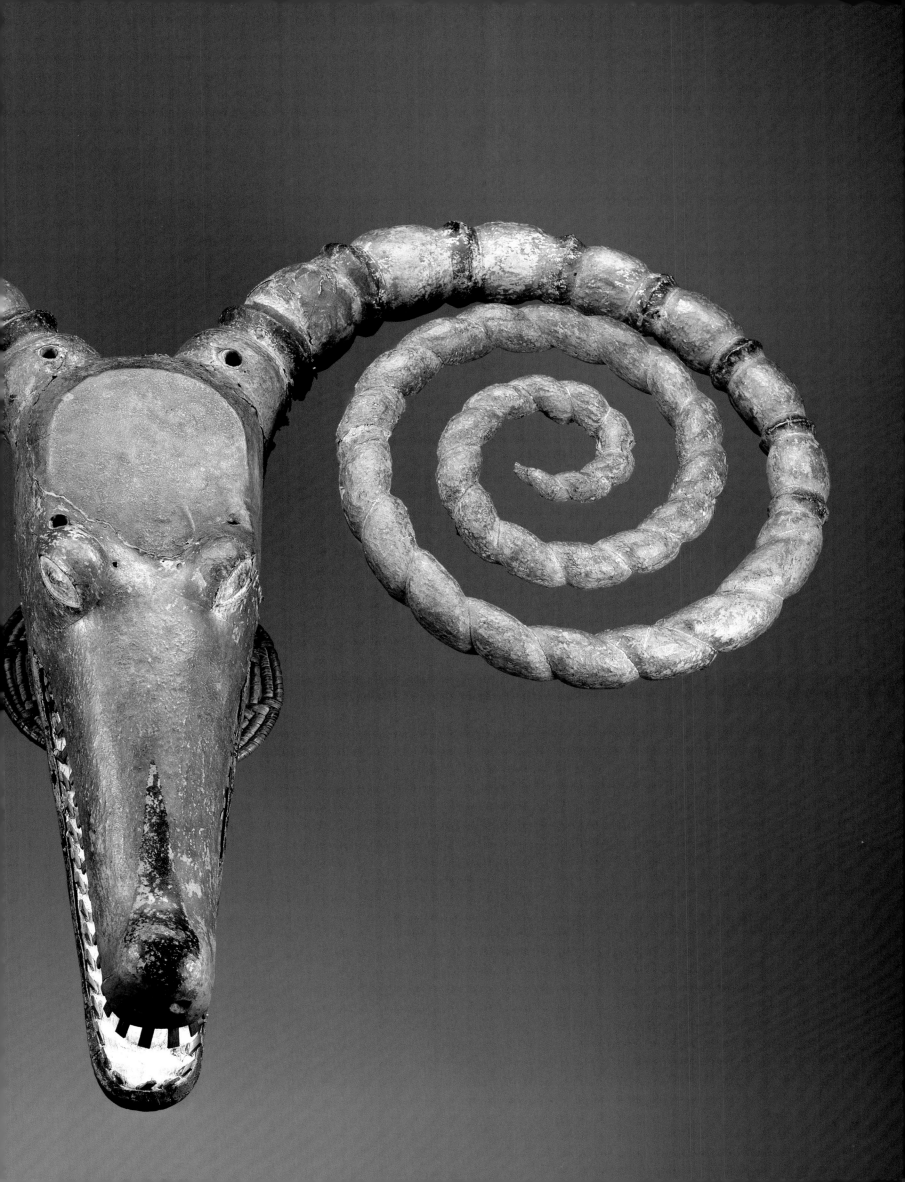

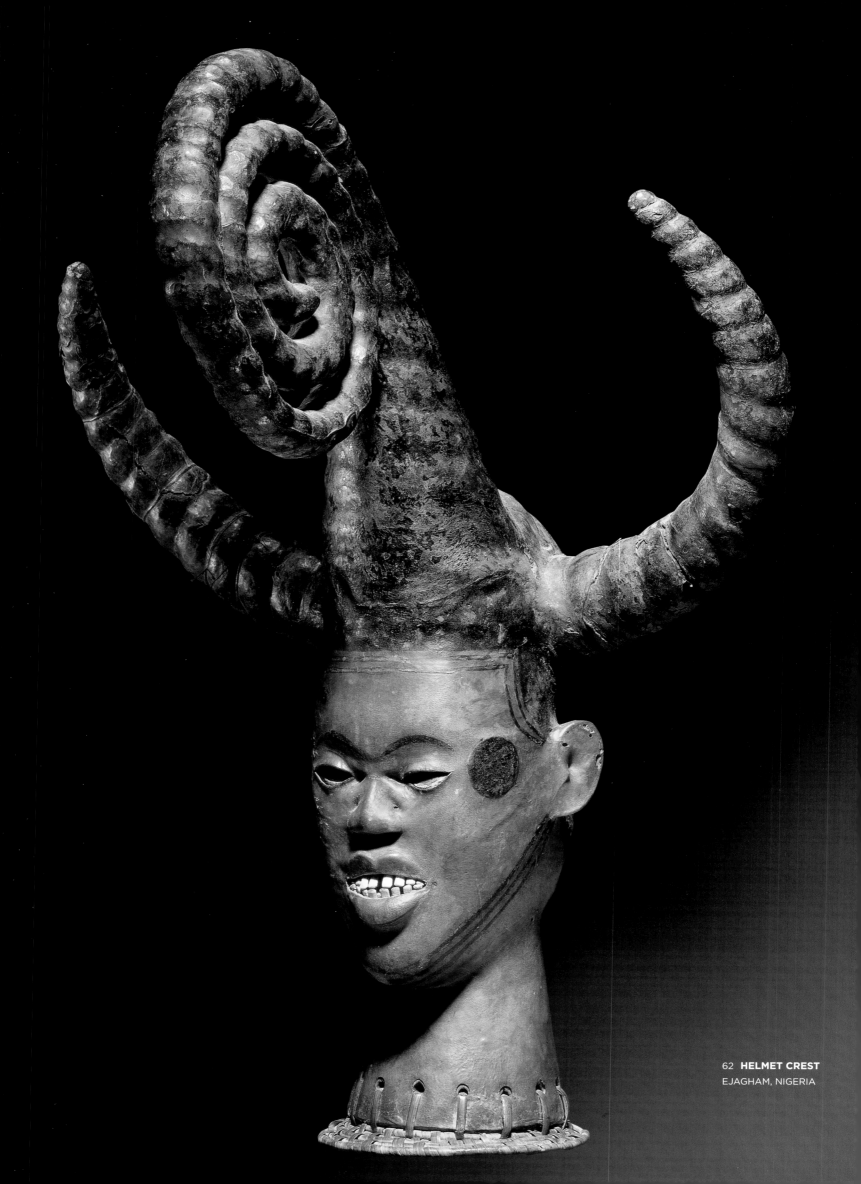

62 **HELMET CREST**
EJAGHAM, NIGERIA

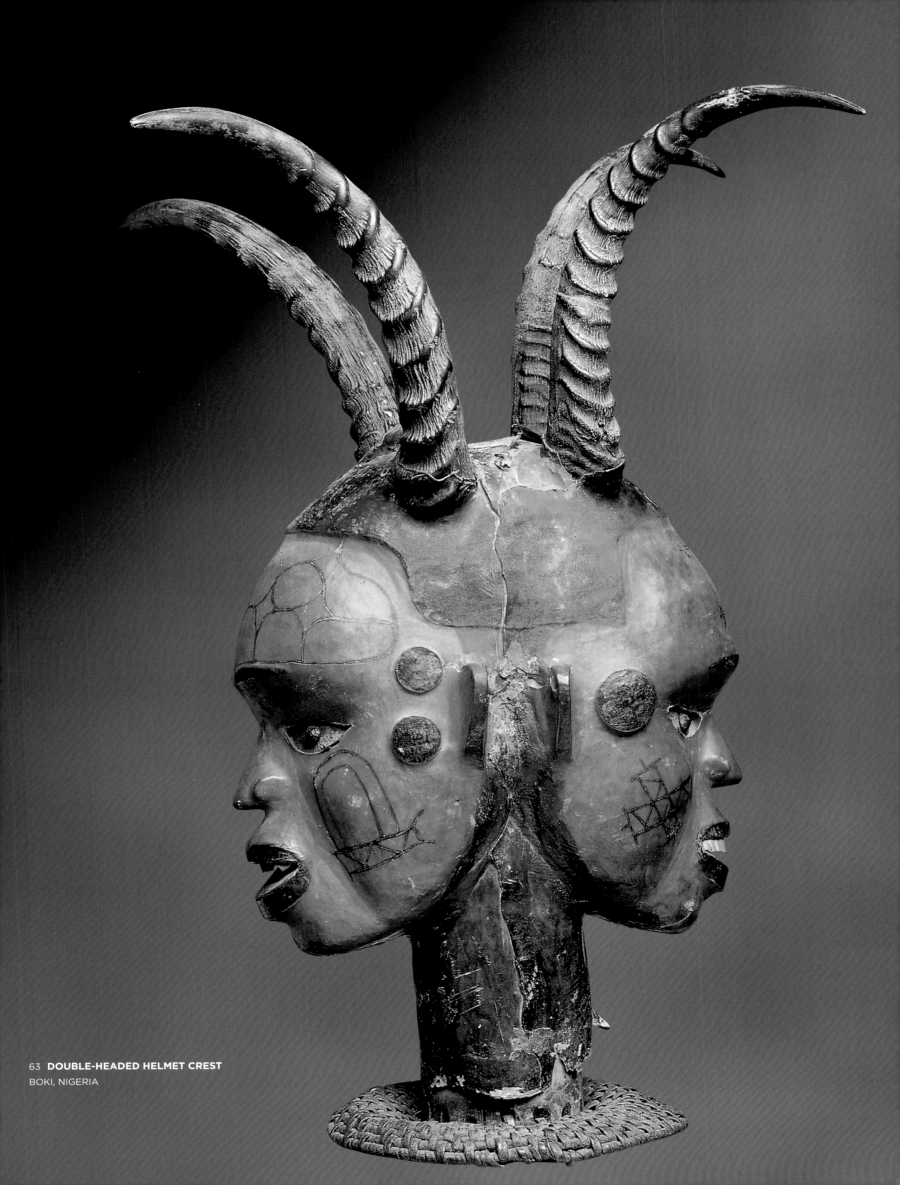

63 **DOUBLE-HEADED HELMET CREST**
BOKI, NIGERIA

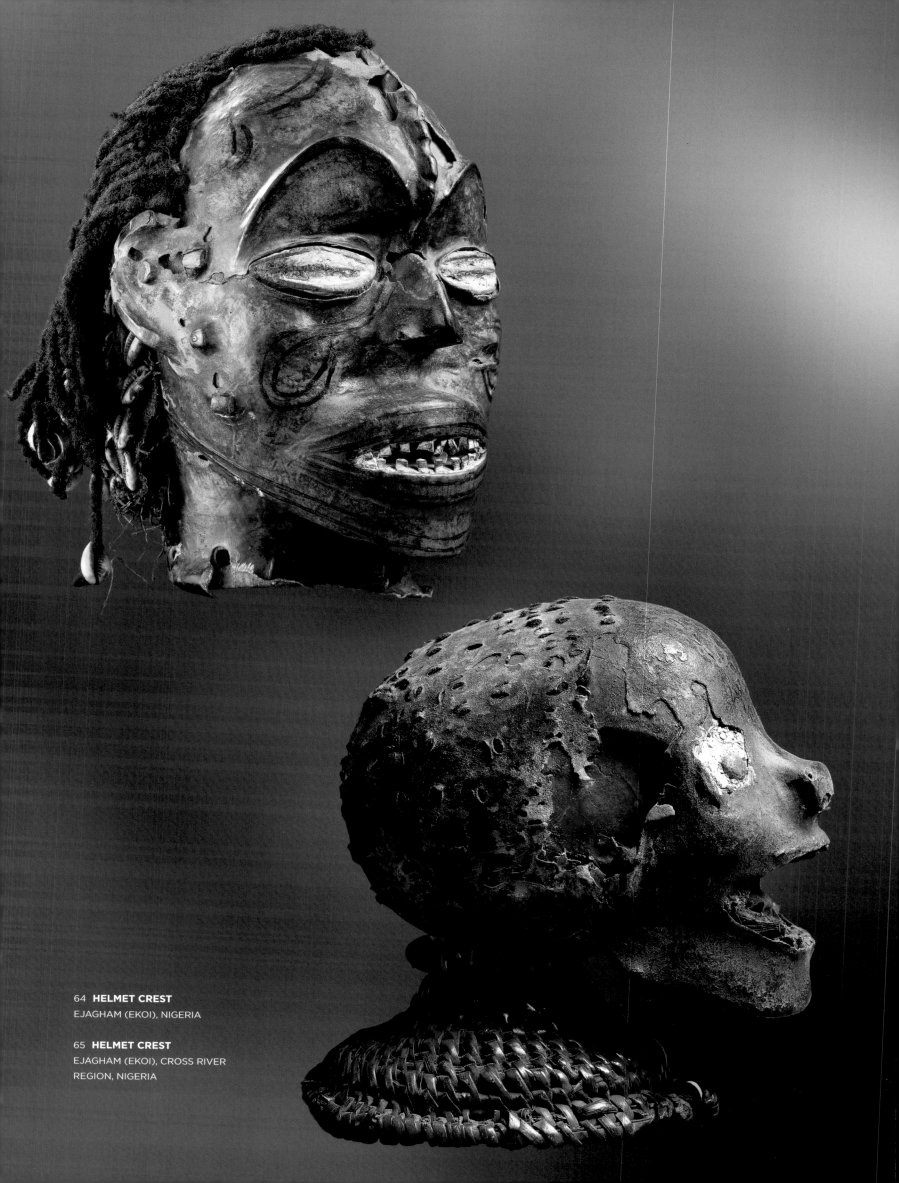

64 HELMET CREST
EJAGHAM (EKOI), NIGERIA

65 HELMET CREST
EJAGHAM (EKOI), CROSS RIVER
REGION, NIGERIA

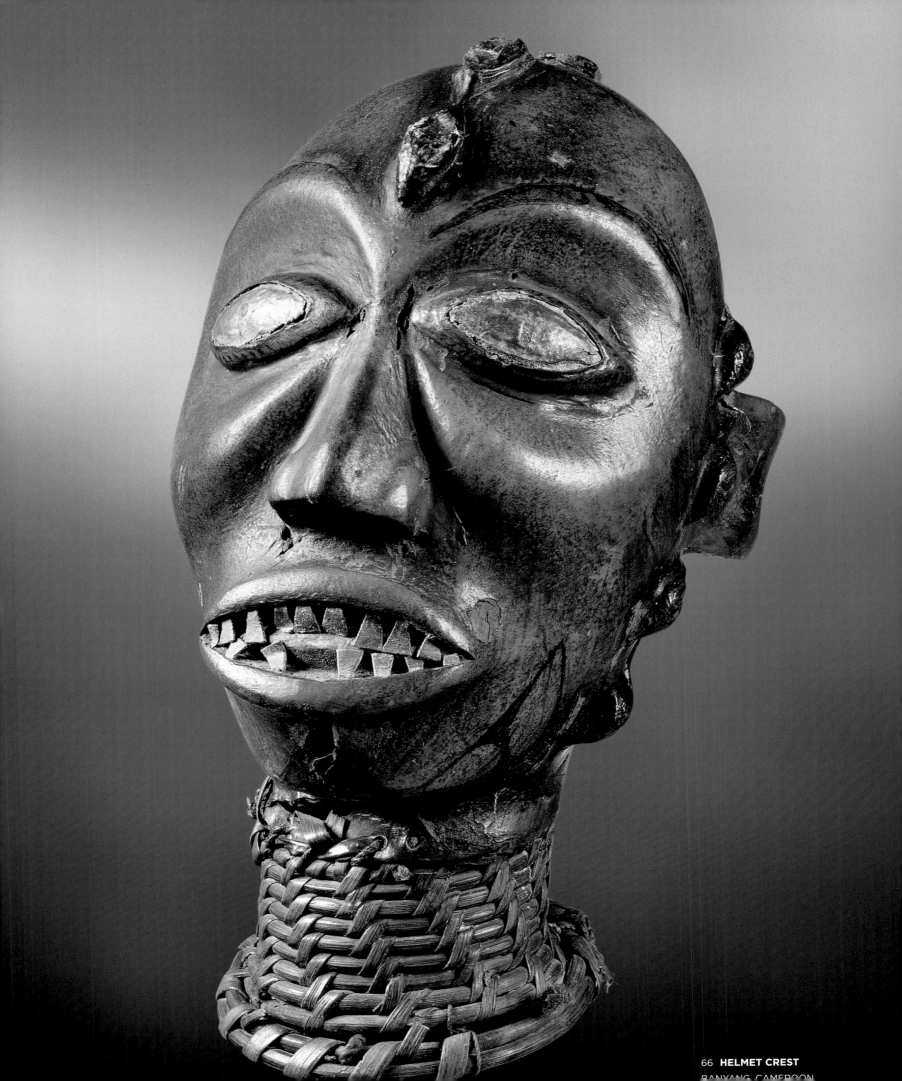

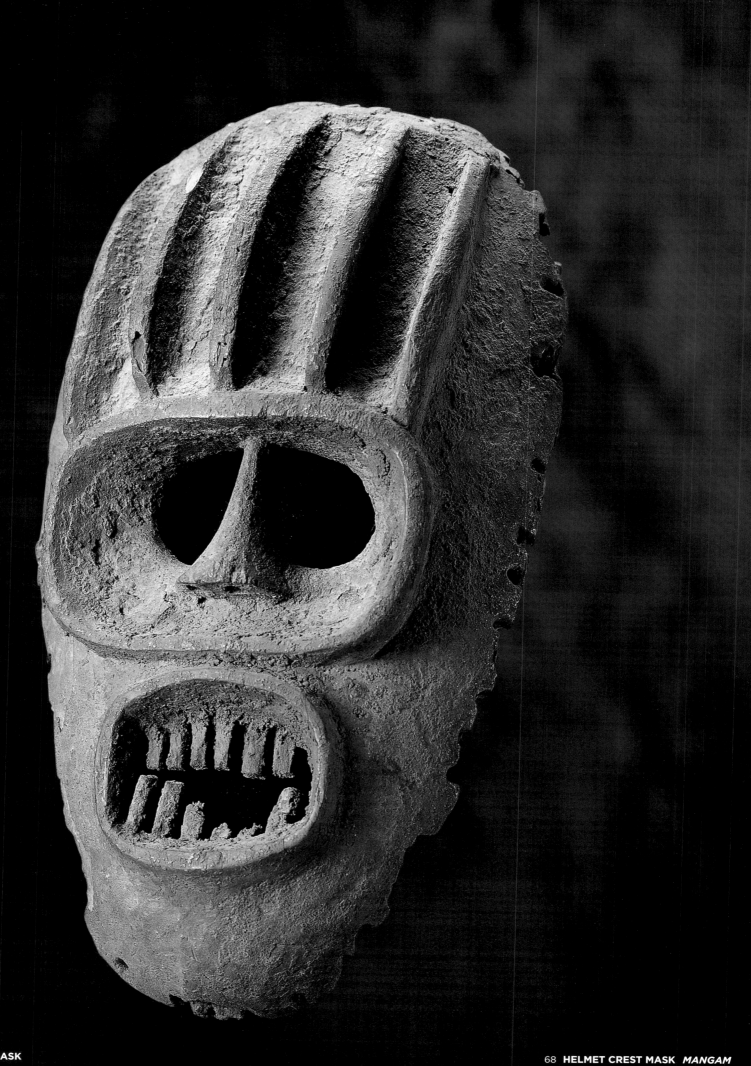

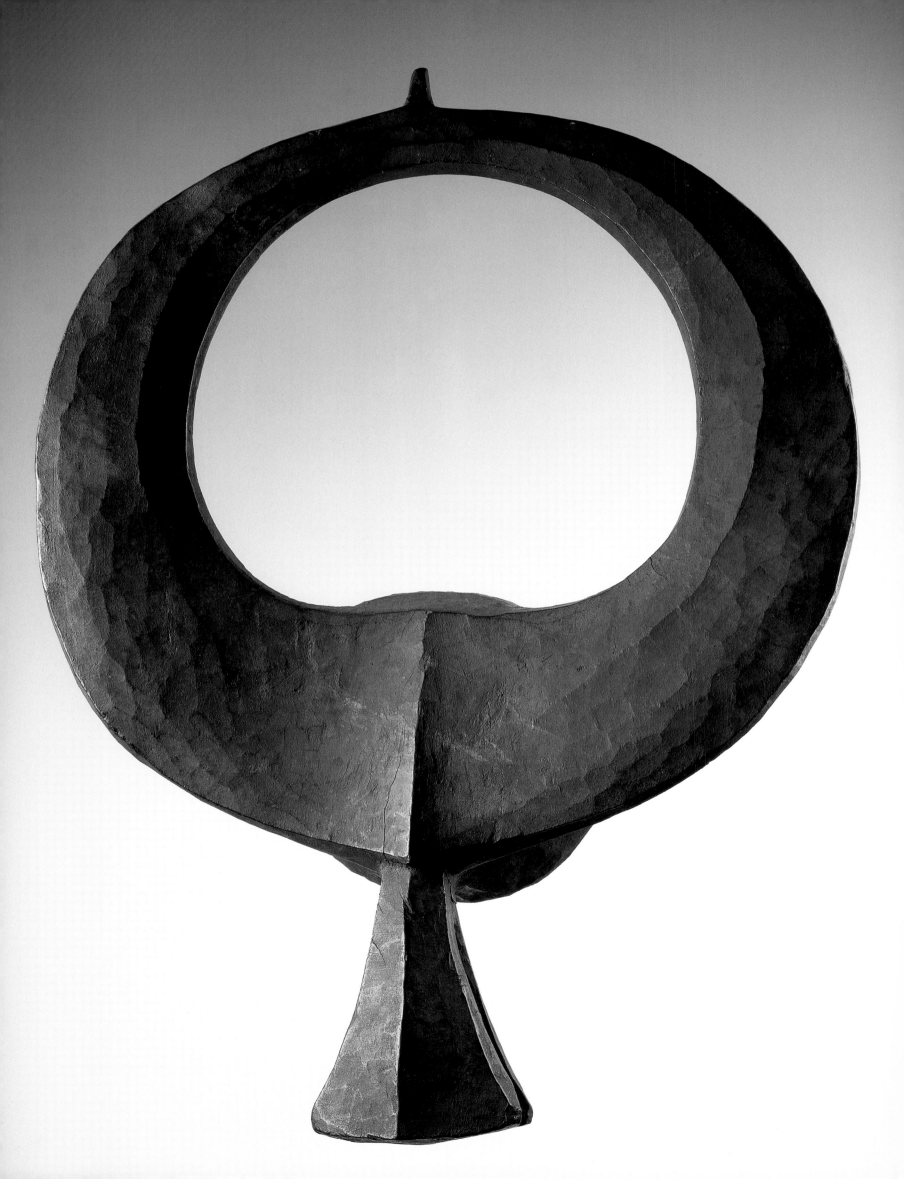

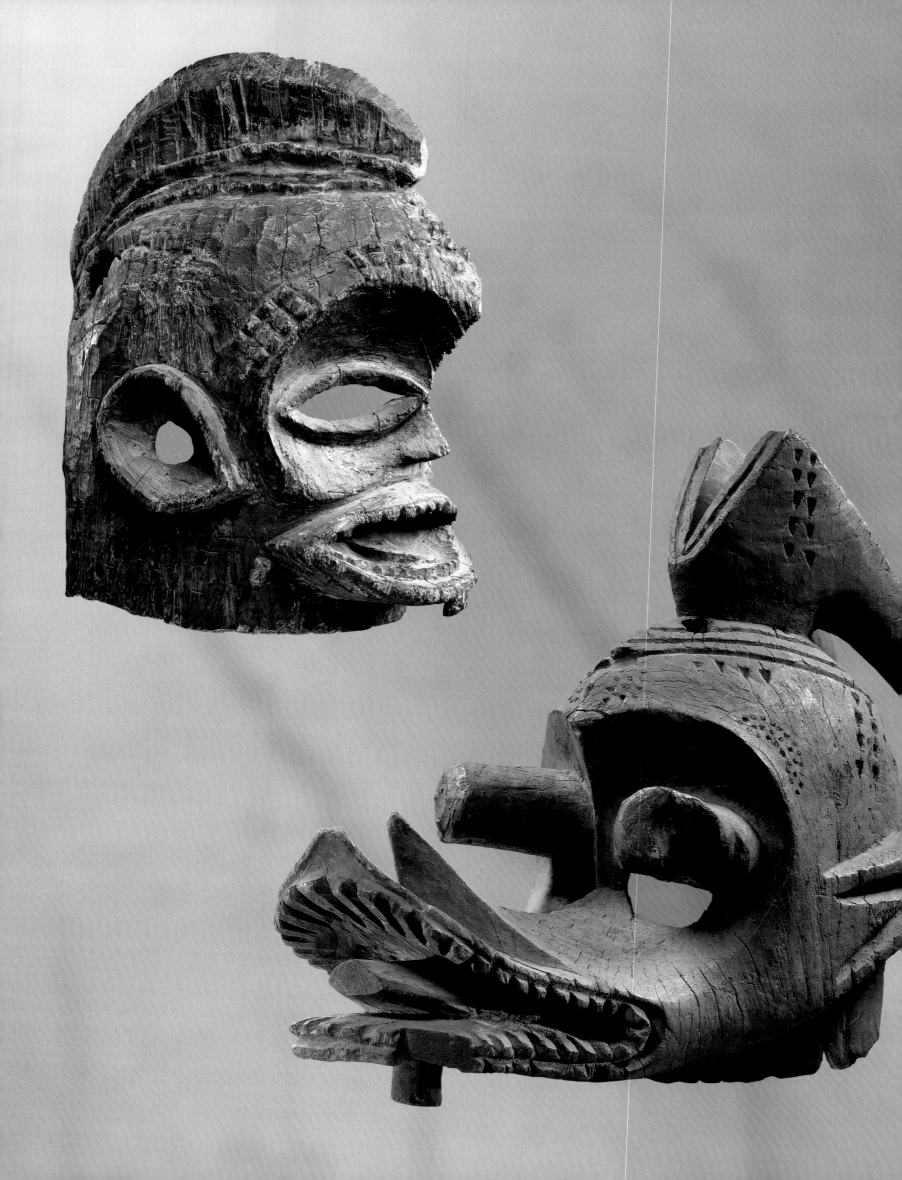

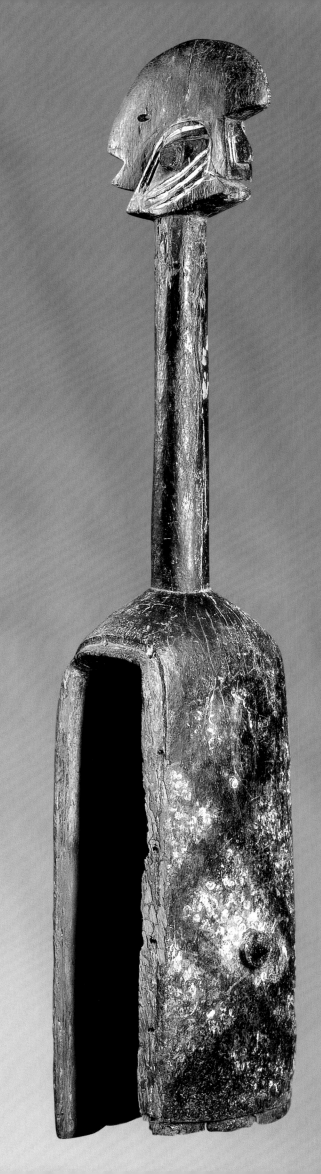

69 HELMET MASK
MAMBILA, CAMEROON/NIGERIA

70 HELMET MASK *SUAGA*
MAMBILA, NIGERIA

71 SHOULDER MASK
BENUE REGION, NIGERIA

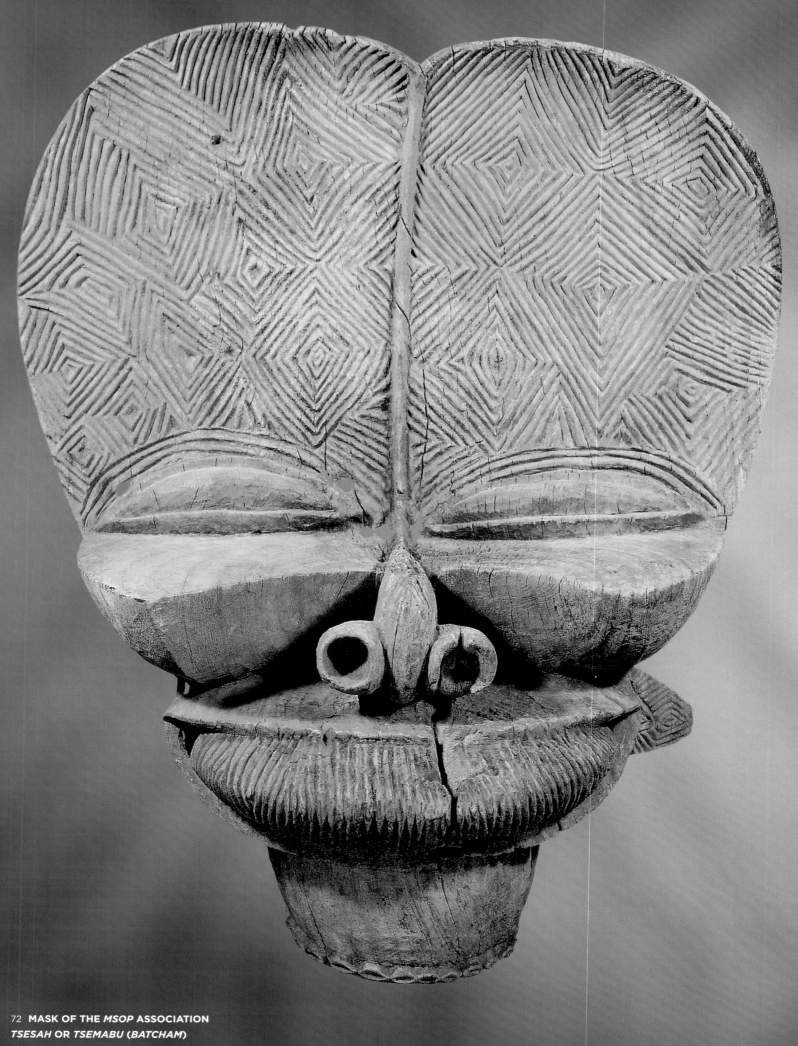

72 **MASK OF THE *MSOP* ASSOCIATION**
***TSESAH* OR *TSEMABU* (*BATCHAM*)**
BAMILEKE (KINGDOM OF BANDJOUN), CAMEROON

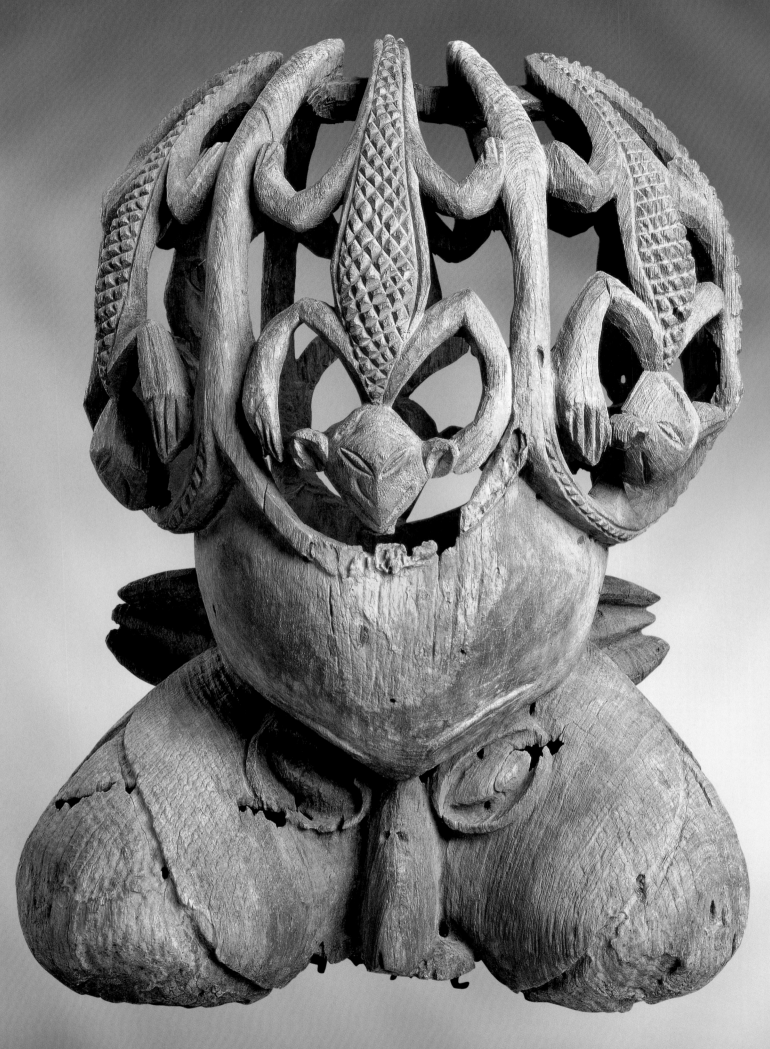

73 **MASK** *TUKAH* **OF THE** *KAH* **ASSOCIATION**
BAMILEKE (KINGDOM OF BAMENDOU), CAMEROON GRASSLANDS

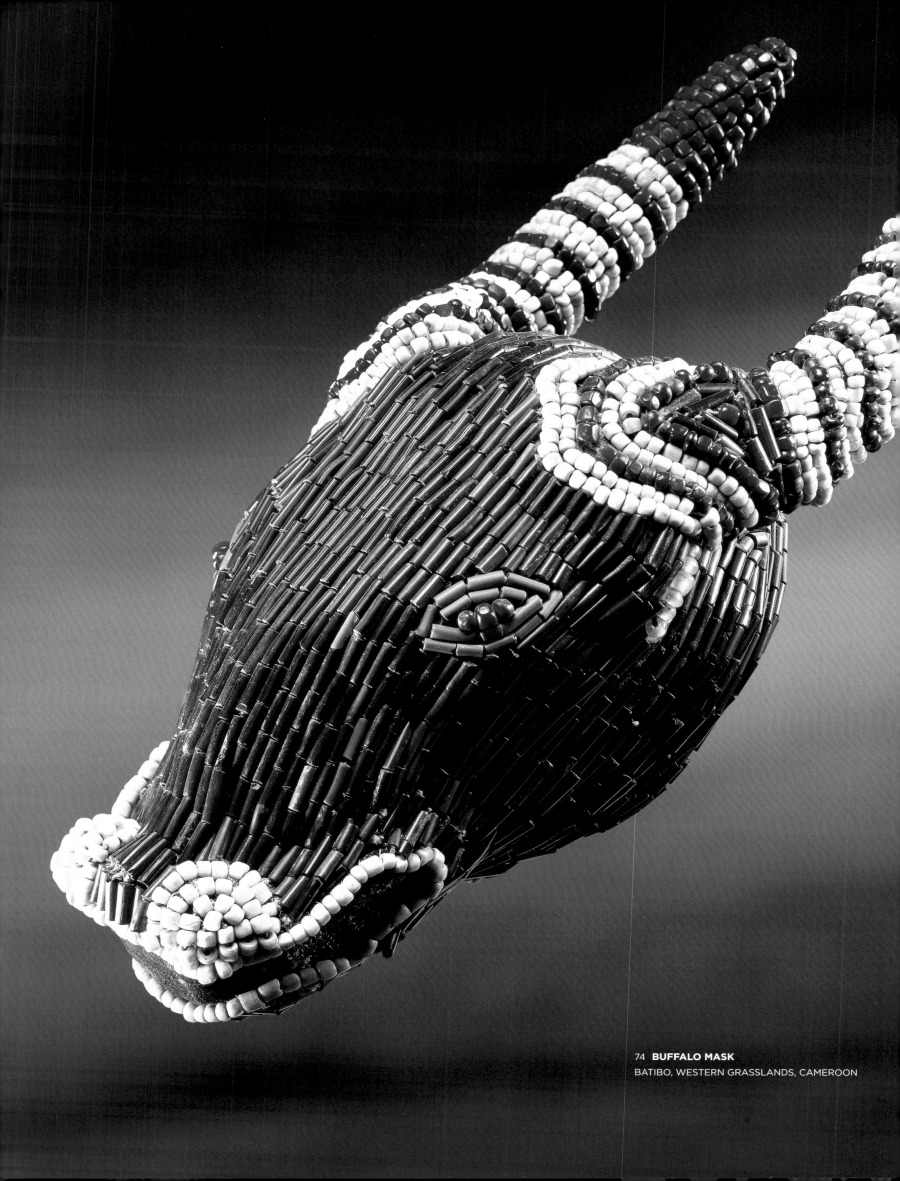

74 **BUFFALO MASK**
BATIBO, WESTERN GRASSLANDS, CAMEROON

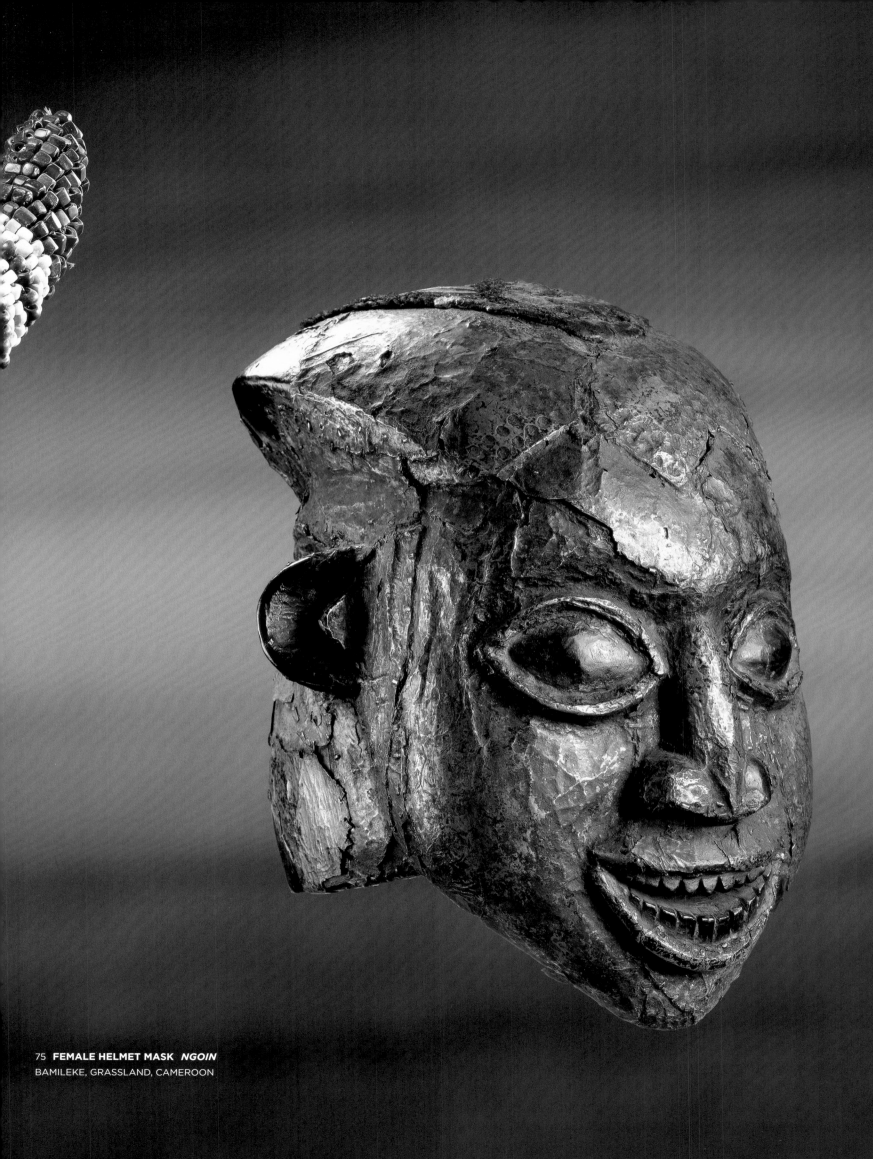

75 **FEMALE HELMET MASK** *NGOIN*
BAMILEKE, GRASSLAND, CAMEROON

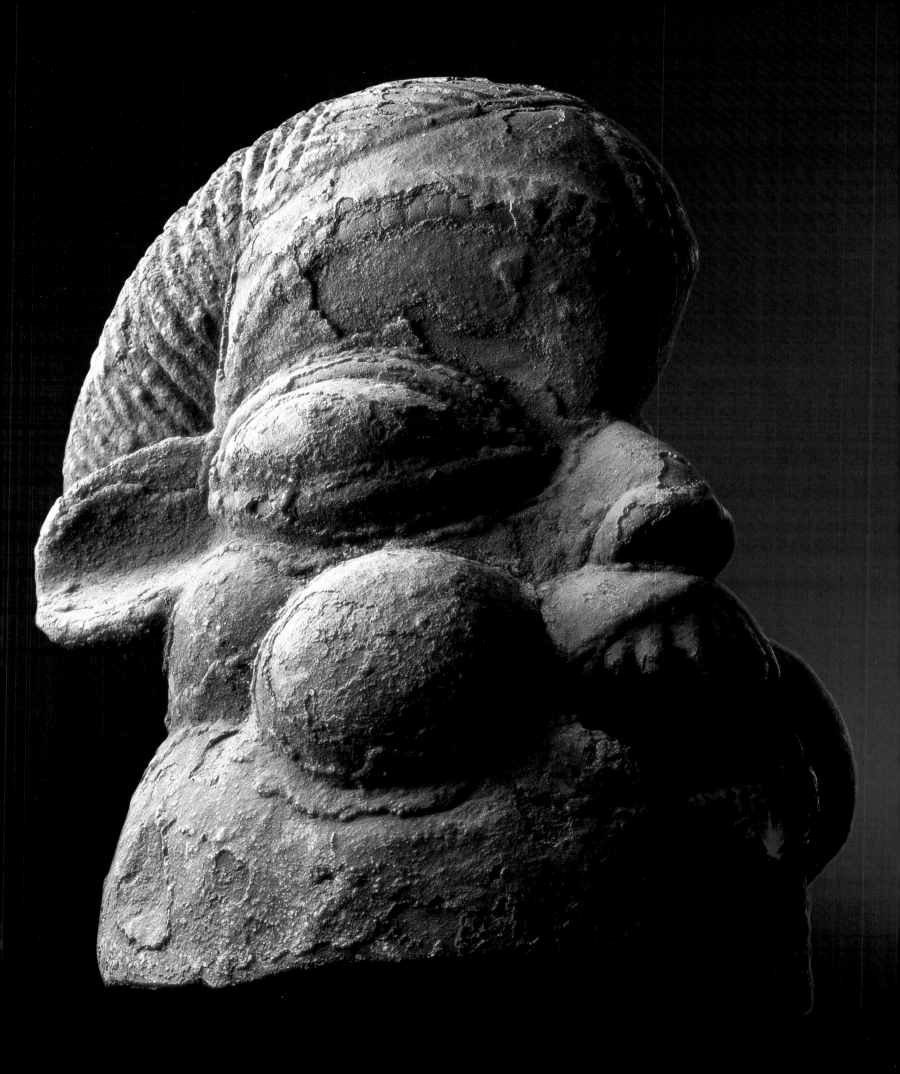

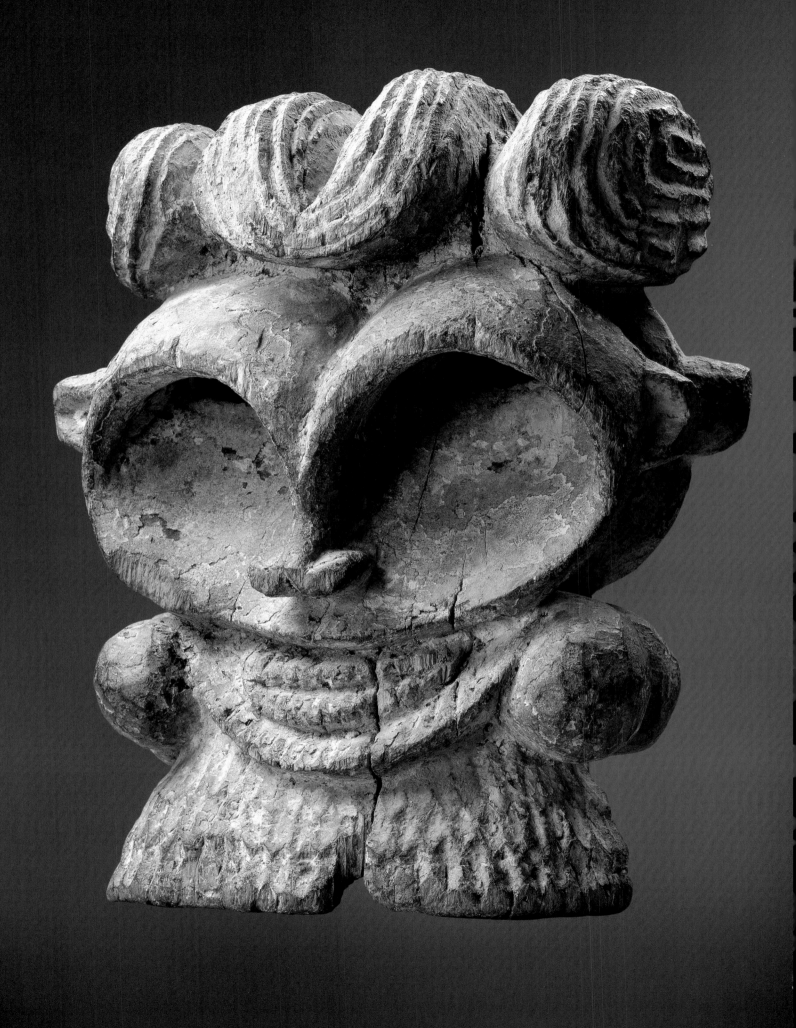

MASK OF THE *TROH* NIGHT SOCIETY
BANGWA, WESTERN PROVINCE, CAMEROON

MASK OF THE *TROH* NIGHT SOCIETY
BANGWA, WESTERN PROVINCE, CAMEROON

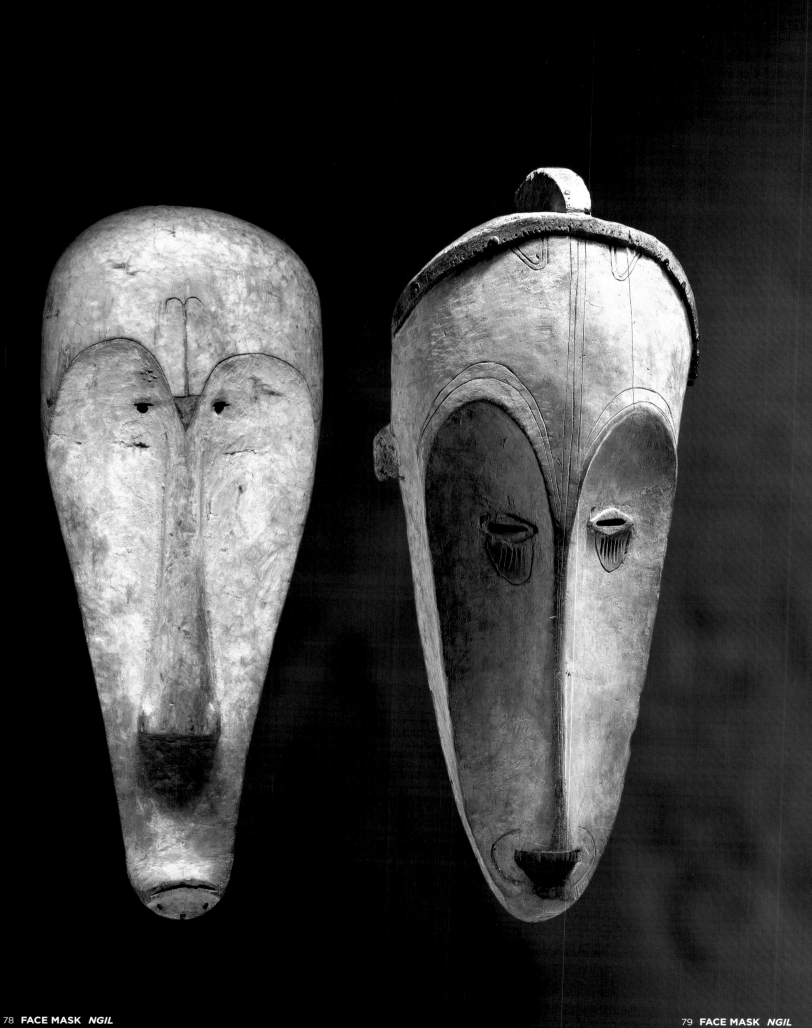

78 FACE MASK *NGIL*
FANG, GABON/CAMEROON

79 FACE MASK *NGIL*
FANG, GABON

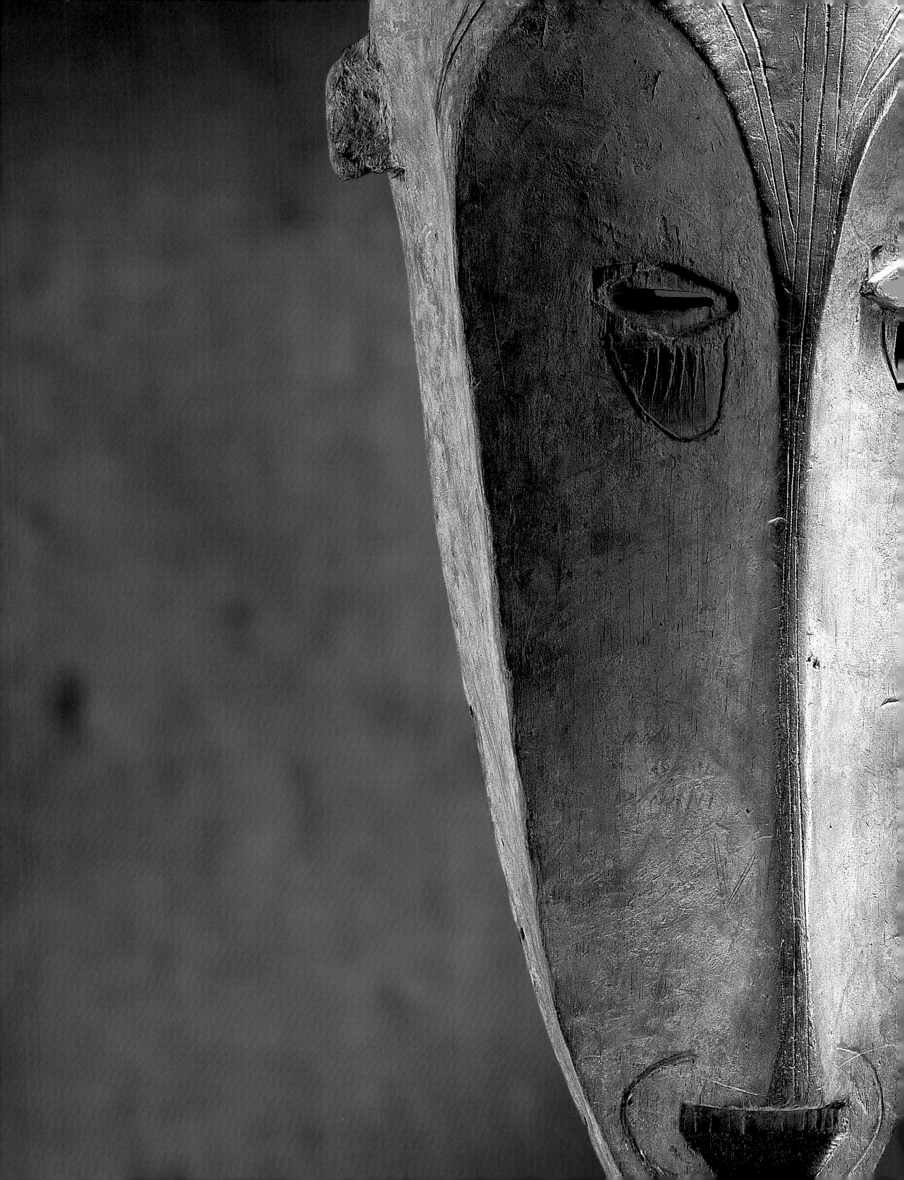

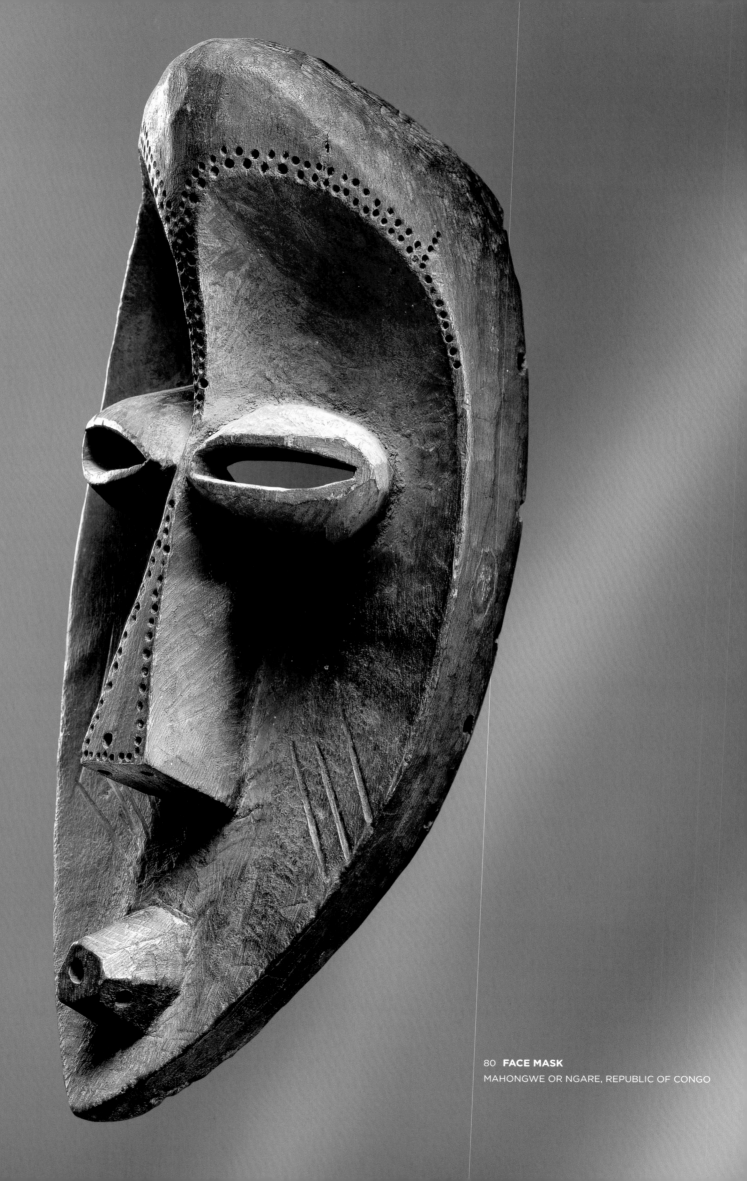

80 **FACE MASK**
MAHONGWE OR NGARE, REPUBLIC OF CONGO

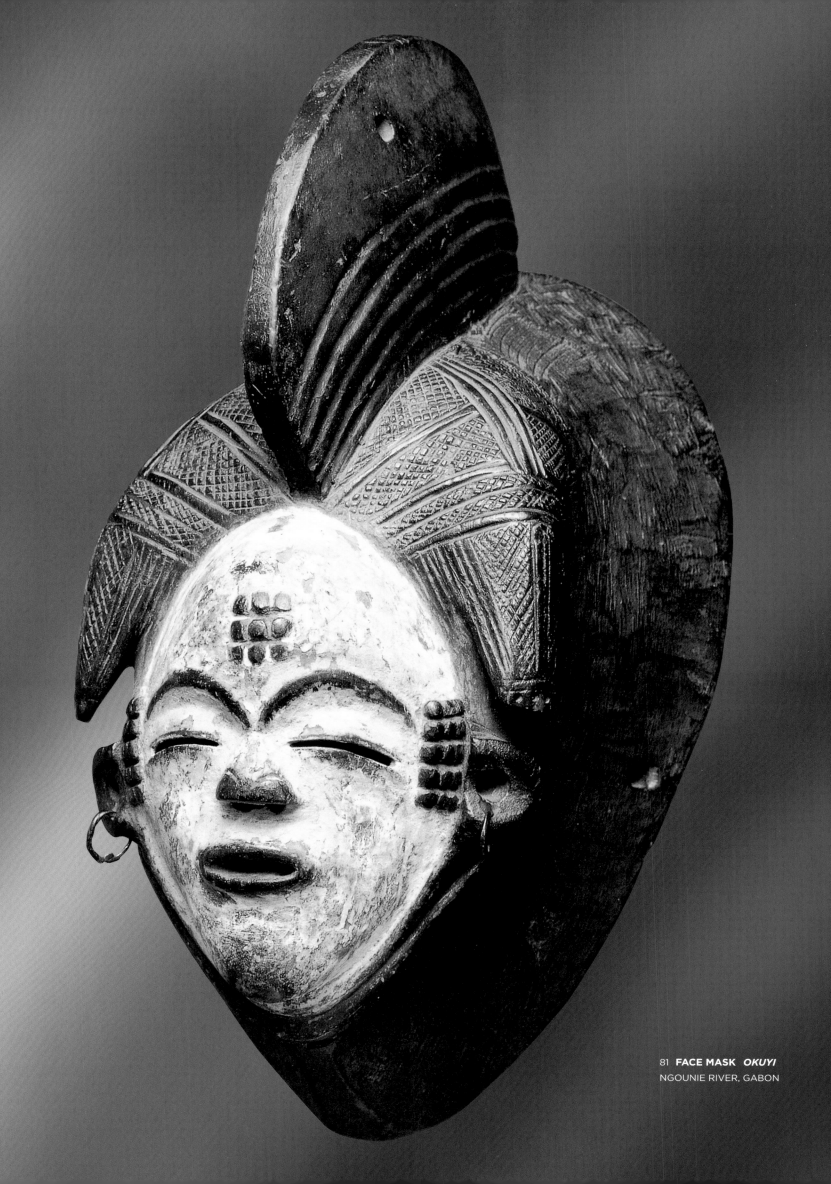

81 **FACE MASK** *OKUYI*
NGOUNIE RIVER, GABON

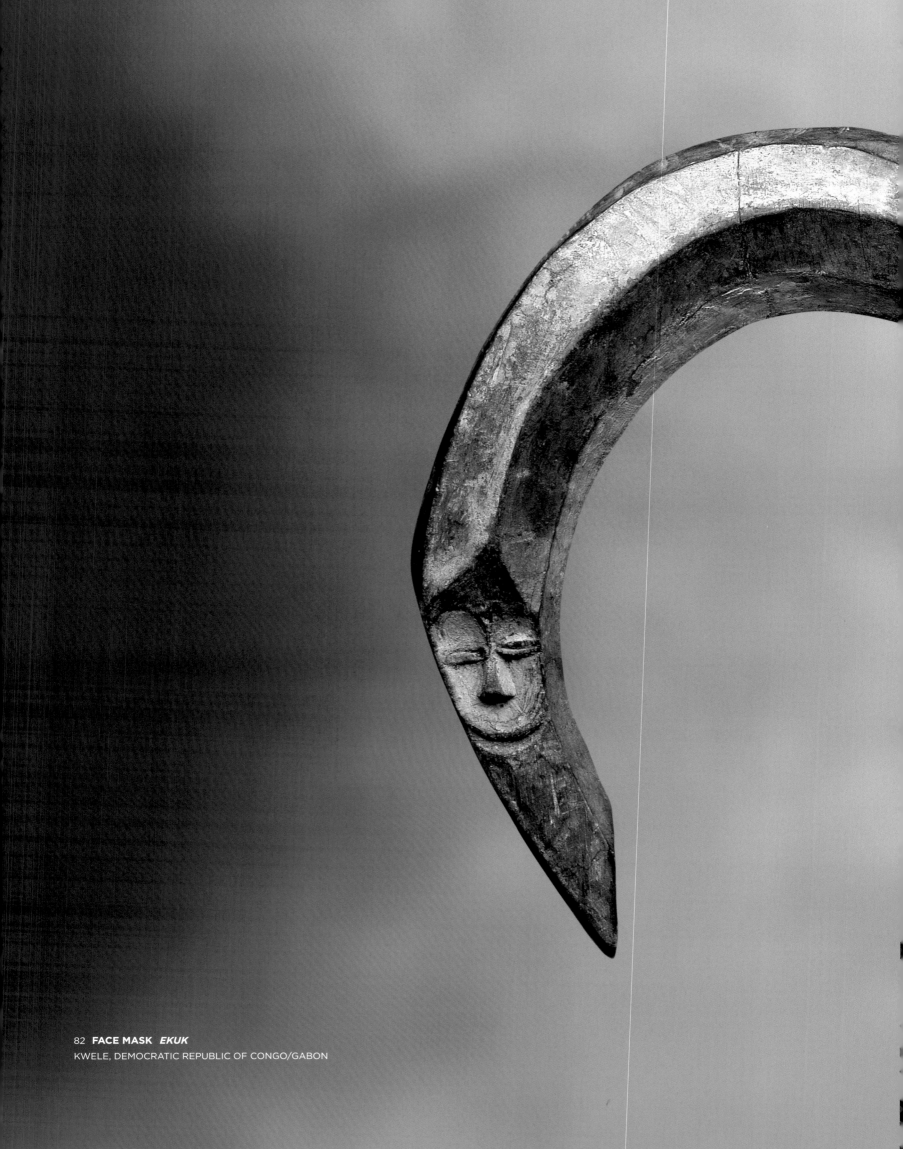

82 **FACE MASK** *EKUK*
KWELE, DEMOCRATIC REPUBLIC OF CONGO/GABON

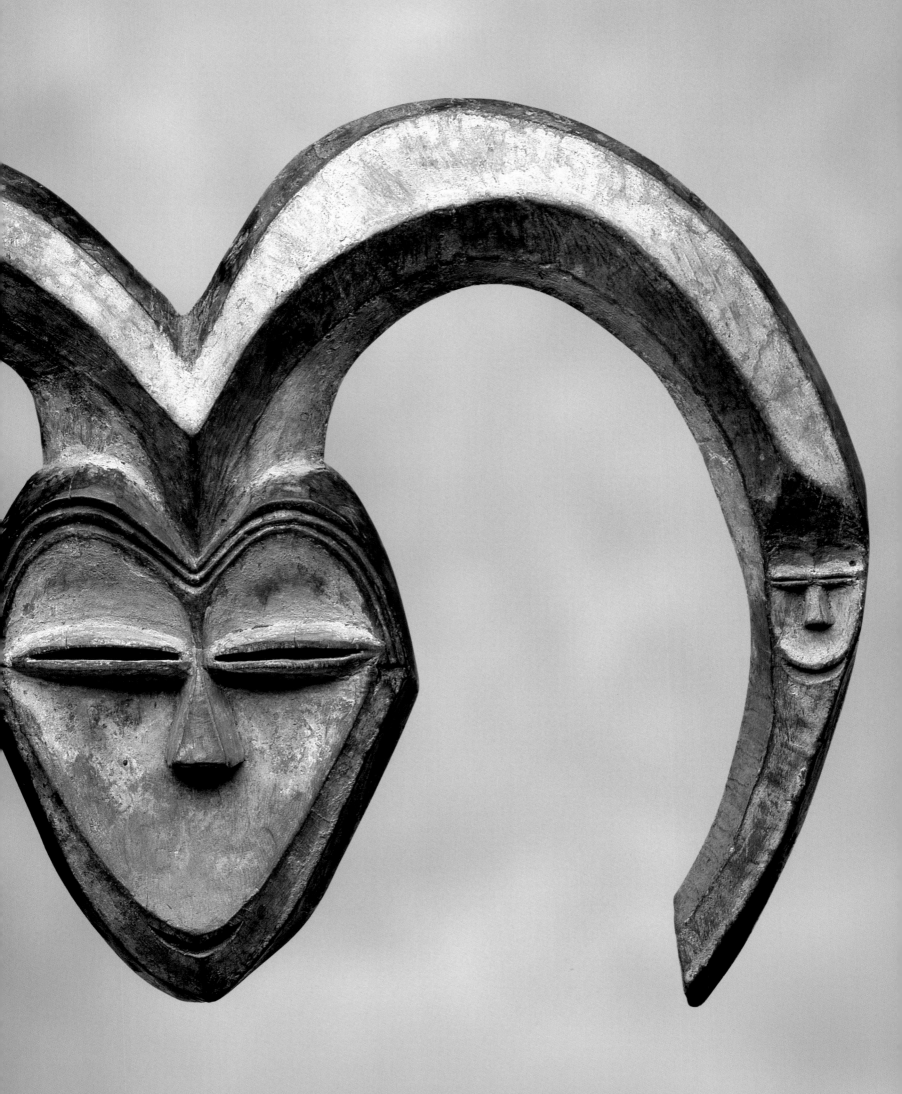

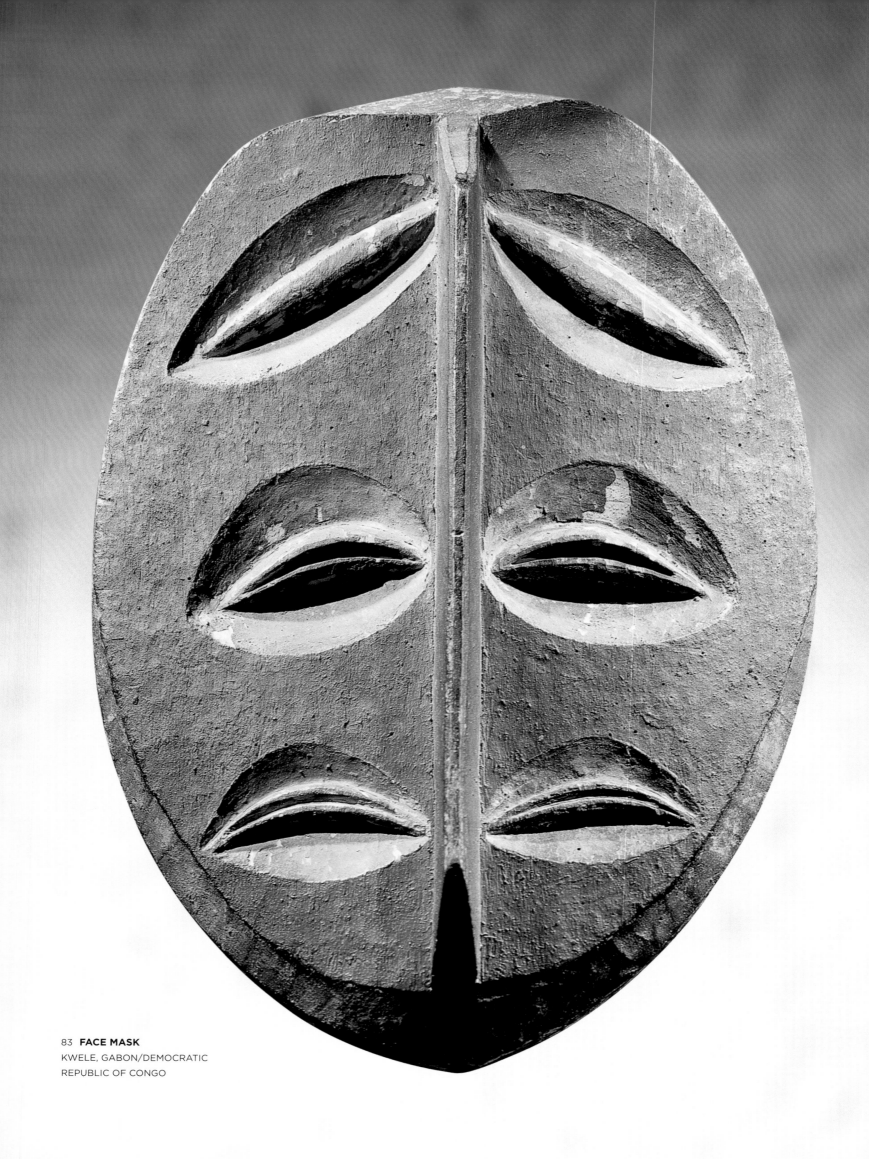

83 **FACE MASK**
KWELE, GABON/DEMOCRATIC
REPUBLIC OF CONGO

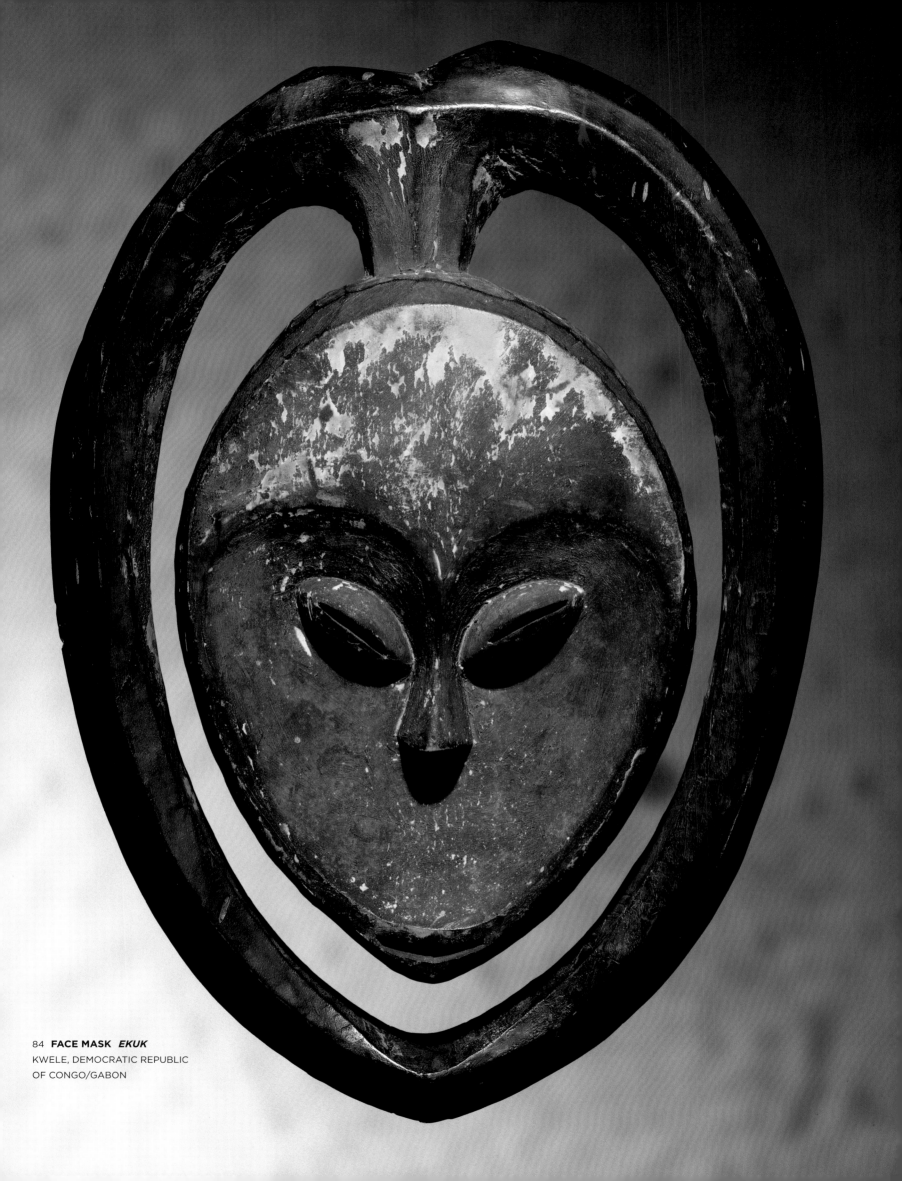

84 **FACE MASK** *EKUK*
KWELE, DEMOCRATIC REPUBLIC
OF CONGO/GABON

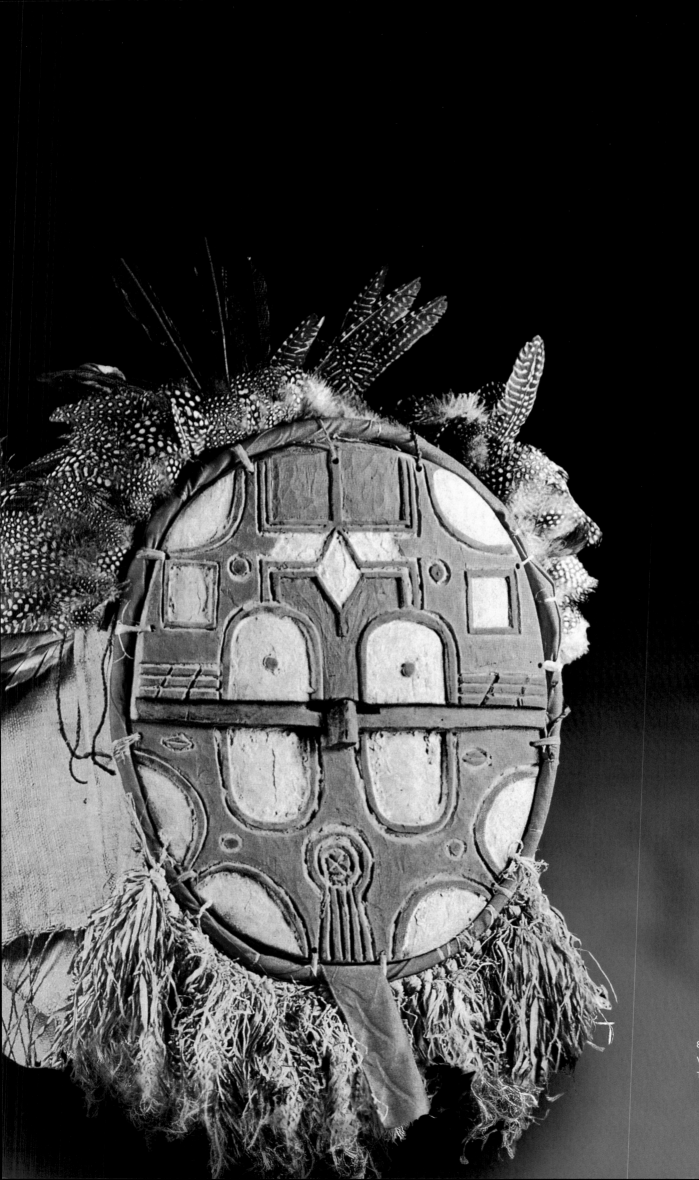

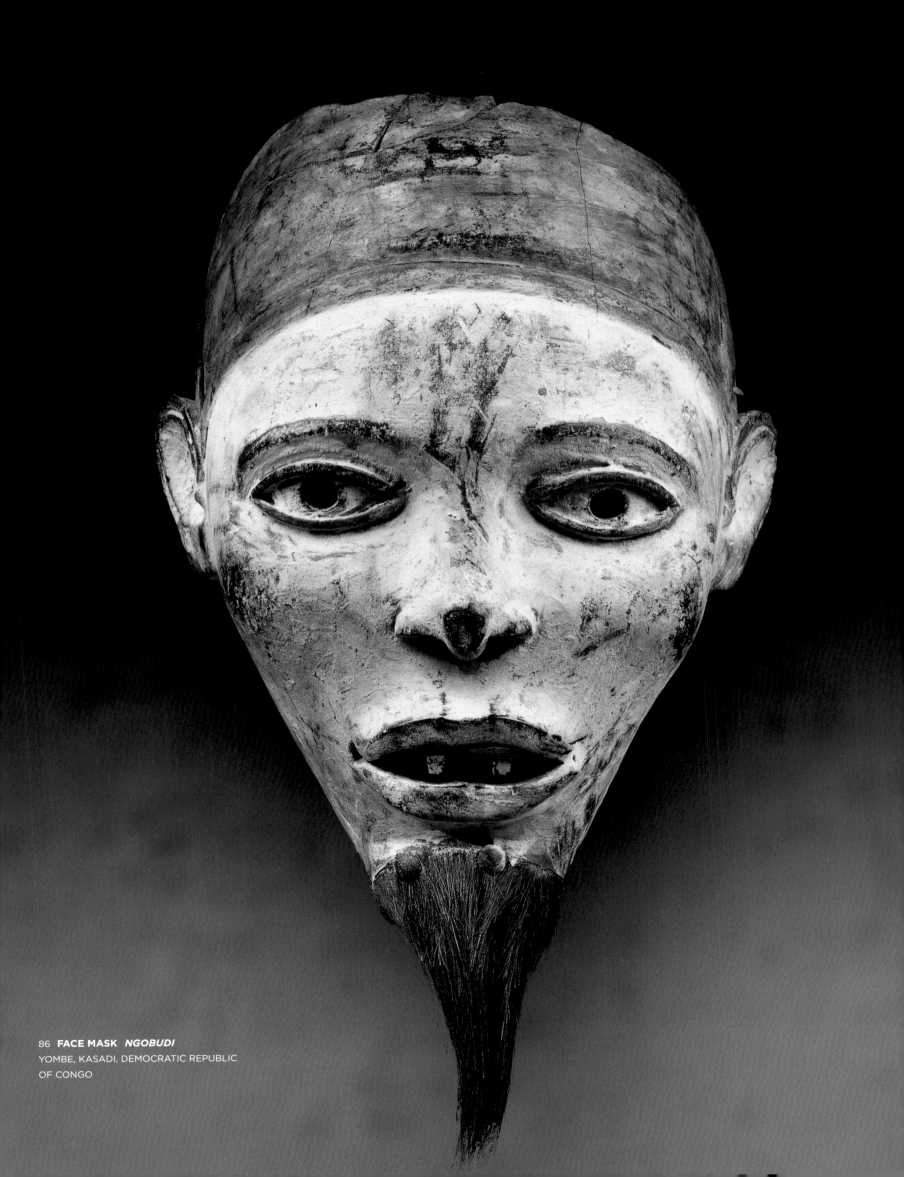

86 **FACE MASK** *NGOBUDI*
YOMBE, KASADI, DEMOCRATIC REPUBLIC
OF CONGO

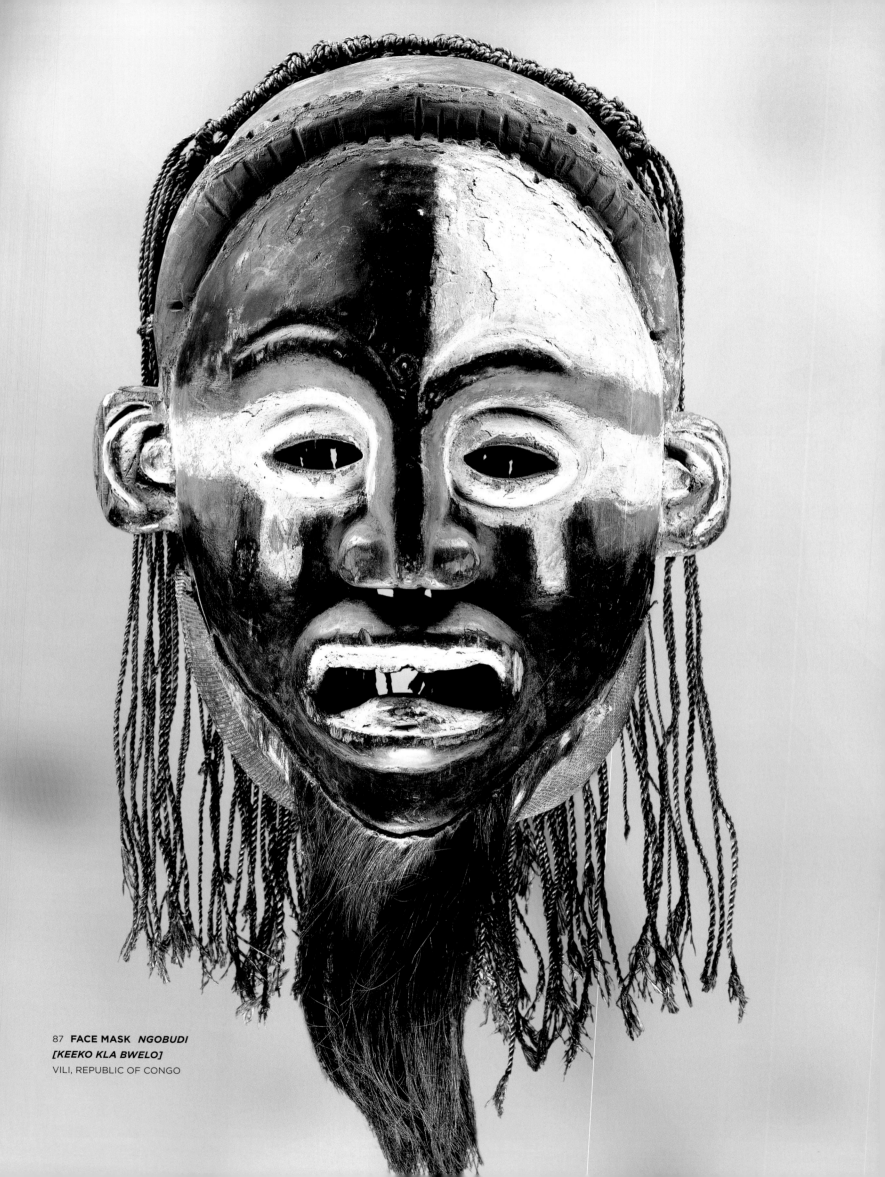

87 **FACE MASK** *NGOBUDI*
[KEEKO KLA BWELO]
VILI, REPUBLIC OF CONGO

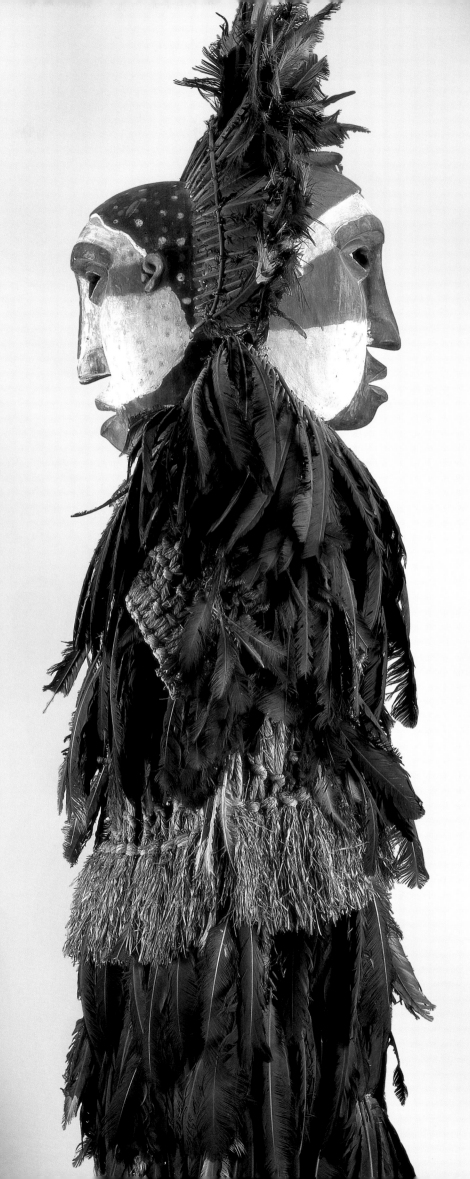

88 **JANUS-HEADED HELMET
MASK *NDUNGA***
VILI OR WOYO, DEMOCRATIC
REPUBLIC OF CONGO

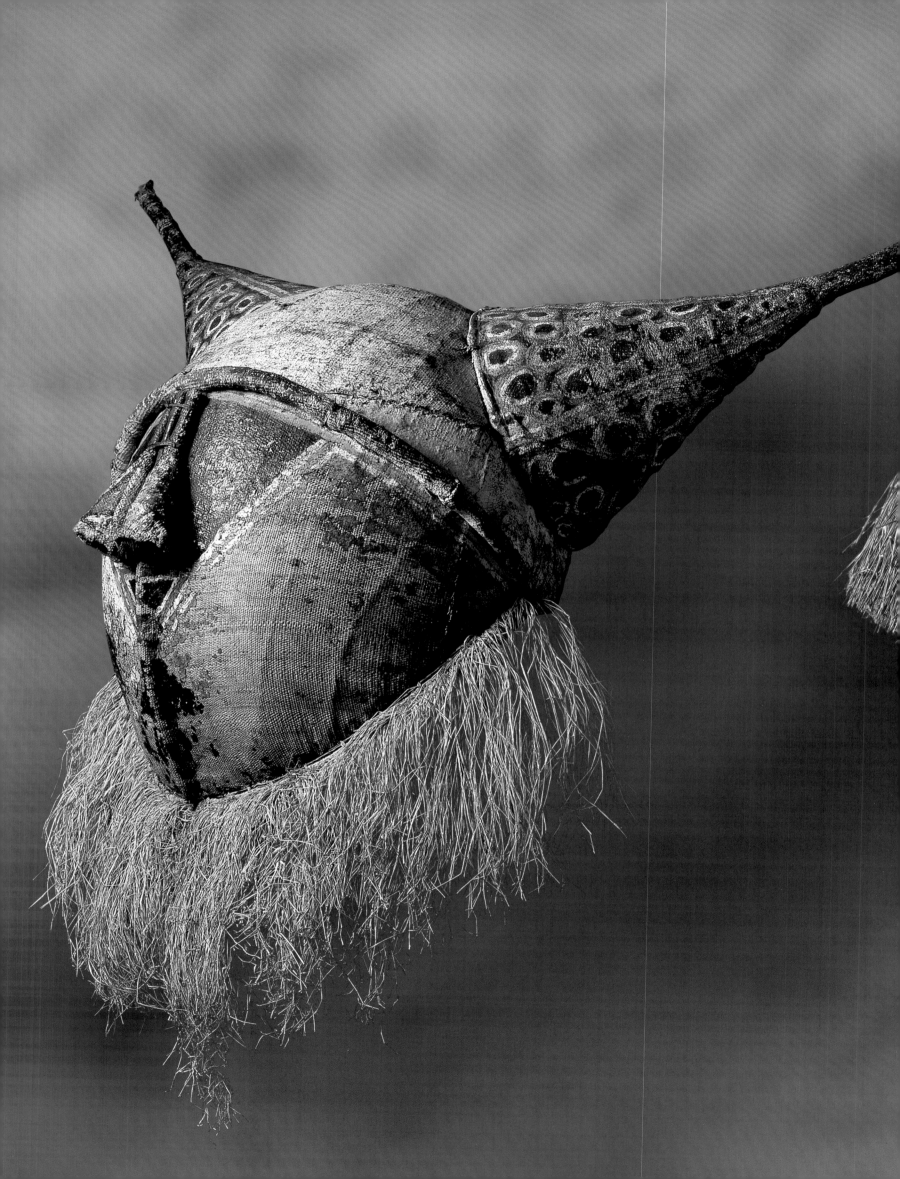

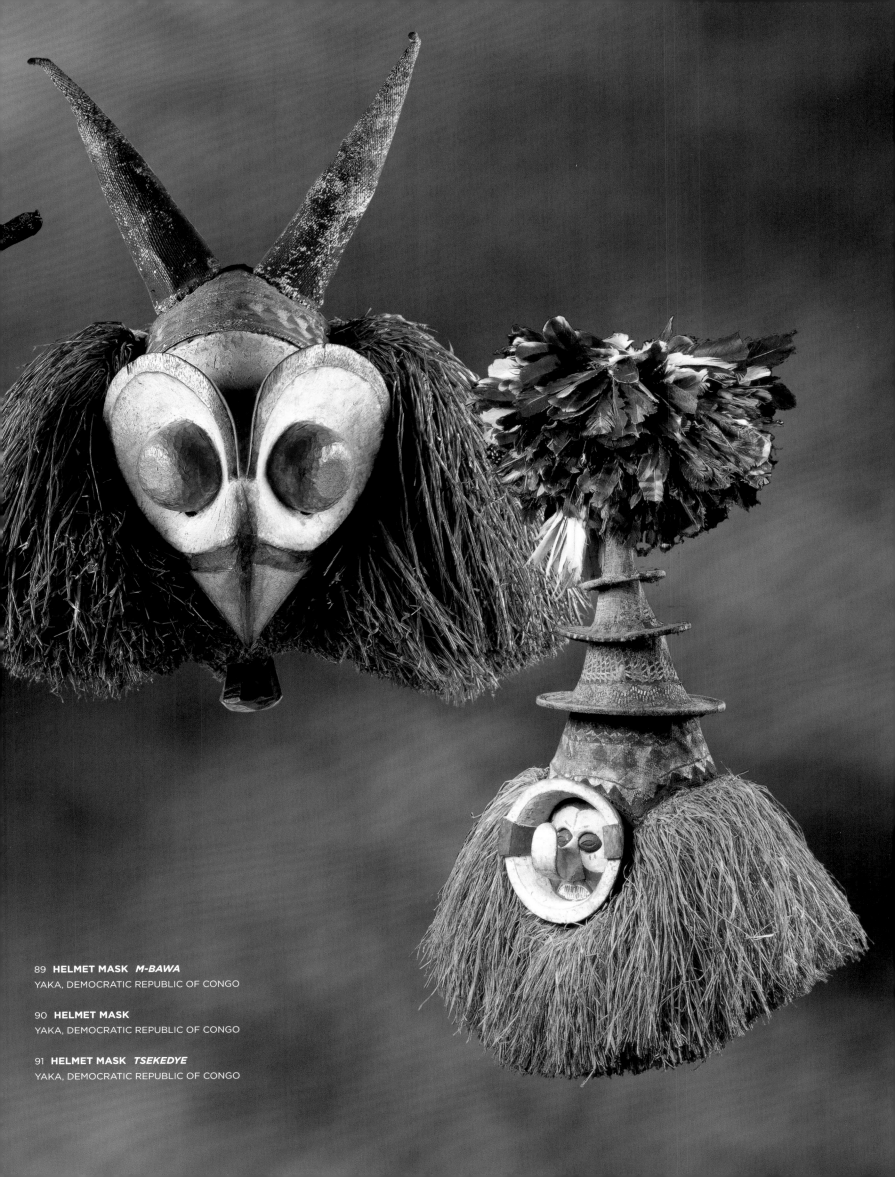

89 **HELMET MASK** *M-BAWA*
YAKA, DEMOCRATIC REPUBLIC OF CONGO

90 **HELMET MASK**
YAKA, DEMOCRATIC REPUBLIC OF CONGO

91 **HELMET MASK** *TSEKEDYE*
YAKA, DEMOCRATIC REPUBLIC OF CONGO

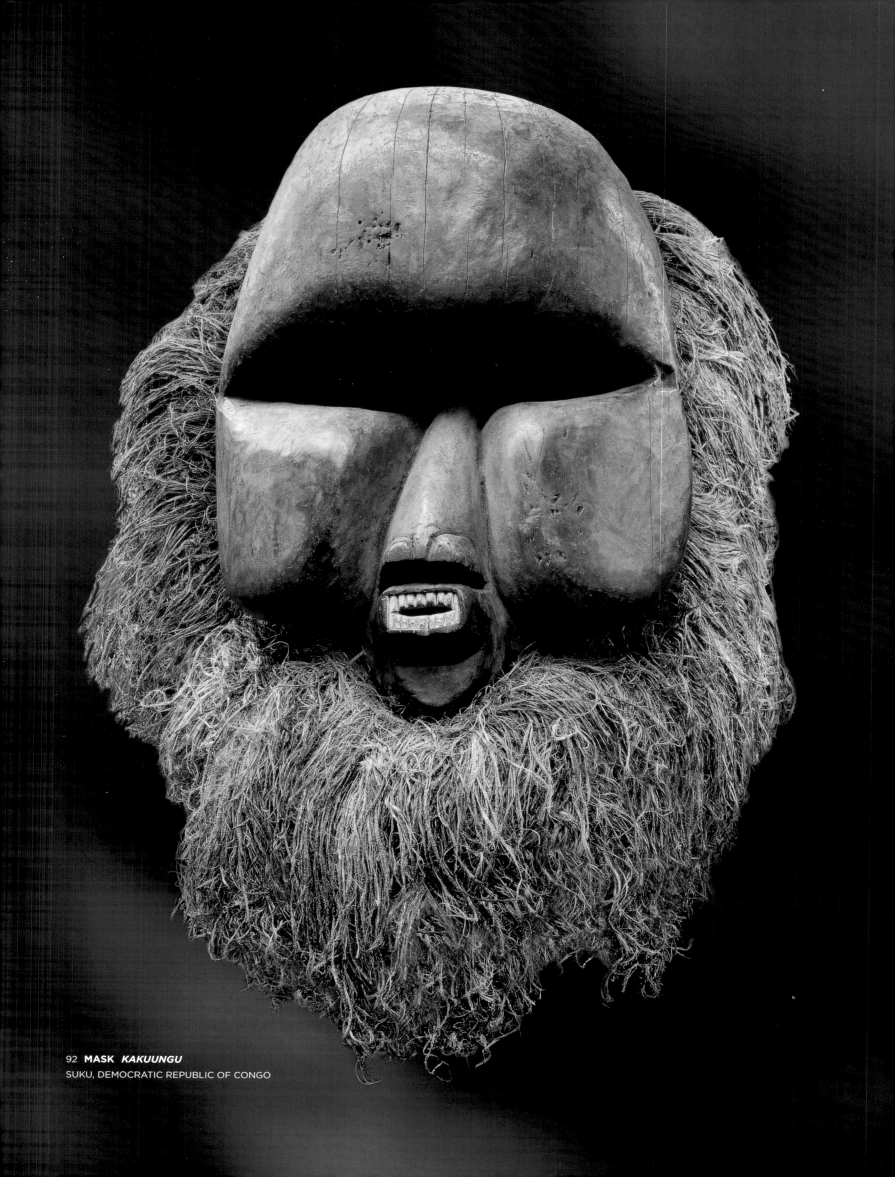

92 **MASK** *KAKUUNGU*
SUKU, DEMOCRATIC REPUBLIC OF CONGO

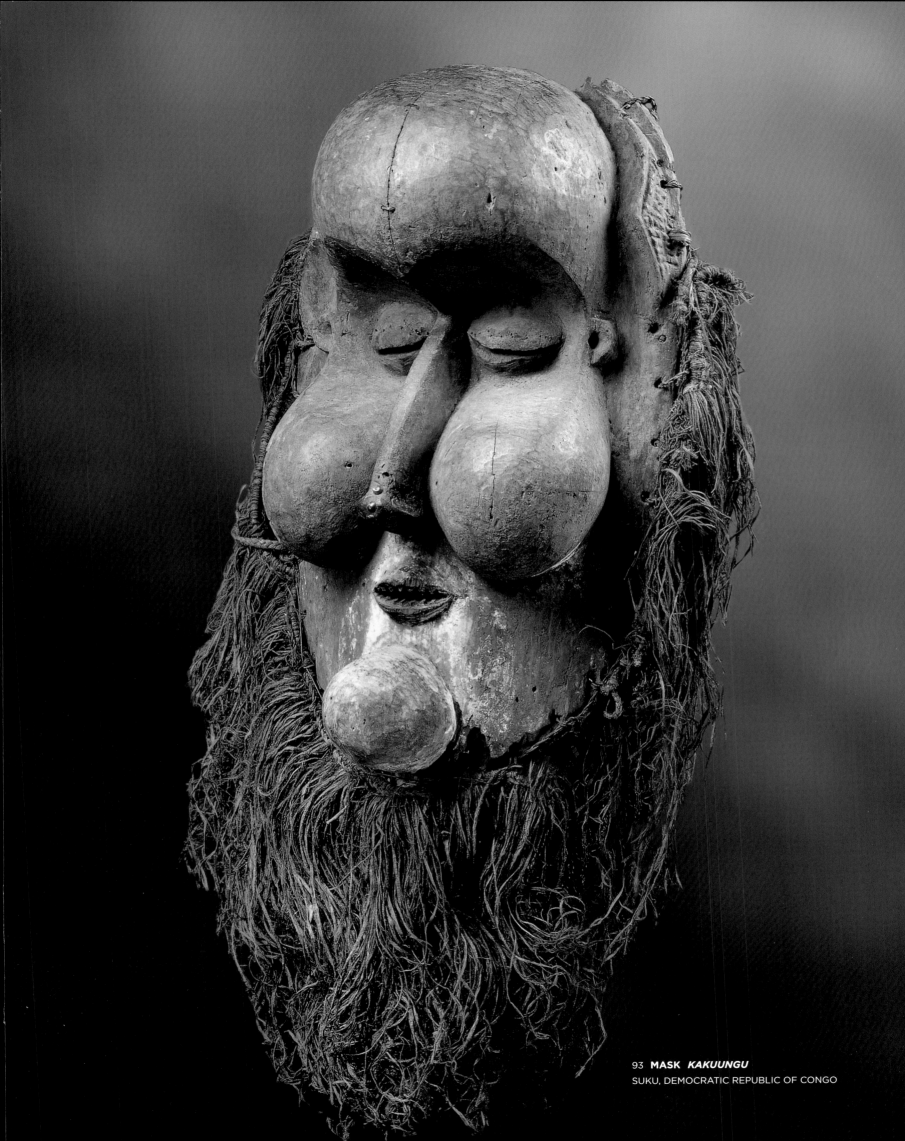

93 **MASK** *KAKUUNGU*
SUKU, DEMOCRATIC REPUBLIC OF CONGO

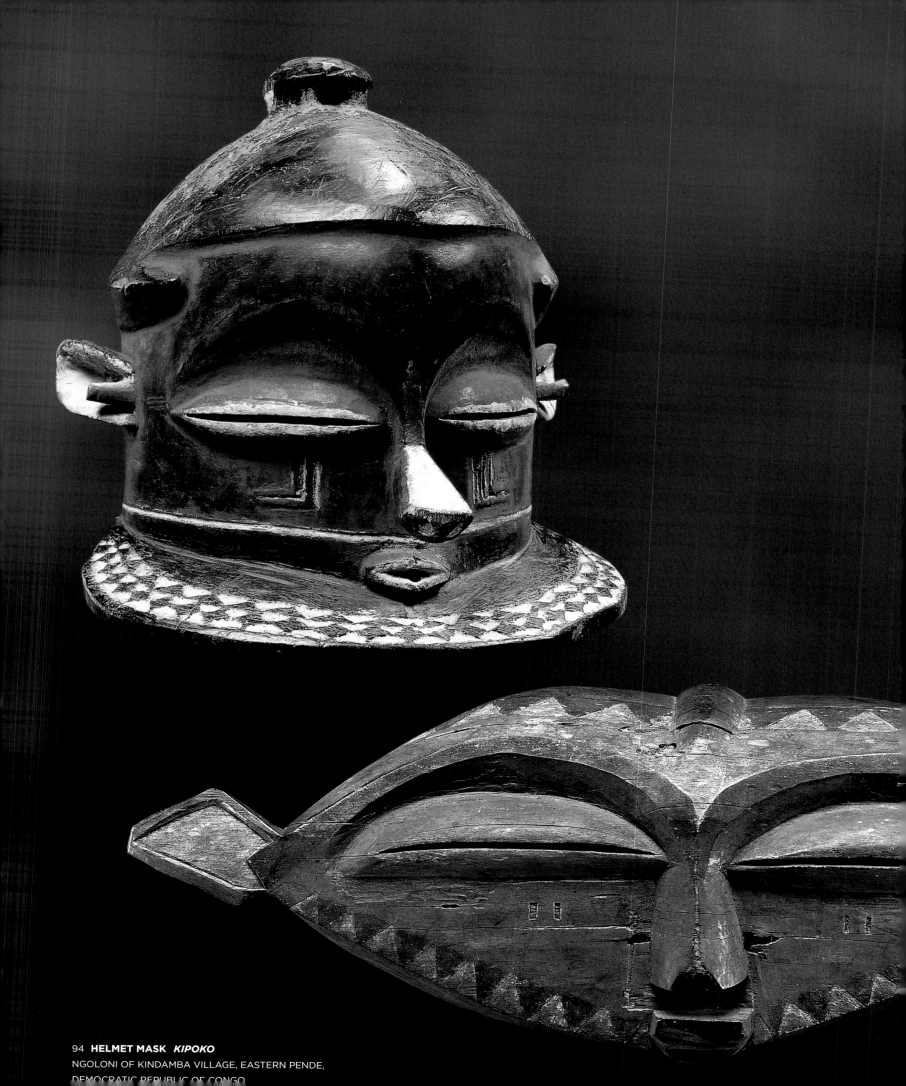

94 **HELMET MASK** *KIPOKO*

NGOLONI OF KINDAMBA VILLAGE, EASTERN PENDE,
DEMOCRATIC REPUBLIC OF CONGO

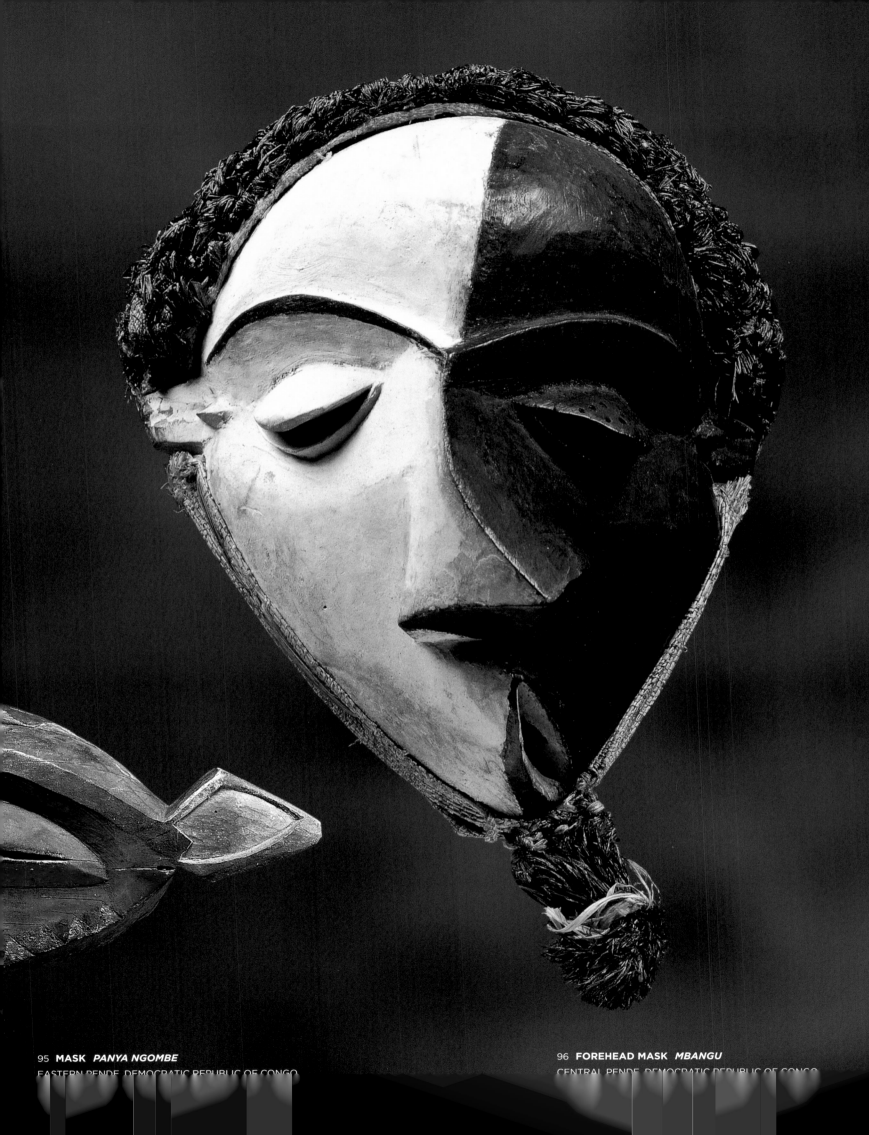

95 **MASK** *PANYA NGOMBE*
EASTERN PENDE, DEMOCRATIC REPUBLIC OF CONGO

96 **FOREHEAD MASK** *MBANGU*
CENTRAL PENDE, DEMOCRATIC REPUBLIC OF CONGO

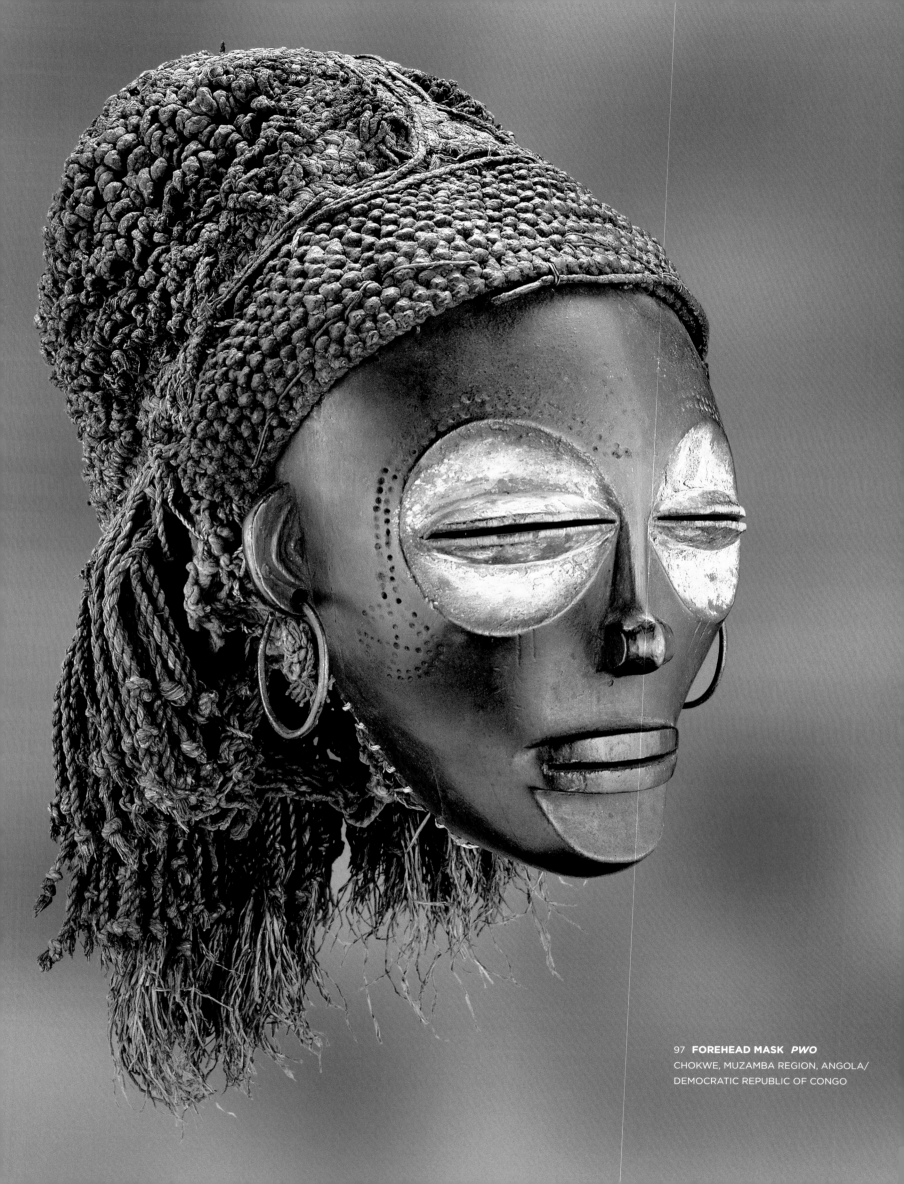

97 **FOREHEAD MASK** *PWO*
CHOKWE, MUZAMBA REGION, ANGOLA/
DEMOCRATIC REPUBLIC OF CONGO

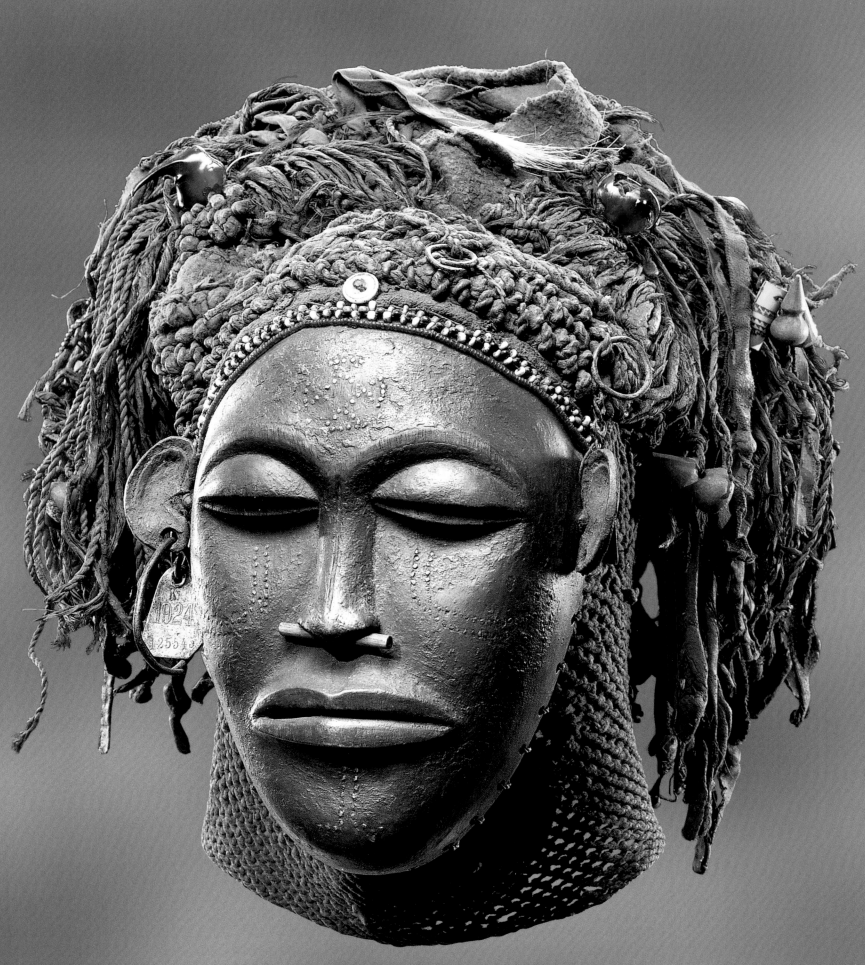

98 **FOREHEAD MASK** *PWO*
CHOKWE, DEMOCRATIC REPUBLIC OF CONGO

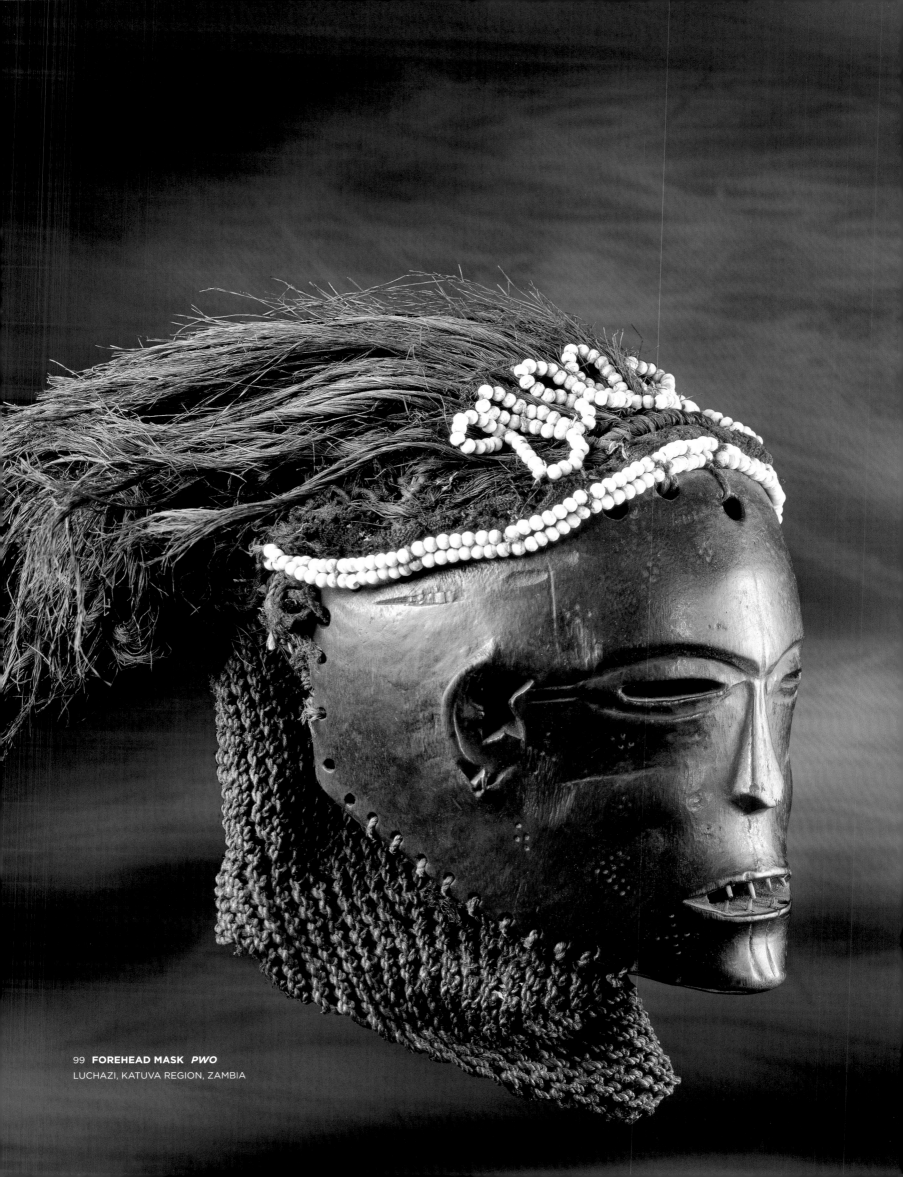

99 **FOREHEAD MASK** *PWO*
LUCHAZI, KATUVA REGION, ZAMBIA

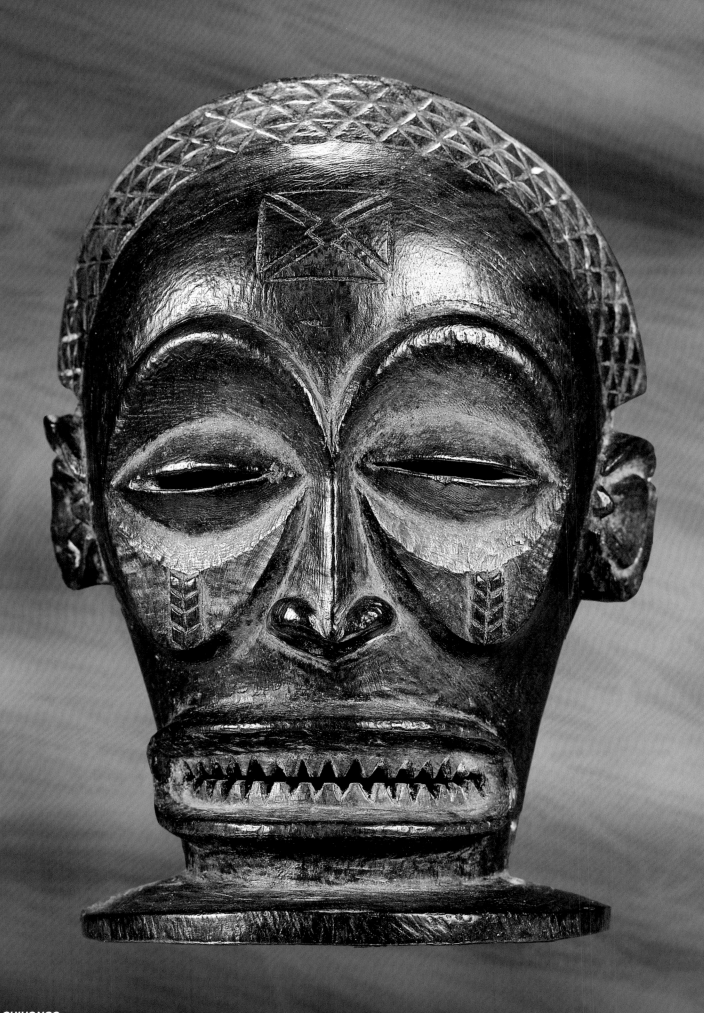

100 **FACE MASK** *CHIHONGO*
CHOKWE, ANGOLA/DEMOCRATIC REPUBLIC OF CONGO

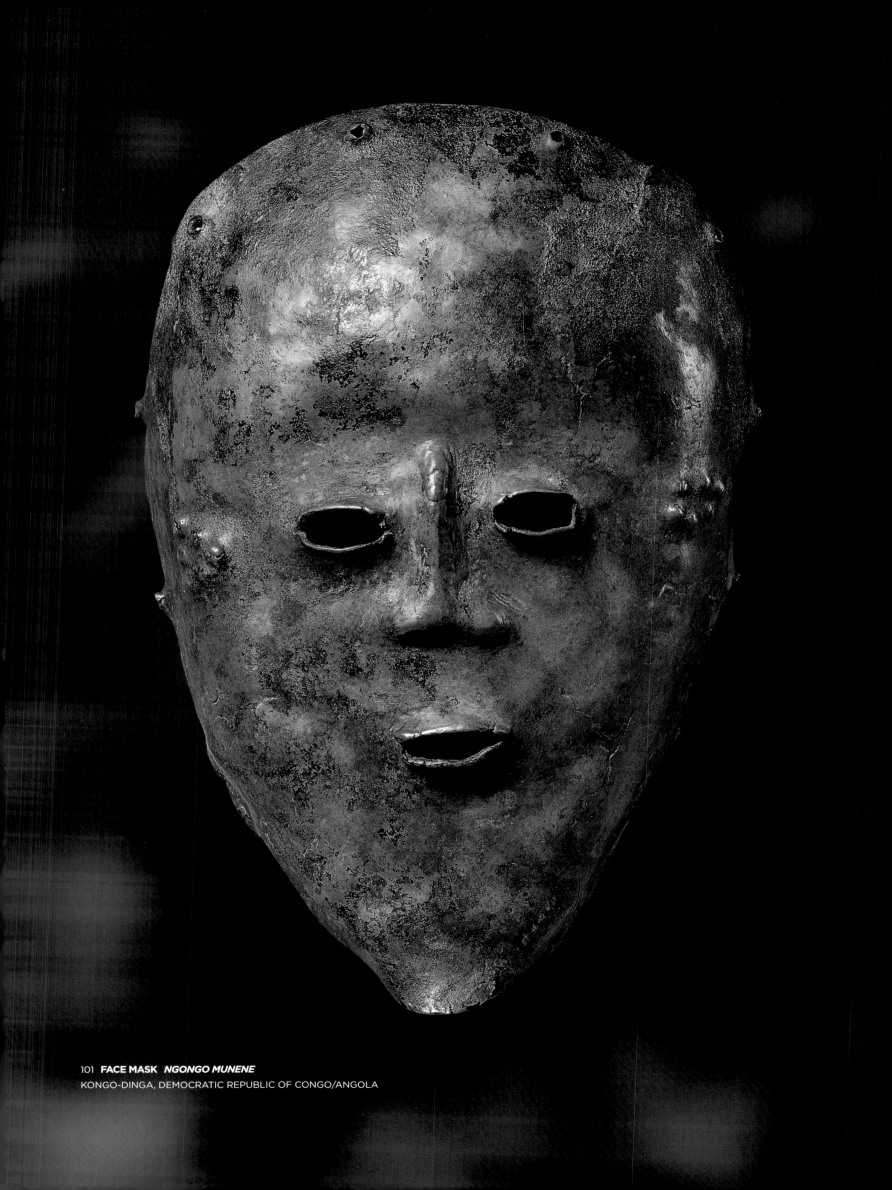

101 **FACE MASK** *NGONGO MUNENE*
KONGO-DINGA, DEMOCRATIC REPUBLIC OF CONGO/ANGOLA

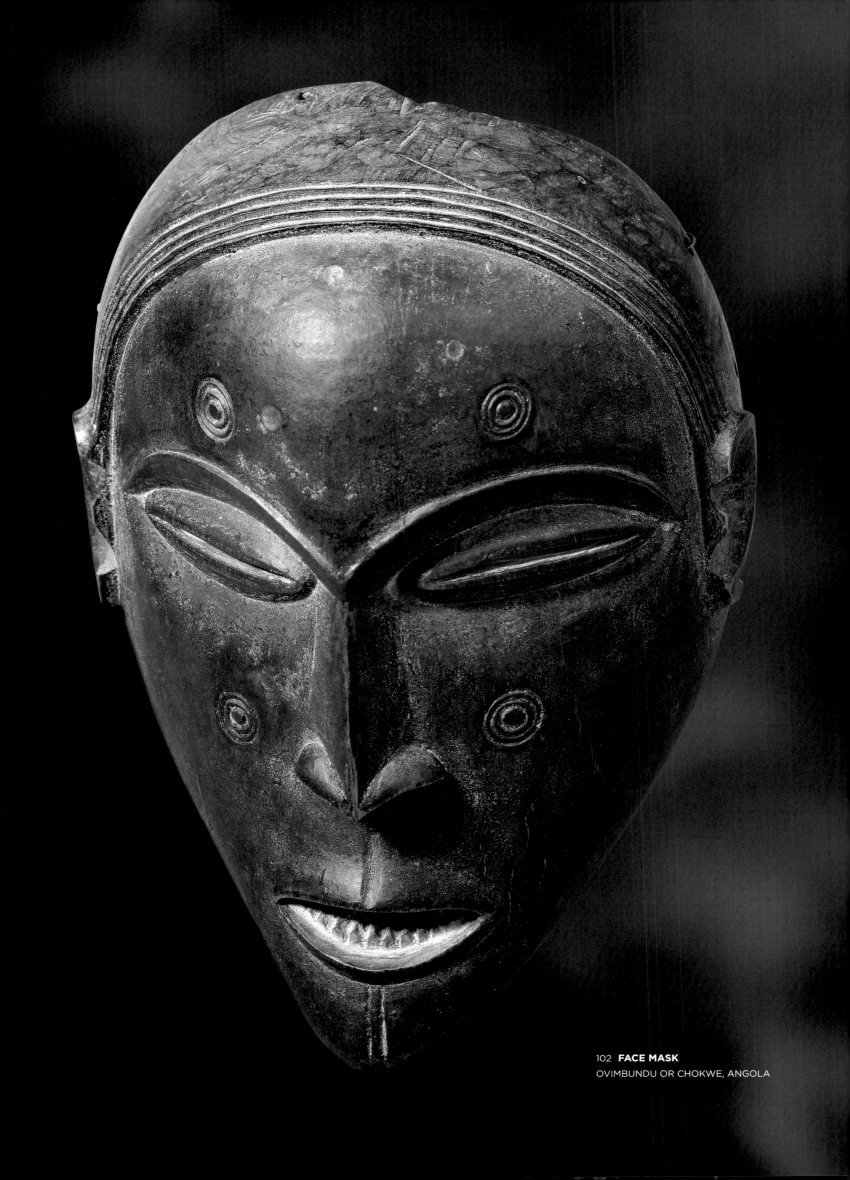

102 **FACE MASK**
OVIMBUNDU OR CHOKWE, ANGOLA

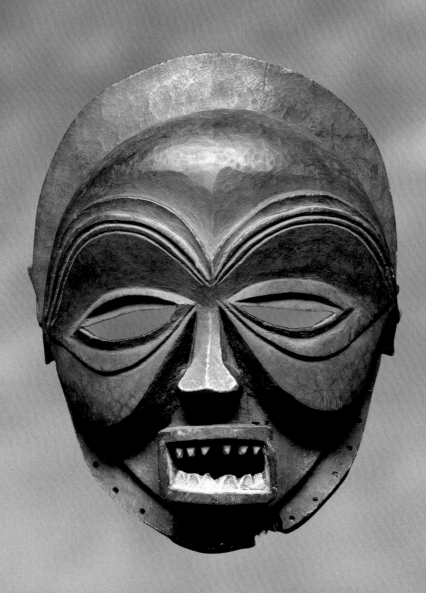

103 **FACE MASK** *SACHIHONGO*
MBUNDA, ZAMBIA

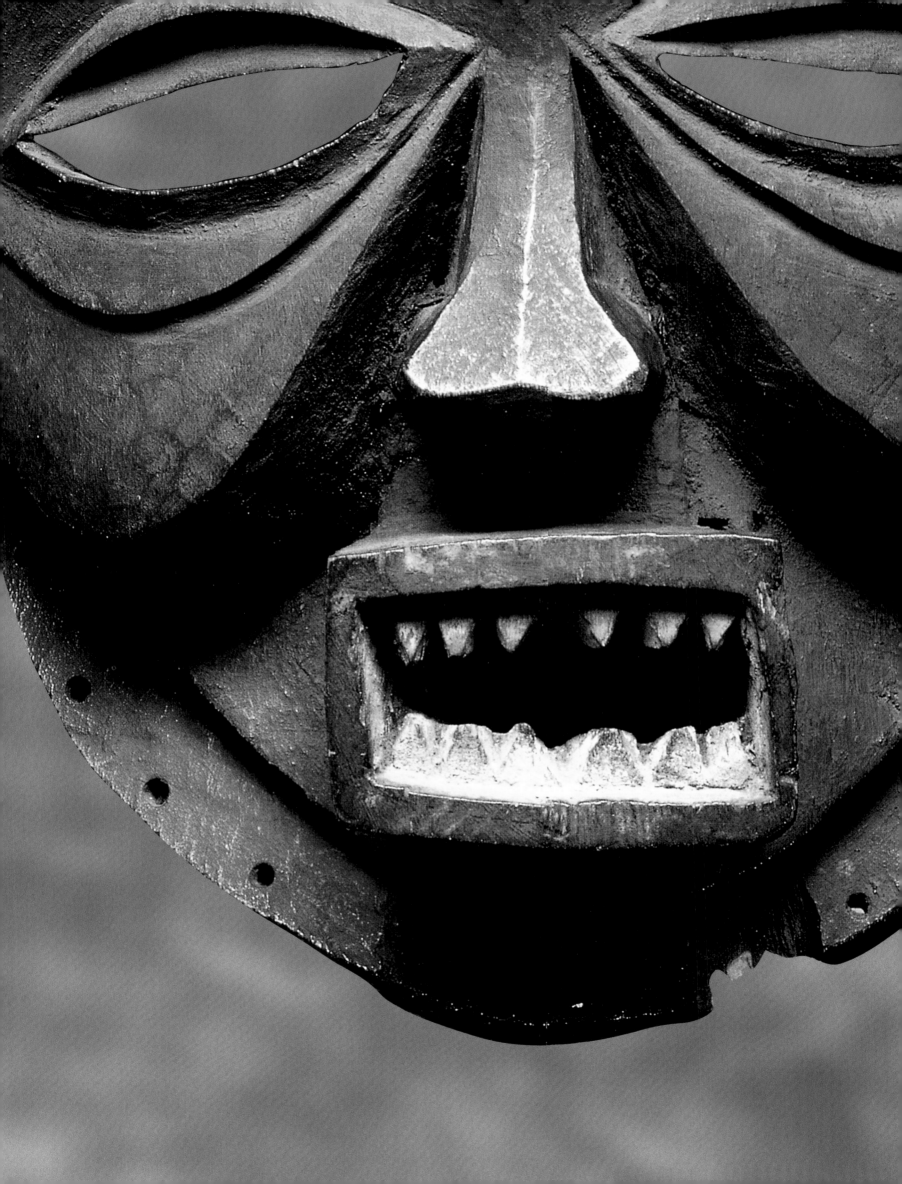

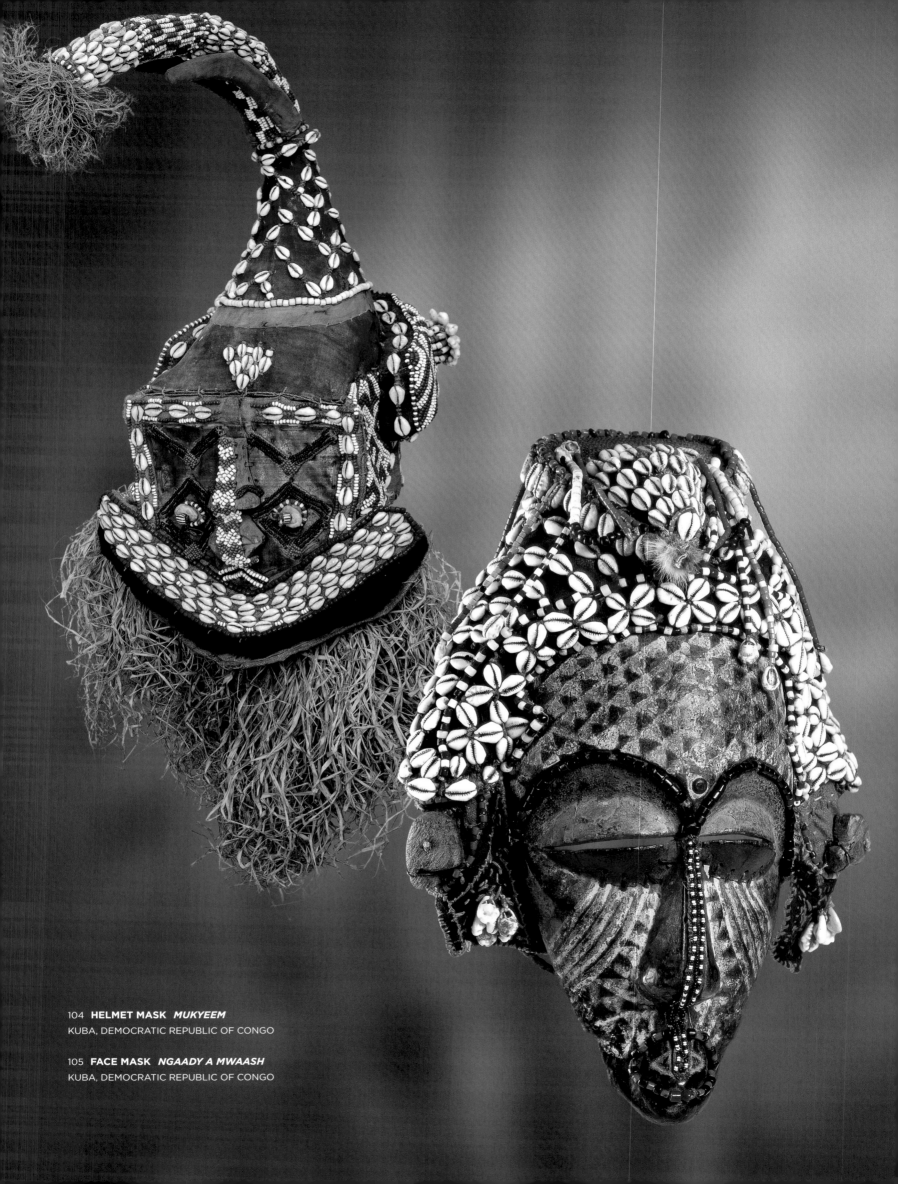

104 **HELMET MASK** *MUKYEEM*
KUBA, DEMOCRATIC REPUBLIC OF CONGO

105 **FACE MASK** *NGAADY A MWAASH*
KUBA, DEMOCRATIC REPUBLIC OF CONGO

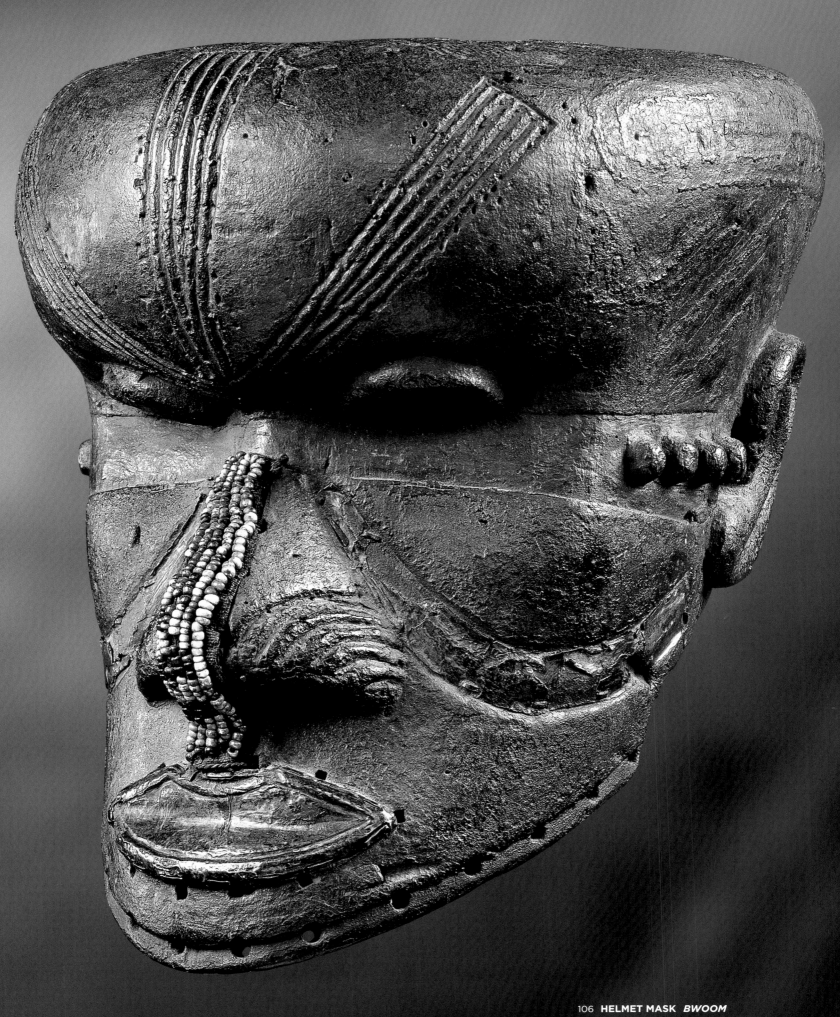

106 **HELMET MASK** *BWOOM*
KUBA, DEMOCRATIC REPUBLIC OF CONGO

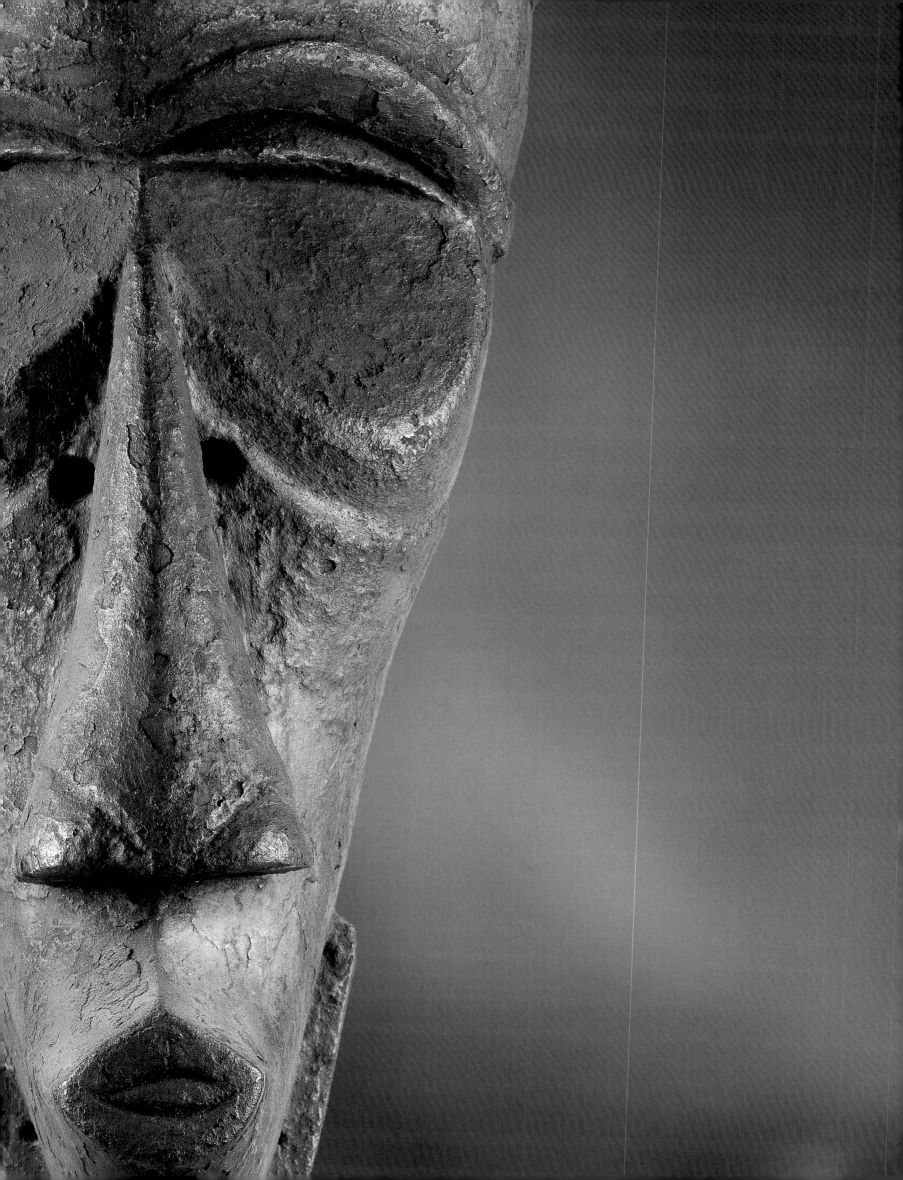

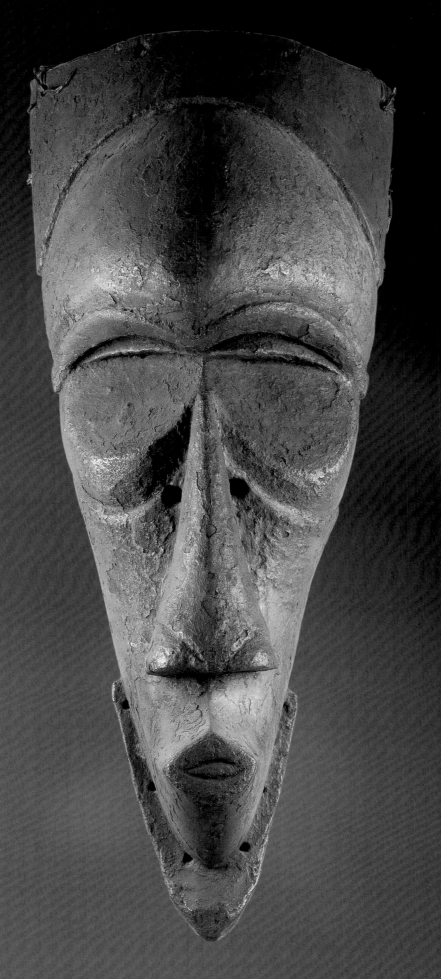

107 FOREHEAD MASK *NYIBITA*
NGEENDE, DEMOCRATIC REPUBLIC OF CONGO

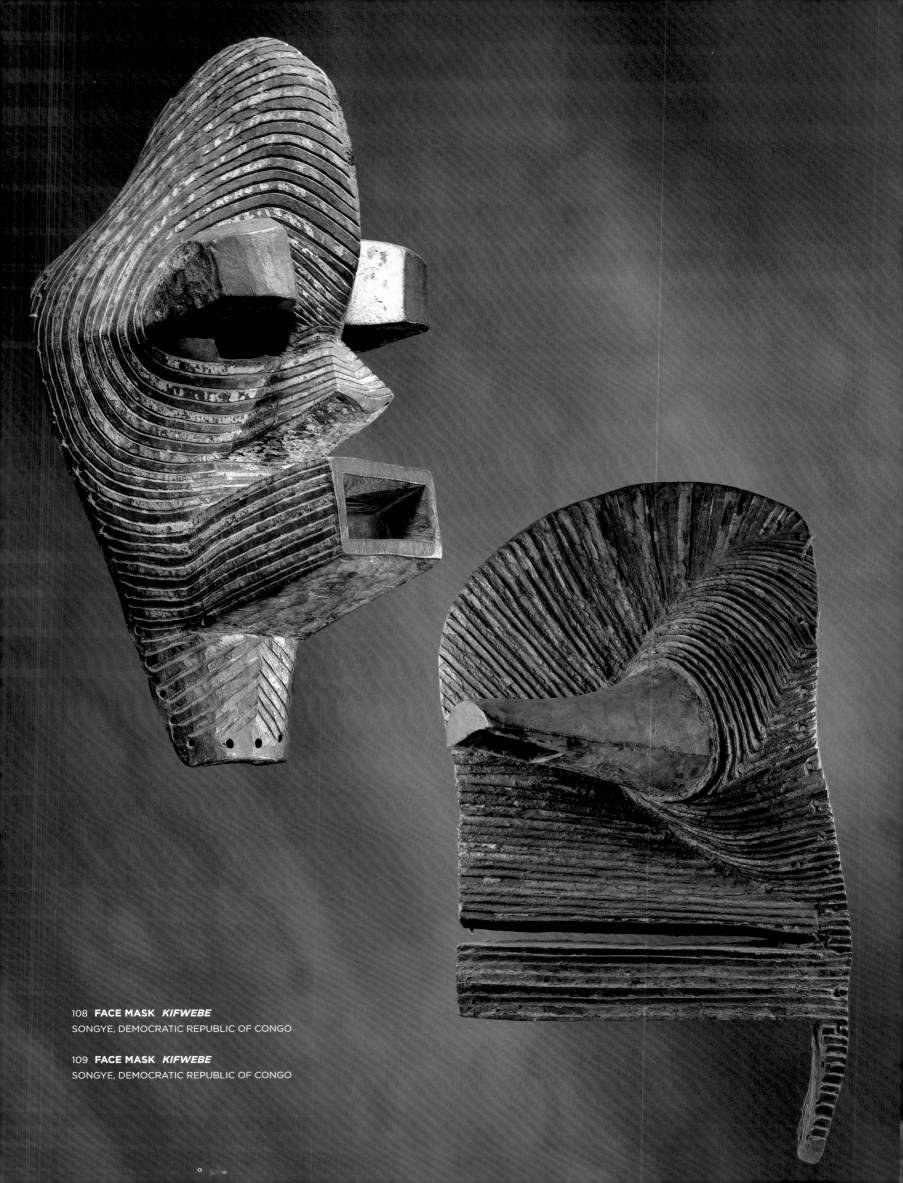

108 **FACE MASK** *KIFWEBE*
SONGYE, DEMOCRATIC REPUBLIC OF CONGO

109 **FACE MASK** *KIFWEBE*
SONGYE, DEMOCRATIC REPUBLIC OF CONGO

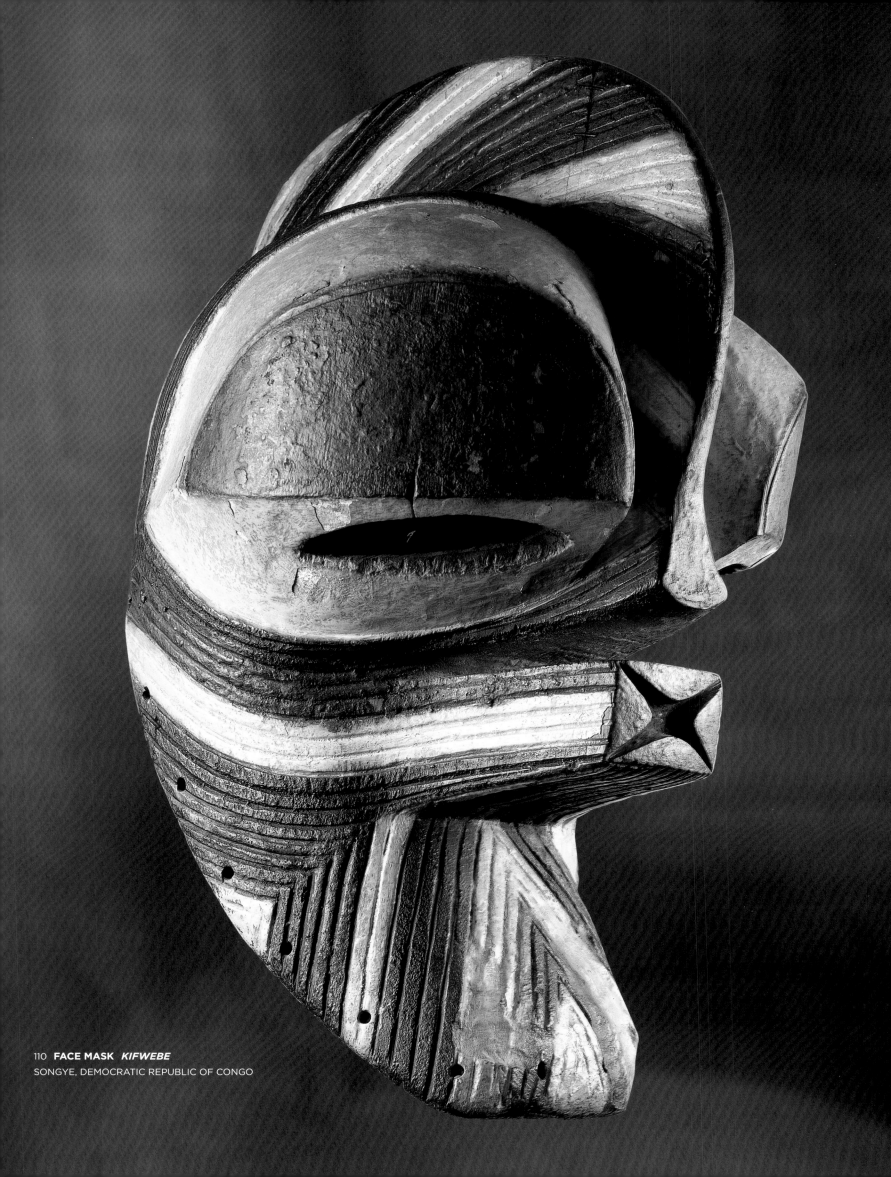

110 **FACE MASK** *KIFWEBE*
SONGYE, DEMOCRATIC REPUBLIC OF CONGO

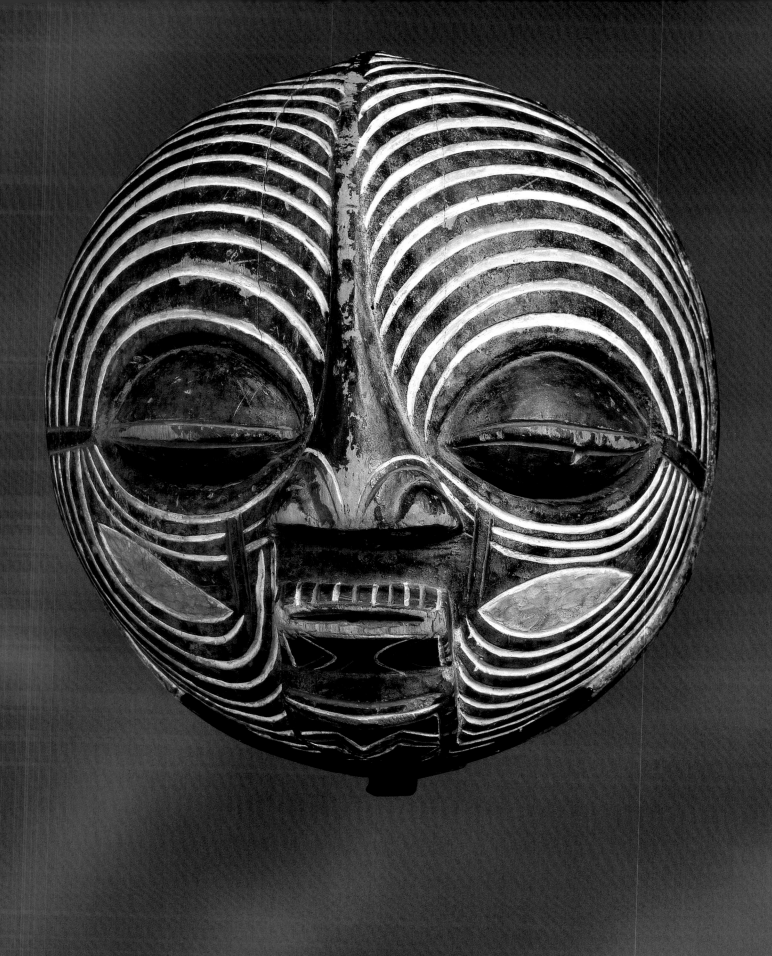

111 **FACE MASK** *KIFWEBE*
LUBA, DEMOCRATIC REPUBLIC OF CONGO

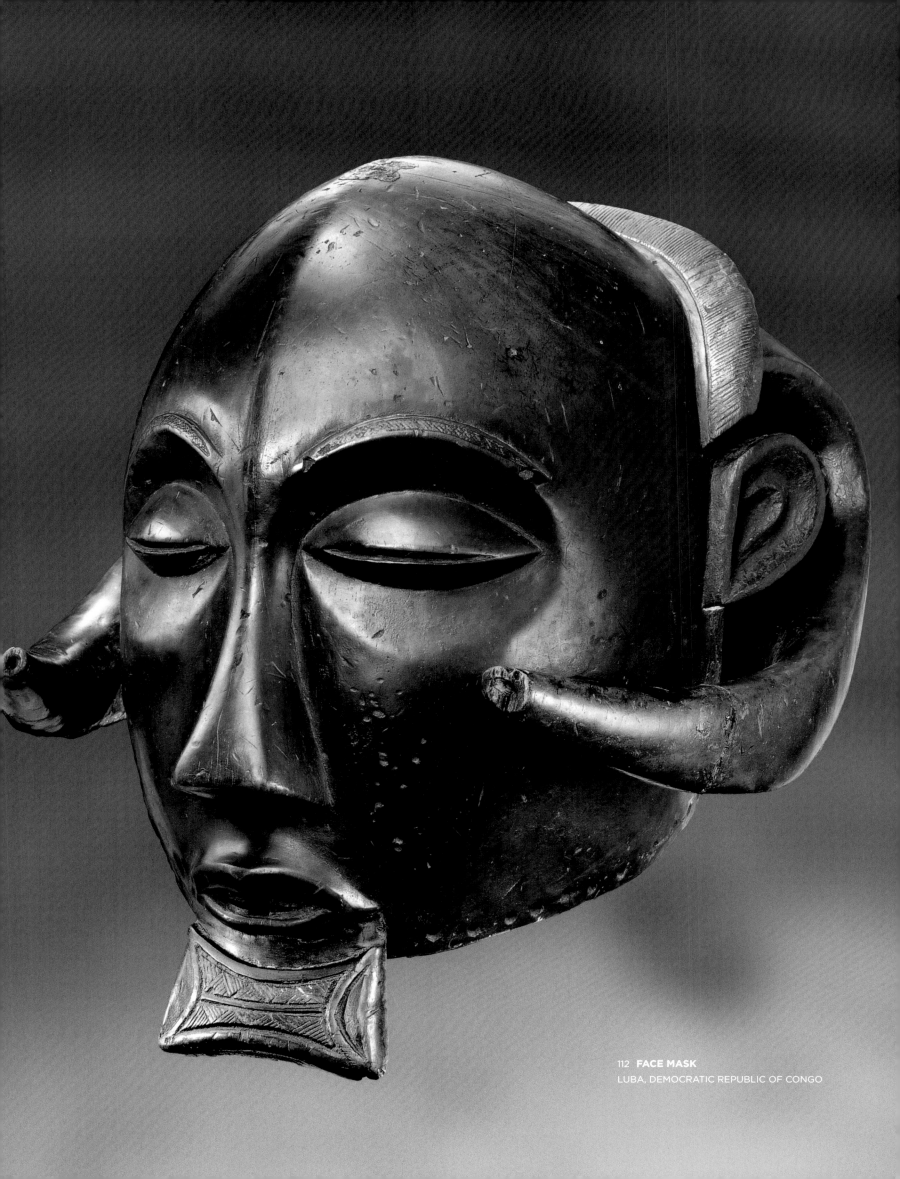

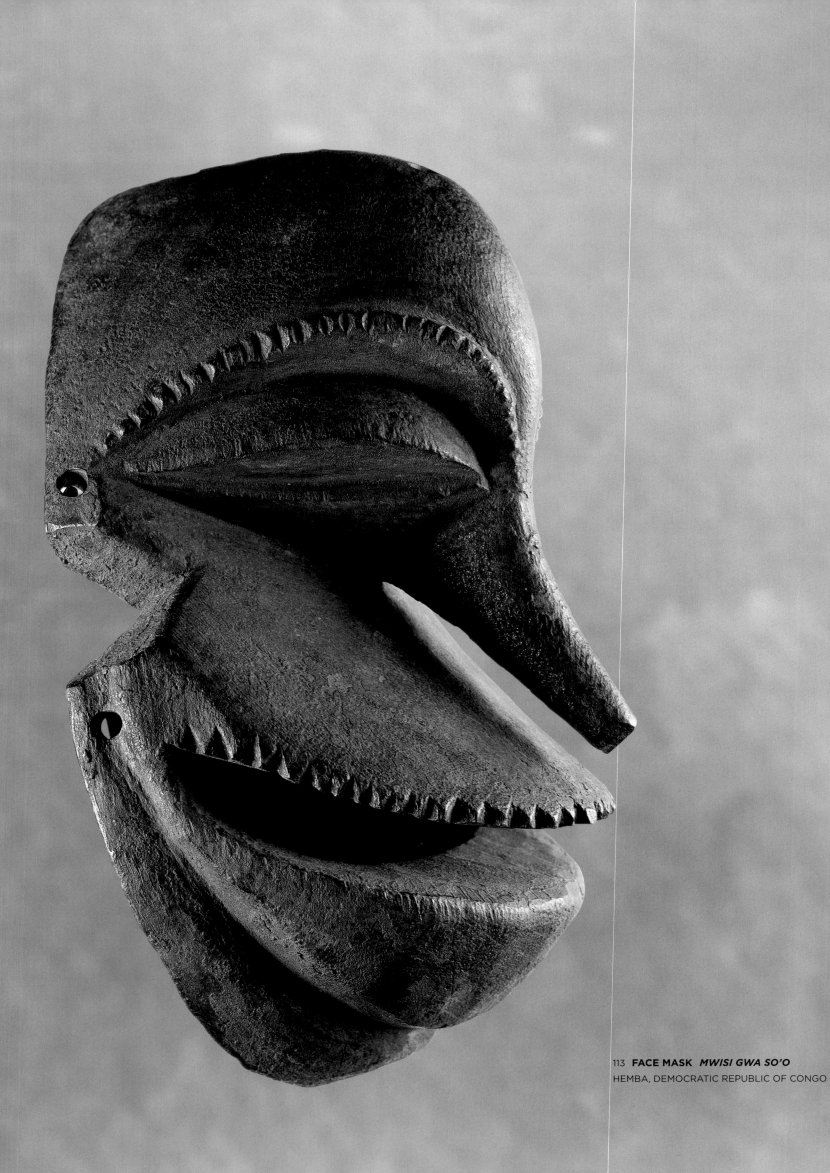

113 **FACE MASK** *MWISI GWA SO'O*
HEMBA, DEMOCRATIC REPUBLIC OF CONGO

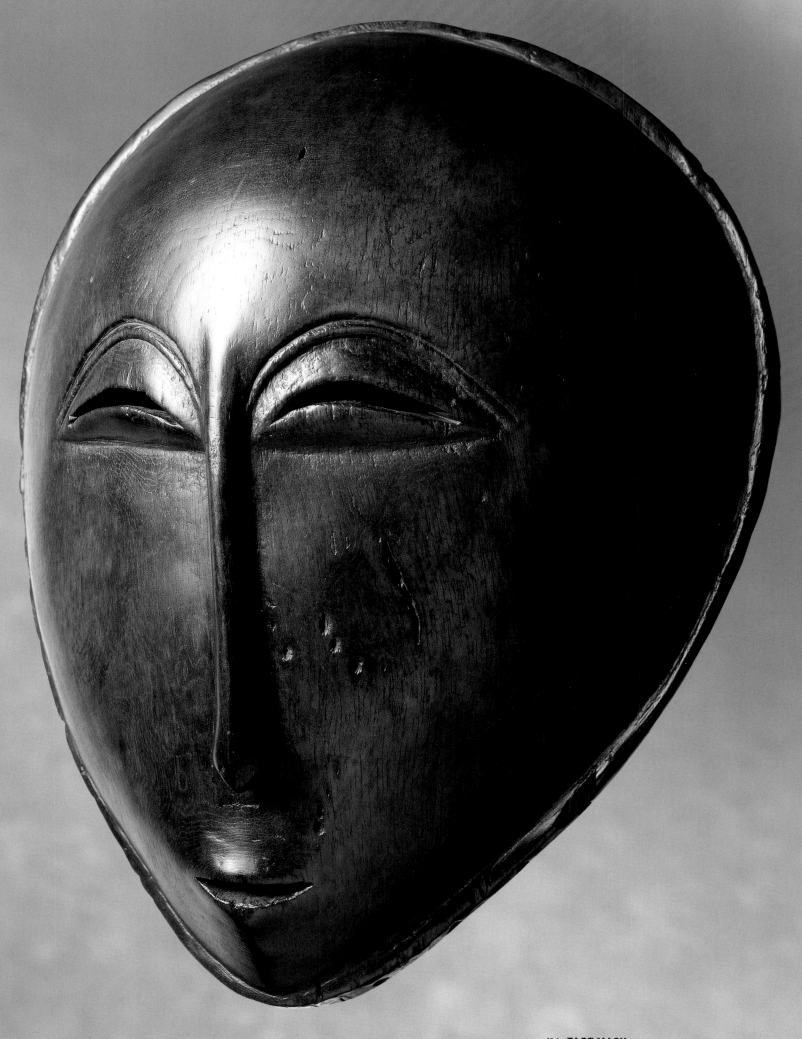

114 **FACE MASK**

HEMBA, DEMOCRATIC REPUBLIC OF CONGO

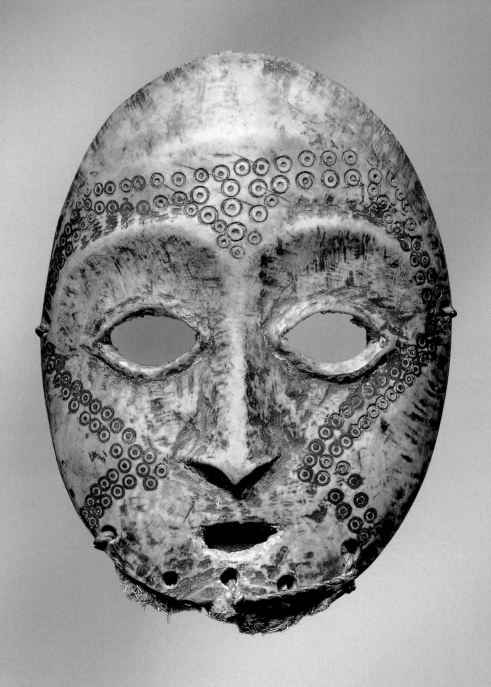

115 **MASK** *LUKUNGU*

LEGA, DEMOCRATIC REPUBLIC OF CONGO

116 **DOUBLE-FACED HELMET MASK** *ALUNGA*

BEMBE, DEMOCRATIC REPUBLIC OF CONGO

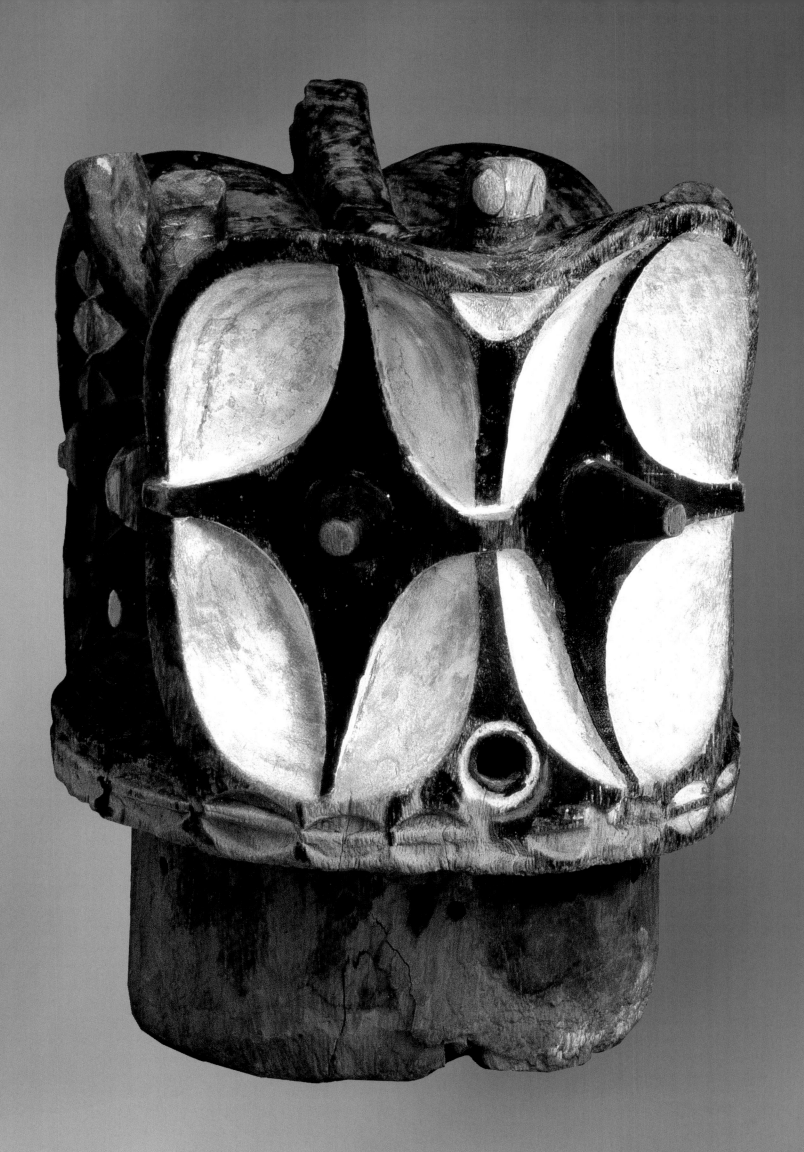

117 **FACE MASK**
BOA, DEMOCRATIC REPUBLIC OF CONGO

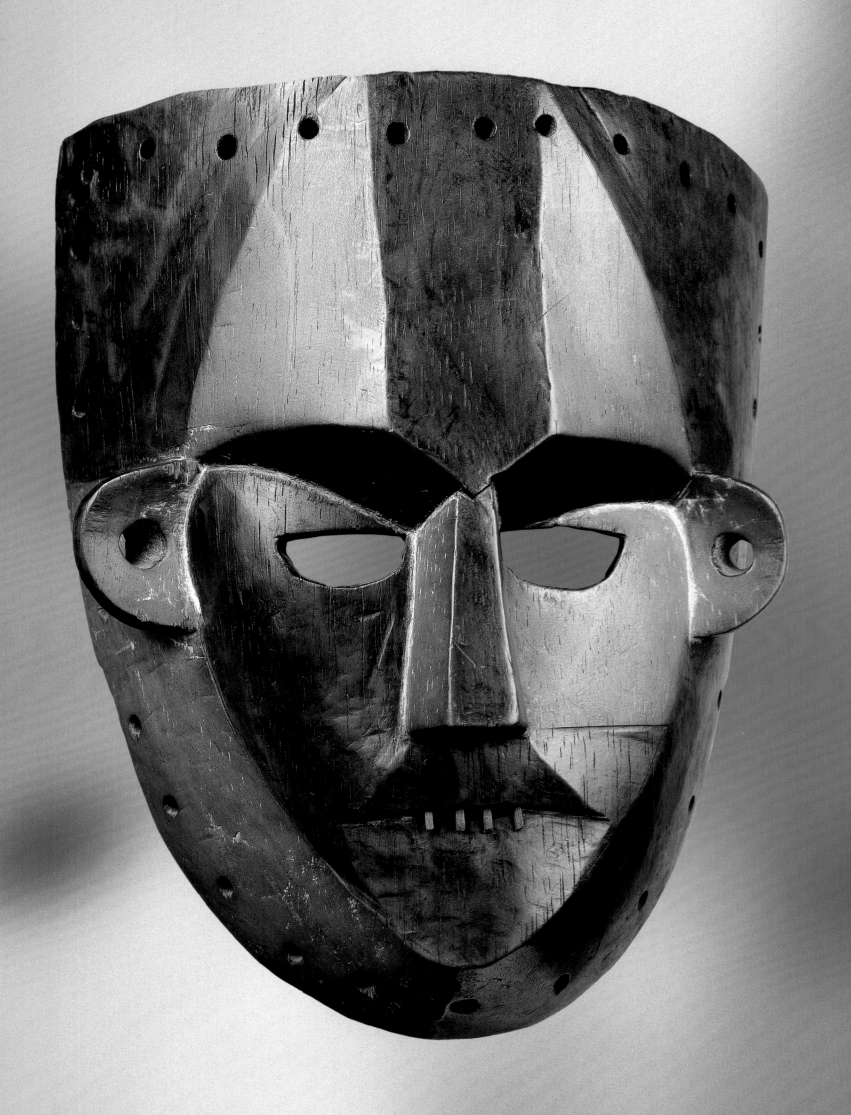

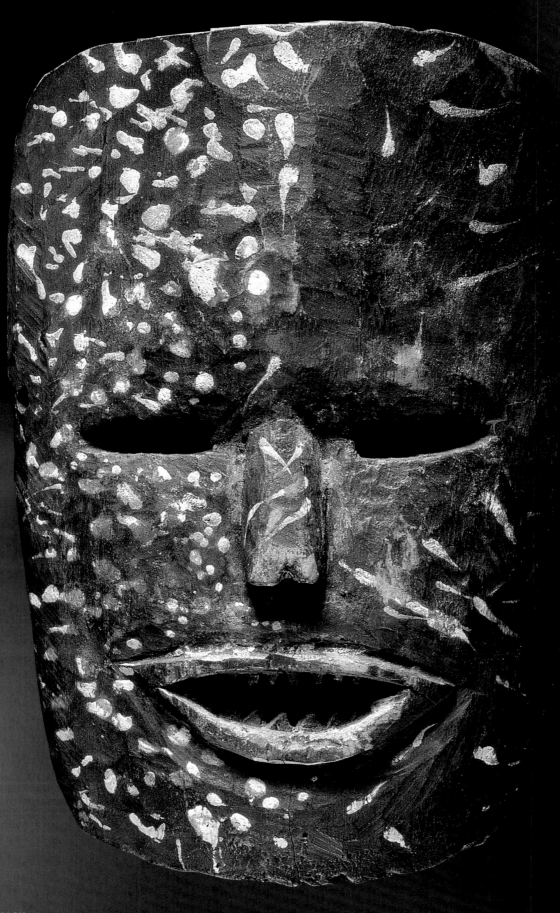

118 **FACE MASK**
BIRA/LESE/KOMO?, ITURI REGION,
DEMOCRATIC REPUBLIC OF CONGO

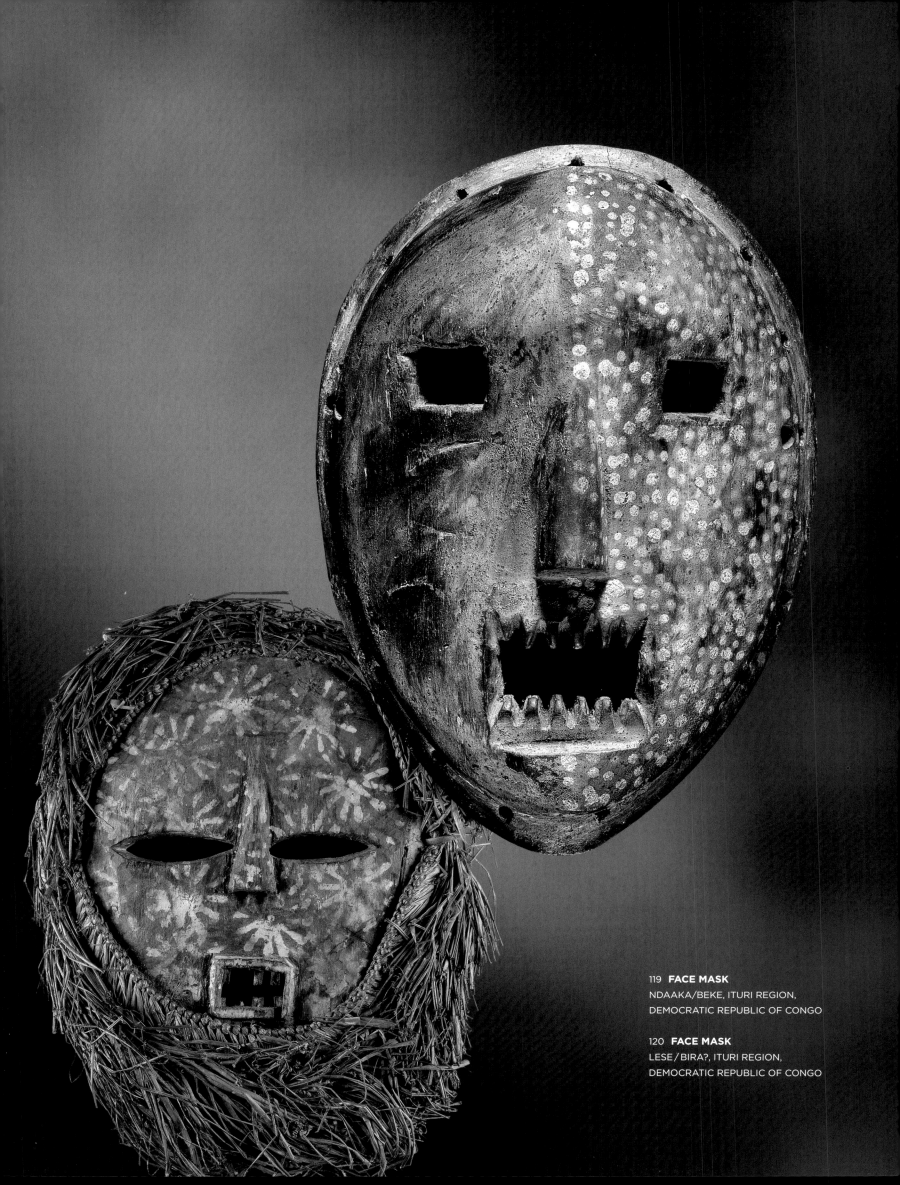

119 **FACE MASK**
NDAAKA/BEKE, ITURI REGION,
DEMOCRATIC REPUBLIC OF CONGO

120 **FACE MASK**
LESE/BIRA?, ITURI REGION,
DEMOCRATIC REPUBLIC OF CONGO

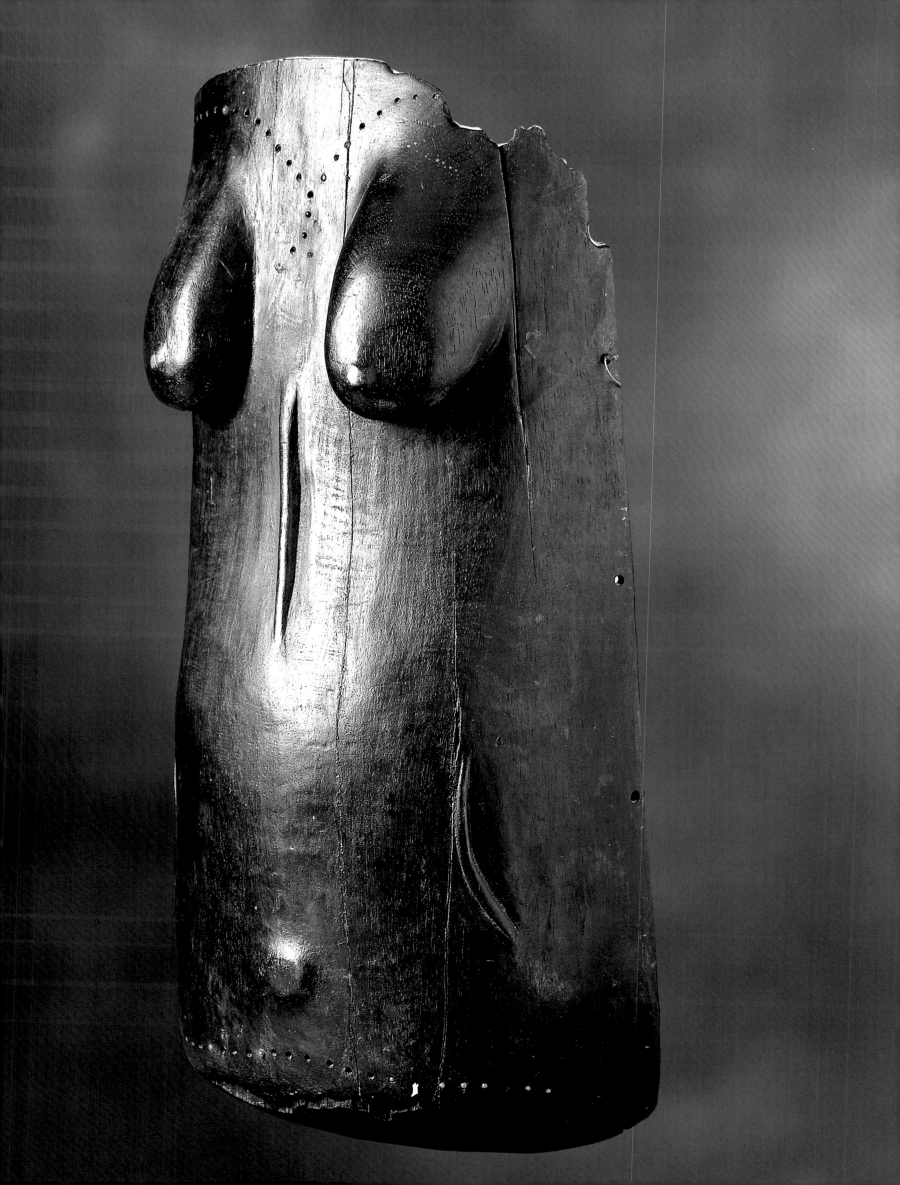

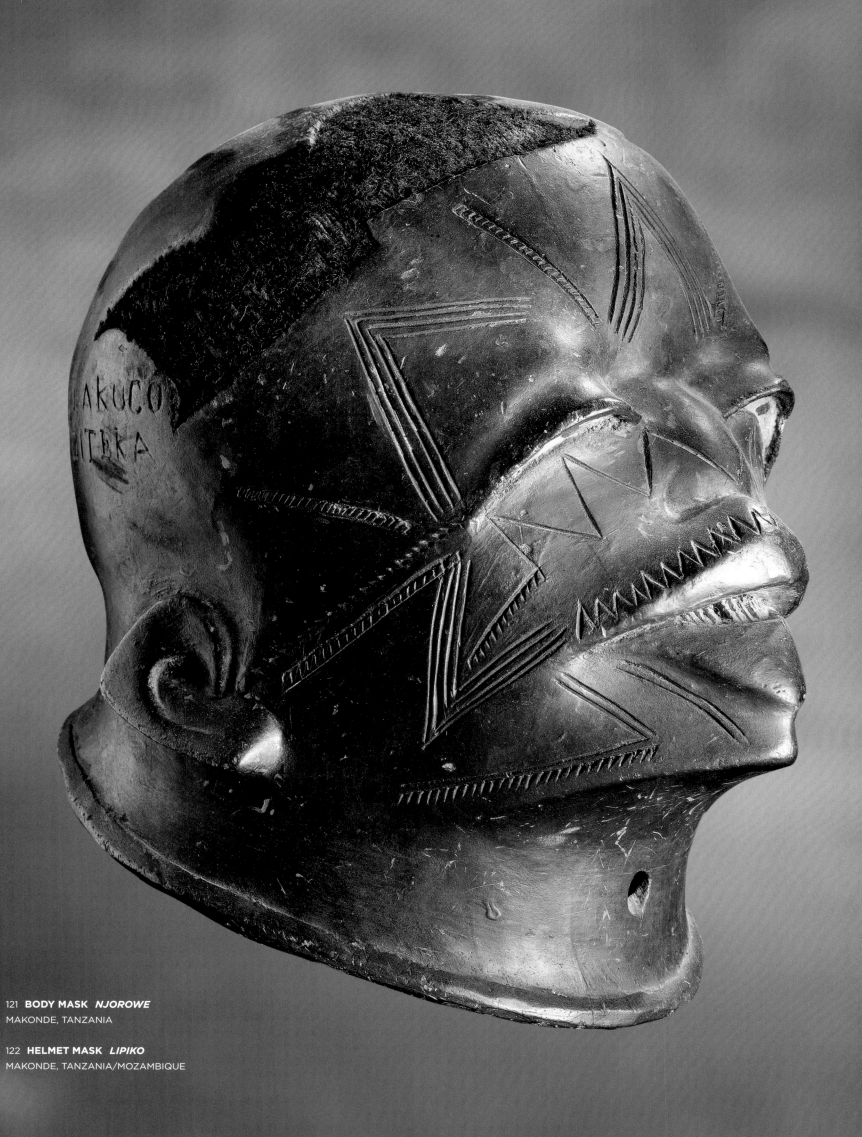

121 BODY MASK *NJOROWE*
MAKONDE, TANZANIA

122 HELMET MASK *LIPIKO*
MAKONDE, TANZANIA/MOZAMBIQUE

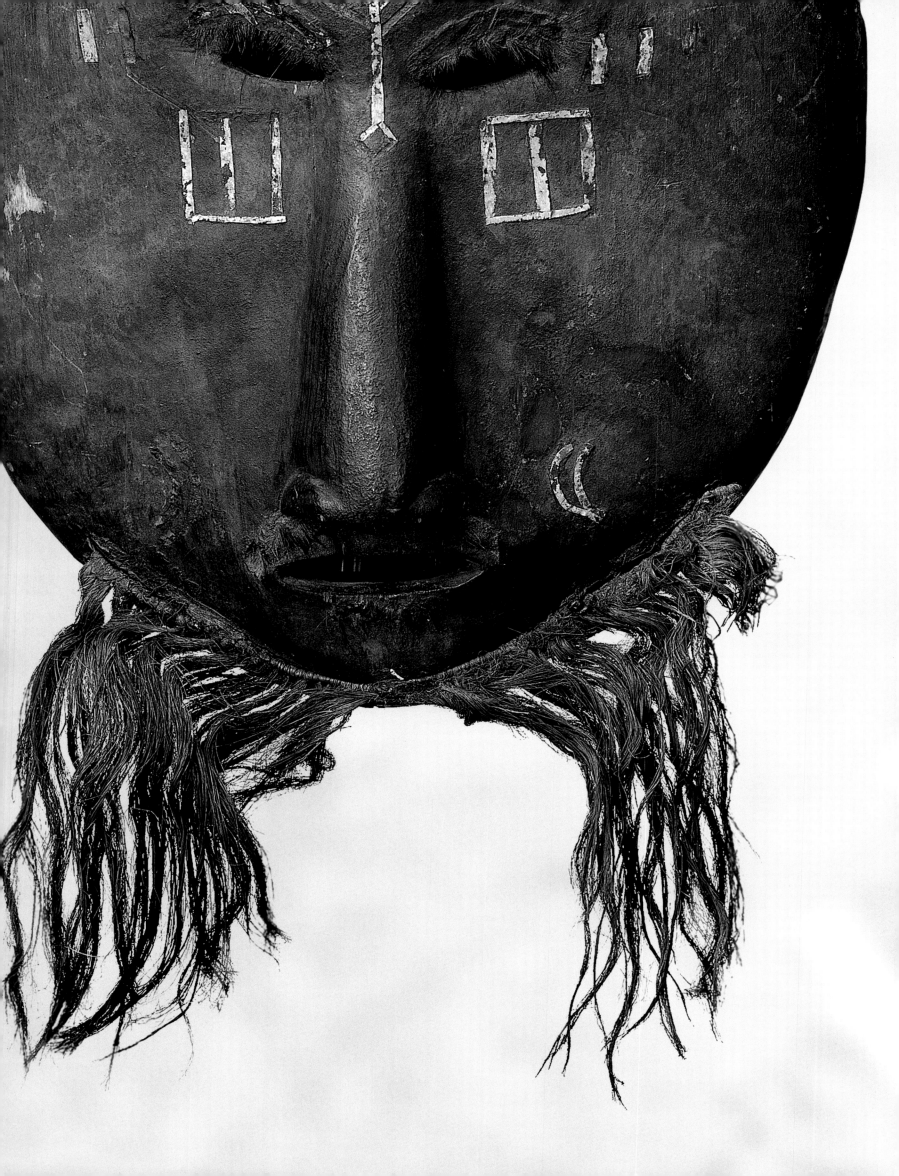

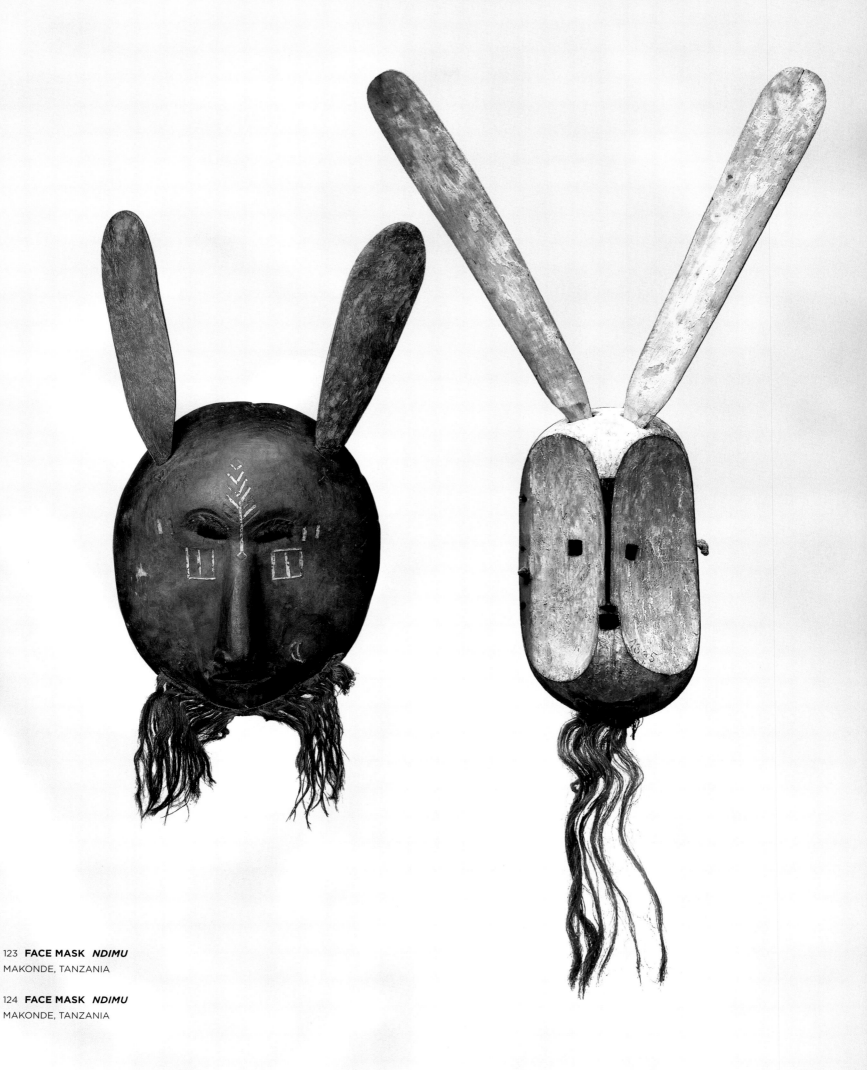

123 FACE MASK *NDIMU*
MAKONDE, TANZANIA

124 FACE MASK *NDIMU*
MAKONDE, TANZANIA

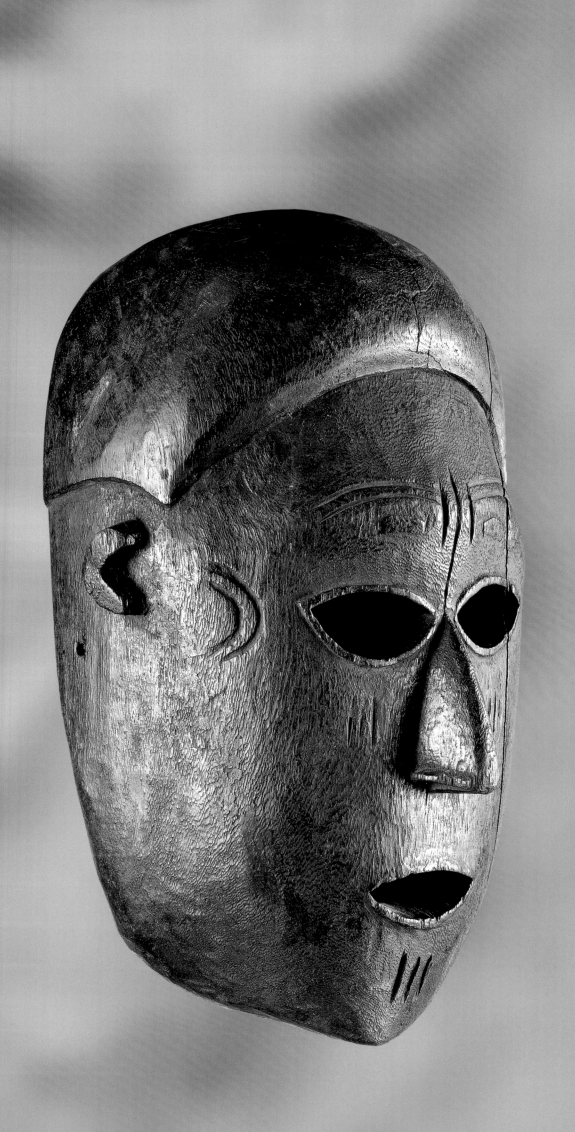

125 **FACE MASK**
LUNGU (RUNGU) ZAMBIA OR TANZANIA

126 **HELMET MASK**
KWERE, TANZANIA

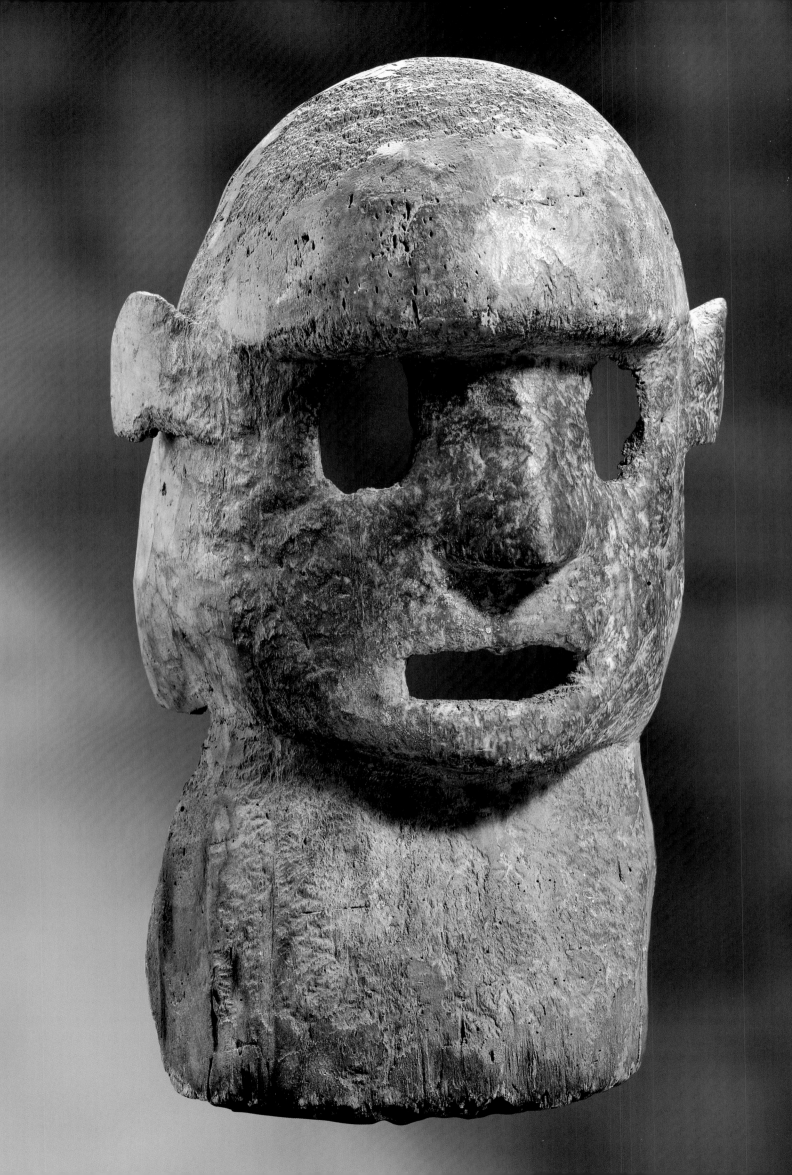

CATALOGUE

1

HELMET MASK *EJUMBA*

DIOLA, SENEGAL

Woven plant fibers, seeds, bovine horns, natural rubber,
height 30 cm

Collected by Dr. Rançon c. 1892–93

Formerly Musée Colonial de Marseille

Musée d'Arts Africains, Océaniens, Amérindiens,
Marseille, Dépôt C.C.I.M.

2

HELMET MASK *EJUMBA*

DIOLA, SENEGAL

Woven plant fibers, bovine horns, leather, mussel shells,
Abrus precatorius seeds, height 35 cm

Formerly collection of Josef Mueller

Acquired prior to 1942

Musée Barbier-Mueller, Geneva

As reports and illustrations from the
seventeenth century indicate, horned
masks resembling those known today
were already in use at that period in the
region of present-day Senegal and
Gambia. Despite the Islamization of a
few groups, the Diola have maintained
these mask traditions. Originally such
ejumba masks served to protect the
population of certain areas from harmful
magic. Nowadays their use is connected
with the initiation (*bukut*) of adolescent
boys and young men, which takes place
only every twenty or twenty-five years
and formerly was a precondition for
marrage. Clad in voluminous costumes
of raffia fiber, the initiates wear such
helmet masks during a celebration
(*kahiçen*) that concludes their weeks-
long seclusion in a bush camp. Their newly
acquired status as adult members of
society is reflected in a few components
of the masks, which consist of a weave
of plant fibers decorated with red seeds
and cattle horns, occasionally supple-

mented by seashells and small mirrors.
The seeds allude to blood and the Diolas'
warlike past, and the horns to the socio-
economic importance of cattle, which
signify prosperity and are slaughtered
only on socially important occasions, in
honor of the ancestors, or as sacrifices
to bring rain, crop growth and fertility.

Bibliography: Hahner-Herzog, 1997, no. 20; Mark, 1983,
1986; Marseille n.d., p. 32

3

SHARK MASK

BIDJOGO, BISSAGOS ISLANDS,
GUINEA-BISSAU

Wood, paints, plant fibers, 65 x 34 cm

Willy and Marthe Mestach Collection, Brussels

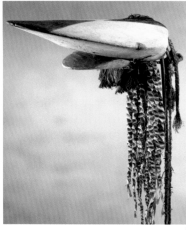

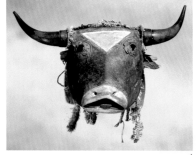

4

HELMET MASK *DUGN'BE*

BIDJOGO, BISSAGOS ISLANDS,
GUINEA-BISSAU

Wood with white, red and black paint, bovine horns,
glass eyes, leather, iron chain, iron rings, metal tacks,
vegetable materials, cord, height 37 cm

Koenig Foundation, Landshut

5

HIPPOPOTAMUS MASK

BIDJOGO, ISLAND OF NAGO
(BISSAGOS ISLANDS), GUINEA-BISSAU

Wood, fiber, leather, animal hair, metal nails, glass eyes,
paint, length 25.5 cm

National Museum of Ethnology, Lisbon

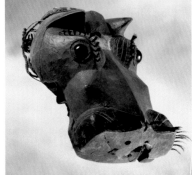

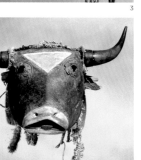

6

SWORDFISH MASK

BIDJOGO, BISSAGOS ISLANDS,
GUINEA-BISSAU

Wood, paint, height 127 cm

Private Collection

To this day the Bidjogo continue to use
numerous different types of painted
masks, which are worn by adolescent
boys and girls during their acceptance
into various age groups. While the per-
formances now have an entertainment
character, sometimes being held on
holidays or in honor of important per-
sonalities, formerly these mask dances
served to demonstrate personal prowess.
They were accompanied by songs in
praise of the young men's fighting skills,
which were underscored by the masks
they chose to wear.

The four most common mask types
represent different varieties of cattle,
known in Creole as *vaca bruto*. Design
details of the quite realistic masks indi-
cate the type they represent: *Dugn'be,*
the domesticated cow, is characterized
by pierced nostrils and a rope, which in
the present example is knotted between
the horns. This mask is worn by members
of the third age class. Other motifs in-
clude the *enie,* or wild bull, recognizable
from its red tongue and the red and
black design painted on its neck; the
zebu or buffalo with its upswept horns
(*iare*); and a bush cow (*gn'opara*).
After the cattle masks, the next most
popular types are swordfish, shark, and

hammerhead shark. The realistic render-
ing of the shark's head seen in the elegant
mask from the Mestach Collection is
frequently amplified in other examples
by the integration of a real shark's jaw,
bristling with teeth. The regalia of the
masked dancer, who leans forward to
imitate a shark's swimming motions,
includes a carved fin attached to his back.
In the large, similarly realistic hippopo-
tamus masks, inlaid glass eyes, attached
eyelashes and nostril hair, and a movable
jaw underscore the evocative effect.
The weight of these masks, which were
fastened to the head with the aid of
cords, was enormous. The dancers who
performed them leaned on two sticks
ending in carved hippo feet as they
imitated the animal's behavior. The use
if this mask type on the islands of Ponts
and Maio ended with the sale of the last
specimen in the late 1970s.

Bibliography: Gallois-Duquette, 1976, 1983; Hahner-
Herzog, 2000; Maurer, 1991, p. 54; Schädler, 1992, p. 37

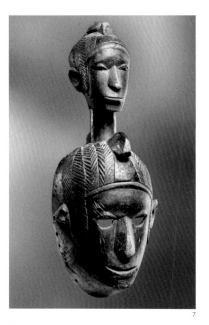

7

FACE MASK

BAGA, BULUÑITS ?, GUINEA

Wood with blackish-brown patina, height 55 cm

Formerly collection of Josef Mueller

Acquired before 1942

Musée Barbier-Mueller, Geneva

No face mask comparable to the present
one is found among the various mask
types of the Baga, Buluñits and Pukur in
the coastal region of northern Guinea.
Moreover, despite recent research, we
have no information on the context in
which it appeared.

The composition is unusual: two super-
imposed, almost identical human heads
that differ only in terms of size. Their
only slightly stylized realism recalls the
heads of many female sculptures found
on various utilitarian objects, on drums
or hair combs, as separate figures or as
supporting or decorative elements. The

mask's gentle facial features, prominent nose, high position of the ears, and the treatment of the coiffure, suggest that it originated from the same workshop as a kneeling female figure attributed to the Buluñits and dated to the early twentieth century. This figure came into the Vlaminck Collection prior to 1939, and is now likewise in the Barbier-Mueller Collection.

Bibliography: Hahner-Herzog, 1997, no. 23; Lamp, 1996, illus. p. 120

8
STELE MASK *MBANCHONG*
NALU, GUINEA

19th /early 20th century

Wood with black, white and red paint, height 240 cm

Collected by Hélène and Henri Kramer, 1957

Formerly Lazard Collection, 1957–89

Dépot du Muséum national d'histoire naturelle—Musée de l'Homme, Paris, Dation 1989

Musée du Louvre, Paris

This mask type, also known by the Susu designation *bansonyi,* was prevalent among the ethnic groups of the region —Nalu, Landuma, Baga, Buluñits and Pukut—down to the 1950s, when Islam gained a foothold in the northern coastal area of Guinea. The present mask embodies a powerful snake spirit that ensured fertility and prosperity and warded off danger from the community. The soaring sculpture evidently represents a sinuous snake's body, symmetrically divided by a marked midline and colored triangular motifs of various sizes. Occasionally such masks were effectively accented by pieces of mirror inlaid in the circular ornaments. For the perform-ance they were adorned with feathers, ribbons and small bells. The dancer, clad in a raffia or textile costume, balanced the mask on his head with the aid of a

reed framework. His appearance in the village was announced by the sound of bells and blasts on antelope horns, warning non-intitiates, who were not permitted to see the mask, to go into their houses. In former times its most important performance took place on the occasion of the circumcision and initiation of men in the various age groups. Nowadays it is only rarely to be observed, and outsiders are still not permitted to witness its performance.

Bibliography: Barley, 1995; Curtis 2000a; Hahner-Herzog, 1997, p. 24; Lamp, 1996; Paulme, 1956

9
HEADDRESS *D'MBA*
BAGA, GUINEA

Wood, height 120 cm

Acquired 1902

Musée Quai Branly, Paris

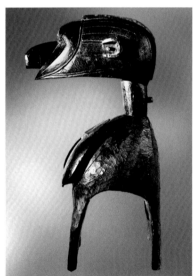

This imposing *d'mba* mask in the Musée Quai Branly, Paris, is among the earliest specimens of the type to have entered a European museum. In the Trocadéro, where it was originally on exhibit, it may well have already attracted Picasso's attention.

Rather than embodying some spirit, *d'mba* masks represent an ideal image of female beauty, dignity and fertility. This is reflected both in the crested coiffure, modelled on the elaborate hairstyle of Fulbe women, and the heavy, pendulous breasts of a mature woman who has given birth to and nursed several children. At the same time, the mask was intended to recall a rhinocerous bird, a symbol of fertility and growth in wide areas of West Africa. In keeping with this idea, such masks were formerly danced at festive occasions such as weddings and thanksgiving celebrations, which underscored the prosperity and perpetu-ation of society. The dancers, dressed in a costume of raffia fibers and black tex-tiles, wore these heavy masks on their

head and shoulders with the aid of four supports, and were able to look out through two holes between the breasts.

Bibliography: Curtis, 2000b; Hahner-Herzog, 1997, no. 22; Lamp, 1986, 1996, 2004b; Rubin, 1984, pp. 283–285

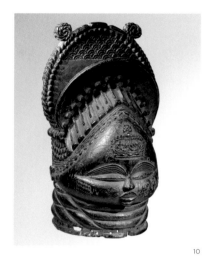

10
HELMET MASK *SOWEI*
MENDE, SIERRA LEONE/LIBERIA

Wood with dark patina, height 63.5 cm

Formerly Trombetta Collection

Collection of Vittorio Carini

This elegant piece of work is representa-tive of a type of mask used during initia-tion ceremonies by the powerful, *sande* woman's society of various peoples in Sierra Leone and Liberia. The decorative elements of the mask, as well as its digni-fied, restrained appearance, reflect a sophisticated, aesthetic concept, which these peoples have retained up to the present time. The neck rings which are a significant characteristic of all *sowei* masks must not be regarded as representing obesity but as placing a plastic emphasis on the fine lines of the neck which is highly esteemed and regarded as being beautiful. However, the great variety of hairstyles, oriented on contemporary fashion and on the many different types, which the women take great pains with, are distinctive characteristics which en-able the identification, dating and differen-tiation of the masks. This specimen also shows a conscientiously detailed hairstyle which is decorated with an additional comb at the back of the head. The dia-dem-like headdress which crosses the head diagonally, however, is somewhat unusual even though crowns and caps are not at all uncommon as decorative elements of this type of mask. An addi-tional, unusual aspect is the British royal crown which appears in bas-relief on the forehead of the mask. When a part of Sierra Leone was declared a British Protectorate in 1896, paramount chiefs expressing their loyalty to the Empire, received a brass copy of the crown of Queen Victoria. *Sowei* masks with the corresponding headdress were en vogue

in the late nineteenth century, when the British Empire controlled the West African colonies.

Bibliography: Boone 1986; McClusky 2002; Phillips 1980; Gottschalk 2005, pp. 90, 126

11
HELMET CREST MASK *BANDA*
NALU, GUINEA-BISSAU

Wood with red, black and white paint, raffia fibers, length 172 cm

Völkerkundemuseum, University of Zurich

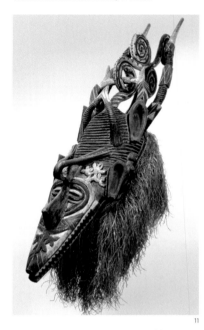

Among the Nalu and their neighbors, the Baga, *banda* masks were viewed as embodiments of a powerful bush spirit who appeared on important ceremonial occasions in order to protect human beings from danger. These traits are re-flected in the composition of the mask, which harmoniously combines human and animal features: a crocodile's snout set with teeth emerging from the lower edge of an elongated human face; ante-lope horns and several spiral-shaped chameleon tails projecting above the coiffure; and two pairs of buffalo ears affixed to the sides. Geometric and floral patterns in black, white and red under-score the composition's impressive effect. Typical traits of these animals were also evoked in the mask figures' dances, which were precisely choreographed and included passages that imitated flying, crawling and swimming motions. Generally only a few men in the village possessed these acrobatic skills. During their performance they wore volumi-nous raffia-fiber costumes, with the masks perched horizontally on the top of their head. Today these masquerade traditions are kept alive in only a few villages of the northern Baga and Nalu.

Bibliography: Hahner-Herzog, 1997, no. 25; Lamp, 1986, 1996, 2004a; Szalay, 1995, p. 62

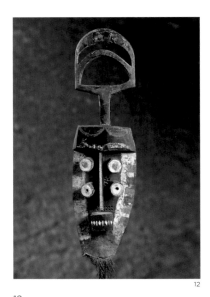

12

PLANK MASK

KRU/GREBO, LIBERIA/IVORY COAST

19th/20th century

Wood, hair, paint, height 74 cm (not including beard)

Acquired from Julius Konietzko, 1920

Ethnologisches Museum, Berlin

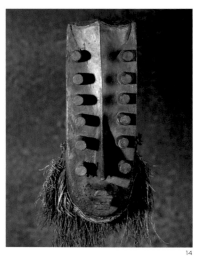

14

PLANK MASK

KRU/GREBO, LIBERIA/IVORY COAST

Wood, plant fibers, height 42 cm

Musée Ethnographique de Dakar

On loan to the Musée National des Arts d'Afrique et d'Océanie; Musée Quai Branly, Paris

The masking traditions of the Grebo and Kru, who live in the coastal region of southeastern Liberia and the adjacent Ivory Coast, are insufficiently documented despite their long contact with Europeans. The ascription of many masks from this region, which have increasingly entered Western collections since the beginning of the twentieth century, is therefore difficult.

Until just a few years ago, vertical plank masks with several pairs of projecting cylindrical eyes, a long, straight nose, and a protruding mouth, were identified as works of the Grebo. In the meantime there are indications that they originated from the neighboring Kru. Based on the

masks' formal traits and the way they were worn, Adams assumes that the Kru, who sailed the West African coast in the service of Europeans as early as the nineteenth century, were inspired by the masks of the Ijo in the Niger Delta, which possess similar geometric features. The multiple pairs of eyes likewise give cause for speculation. Possibly they were intended to convey the mask's power to see hidden things, an ability thought to be possessed by socerers and clairvoyants in particular.

Many Kru masks served entertainment purposes; others were evidently reserved for the use of men's societies. For their performance, the masks were attached to a wicker framework which the dancer wore on his head. In addition, there are indications that the backs of the masks were treated with magical substances and placed for protection and as a sign of authority in front of the village chief's house.

Bibliography: Adams, 1995; Fischer, 1999a; Meneghini, 1974

13

FACE MASK

WE, IVORY COAST

Wood, height 33 cm

New acquisition 1996

Ethnologisches Museum, Berlin

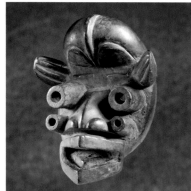

The name We encompasses the *Kru*-speaking Guere and Wobe, who in Liberia are known as Kran. Both peoples have numbers of mask figures (*gle*), who belong to family lineage associations and are controlled by a masquerade society. They embody nature spirits, and their functions can be divided into masks with social tasks and entertainment masks. Singing, dancing or beggar masks serve to entertain the populace; the much older and more significant king, war, initiation, guard and runner masks oversee social and political affairs and appear at rituals associated with the harvest or burials. These carved wooden masks usually have anthropomorphic features, either male or female. The male masks are dominated by a geometric design which is occasionally heightened to the point

of grotesqueness by carved elements such as tubular protuberances or tusk-like configurations.

Features of this kind are seen in the present mask, which presumably represents a singing mask. However, its function is not entirely evident from its design, since the mask figure was defined by headgear, costume and attributes, and occasionally by painted patterns as well.

Bibliography: Adams, 1987; Fischer, 1996; Harter, 1993; Homberger, 1997; Poynor, 1995; Verger-Fèvre, 1985

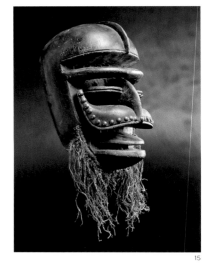

15

FACE MASK

BETE, IVORY COAST

Wood with blackish-brown patina, upholstery tacks, plant fibers, height 30 cm

Formerly collection of André Lhote

Musée Barbier-Mueller, Geneva

Masks with grotesquely exaggerated features dominated by geometric forms and only vaguely reminiscent of a human face are found among several ethnic groups in southwestern Ivory Coast. The Bete adopted this mask type from the neighboring Nyabwa, who in turn were inspired by the *gla* masks of the We (Wobe and Guere). This origin is still underscored today by the use of the Nyabwa language during mask dances and the fact that every Bete mask wearer is introduced to its use by an initiated Nyabwa. By comparison to their We prototype, the Bete masks evince a more highly stylized and refined design.

In former days, mask figures appeared in advance of and during armed conflicts and exerted social control. This original function of a war mask is still recalled today by the lance carried by the dancer or his attendant during performances, which are held in honor of important people or at funerals, and are principally intended to entertain.

Bibliography: Hahner-Herzog, 1997, no. 35; Holas, 1968; Rood, 1969; Verger-Fèvre, 1985, 1993a, 1993b

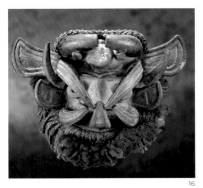

16

FACE MASK

GUERE, IVORY COAST

Wood, vegetable fibres, cowrie shells, height 32 cm

Private collection

This striking face mask belongs to the *gla* society of the We (Wobe and Guere), which utilises various mask forms to watch over public life and pronounce judgement, as well as taking part in harvest festivities and the burials of important personalities. The masks, which are regarded as manifestations of supernatural powers, can be divided—in accordance with their functions—into masks for singers, dancers and beggars used for entertainment and, in addition, war and spirit-chasing masks of social significance. Independent of the function, the We differentiate between female masks, with indications of the prevailing ideal of beauty, and male masks which, with their angular facial outlines, tubular eyes and carved deformities and tusk-like shapes, display grotesquely exaggerated features. In addition, the forehead of this male mask is decorated with magical substances and cowrie shells. This is an indication that the mask possessed especially potent powers and probably had an important function, possibly in the area of judgement proclamation.

Bibliography: Adams 1987; Bacquart 1998, p. 45f.; Harter 1993; Homberger 1997; Verger-Fèvre 1985

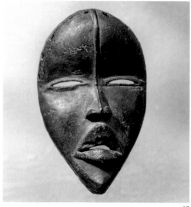

17

FACE MASK *DEANGLE* OR *TANKAGLE*

DAN, IVORY COAST/LIBERIA

Wood, blackish-brown patina, height 24.5 cm

Museum Rietberg, Zurich

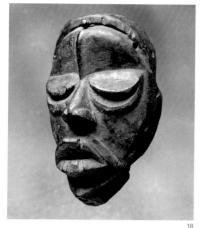

18
FACE MASK *DEANGLE* OR *TANKAGLE*
DAN, IVORY COAST/LIBERIA

Wood, height 25 cm

Formerly collections of Charles Ratton and Carlo Monzino

Private collection

The Dan possess numerous mask figures that embody bush spirits and either fulfil social tasks or appear for the entertainment of onlookers. Based on formal criteria, eleven masks types can be distinguished. Their configuration, depending on region of origin, ranges from delicately modelled features to geometric stylization. This holds for the two present objects, which belong to the same category. Yet while the mask from the Museum Rietberg evinces the stylized realism that is characteristic of Dan masks in general, the one from the former Monzino Collection shows influences of the Wobe and Guere, whose works are marked by an emphasis on plasticity. Regardless of stylistic details, both masks with their oval face, narrow eye slits, narrow nose and full lips reflect the Dan's ideal of female beauty. This type of mask can be associated with a number of different mask figures, since its character depends on the costume, headdress, accessories and "choreography" that accompany its performance.

Female masks with narrow eye slits can appear, on the one hand, as the dance mask *tankagle* for the audience's amusement, or as the singer-mask *gle sö*, which accompanies the "great mask" *go ge* to demonstrate the power of the influential *go* society. On the other hand, formally identical masks can be identified as *deangle*, or guard masks, which serve as intermediaries between the circumcision camps for adolescent boys and the village.

Bibliography: Fischer/Himmelheber, 1976; Harter, 1993; Homberger, 1997; Reed, 2004; Stepan, 2001, p. 94; Verger-Fèvre, 1985, 1993c; Vogel, 1986, p. 40

19
FOREHEAD MASK OF THE *JE* GROUP
GURO, IVORY COAST

Wood with black and peeling reddish-brown paint over light brown primer, height 33 cm

Formerly collection of Josef Mueller; acquired before 1942

Musée Barbier-Mueller, Geneva

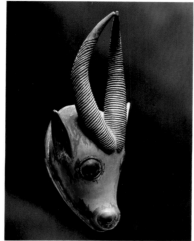

In pre-colonial times, political authority among the Guro was wielded by a council of elders and a men's association known as *je*. This group was responsible for social, political and juridical affairs, and decisions of peace or war. It appeared in public on the occasion of its members' funerals. Some of these functions, like the associated masking tradition, have been retained to this day.

The association uses various masks, most of which represent wild animals, each with a certain task to perform. The arrival of the mask dancers in their voluminous, multipartite costumes of raffia fibers, palm-leaf strips or reed grass is always announced in advance in the village, in order to give the women time to retire to their houses, the sight of these masks being considered dangerous for women. The present small, naturalistic mask can be identified on the basis of its fluted horns as representing a waterbuck (*Kobus defassa*, also known as a roan antelope). Dancers wearing this type of mask imitate an antelope's gait during their performance, and have the task of lighting a fire over which the other *je* maskers leaped at the close of a ceremony.

Bibliography: Deluz, 1988, 1993a, 1993b; Fischer/ Homberger, 1985a, 1985b; Hahner-Herzog, 1997, no. 36

20
FACE MASK *GU*
GURO, IVORY COAST

Master of Bouaflé (active from the late 19th c. to 1910-20)

Wood with brown, black, and traces of white paint, height 36 cm

Formerly collections of the Barnes Foundation and Han Coray

Museum Rietberg, Zurich

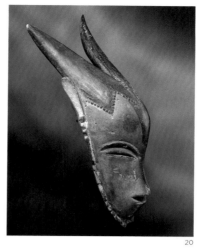

This small mask is attributed to the Master of Bouaflé, a carver of the southeastern Guro area whose works began to enter Western collections as early as the 1920s. Some of these pieces show absolutely no signs of use or wear, indicating that they may have been made on order for travellers or colonial officials.

Characteristic traits of these masks are an elongated face, bulging forehead with deep, zigzag hairline, slanting eye slits and brows, a narrow nose, and a sickle-shaped, lipless mouth. The faces are supplemented by attached figures, elaborate coiffures, or—as in the present example—by horns.

This delicate anthropomorphic mask has been identified as *gu*, part of an ensemble of three mask figures. Along with *zauli* and *zamble*, masks with animal faces and long horns viewed as male, the *gu* mask, representing *zamble's* wife, appear at funerals or other ceremonial occasions. *Gu* always has a feminine face with features reflecting the aesthetic ideal of the Guro. In keeping with perfect female deportment, the mask dancer moves slowly and gracefully during the performance.

Bibliography: Deluz, 1993a; Fischer/Homberger, 1985a, 1985b

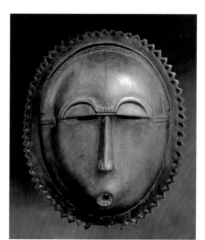

21
MOON MASK OF THE *MBLO* GROUP
BAULE, IVORY COAST

Wood, height 22.5 cm

Collection of Waltraud and Udo Horstmann

This finely carved specimen belongs to a comparatively rare mask type of the Baule. Despite its anthropomorphic appearance, it embodies the moon, which along with sun and rainbow was among the natural phenomena evoked in Baule entertainment masks.

These gentle-looking masks, the majority representing humans or animals, were performed on holidays, at festivities and for important visitors, but also as diversions and entertainments during funerals of women and members of the dance troupe. These performances are known as *mblo*, or in some regions by other names. Similarly to Western operas, they are based on a precise dramaturgy, which is altered and brought up to date from time to time. The acting and graceful dances are always performed by men. Accompanied by singing, they enter the dancing area individually, the less powerful masks such as the present moon mask appearing at the beginning of the performance to prepare the audience for the entry of the more influential masks.

Bibliography: Boyer, 1993; D'Alleva, 1991; McNaughton, 2002; Vogel, 1997, pp. 141-68

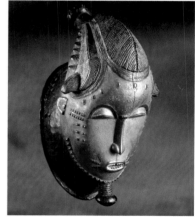

22
FOREHEAD MASK *KP(W)AN*
BAULE, IVORY COAST

Hardwood, traces of polychrome painting, height 45.3 cm

Former Hubert Goldet Collection

Musée Barbier-Mueller, Geneva

This extremely elegant piece of work belongs—along with no. 24—to the group of *goli* masks. Today, these are principally used for entertainment. On the basis of its anthropomorphic appearance, the mask can be identified as an example of the *kp(w)an* variety which appeared as the last of all the masks at the climax of a festivity and took on the female role within the masked group, at the same time acting as its leader. This leading

role could be a reference to the influence and importance of women in the Baule society, as Vogel (p. 185) surmised. With its fine features, detailed scarification patterns on the forehead, temples, cheeks and at the corners of the mouth, as well as the highly detailed hairstyle with its braids, bulges and chignons, this mask bears a strong resemblance to one from the Indiana Art Museum, depicted by Vogel, which was published by Maurice Delafosse as early as in 1927. The stylistic similarities lead one to the conclusion that both pieces were created by the same artist.

Bibliography: Bacquart 1998, p.50; Boyer 1993; Vogel, 1997, pp.169–186

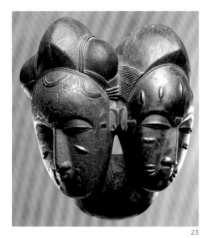

23

TWIN MASK OF THE *MBLO* GROUP
BAULE, IVORY COAST

Wood with red and black paint, height 29 cm

Collected in the mid 1930s

Formerly collection of Roger Bédiat

Musée Barbier-Mueller, Geneva

Such twin masks, extremely rare among the Baule, belonged to the group of *mblo* masks that appeared for entertainments on holidays or festive occasions. In addition to animals, the mask repertoire commonly included human faces, which were viewed as portraits of lovely women and occasionally of brave men. With the Baule, the birth of twins is a happy event to be celebrated by special ceremonies, a positive attitude that is reflected in masks of this kind.

Except for the scarification patterns and the coiffures, the two heads on the mask are of nearly identical design. The originally differing color scheme, still visible through the craquelé on the one face, possibly indicates a depiction of different genders, something seen in other Baule masks as well. At the same time, this color distinction, like the mask itself, evokes this ethnic group's dualistic world view, an order in which harmony is achieved through an interplay of two complementary principles.

Bibliography: Boyer, 1993; Hahner-Herzog, 1997, no. 41; Vogel, 1988

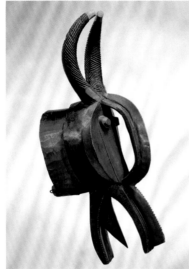

24

HELMET MASK *GOLI GLIN*
BAULE, IVORY COAST

Wood, height 109 cm

Formerly collection of Pablo Picasso

Collection of Jan et Marie-Anne Krugier-Poniatowski

According to the Baule, this formally balanced zoomorphic helmet mask with its characteristic arched fillet over the face represents a synthesis of bush cow, antelope and crocodile. It belongs to an ensemble of four mask types that usually appear in pairs of nearly identical appearance which are viewed as a family. The *goli glin* figure, considered the oldest member of the *goli* group, wears an elaborate costume of fresh palm fibers and an antelope skin. It performs a wild, rapid dance to the accompaniment of rhythmical music played on rattles and an antelope horn-trumpet.

It was not until the end of the nineteenth century that the Baule adopted the *goli* masking tradition from the neighboring Wan, whose language is still used in the songs that accompany the mask dances. *Goli* masquerades, held for entertainment or at the funerals of important personalities, are today among the most popular mask performances of the Baule.

Bibliography: Boyer, 1993; Vogel, 1997, pp. 169–186

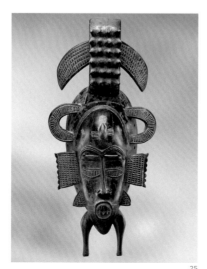

25

FACE MASK *KPELIYE'E*
SENUFO, IVORY COAST

19th century

Wood, height 42.2 cm

The Detroit Institute of Art; Founders Society Purchase, Joseph H. Boyer Fund, Joseph M. DeGrimme Memorial Fund, General Endowment Fund, New Endowment Fund, Edith and Benson Ford Fund, K. T. Keller Fund, Laura H. Murphy Fund, Mary Martin Semmes Fund, and Barbara L. Scripps Fund

The Senufo have a great variety of mask types, which differ both regionally and by social grouping but are generally associated with the age classes of adolescent boys and various men's associations. Anthropomorphic face masks of wood or metal are fabricated by carvers (*kulebele*) and metal founders (*fonobele*), for the *poro* societies to which they belong. The masks appear as diversions towards the conclusion of the elaborate and costly funerals of society members, and nowadays sometimes dance on secular occasions such as visits from important persons or tourists.

These masks invariably represent an idealized female face with charming features and the formerly common tatooes. The scars on the forehead of this finely modelled sculpture was intended to symbolize the vulva, and alludes to a ritual in the final phase of initiation in which adepts enter a symbolic union with the *poro* society. Various elements attached to the sides can be read as pendant earrings and hair adornments. The knobbed projection over the forehead represents the fruits of the kapok tree. This motif, frequently found on *kpeliye'e* masks, was meant to remind people that the *kulebele* receive their knowledge about the *poro* in a sacred grove where a number of these trees grew.

Bibliography: Förster, 1988; Garrard, 1993b; Glaze, 1981; Kan/Sieber, 1995, p. 54; Koloss/Förster, 1990

26

DOUBLE-HEADED HELMET MASK *WANYUGO*
SENUFO, IVORY COAST

Wood, white, black and ocher paint, width 74 cm

Formerly collection of Josef Mueller, acquired 1952–53 from the collection of Emil Storrer

Musée Barbier-Mueller, Geneva

Among the Nafara in the southern Senufo region a society known as *wabele* battles

sorcery or negative influences (*dee bele*) and harmful spirits (*nika'abele*) that appear in the form of wild animals or monsters and threaten people in times of crisis or vulnerability.

The society's most important paraphernalia are single- or double-headed *wanyugo* masks, which are considered especially dangerous, even being said to occasionally breathe fire or emit swarms of bees. Design features recalling various wild animals underscore the mask's aggressiveness: powerful jaws with sharp teeth representing a crocodile's or hyena's snout, and tusks like those of a wart hog. The small cup on top of the head, in this specimen held by two chameleons, served as a receptacle for magical substances (*wah*). These lent the mask figure its extraordinary powers, which came into play in the context of a ceremony.

Bibliography: Bochet, 1988; Förster, 1988; Glaze, 1981, 1993a; Hahner-Herzog, 1997, no. 12; Koloss/Förster, 1990

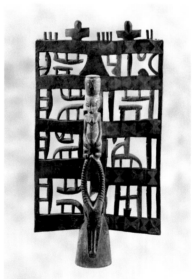

27

HELMET CREST MASK
SENUFO, IVORY COAST

Wood, paints, height 145 cm

Acquired from the trade in 1967

Ethnologisches Museum, Berlin

This helmet crest mask combines forms and motifs known from other Senufo masks in an unusual way. Its rectangular panel recalls the *kwo(n)ro* headdresses that were worn until the 1950s by members of the age group of that name at initiation rituals of the *poro* society of the Nafara, a southern Senufo group. In contrast to these plain masks, usually decorated with a monitor lizard, however, the present specimen evinces a number of stylized figures. While some of these are difficult to interpret, others clearly represent animals—possibly monitors, symbols of a nature spirit. More realistically treated are the antelope head on the carved helmet portion, whose horns

are crowned by a female figure, and a further antelope head on the back of the pierced plank, which bears a bird figure.

Traits of antelopes combined with those of other animals are also found in other Senufo masks, which likewise appear during initiation ceremonies or at funerals of members of the *poro* society. Female figures, on the other hand, are used to adorn not only the dance staffs that are the mark of the *kworo* age class but many *dagu* headdresses, which in other Senufo areas are used in the same context as the *kworo* headdresses. A common motif is the rhinocerous bird, which is considered a mythical, primordial animal and likewise appears on masks, staffs, and in the form of freestanding figures.

Bibliography: Bochet, 1993; Förster, 1988; Goldwater, 1964; Junge, 2003; Koloss/Förster, 1990

28
HELMET MASK WITH FEMALE FIGURE *DEGELE*
SENUFO, IVORY COAST

Wood, height 101 cm

Former Josef Mueller Collection; purchased 1950–51 from Emil Storrer; collected by Pater Clamens in Latuha

Musée Barbier-Mueller, Geneva

This rare type of mask, which was first documented in 1936, was restricted to very few locations in the area around the city Korhogo. A large number of these masks—including this piece—found their way into western collections in the 1950s when, as a result of the militant *massa* cult, numerous sacred objects could only be protected from destruction through their sale.

The masks, which are always executed as a male-female couple, were in the possession of the *poro* society of the Fodonon, a southern Senufo group. They were only used for the funeral of a society member or for memorial celebrations for important elders who had died within the previous four to five years. At all other times, the masks were stored in the sacred grove where Pater Clamens photographed the mask shown here, along with its male complement, in situ in 1951.

The masks were created by specialised carvers, the Kulebele. This specimen was probably made by Do Koné, a carver working in Korhogo, who died in 1975. The precisely worked female figure shows the typical characteristics of this type of mask: armless, shortened legs and protruding, pointed breasts. According to recent research, the body which is depicted as a bulge is the adaptation of a piece of cloth, twisted like a cord, which represented the body of the dead at remembrance ceremonies.

Bibliography: Garrard 1995; Glaze 1993b; Hahner-Herzog 1997, no. 14

29
FACE MASK *N'DOMO*
MARKA, BURKINA FASO/MALI

Wood, brass, height 42 cm

Donation of Léonce-Pierre Guerre

Musée d'Arts Africains, Océaniens, Amérindiens, Marseille

The Marka, who presumably descend from the Soninke, live as traders in extensive regions south of the Niger River. Northern neighbors of the Bamana, these groups adopted many cultural institutions and customs from them. Among these is the initiation of uncircumsized boys, known as *n'domo* or *n'tomo,* which prepares them for circumcision and introduces them to their future duties and tasks as adult men. The masks that appear at this phase have an elongated anthropomorphic face. Above it project horns in various numbers, which signify gender distinctions. The missing or only suggested mouth indicates that neophytes are forbidden to speak during the inititation rites.

Although Marka and Bamana masks have very similar designs, the present one can be ascribed to the Marka, since they frequently cover their pieces with sheet brass. Possibly other masks decorated with brass used by the Bamana were fabricated by Marka artists as well.

Bibliography: Colleyn, 2001; Marseille n.d., p. 33; Zahan, 1974

30
FACE MASK OF THE *DO* SOCIETY
DYULA, IVORY COAST

Late 18th/early 19th century

Brass, height 25 cm

Formerly collection of William Moore, Los Angeles

Collected in the 1950s, 35 km west of Korhogo

Musée Barbier-Mueller, Geneva

The Dyula and other Islamic ethnic groups in the northern area of the Ivory Coast disprove the widespread opinion that Islamic communities do not use masks. Elaborate and colorful mask performances by members of the *do* society take place in these trading communities during funerals and on important Islamic holidays—especially the *'id al-fitr* celebrations at the end of Ramadan. In addition to wood, the Dyula make masks of metal, which are polished to a high gloss with sand or other substances before each performance.

This well-preserved mask combines a human face with two downward-curving horns and is adorned with a small human head with a braided coiffure and similar horns. Its workmanship is extremely fine. This, along with the type of metal used in the casting—a copper-zinc alloy with a small proportion of lead and traces of iron and tin—suggests a dating to between the late eighteenth and early nineteenth century. At that period, European armlets made of this alloy were exported to Africa, where many were melted down and used for other purposes.

Bibliography: Garrard, 1993a, 1993b; Hahner-Herzog, 1997, no. 16

31
HELMET MASK OF THE *KOMO* SOCIETY *WARAKUN*
BAMANA, KOULIKORO REGION, MALI

Wood, antelope horn, pig bristles, feathers, length 74 cm

Urs Albrecht Collection, Basle

32
HELMET MASK OF THE *KOMO* SOCIETY *WARAKUN*
BAMANA, KOULIKORO REGION, MALI

Wood, antelope horn, length 54 cm

Former Eduard von der Heydt Collection

Rietberg Museum, Zürich

These two impressive helmet masks are representatives of a type of mask used by the *komo* society of the Bamana people. In addition to the *warakun* masks, the members of this secret society are in possession of various objects charged with power and occult knowledge making it possible for them to exert control in the areas of judgement pronouncement and public order and to protect the society from sorcerers and evil spirits. The *warakun* masks unite the characteristics of various animals—crocodiles, antelopes, birds, hyenas and pigs, among others—which are not only depicted on the carved helmets but also on the accessories. These additional materials, along with the thick crust of mud and sacrificial offerings which is applied from time to time, amplifies the power and reputation of the mask while, at the same time, producing a dramatic effect. This can be observed in a particularly

outstanding way in the mask from the private collection which is decorated with antelope horns and dense tufts of pig bristles and feathers.

The performance of the mask wearers on ceremonial occasions is just as spectacular as their appearance. Wearing elaborate costumes made of the feathers of birds of prey, the dancers perform astonishing acrobatic feats and sometimes even spew out flames or fountains of water.

Bibliography: Jespers o. J. (1995); McNaughton 2001a; 2001b; Zahan 1974

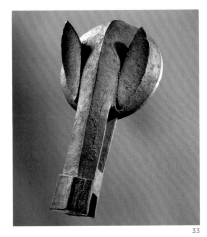

33

FOREHEAD MASK *KONO*

WORKSHOP IN THE SEGOU REGION, BAMANA, MALI

Wood, height 48 cm

Private collection

Kono is one of several powerful Bamana initiation societies (*jow*), whose authority rests on occult knowledge, ritual acts and objects, and a great spiritual energy known as *nyama* which is capable of influencing forces of nature. In addition to ensuring the fertility of fields and people, the *kono's* tasks include jurisdiction, punishment, and warding off sorcerers or witches. The society's eponymous masks, worn during initiations of new members, exhibit lucid stylized forms and are covered by an encrustation of organic materials that is regularly washed off. They are meant to represent both a bird and an elephant, the former standing for the human spirit and the latter for intelligence.

During initiation rites the dancer, possessed by the *kono* spirit, appears in a feather-covered costume and accompanies his dance steps with shrill notes played on a reed whistle.

Bibliography: Colleyn, 2001a; McNaughton, 2001a; Zahan, 1974

34

FACE MASK *N'DOMO*

BAMANA, SARO REGION, MALI

Wood, paint, height 69 cm

Private collection

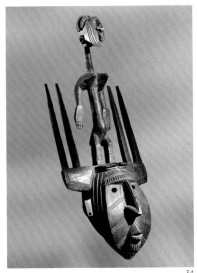

34

Anthropomorphic face masks, crowned with several vertically upward-pointing horns, serve as the emblem of the *n'domo* society of the Bamana people. In this remarkable object the central horns are replaced by a female figure. We have no information on the function of this aspect in the *n'domo* context. The two-dimensional shaping of the faces, the arrow-like shape of the nose, the abundant ornamental scarring on the figure's body, as well as the outward-turned palms of the hand permit the attribution of this mask to the Segou region.

As the first of the numerous initiation and secret societies of the Bamana people, the *n'domo* or *n'tomo* is open to uncircumcised boys. Over a period of five years, the boys receive their first knowledge of social and religious values, which they extend and deepen in their subsequent membership in other societies.

Bibliography: Bacquart 1998, p. 64; Colleyn 2001; Sieber/Walker 1987, no. 14; Zahan 1974

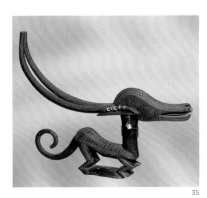

35

HEADDRESS MASK *TYI WARA*

WESTERN BAMANA, MALI

Early 20th century

Wood, glass beads, mussel shells, metal, height 44.5 cm

Donation of Mrs. Ralph M. Coe in memory of Ralph M. Coe Cleveland Museum of Art

The head crests of the *tyi wara* society are among the most famous Bamana masks. The society—which today has been largely superseded by the *ton* youth society—was responsible for all aspects of agriculture, which forms the basis for the Bamana's existence. The masked dancers, whose bodies were completely covered by a fibrous costume, performed during chopping championships and joint work in the fields. Originally, the dances invoked the favour of a mythical cultural hero who supposedly taught the Bamana how to cultivate crops. Over time, secular aspects predominated these performances which were used to spur on the zeal of the young men.

This headdress mask, which originated in the Djitournou region in the western Bamana area, represents one of three iconographically differing types, which can be assigned to specific zones. The fact that the head and body are carved separately and joined by a broad metal band in the region of the neck is typical of this type. The fine decoration of carved circles, lines, triangles and zigzag ornaments covering the head, horns, body and tail, as well as a row of small metal rings on the upper part of the ear is particularly noteworthy. This mask depicts, in an almost realistic manner, a hybrid animal—a mixture of antelope and aardvark. The latter is renowned for its ability of being able to burrow quickly through the ground and it was probably for this facility that it served as a model for the Bamana farmers.

Bibliography: Colleyn 2001b; Hahner-Herzog 1997, no. 2; Imperato 1970, 1981; Petridis 2003, pp. 36–37; Stepan 2001, p. 112; Zahan 1974; 1980

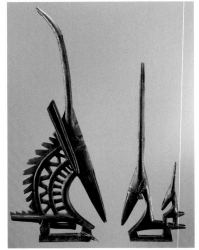

36/37

HEADDRESS MASKS *TYI WARA*

BAMANA, SEGOU REGION, MALI

Wood, height 87 cm and 66 cm

Collection of Alain Schoffel, Rouziers de Touraine

38

HEADDRESS MASK WITH KID *TYI WARA*

BAMANA, SEGOU REGION, MALI

Wood, height 66 cm

Private Collection

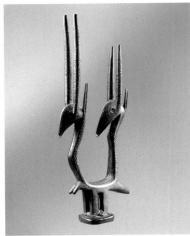

38

A third decorative method dominates the *tyi wara* headdresses from the eastern Bamana region, between the cities of Sikasso in the south and Segou in the north. Here, we have a pair of masks representing a male roan antelope with horns tightly curved backwards and a female oryx antelope with long horns pointing in a vertical direction. The natural characteristics of the two species of antelope are used in these mask figures to demonstrate the differences between the sexes: The male mask is distinguished by a powerful head with large ears and a thick neck with a luxuriant, ornamental mane and, in many cases, a penis, whereas the female mask is notable for its graceful, modest forms as well as for the baby animal on her back. In many aspects, the pair of masks has a symbolic meaning. On the one hand, the depiction of an antelope symbolises a mythological, primeval time when this animal taught the people how to cultivate the ground. On the other, the appearance of a "family" of masks provides a link between the cultivation of the earth and marriage and reproduction.

Bibliography: Colleyn 2001b; Hahner-Herzog 1997, no. 1; Imperato 1970, 1981; Roberts 1995 pp. 82–83; Stepan 2001, p. 112; Zahan 1974, 1980

39

HEADDRESS MASK *TYI WARA*

SOUTH-WESTERN BAMANA REGION, MALI

Wood, height 45.4 cm

New Orleans Museum of Art; Estate of Victor K. Kiam

This *tyi wara* mask, which originated in the Bougouni or Dioila region, depicts, in an abstract form, three individual animals—aardvark, pangolin and roan antelope—united to form a harmonious composition of curves and zigzags. The aardvark forms the base which is a characteristic of this type of mask. Its appearance is highly stylised in this piece and it is only its short buckled legs which make it recognizable as an animal. The almost oval form located above this represents an pangolin with

two antelope horns and a zigzag structure growing out of its back. All three animals have a special meaning for the Bamana which is closely related to work in the fields.

Bibliography: Colleyn 2001b; Hahner-Herzog 1997, no. 3; Imperato 1970, 1981; Roberts 1995, pp. 82–83, Zahan 1974, 1980

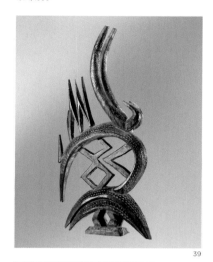

39

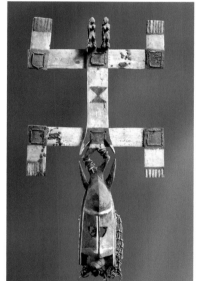

40

40
FACE MASK *KANAGA*
DOGON, MALI

Wood with white, black, red and blue paint, leather
and fur cords, raffia net, height 115 cm
Formerly collection of Josef Mueller
Acquired before 1952
Musée Barbier-Mueller, Geneva

One of the most widespread varieties of the over seventy anthropomorphic and zoomorphic masks of the Dogon is the *kanaga*. It has the characteristic shape of a dual cross with short bars extending upwards or downwards at the ends of the crossbars, abstract painted forms, attached animal figures, or—as in the present example—human figurines. The Dogon interpret this mask in many ways in the context of their creation myths. To non-intitates, it embodies a bird (*kommolo tebu*), whose black and white feathers are evoked in the color scheme of the double cross. Initiates recognize

it to represent the god of creation, Amma, pointing to the sky with one hand and to the earth with the other. Furthermore, the mask is associated with a water insect (*baramkamza dullogu*), with whose aid animals, plants and the ancestors of human beings once reached the earth. A final interpretation makes reference to the mythical figure of a fox (*yurugu*) that brought chaos into the divine order and subsequently died of thirst, lying on his back with legs in the air.

Quite large groups of *kanaga* masks appear during memorial celebrations for the dead known as *dama,* which are held every five years and may include as many as four hundred dancers, as well as during the *baga-bundo* rites conducted before the burial of a male Dogon. Their spectacular, precisely choreographed dances are intended to recall the gestures of the god of creation as he brought the world into being. Since the performances subjected these masks to great wear and tear, used but well preserved examples such as this one are rarely found in Western collections.

Bibliography: Dieterlen, 1989; Griaule, 1938; Hahner-Herzog, 1997, no. 7; Ndiaye, 1995; Stepan, 2001, p. 108

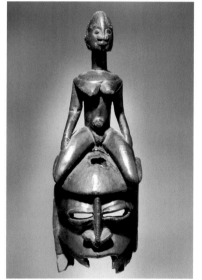

41

41
FACE MASK *SATIMBE* (?) WITH KNEELING FEMALE FIGURE
DOGON, MALI

Wood, height 58 cm
Formerly collections of Rasmussen and Gaston
de Havenon
Private collection

This mask may well originate from the same artist as a representation of mother and child attributed to the *Maître de la maternité rouge* (Master of the Red Maternity). Its subject, although well known among the Dogon, appears in an unusual combination: a kneeling female figure whose firm, full breasts suggest that she has yet to bear children.

Perhaps we are dealing with an unusual form of *satimbe* mask, which normally exhibits a rather stylized standing female figure with raised arms. Yet the astonishing thing about this piece is not only the figure but the mask face proper, which has anthropomorphic features of a rather realistic kind, in contrast to *satimbe* masks, which typically exhibit a stylized antelope depiction.

Satimbe is interpreted, on the one hand, as Yayemme, a woman who in mythical times was the first to discover the use of masks. Her identity was uncovered by men, and she was permitted, as "sister of masks," to continue to view mask performances. On the other hand, the figure represents Yasigi, a character from the Dogon myth of creation who served beer to the participants in the first *sigi* festival, held every sixty years to celebrate the changeover of generations. Not only the mask continues to recall these two mythical figures to this day but also the institution of Yasigine, the only woman permitted to attend mask dances and participate in the *sigi* celebration.

Bibliography: Bouloré, 2000; Dieterlen, 1989; Falgayrettes-Leveau, 2000, pp. 74–75; Griaule, 1938; Hoffmann, 1995

42
FACE MASK *WAN-BALINGA* OR *WAN-MWEGA*
MOSSI, BURKINA FASO

Late 19th century

Wood, leather, black and red pigments, height 28.6 cm
The Baltimore Museum of Art, Friends of Art Fund

With the Mossi, the largest ethnic group in Burkina Faso, masquerade customs are limited to farmers (*nyonyose*) and smiths (*saya* or *saaba*), while the leadership (*nakomse*) uses figurative sculptures in the same ritual context. The masks (*wango*) are owned by family lineages and embody the clan's totem animal, which is believed to have played a key role in its emergence. The maskers appear at funerals and homages to important deceased clan members, as well as occasionally at secular festivities. Stylistically, these masks can be classified in three groups, which are associated with certain regions. The present mask represents the style known as southwestern Ouagadougou. Further characteristic traits are its small size, striking painted geometric patterns, and a three-flap headdress. In the case of animal masks, this is interpreted as a crest or head feathers, and in anthropomorphic masks as a Mossi women's hairstyle known as *gyonfo*.

This mask is unusual in several respects. Unlike most other Mossi masks of this

stylistic region, its eyes are perforated. Also, the white finish precludes any clear identification. Although it has been interpreted as representing a female (*wan-balinga*), masks that depict a Fulani woman or—when they have the suggestion of a goatee—the mythical female figure Poughtoenga, generally have a black-painted face. A light, especially red finish, in contrast, points to an albino (*wan-mwega*), although in this case the characterization usually includes a beard.

Bibliography: Roy, 1983, 1984, 1987, 2002

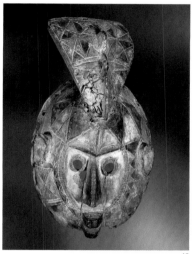

42

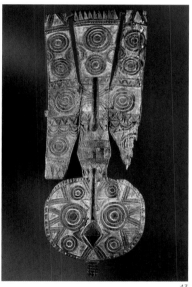

43

43
FACE MASK
NUNUMA (GURUNSI), BURKINA FASO

19th century

Wood, color pigments, height 123 cm
Musée d'Arts Africains, Océaniens, Amérindiens,
Marseille

In addition to a series of other ethnic groups, the culturally related Nunuma and Nuna belong to a group of peoples who are usually referred to as Gurunsi by the neighboring Mossi and in ethnological reports. Numerous masks by these farming peoples are known. They are characterized by circular eyes, a protruding mouth, black and white paint finish, and

striking geometric patterns. This decor is not arbitrary but corresponds to the vocabulary of a secret language known only to initiates, whose full meaning reveals itself only with increasing age and insight.

In addition to zoomorphic masks representing antelopes, buffaloes, hyenas, hornbills or snakes, the Nuna and Nunuma fabricate abstract plank masks that are studded with bent hooks and occasionally adorned with figures at the upper edge or between the boardlike superstructure and face area. Regardless of their design, all of these masks represent nature spirits that ensure the protection, prosperity and perpetuation of the community.

The present mask perhaps represents a type of sacred mask (*wankr*) made at the behest of a supernatural being who revealed himself to the mask's owner, and is characterized by great age. These masks are reserved for use in various ritual contexts such as purification ceremonies, funerals and the initiation of adolescent boys who, during a two-week seclusion, are introduced to the esoteric knowledge surrounding the masks and the social and ethical values of their community. Beyond this, offerings are made to the masks. Less old and revered masks (*wamu*), made on order of their owner for a certain purpose, are mainly danced to provide entertainment on secular occasions such as market days.

Bibliography: Bravmann, 1995; Roy, 1987, 1997, 2002; Zwernemann, 1978

44

BUTTERFLY PLANK MASK
BWA, MALI/BURKINA FASO

Wood, polychrome paint, height 35.5 cm

Musée d'Arts Africains, Océaniens, Amérindiens, Marseille

Masks have continued to determine the ritual, social and political life of the Bwa to this day. Leaf masks (*bieni*) are used in the *do* cult in the entire Bwa region. In addition, the southern Bwa have many mask types carved of a lightweight wood, which they originally adopted from the neighboring Nunuma and Winiama. These zoomorphic or abstract masks are owned by extended families and embody spirits of nature that play a role in the mythology of the lineage group. They appear at initiations and burials to ensure the protection of

families, but also for entertainment on market days.

This plank mask represents a butterfly, a symbol of the awakening of nature after the dry period and the emergence of fresh life. It differs from most other butterfly masks, which are decorated with large, target-like circles, in its unusually finely articulated geometric decor of dark triangles inscribed in light roundels. These patterns, also found on other mask types, have a symbolic meaning that reveals itself to initiates only gradually, as their experience and knowledge increase.

Bibliography: Marseille n. d., p. 34; Roy, 1987, 2002; Zwernemann, 1978

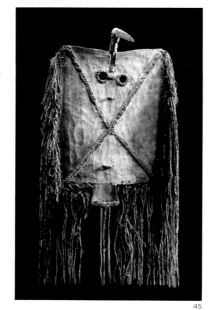

45

PLANK MASK *LONIAKEN*
TUSYAN, BURKINA FASO

Wood, *Abrus precatorius* seeds, cowrie shells, kaolin, black plant fibers, height 67 cm (not including fringe)

Acquired in 1968 from the collection of Robert Duperrier, Paris

Musée Barbier-Mueller, Geneva

The Tusyan, a small ethnic group in southwestern Burkina Faso, are known for helmet masks with carved buffalo horns (*kable*), but especially for large, rectangular plank masks (*loniaken*) with figurative depictions or buffalo horns on the upper edge. These attached elements symbolize the totem animal of the clan to which the mask's owner belongs. Also characteristic is their decor in a shape recalling a Saint Andrew's cross consisting of red *Abrus precatorius* seeds, which also surround the round eye openings (mostly lost in the present specimen). The guardian animal of the clan that owned this mask was a bird, possibly a gray hornbill (*Tockus nasutus*). The bird's tail is evoked at the lower edge by a trapezoidal extension.

Such masks were used exclusively at great initiation rites held every forty

years, the last of which took place in 1933 in the town of Toussiana and in 1960 in Guena. Men who had gone through a first initiation as adolescents were prepared in a second phase for the ritual dances they would subsequently perform in the bush. At this point they wore only these masks with attached bunches of twisted plant fibers, which were made by the village smith during the initiation period and subsequently passed into the possession of the initiates.

Bibliography: Hahner-Herzog, 1997, no. 11; Haselberger, 1969; Newton/Waterfield, 1995, p. 72; Roy, 1987, 1988, 2002

46

PENDANT IN MASK FORM
BENIN KINGDOM, NIGERIA

Early 16th century

Ivory, iron, copper, height 25 cm

The British Museum, London

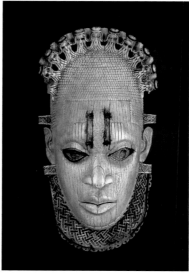

46

This elegant specimen is one of four known ivory miniature masks with naturalistic faces from the old Kingdom of Benin and dates from the early sixteenth century. They probably belonged to the monarch (Oba) and were worn on a belt around the hips or served as a fibula on ceremonial clothing—as is also the case with the cast-brass pendant (cat. 47). The Oba held the monopoly on both cast-brass objects and ivory, which was associated with purity and prosperity. The absolutely symmetrical face depicted on the mask portrays a queen mother (Iyoba) who not only held a prestigious office but was also extremely influential. The Iyoba shows a characteristic facial design mirrored, on the forehead of the mask, by a vertical striped pattern. The two central bands and the eyes were originally lined with copper. The highly developed, striking hairstyle is crowned with a diadem constructed of small human heads which—because of their beards, hairstyles and headdresses—can

be recognised as being Portuguese. This motive can be seen on other works originating from Benin and is indicative of the esteem in which the Portuguese were held in the Edo Kingdom. The coral collar and the ruff, ornamented with looping ribbons which are tied below the ears and chin, are also indications of a royal depiction.

Bibliography: Ezra 1984; Mullen Kreamer 1987; Stepan 2001, p. 74

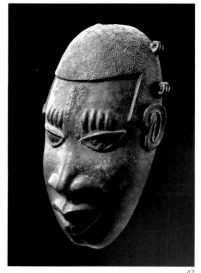

47

47

PENDANT IN MASK FORM
BENIN KINGDOM, NIGERIA

15th/16th century

Brass with encrusted patina, iron inlays, height 17.9 cm

Formerly collection of Baudouin de Grunne

Musée Barbier-Mueller, Geneva

In the Edo kingdom of Benin, whose origins reach back to the fourteenth century, the king, or *oba,* held a monopoly on all works made of brass, which he could pass on as signs of favor to his dignitaries, courtiers and neighboring rulers. Many such works were made on royal order by specialist craftsmen using the lost wax process. The great number and variety of these metal pieces included pendants with various motifs, which were worn on a belt around the hips. This custom is recorded in some of the renowned Benin relief plaques representing dignitaries and current kings. The present example in the form of a mask, showing an only slightly stylized human face, was likely made during the first phase of expansion of the Benin kingdom in the late fifteenth and early sixteenth century. This is indicated not only by the extremely thin casting but by the inlaid iron pupils and forehead scarifications, and the concentric-circle design on the hair.

Bibliography: Ben Amos, 1988; Freyer, 1987; Hahner-Herzog, 1997, no. 44; Newton/Waterfield, 1995, p. 103

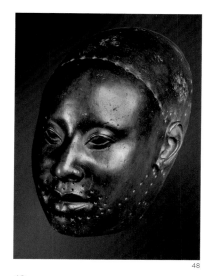

48

MASK

YORUBA, IFE, NIGERIA

12th–15th century

Copper, height 33 cm

The National Commission for Museums and Monuments, Lagos

Since the early twentieth century, great numbers of human figures and heads in terracotta and metal have been excavated in Ife, the sacred city of the Yoruba and residence of the *Oni,* the highest Yoruba dignitary. These works, which can be dated to the eleventh to fifteenth century, are characterized by a portrait-like realism and attest to the outstanding mastery of the artists who made them.

The present mask is a masterpiece of casting technique, made of a pure copper that is difficult to cast without alloys. It is thought to represent the *Oni* Obalufon II, who is credited with introducing the art of bronze casting to Ife. The royal rank of the depiction is indicated, among other details, by the holes along the hairline and in the chin area, to which a crown and pearl veil were perhaps attached, insignia that are still worn to today by Yoruba rulers on public occasions. Viewing slits underneath the mask's eyes indicate that it was intended for wearing despite its great weight (about 5.8 kilograms).

Bibliography: Abiodun/Drewal/Pemberton, 1991; Eisenhofer, 2000; Eyo/Willett, 1983; Willet, 1995

49

HELMET MASK *EGUNGUN*

OLOWE OF ISE, YORUBA, NIGERIA

Wood, height 45 cm

Formerly collection of Deborah and Jeffrey Hammer, Sherman Oaks, California

Private collection

In Oyo and among the western and southern Yoruba groups, a cult society known as *egungun* is responsible for maintaining the link between the living and their ancestors. The mask figures appear as embodiments of ancestors

in times of crisis and at festivities lasting several weeks, in order to ensure the protection and prosperity of the community. The masks usually consist of several layers of materials that completely obscure the dancers' bodies and heads. Occasionally the costumes include carved face or headdress masks that represent human beings, animals, hybrid creatures, or groups of figures.

The present *egungun* mask originates from Olowe, a Yoruba carver who was active in Ise in the southeastern Ekiti region. Olowe, who died in 1938, is today still honored by the Yoruba as a gifted artist and celebrated in songs of praise. With its fine facial features, characteristic scarifications on the cheeks, and detailed *agogo* hairstyle, worn by young brides, the mask embodies the ideal of feminine beauty and is a further, compelling example of Olowe's skill.

Bibliography: Abiodun/Drewal/Pemberton, 1991; Drewal, 1978; Fagg/Pemberton/Holcombe, 1982; Houlberg Hammersley, 1978; Morton-Williams, 1997

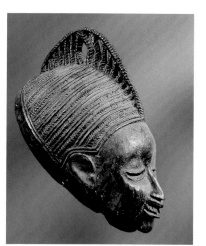

49

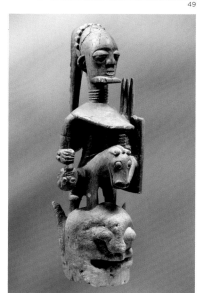

50

50

HELMET MASK

EKITI (YORUBA), NIGERIA

Late 19th century

Wood, height 103 cm

The Trustees of the British Museum, London

The Ekiti and Igbomina in the northeastern Yoruba region still cultivate a masking tradition that is known in the northern area as *epa* and in the southern area as *elefon.* The occasions for mask performances are many and various, ranging from harvest festivities and memorial celebrations for the dead to festivals dedicated to Ogun, the god of fire and war, who is revered above all in the town of Ire. Possibly the present mask was used in ceremonies in honor of Ogun. This is suggested by stylistic traits characteristic of works from the town of Oye-Ekiti, which lies very near Ire. The mask's grotesque helmet portion, possibly deformed by offerings made to it, is topped by the figure of a mounted warrior holding a shield, arrows and a human skull. His headgear is a cap with a long tip, an attribute of hunters. This motif is commonly found in *epa* and *elefon* masks, which appear in a precisely defined sequence during performances. First comes Oloko, "master of the farmstead," whose superstructure bears a leopard bringing down an antelope. Next come Jagunjagun, the warrior, and Olasanyin, the healer. The train is brought up by a mask with a female figure or a mother and child group on its superstructure.

Bibliography: Fagg/Pemberton/Holcombe, 1982; Pemberton, 1989; Picton, 1995, 1997

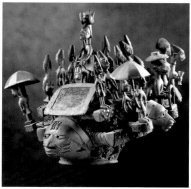

51

51

DANCE HELMET CREST MASK *MAGBO*

YORUBA, NIGERIA

Before 1898

Wood, velvet, textile band, sequins, upholstery tacks, paint, depth 68 cm

Acquired by exchange from the Museum für Völkerkunde, Berlin, 1937

Rautenstrauch-Joest-Museum für Völkerkunde, Cologne

Many Yoruba masks have superstructures depicting a scene that alludes to human behavior or proverbs and illustrates social roles. In addition to the *epa* masks from the northern Yoruba region (cat. 50), *gelede* masks, whose performance honors the spiritual powers of women, evince a great variety of motifs. Although the present piece has a typical *gelede* mask

face, due to its complex superstructure it has been described as a *magbo,* a type of mask used by the Ijebu, a southern Yoruba group, in their annual *oro* celebrations.

The feared *oro* men's association functions as an executive organ of the *ogoni* (*osugbo*) society, which is responsible for judicial matters, and carries out its verdicts against sorcerers and other miscreants who threaten the social order. The society's far-reaching social significance and responsibility finds expression in the scene represented on the mask. The composition is centered around a horseman, whose full beard, headgear and fly switch identify him as a king and military commander in chief. His status is additionally emphasized by a bird perched on his head, the symbol of Yoruba rulers' power. He is surrounded by a retinue of twenty-six figures attached to two horseshoe-shaped arcs, who represent women, musicians, armed warriors, sunshade bearers, and priests.

Bibliography: Drewal, 1997; Fagg/Pemberton/Holcombe, 1982; Schneider 1999

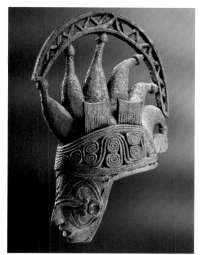

52

52

HELMET MASK *AGBOGHO MMUO*

IGBO, NIGERIA

Wood, dark encrusted patina, height 55 cm

Private collection

This mask represents a type widespread among the Igbo, the "young girl" (*agbogho mmuo*), whose fine facial features, straight nose, and small mouth reflect the group's ideal of feminine beauty. That it represents an unmarried girl can be gathered from the elaborate carved coiffure. It apparently derives from the complicated hairstyles, modelled with clay and adorned with combs and other accessories, that girls formerly wore prior to their wedding. Raised arched bands extending from the eye area to behind the ears evoke the *uli* pattern, which girls applied in indigo on the occasion of puberty rites and other festivities.

These masks are danced at harvest celebrations at the onset of the dry period and at ceremonies in honor of the *ane*, or earth spirit. The dances, occasionally parodying women's behavior, serve foremost to entertain the audience. In keeping with the meaning of the mask figure, the dancers, recruited from among the male members of the age classes, appear in colorful, tightly fitting costumes with false breasts.

Bibliography: Cole, 1997; Cole/Aniakor, 1984; Guggeis, 1997; Jones, 1984; Schädler, 1992, p. 140

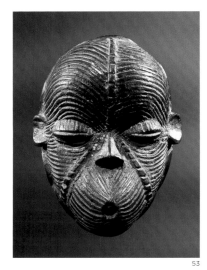

53
FACE MASK
ADA-IGBO, NIGERIA

Wood, height 20 cm

Private collection

This exceptional mask, completely covered with a grooved ornamentation, probably originated from the Ada in the north-eastern Igbo region. Stylistic features, also recognisable in other wooden masks from this region, are indicative of this. In particular, the prominent conical mouth section which leads to a round opening reminds one of a goat mask shown in Jones (1984, p. 212). The unusual grooved pattern gave rise to the assumption that it was a depiction of a monkey. The fact that the Ada, apart from human faces, only depicted goats and birds on their masks speaks against this theory.

Among the Ada people, masks belong in the environment of the secret societies which every man joins upon reaching adulthood, at the very latest. Masked performances generally take place during the dry season and in public. Today, the originally religious character of these masked celebrations has, to a large degree, been superseded by entertainment aspects and the aesthetic admiration of the masks.

Bibliography: Jones 1984, pp. 209–213; Kerchache et al. 1989, ill. 112, p. 107; Ottenberg 1997

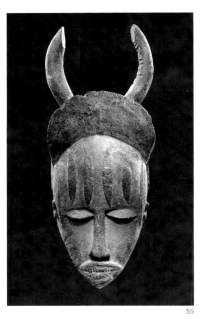

54
FACE MASK
IGBO, NIGERIA

Wood with traces of white and red paint, height 68.2 cm

Musée Barbier-Mueller, Geneva

The Igbo have no central authority, being divided into numerous small territorial groups. They possess a variety of regionally different mask types and styles ranging from quite realistic to entirely abstract. This graceful mask with its conical face portion framed by a carved pattern of open triangles and surmounted by a short stele of similar openwork design, likely comes from Uzouwani or the adjacent Nsukka region in the extreme north of the Igbo region.

Although little is known about the meaning and function of such masks, they seem to have been used not in a political context but during celebrations to mark the conferring of men's titles. Such titles are extremely important, since they enhance their bearers' prestige and status in the community and are obtained and improved by the payment of considerable fees.

In a recent publication (Joubert, 1997), a similar piece was ascribed to the Afikpo, whose abstract, colorfully painted "yam knife" masks (*mma ji*) with sickle-shaped superstructures are well documented. Yet these works show no stylistic affinity with the mask type illustrated here. Nor is this provenance confirmed by the publications of Ottenberg, an expert on the Afikpo.

Bibliography: Elsas/Poynor, 1984; Hahner-Herzog, 1997, no. 56; Joubert, 1997; Ottenberg, 1975

55
FACE MASK
URHOBO, NIGERIA

Wood with encrusted patina and remnants of white and black paint, height 46 cm

Formerly collection of Philippe Guimiot

Musée Barbier-Mueller, Geneva

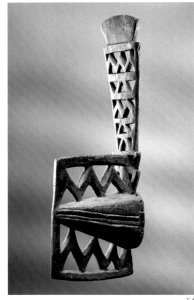

The Urhobo in the western Niger Delta are known principally for human figures of various sizes that embody ancestors or nature spirits (*edjo*). Less frequent in Western collections are the masks which were worn in ceremonies in honor of water spirits (*edjorame*). The group's most important masquerade festivals are devoted to Ohworu, spirit of the deep waters and forests, who also serves to watch over marital fidelity. This is the context in which the present female mask with its finely nuanced features and cosmetic scars on the forehead—characteristic of Urhobo works—should be seen. It likely represents a young woman of marriageable age (*opha*). This is indicated by the arched coiffure with two hornlike projections, which recalls the elaborate hairstyle worn by adolescent girls when their status as a future bride is announced.

This mask type, said to have been adopted from the neigboring western Ijo, is today still used in Urhobo communities to invoke "the blessing of the deep waters" when the Niger River reaches its highest level.

Bibliography: Foss, 1988, 1997, 2004; Hahner-Herzog, 1997, no. 46; Jones, 1984

56
HELMET CREST MASK
IJO, NIGERIA

Wood, height 54 cm

Willy and Marthe Mestach Collection, Brussels

The mask figures of the Ijo, who live as fishermen in the area of the Niger Delta and in the eastern coastal region down to the New Calabar River, are considered to be incarnations of water spirits (*bou oru*) who ensure the welfare of men. To placate these spirits and win their favor during the dry period, celebrations lasting several days are held, with masquerade

performances accompanied by offerings and invocations.

Apart from a combination of anthropomorphic and zoomorphic elements, these masks represent water animals above all, but also land animals—antelopes, monkeys, leopards and buffalo—and birds, which are viewed as representatives of the water spirits. The configuration of the masks extends from realistic depictions to extremely stylized forms, as in this unusual piece. It can be read either as a bird with wings slightly extended to the sides, or as a human figure; its central portion, moreover, recalls a ram's head. The stylistic range of Ijo masks might be explained by the fact that their carvers not only rely on natural models but, as they themselves point out, translate dreams or visions in their work.

Bibliography: Anderson, 1997; Horton, 1965; Maurer, 1991

57
HELMET CREST MASK
IJO, NIGERIA

Wood, length 113 cm

Collection of Rolf and Christina Miehler

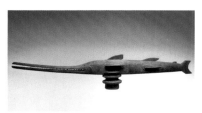

The zoomorphic masks of the Ijo that embody water spirits (*bou oru*) include many types that depict water animals such as crabs, hippopotami and crocodiles. The most common motif, however, is fish, especially fish of prey such as sharks, swordfish and hammerhead sharks. These are depicted with striking realism, often having a movable jaw studded with sharp teeth (or nails). This is not surprising, seeing as the Ijo live by

fishing in the Niger Delta and face the threat of these dangerous fish every day.

Such fish masks appear to have been originally developed by the Abua and later adopted by the neighboring Ijo-Kalabari, Ijo-Okodoa and Ibo-Ekpeye. The works from these various regions are difficult to distinguish on a stylistic basis; yet separately carved and attached fins, like those seen in the present piece, are considered a trait of Abua masks. In all of these groups in the eastern delta area, the masks are used in the context of the *sekiapu* cult (Abua: *egbukele*; Kalabari: *ekine*), in which the water spirits are placated and implored to ensure the welfare of the community.

Bibliography: Anderson, 1997; Cole/Aniakor, 1984; Féau, 1997; Schädler, 1992, pp. 132–33

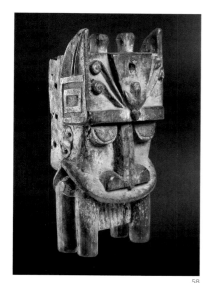

58
HELMET CREST MASK
OTOBO

EASTERN IJO-KALABARI, DEGEMA REGION, NIGERIA

Wood, encrusted patina, height 43 cm

Collection of Rolf and Christina Miehler

With the Kalabari, an eastern Ijo group, *otobo* is one of the most important mask figures, which appears at celebrations in honor of the water spirits. Beyond this, miniature *otobo* masks often adorn the sculptures placed at memorials to important deceased people. Otobo is described by the Ijo as a being who is part human, part hippopotamus, and whose power enables him to withstand even terrible floods. Reflecting this idea, the mask combines human features with the traits of a hippopotamus. Its stylized design represents a constant type among the eastern Ijo, not even local differences being detectable.

Like most masks that represent water spirits, *otobo* masks are worn horizontally on the head with the face looking upwards. If we imagine it in this position,

adorned with cock feathers and surrounded by palm fronds attached to the edge, which are said to protect against evil spirits, the mask would strikingly evoke the head of a submerged hippo.

Bibliography: Anderson, 1997; Horton, 1965; Pelrine, 1996, p. 43; Sieber/Walker, 1987, p. 76

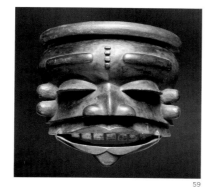

59

59
FACE MASK

SOUTHERN IBIBIO (ANANG), NIGERIA

19th century

Wood, height 25 cm

Acquired from M. von Stefenelli, 1904

Ethnologisches Museum, Berlin

A number of masks of various types and styles are ascribed to the Ibibio. These masks were owned by the *ekpo* secret society, which in the pre-colonial period governed the group's social, political and ritual life. The mask dancers, embodying ancestral spirits (*ekpo*), appeared on many ceremonious occasions, such the funerals of society members or after the yam harvest.

Besides the type of the "beautiful," gentle spirit (*mfon*), whose face was white and who danced mainly for entertainment, there were dark masks with grotesque features. These represented dangerous roving spirits (*idiok*), whose appearances were greeted with respect and timid admiration. Their frightening character was underscored by marked, exaggerated facial features and a movable lower jaw, whose bared teeth were viewed as a threat of violence. This impression was augmented by the dancers' costume, a cloak made of black-dyed raffia fibers, under which their bodies were blackened with soot.

The present, old mask belongs to this group of *idiok* masks. Stylistically, it can be attributed to the southern Ibibio. Visible on the forehead and temples are striking scarifications of a type once common among this ethnic group. The bulging upper edge represents a leather band like those worn by members of the influential *idiong* association of soothsayers and healers. This would seem to indicate that the mask embodies the spirit of an *idiong* priest.

Bibliography: Jones, 1984; Nicklin, 1995a; Nicklin/Salmons, 1995

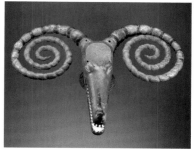

60

60
FACE MASK

OGONI, NIGERIA

Wood with smoked black patina; partly restored in mouth area, height 19.3 cm

Musée Barbier-Mueller, Geneva

To this day the Ogoni, who live east of the Niger Delta, use numerous types of mask for entertainment or on ceremonious occasions. Some of these originate from their own carving tradition, others from neighboring peoples such as the Ijo or Ibibio. The repertoire includes anthropomorphic face masks with movable lower jaw.

This type is exemplified by the present small mask, patinated by long use and displaying the typical raised scars on temples and middle of the forehead. Based on its emphasized nostrils, it can be attributed to the Kana clan. Narrow eye slits and coiffure indicate a female depiction.

In 1992, Nicklin and Salmons had an opportunity to observe such masks, known as *nualu*, in action during the three-month-long celebrations held in conjunction with the yam harvest.

The masks were danced by young men, dressed in costumes of fresh leaves and various types of mask, including the classical one with movable jaw and zoomorphic *karikpo* masks. Their wild dances were rewarded by small gifts of money, food or beverages from the onlookers.

Bibliography: Hahner-Herzog, 1997, no. 50; Jones, 1984; Nicklin, 2004; Nicklin/Salmons, 1997

61
HELMET CREST

EJAGHAM, NIGERIA

Wood, antelope skin, palm fibers, bamboo, metal, pigments, width 86 cm

The National Museum of African Art, Washington

Leather-covered helmet crest masks, disseminated throughout the Cross River region, usually represent human females or males. Less common are

depictions of animals or hybrid creatures with a combination of zoomorphic and anthropomorphic features. The present mask with its long, tooth-studded snout is reminiscent of a crocodile, although the attached, spiraling horns, as in the female masks, allude to a women's hairstyle typical of the region. These additions, like the realistic approach, point to an origin in the lower Cross River area. Masks representing hybrid creatures or crocodiles were emblems of the *obassinjom* cult, which emerged among the Ejagham in the early years of the twentieth century. This ritual society, also active among other Cross River peoples until the 1960s, devoted itself to battling witchcraft or sorcery. For its performance the mask was adorned with a headdress of blue and yellow feathers and affixed to the dancer's head. The dancer wore a long blue cloak hung with an abundance of magic charms.

Bibliography: Jones, 1984; Nicklin/Salmons, 1984, 1997; Puccinelli, 1999

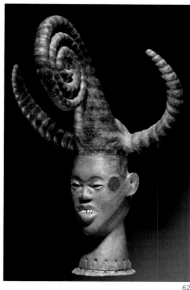

61

62

62
HELMET CREST

EJAGHAM, NIGERIA

Late 19th/early 20th century

Wood, antelope skin, bone, plaited reeds, paint, height 67.3 cm

The Cleveland Museum of Art; Andrew R. and Martha Holden Jennings Fund 1990.23

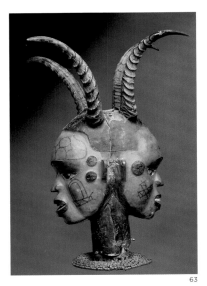

63

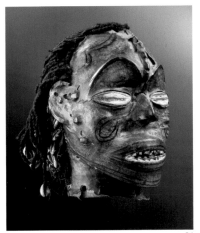
63

DOUBLE-HEADED HELMET CREST

BOKI, NIGERIA

Wood, leather, horns, paint, plaited reeds, height 54 cm

Formerly collection of Carlo Monzino

Private collection

Wooden masks, and occasionally human skulls covered with thin antelope skin, represent a unique type of mask that may have been derived from the head trophies of defeated enemies. The focus of this tradition lay among the Ejagham and Ekoi of the central Cross River region, whence it evidently began to spread along trade routes to other peoples in southeastern Nigeria and Cameroon in pre-colonial times.

Female masks are usually characterized by protruding and occasionally snail-shaped carved "horns," which in the present, double-headed Boki mask are replaced by real horns. These are intended to recall a woman's hairstyle with protruding braids, which was formerly worn by young girls and married women on festive occasions. The realistic effect of the masks is underscored not only by inserted teeth and metal-inlaid eyes but by painted and low-relief patterns. These correspond to the tatooes (*nsibidi*), scarifications and face painting common throughout the Cross River area. Although the meaning of these once popular symbols is difficult to fathom, the rounded linear decor of the forehead of the Boki mask may allude to aspects of love, the triangles on the cheeks to a leopard's coat, and the branching lines to membership in the leopard society, once influential in political, social, commercial and religious affairs in the Cross River region.

The Janus-faced form of the Boki mask, which is also found quite frequently in the helmet masks of the Cross River region, alludes to the mask spirit's ability to discover secrets both in the world of the living and the realm of the dead.

Bibliography: Jones, 1984; Nicklin, 1974, 1999b; Nicklin/Salmons, 1984, 1997; Petridis, 2003; Stepan 2001, p. 82

64

HELMET CREST

EJAGHAM (EKOI), NIGERIA

Wood, leather, metal, human hair, cowrie shells, textile; black and white paint, height 26 cm

Collection of Rolf and Christina Miehler

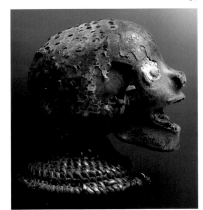
64

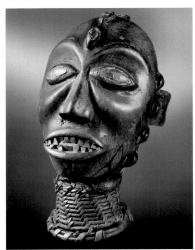
65

65

HELMET CREST

EJAGHAM (EKOI), CROSS RIVER REGION, NIGERIA

Human skull and hair, leather, metal tacks, fur, pigments, organic material, basketweave, height 22 cm

Koenig Foundation, Landshut

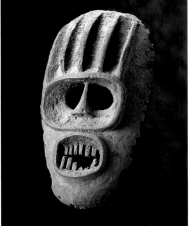

66

HELMET CREST

BANYANG, CAMEROON

19th century

Wood, leather, iron, plaited reeds, height 24 cm

Acquired from Alfred Mansfeld in 1906

Ethnologisches Museum, Berlin

Human skulls covered with leather, apparently those of defeated enemies or slaves, are considered predecessors of wooden masks covered with antelope skin. These were used by members of the age classes and warriors or hunters associations that in pre-colonial times served to maintain the social order but whose functions have since been curtailed, if the associations have not disappeared entirely. Still, their masking tradition is still alive among many ethnic groups in the region, and may be observed at the funerals of association members or on festive occasions.

Like the female examples (cat. 62, 63), these male masks have a very realistic appearance. This effect, produced by the leather covering, is augmented by the inlaid metal eyes, inserted teeth, and, in the case of nos 64 and 66, by the face painting and bulging scarifications on forehead and temples. Possibly these painted patterns in the chin and neck area of the Banyang mask were intended to represent beard stubble. Moreover, cat. 64 has a coiffure of human hair, remnants of which are also found on the back of the head in the second Ekoi mask (cat. 65). This feature was apparently intended to underscore the masks' naturalistic effect.

Bibliography: Hahner-Herzog, 2000a; Jones, 1984; Nicklin, 1974, 1999b; Nicklin/Salmons, 1984, 1997; Vogel, 1986, pp. 105–106

67

FACE MASK

CENTRAL CROSS RIVER REGION, NIGERIA

Wood, height 32.5 cm

Private collection

This unique mask combines human facial features with traits of an ape, possibly a

mandrill (*Papio sphinx*), a type of baboon that was once hunted for food in the Cross River region. Nicklin (1995) discovered a similarity in the mouth and brow areas with dual-headed helmet masks from the central area of this region, from which the present mask is thought to originate as well.

The Cross River region is populated by numerous small ethnic groups whose social structure was formerly determined by age and warriors and hunters societies. In initiation rites, burial ceremonies and agrarian celebrations, members of these groups used various face, helmet and helmet crest masks, some covered with leather. These represented female and male types, and displayed corresponding gender-specific behavior in their dances. Moreover, the aggressive, challenging actions of the male mask figures recalled the behavior of apes. This association was underscored by a shaggy costume made of plant fibers.

Bibliography: Nicklin, 1974, 1995; Nicklin/Salmons, 1984, 1997

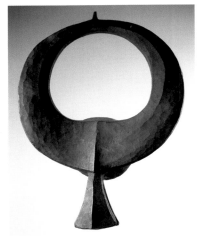
68

68

HELMET CREST MASK
MANGAM

KANTANA (MAMA), NIGERIA

Wood, 50 x 36 cm

Willy and Marthe Mestach Collection, Brussels

Masks representing buffaloes and antelopes are used by various agricultural peoples on the Jos Plateau in central Nigeria. The present buffalo mask, highly stylized and reduced to a few geometric forms, originated from the Kantana, who until the late 1950s were subsumed with many other ethnic groups under the name Mama.

The significance of buffaloes for the Kantana is reflected not only in their masks but in their custom of incorporating buffalo skulls in the walls of secular buildings. However, detailed information about this group's religious ideas and rites, as well as their masking traditions, is still lacking. From the few available reports we can gather that the masks

appeared in the context of the *mangam* cult, to placate the spirits of the ancestors and ensure a good harvest. During their performance the dancers wore a voluminous raffia costume that entirely concealed their bodies.

Bibliography: Berns, 1997; Berns/Fardon, 1997; Maurer, 1991, p. 53

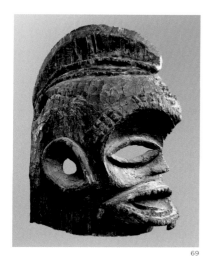

69
HELMET MASK
MAMBILA, CAMEROON/NIGERIA

Wood with encrusted patina and remnants of black paint, height 40 cm

Formerly collections of Charles Ratton and Arman

Musée Barbier-Mueller, Geneva

This sparingly painted mask, worn over the entire head, is of an unusual type in the mask repertoire of the Mambila. Although little detailed information about it is available, it displays a number of stylistic traits that are familiar from this group's figurative sculpture and anthropomorphic helmet crest masks: low, protruding forehead, concave eye area, short, triangular stub nose, and large, open mouth. These features are also found in an anthropomorphic helmet mask (illus. in Gebauer, 1979, p. 24), which in addition has notches along the upper lip and ears of similar form. The almond-shaped eyes, on the other hand, are of a type seen in the simple *kiki* figures of the Mambila.

Influences from the Cross River area and the Grasslands are perhaps reflected in the knob pattern on the brows and middle forehead, as well as in the large eye openings and gaping mouth. Conceivably the artist was inspired by pieces from these neighboring regions, with which the Mambila maintained trade contacts.

Bibliography: Gebauer, 1979; Hahner-Herzog, 1997, no. 61; Zeitlyn, 1994, 1997

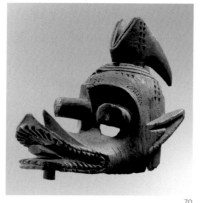

70
HELMET MASK *SUAGA*
MAMBILA, NIGERIA, 19TH CENTURY

Wood, height 44.5 cm

The Metropolitan Museum of Art, New York

Although the Mambila confess Christianity or Islam, they continue to maintain a masking tradition that serves to ensure fertility and the cohesion of the community. Carved masks appear in the context of annual *suaga* celebrations, which are reserved for men, while the women conduct their own *suaga* rites, in which they use leaf or foliage masks.

This zoomorphic mask with its characteristic horns curving back over the head, cylindrical eyes, and gaping, tooth-studded snout, represents the important category of *suaga due* (big *suaga*) or *suaga bor* (dog *suaga*). It is difficult to distinguish these two types from one another, since the Mambila themselves do not clearly categorize them. In some areas every mask figure is called a *suaga due,* while in others, this type is identified by additional feather decor on the net costume. Moreover, such masks bear individual names that refer to the magic-working substances possessed by their owners. Zeitlyn assumes that the preparation of many of these substances requires the ritual sacrifice of dogs, hence the mask name *suaga bor.*

Bibliography: Gebauer, 1979; Hahner-Herzog, 1997, no. 60; Zeitlyn, n.d., 1994, 1997

71
SHOULDER MASK
BENUE REGION, NIGERIA

Wood, height 182 cm

Collection of Rolf and Christina Miehler

Since the 1960s, we have knowledge of shoulder masks, displaying a human head with a sagittal hairstyle reduced to its fundamental elements, supported on an elongated neck, originating from several peoples of north-eastern Nigeria. So far, it has only been possible to make an indisputable attribution in the cases of some Mumuye masks which are distinguished by their characteristic head shaping with large perforated ear lobes.

The origin of the piece shown here can not be determined with certainty as comparable masks have been assigned to both the Wurkun and their neighbours the Waja. In addition, the Jukun, Jen and Chamba who settle in this area have also been considered possible. To make matters even more difficult, comparatively little information is available on the artistic production of these peoples and their usage of such objects.

Bibliography: Bacquart 1998, pp. 96–97; Kan/Sieber 1995 no. 38: Schädler 1992, p. 156

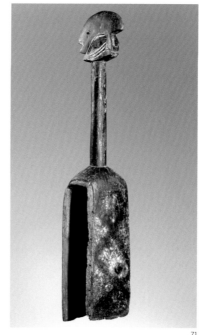

72
MASK OF THE *MSOP* ASSOCIATION *TSESAH* OR *TSEMABU (BATCHAM)*
BAMILEKE (KINGDOM OF BANDJOUN), CAMEROON

19th/early 20th century

Wood, height 88.9 cm

Collected in Bandjoun before 1960

Formerly collection of Valérie B. Franklin

Musée national des Arts d'Afrique et d'Océanie, Paris

Musée Quai Branly, Paris

Masks of this type are referred to as *batcham,* after the kingdom in which

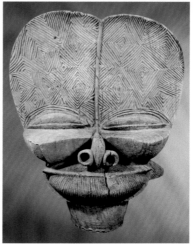

the first of them were collected in 1904. In the Kingdom of Bandjoun, formerly the most important carving center of these sculptures, however, this mask type was known as *tsesah* or *tsemabu,* and in other Bamileke areas as *tukah.* Despite general similarities, all of these masks display stylistic idiosyncracies. In the present specimen, the high, arched surface above the eye area is decorated with a diamond pattern, which has been interpreted as a stylized crocodile belly and, at the same time, as a reference to the body scarifications of famous warriors, married women, and members of the royal family.

Such masks represent the head of an hippopotamus emerging from the water. This animal is viewed as the alter ego (*pi*) of high dignitaries in the kingdom. The masks are owned by the *msop* association, to which the Fon (king) and various high-ranking court officials belong. This magical, religious institution also serves as the king's guards. At funerals and enthronements of the Fon and his nine advisors (*nkamvu'u*), and at the *tsodung,* or elephant dance, the highest-ranking members of the association perform the mask to demonstrate its power and that of the kingdom.

Bibliography: Notué, 1993

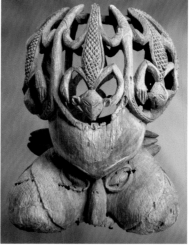

73
MASK *TUKAH* OF THE *KAH* ASSOCIATION
BAMILEKE (KINGDOM OF BAMENDOU), CAMEROON GRASSLANDS

First half of 19th century

Wood, height 86 cm

Collected by Pierre Harter, 1957

Musée national des Arts d'Afrique et d'Océanie

(legs Harter 1992)

Musée du Louvre, Paris

This striking mask is one of only four specimens of its type in Western collections. Pierre Harter received the mask, in 1957 from the then Fon, or king, of the small Kingdom of Bamendou in the

western Bamileke region, as thanks for his medical attentions.

A visible sign of the Fon's authority and the perpetuation of the kingdom through several generations, this mask was among the most important ritual objects of Bamendou. It was in the keeping of a secret society known as *kah*, composed of notables of the kingdom who advised the ruler. The mask was taken from its closely guarded hut in the bush and publicly displayed only every five years, and also appeared at the enthronement or funeral of a Fon or a high dignitary. Due to its weight and the power ascribed to it, the mask was not worn on the head. The holes in the cheeks and at the neck may have served to attach a frame to carry it.

With its headdress, a "pergola" of six lizards separated by arched elements, and puffed cheeks, the mask recalls many of the clay pipe heads which were reserved for high dignitaries in the Grasslands. Like the mask itself, its separate motifs possess a symbolic meaning. The lizards stand for fertility and the continual renewal of the kingdom, the domed forehead alludes to wisdom and secrecy, and the puffed cheeks are considered signs of prosperity and abundance.

Bibliography: Féau, 1995a; Harter, 1986; Notué, 2000; Perrois, 1993, pp. 120-123

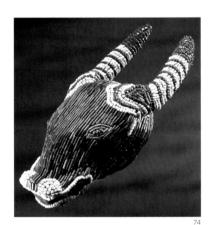

74
BUFFALO MASK
BATIBO, WESTERN GRASSLANDS, CAMEROON

19th century

Wood, textile, glass, plant fibers, height 71 cm

Acquired from Hans Glauning, 1907

Ethnologisches Museum, Berlin

Apart from anthropomorphic masks, depictions of various animals such as monkeys, elephants or cattle occur in the Grasslands of Cameroon. The buffalo, symbol of strength, courage and power, is one of the best known and most widely disseminated mask motifs. Kept by family lineages or secret societies, the masks still appear at funerals and ceremonies in memory of the dead to this day.

The present variant, adorned with glass beads, was used only on special occasions, such as the enthronement of a Fon, or king. Like all beaded objects, it was reserved for the use of members of the royal household, who had a monopoly on such beads, which were imported from Europe and therefore especially valuable. Although the mask was acquired in Batibo in the western Grasslands, it may well have been fabricated by an artist from Bamum or the Bamileke area, since beaded objects were primarily made and used in these two regions.

Bibliography: Féau, 1995b; Koloss, 1999

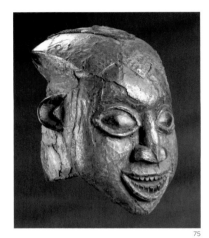

75
FEMALE HELMET MASK *NGOIN*
BAMILEKE, GRASSLAND, CAMEROON

Wood, Brass height 36 cm

Private collection

The carved wooden helmet masks from the grasslands of Cameroon, which are so highly esteemed in the west, are in the possession of family associations (lineages). An ensemble, which performs at celebrations in honour of important deceased persons, can possess more than twenty masks. Occasionally some types are duplicated but usually different characters are portrayed—some of which are obligatory. These include the leading male mask *kam* and *ngoin*, which is regarded as his wife. The ensemble is completed with additional anthropomorphic and zoomorphic masks.

This specimen, set with metal, can be identified as a *ngoin* mask on the grounds of its tongued hairstyle which was reserved for queens. This type is always completely plastic without eye-openings, which means that the dancer must wear it on his head with his face covered by a fine cloth.

This mask comes from the Bamileke region and is closely identified with the Oku kingdom. It is, however, problematic to provide an exact assignment of the style of carving to a specific area or kingdom seeing that, in the Cameroon grasslands, particularly talented carvers were

widely known and worked for a large number of patrons. In addition, there was a great deal of trading between the individual kingdoms of the grasslands.

Bibliography: Koloss 1999; Northern 1973, 1984; Schädler 1992, p. 168; Wittmer 1991

76
MASK OF THE *TROH* NIGHT SOCIETY
BANGWA, WESTERN PROVINCE, CAMEROON

Wood with encrusted patina, height 27 cm

Musée national des Arts d'Afrique et d'Océanie

Musée Quai Branly, Paris

77
MASK OF THE *TROH* NIGHT SOCIETY
BANGWA, WESTERN PROVINCE, CAMEROON

Wood with encrusted patina, height 41.5 cm

Musée Barbier-Mueller, Geneva

In the Bangwa chiefdoms in the southwestern Grasslands of Cameroon, the *troh*, a men's association known as a "night society," performs important political and religious functions. Its nine highest-ranking members, who descend from companions of the dynasty's founder, control the social order and play a significant role in the funerals of deceased chiefs and the enthronement of their successors. Each of these men owns a mask that is passed down through generations and is always carefully stored and guarded, since it is considered extremely dangerous. For this reason it is not worn on the head during its ap-

pearances but carried on the shoulders, and treated with the greatest respect and caution.

These two masks with their encrusted patina, a sign of their great age, represent two different stylistic variations of the same mask type. The dual-faced specimen from the Barbier-Mueller Collection is highly abstracted. In milder form, this feature is still observed in late-1980s works by the carver Atem, who was active in the western Bangwa region. The mask from the Paris collection, in contrast, shows a "baroquely" exaggerated realism that recalls works by the neighboring Bamileke.

Bibliography: Brain/Pollock, 1971; Hahner-Herzog, 1997, no. 64; Harter, 1986; Lintig, 1994, 2004; Perrois, 1993, pp. 116-117

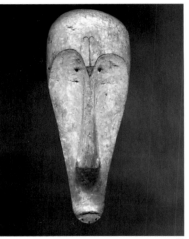

78
FACE MASK *NGIL*
FANG, GABON/CAMEROON

19th century

Wood, kaolin, height 78 cm

Purchased by Oelert (Abel Collection), 1895

Ethnologisches Museum, Berlin

79
FACE MASK *NGIL*
FANG, GABON

19th century

Wood, kaolin, brass nails, height 66 cm

Musée du Quai Branly, Paris; Dépôt Musée de l'Homme

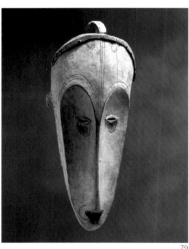

These two works which, on account of their minimalist features and simple elegance, are so striking represent one of the four, known Fang mask types. The elongated face, in which a heart form is carved and where the sense organs—eyes, nose and mouth—are extremely reduced, is characteristic of this type. The economical use of the carved lines used for decoration on the forehead and below the eyes represents the varied scarification patterns which were formerly common. The crescent-shape on the top of the mask from the Parisian museum reminds one of the elaborate hairdresses and wigs which visitors to the Fang could still observe at the beginning of the twentieth century.

We have little information on the use of *ngil* masks, whose white painting reminds one of the dead, seeing that the tradition associated with them disappeared before the First World War. They obviously were a part of the paraphernalia of a hierarchically-structured male society which used the masks at initiation ceremonies and to pursue and punish sorcerers and offenders. The supposedly gentle expression of the masks therefore stands in striking contrast to the extremely frightening, threatening character of the masked performers who only performed at night in the light of torches.

Bibliography: LaGamma 1999; Perrois 1985; Stepan 2001, p. 20; Tessmann 1913

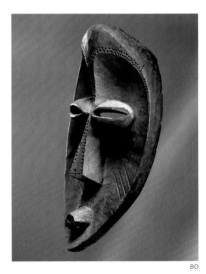

80
FACE MASK
MAHONGWE OR NGARE, REPUBLIC OF CONGO
Wood with pigments, height 35.5 cm
Formerly collections of Aristide Courtois (prior to 1930),
Charles Ratton, and The Museum of Modern Art,
New York (1939)
Musée Barbier-Mueller, Geneva

Before William S. Rubin disproved the theory in the 1980s, this mask was for decades considered a source of inspiration for Picasso's *Les Demoiselles d'Avignon*, 1907. Despite the widespread interest it has attracted, many questions still remain concerning the mask's origin, context and function, especially as very few comparable works have come to light. The mask was collected in the 1920s in Etumbi, on the upper Likuala River, an area inhabited by a few Mahongwe groups and the Mboko and Ngare, who are viewed as related to the Babangi. A stylistically similar piece in the Brooklyn Museum, New York, likewise from this region, suggests that both works represent a specific Babangi style. On the other hand, the shape of eyes and nose, as well as the cut of the face, show affinities with works of the Kota in Gabon, a group to which the Mahongwe belong. Then again, the diagonal grooves on the cheek, corresponding to scarification patterns once common among the Ngare, would speak for an attribution to this Babangi group.

Bibliography: Hahner-Herzog, 1997, no. 73; Perrois, 1988a; Rubin, 1984; Siroto, 1954

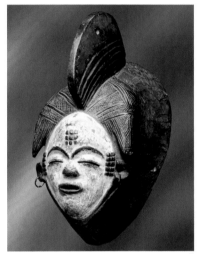

81
FACE MASK *OKUYI*
NGOUNIE RIVER, GABON
Wood, pigments, height 31 cm
Formerly collections of Stephen Chauvet,
Jean Roudillon, Camilla Pinto, and Carlo Monzino
Private collection

This mask with a small face encompassed by a broad border belongs to a group known as "the white masks of Ogowe." The majority of them come from the Punu and Lumbo, who live in southern Gabon west of the Ngounie River to the coast. This example, too, may originate from this area, although the treatment of the eyebrows and the mouth recalls masks of the Mitsogo, farther north. Characteristic of Punu and Lumbo masks are their coiffures, rich in variations but always tinted black. The elaborately-crested hairstyles in particular, derived from styles once worn by women in this area, and the narrow eye slits, have repeatedly prompted comparisons of these African works with Japanese *nô* masks. Besides the coiffure, the scale-like scarifications on forehead and temples, based on formerly common female scarifications, indicate the mask's genre, while the white kaolin finish of the face points to the representation of a deceased person. Depending on their design these masks, originally used during burials and known as *okuyi*, *mukuyi* or *mukudji*, are considered portraits of male or female ancestors. Nowadays the mask figures appear mostly for entertainment, sometimes on stilts up to two meters long, and emit shrill screams that send shivers down the onlookers' spines.

Bibliography: Bolz, 1966; Felix et al., 1995; Perrois, 1979, 1985; Vogel, 1986, p. 150

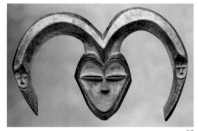

82
FACE MASK *EKUK*
KWELE, DEMOCRATIC REPUBLIC OF CONGO/GABON
Wood with white and black paint, height 42 cm
Formerly collection of Josef Mueller
Acquired from Mme. Charles Vignier before 1939;
collected by Aristide Courtois, a government official,
before 1930
Musée Barbier-Mueller, Geneva

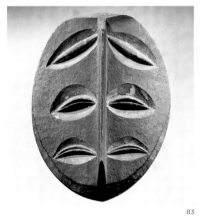

83
FACE MASK
KWELE, GABON/DEMOCRATIC REPUBLIC OF CONGO
Wood with dark paint finish, height 36 cm
Collected by Aristide Courtois
Formerly collections of Charles Ratton,
Madelaine Rousseau, and Charles Lapique
Private collection

The Kwele are known for several masks with long, more or less stylized elephant trunks that emerge from the forehead of a round or oval face and hang downwards parallel to it. The present, extremely stylized specimen may well belong to this type, since the protruding vertical ridge that symmetrically divides the face with its three pairs of eyes suggests a rudimentary trunk.

Like all Kwele mask types, their "trunk masks" were part of the *beete* (*bwete*) cult, which served principally to ward off sorcery or witchcraft. The masks embodied protective bush spirits. A few of them, especially the dark-colored zoomorphic masks, however, were intended to spread fear and trembling. One of these was the *gong*, a gorilla mask. Depictions of elephants, feared by the Kwele on account of their power and dangerousness, likewise seem to allude to a mighty and terrifying spirit of nature.

Bibliography: Bacquart, 1998, p. 123; Perrois, 2001; Siroto, 1972

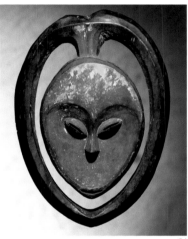

84
FACE MASK *EKUK*
KWELE, DEMOCRATIC REPUBLIC OF CONGO/GABON
Wood and pigments, height 55 cm
Formerly collections of Aristide Courtois
and Charles Ratton
Musée Dapper, Paris

The Kwele practiced a cult known as *beete* (*bwete*) to ward off the evil machinations of sorcerers, who were held responsible for illnesses, deaths and other inexplicable happenings. The rites were accompanied by various mask types with anthropomorphic or zoomorphic traits that represented benevolent bush spirits. A few of these were painted white to symbolize clairvoyance and circumspection, two essential factors in the fight against evil. Masks with heart-shaped faces and arching, occasionally angular, horns, belonged in this context (cat. 82). Although they were originally interpreted as representing rams, more recent research suggests that the masks' horns actually alluded to large antelopes or women's hairstyles with long braids of a kind popular in Gabon in the nineteenth century. Many of these masks have no eye openings, indicating that they were

not designed for wearing. They were hung on houses during ceremonies or initiations into the cult. Masks with eye apertures were performed by dancers clad in a voluminous costume of fibers.

Bibliography: Bolz, 1966; Falgayrettes-Leveau, 2000; Hahner-Herzog, 1997, no. 69; Perrois, 1985, 1988b, 2001; Roberts, 1995, p. 38

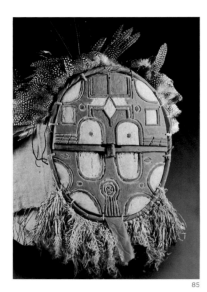

85

FACE MASK

WESTERN TEKE, REGION NORTH OF THE NIARI, REPUBLIC OF CONGO

Wood, feathers, down, plant fibers, paint, height 38 cm

Private collection

Unlike the carved figures of the Teke, their disk-shaped polychrome masks are relatively unfamiliar. Their geometric motifs, symmetrically arranged around a vertical axis, are found with slight variations on most of the known masks. They have a symbolic meaning that has yet to be precisely decoded, but that apparently relates above all to animals and heavenly phenomena.

The *kidimu* tradition died out in the early twentieth century and was not revived until the Congo gained its independence and masquerading for entertainment was established. In former times it was maintained by a hierarchically ordered masking society. The performances of ten or more dancers from various villages at the funerals of chiefs and other festive occasions served to confirm and perpetuate a society that was split into numerous small political units.

Bibliography: Dupré, 1968, 1979; Lehuard, 1977; Leuzinger, 1971

86

FACE MASK *NGOBUDI*

YOMBE, KASADI, DEMOCRATIC REPUBLIC OF CONGO

Wood (*Ricinodendron cfr. heudelotii*), pigments, animal skin, upholstery tacks, height 23 cm

Donation of R. F. L. Bittremieux, 1937

Royal Museum for Central Africa, Tervuren

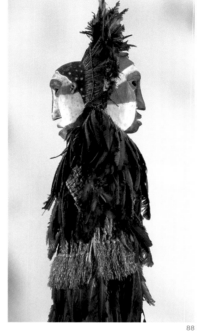

86

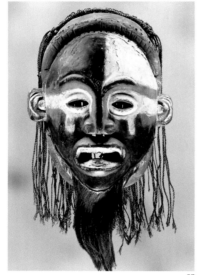

87

87

FACE MASK *NGOBUDI* (*KEEKO KLA BWELO*)

VILI, REPUBLIC OF CONGO

Wood with white, red and black paint, animal hair, raffia cord, lizard skin, height 28 cm (not including beard)

Acquired by Wilhelm Joest in 1887

Ethnologisches Museum, Berlin

In addition to various initiation societies that performed religious, social and political tasks, the soothsayers and priests (*nganga diphomba*) among the Vili and Yombe used masks to detect sorcerers and reveal the causes of misfortunes. The term *ngobudi*, generally applied to these masks, alludes to their terrifying nature. Beyond this, they had special names that referred to a force (*nkisi*) possessed by the mask and its owner, which could be controlled through ritual activities and turned to the welfare of the community.

The name *keeko kla bwelo* of the polychrome Vili mask, for instance, refers to a *nkisi* known as *bwelo,* a power that permitted it to look into the world beyond. This ability was likewise indicated by the color white, symbol of sacredness, transcendent powers, and the ancestors. Red signified danger, and black sorrow and misfortune.

In the largely white-painted, realistic Yombe mask, a *nkisi* whose name was associated with the concept of *mpemba* took effect, which was also associated with the color white. Both specimens have a beard, a symbol of dignity and the knowledge and experience of the *nganga* who used the mask.

Bibliography: Felix et al., 1995; Koloss, 1987; Lehuard, 1993; MacGaffey, 1995; Thomson, 1999

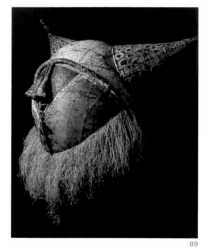

88

88

JANUS-HEADED HELMET MASK *NDUNGA*

VILI OR WOYO, DEMOCRATIC REPUBLIC OF CONGO

Wood, plant fibers, feathers and pigments, height 180 cm

Collected before 1891

Museu Etnográfico, Sociedade de Geografia, Lisbon

An ancient institution reponsible for social and political order has survived to this day among the Woyo, Vili, Solongo, Sundi and Kuni. Its mask figures, known as *ndunga,* still appear in voluminous costumes of dried banana leaves or feathers to ensure peace in the community, oversee public order, or practice ritual functions.

These large masks may have a single face or—like the present specimen—a double, Janus head, which may refer to their ability to see everything happening around them. Usually these masks are painted with large areas of several symbolic colors, a combination of black, white and red predominating. The arrangement of these colors and the paraphernalia carried by the mask figures during their performances indicate the tasks for which they are responsible.

Bibliography: Felix et al., 1995; Habi Buganza Mulinda, n.d., 1996; Lehuard, 1993; Nsondé, 2000; Volavka, 1976

89

HELMET MASK *M-BAWA*

YAKA, DEMOCRATIC REPUBLIC OF CONGO

Cane framework, woven bast, paints, metal, raffia fibers, width 146 cm

Musée Barbier-Mueller, Geneva

In the context of the circumcision and initiation rites (*n'khanda*) that every ten- to fifteen-year-old boy must pass through, the Yaka and Suku use a number of masks that either have carved components, consist entirely of wood, or are made of plant materials.

In fabricating the extremely large *m-bawa* masks, which are seldom found in Western collections, a nearly spherical cane framework is covered with woven raffia, fitted with carved or real animal horns, or—as in the present specimen—conical horns made of bast, and painted with patterns of various colors. The mask, associated with the fierce buffalo *m-pakasa* (*Syncerus caffer*), appears several times during the initiation period to frighten the women and children in the village. In addition, it is believed to be capable of making great leaps, preventing rain, and recognizing women's pregancy even before it becomes evident.

Bibliography: Biebuyck, 1985; Bourgeois, 1984, 1985, 1993; Hahner-Herzog, 1997, no. 79

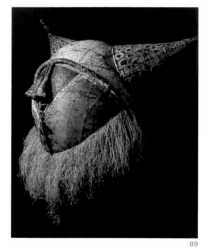

89

90

HELMET MASK

YAKA, DEMOCRATIC REPUBLIC OF CONGO

Wood, plant fibers, paints, height 49 cm

Willy and Marthe Mestach Collection, Brussels

Many Yaka and Suku masks used in the initiation of adolescent boys (*n'khanda*) combine human faces with animal traits. The nose of the *mweelu* mask, made of raffia fibers and calebashes, has the physiognomy of a hornbill; the huge *m-bawa* mask (cat. 89), likewise consisting of plant material, represents a buffalo and has animal horns. The carved masks with an anthropomorphic face are frequently surmounted by a superstructure that, besides human

figures, is adorned with various animals—mammals, amphibians or birds. Beyond this, there are masks with zoomorphic faces like the present piece, which presumably represents an owl. The meaning of these animal depictions has yet to be investigated in detail. Yet Bourgeois suspects that the Yaka, hunters who are familiar with the animal realm, employ these motifs to draw an analogy between human reactions and animal behavior. Masks in animal form stand at the lower end of the mask hierarchy and in performances usually appear after the anthropomorphic masks. Still, this sequence is not compulsory and may be reversed for dramaturgical reasons.

Bibliography: Biebuyck, 1985; Bourgeois, 1981, 1985, 1993; Herremann, 1993, p. 12; Neyt, 1981, pp. 107–17

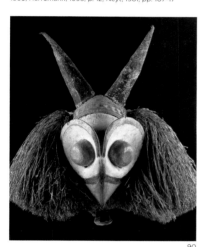

90

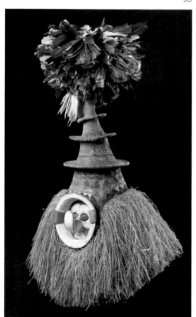

91

HELMET MASK *TSEKEDYE*
YAKA, DEMOCRATIC REPUBLIC OF CONGO

Wood (*Alstonia congensis*), plant fibers, feathers, paint, height 63 cm

Gift of Colonel E. Wangermée, 1933

Royal Museum for Central Africa, Tervuren

The masquerades of the Yaka and Suku occur in the context of circumcision and initiation rites (*n'khanda*) for adolescent

boys, to prepare them for their role as adult men and acquaint them with the values of their community. Especially towards the end of the initiation, various mask figures sequentially appear, which, depending on their type, are danced either by *n'khanda* supervisors or by the initiates themselves. Their dances invoke the presence of the ancestors, and the accompanying songs attest to the young men's newly acquired social status.

The present *tsekedye* mask belongs to a group of mask types that are made by a carver especially for the final ceremonies shortly before the end of the seclusion period, and afterwards are sold or destroyed. A typical trait of these usually anthropomorphic masks is the upward-turned nose, which has been interpreted as a phallic symbol. The design elements of the headdress, circular faces, and color scheme reflect cosmological notions of the Yaka and, at the same time, underscore the male-female antagonism. For instance, the front face of the present mask is thought to represent the moon, and the back face the sun. This combination alludes to the transition from the female sphere (moon) into the male world (sun), which is completed with the boys' initiation.

Bibliography: Biebuyck, 1985; Bourgeois, 1984, 1985, 1993; Devisch, 1995; Neyt, 1981, pp. 109–17

92

MASK *KAKUUNGU*
SUKU, DEMOCRATIC REPUBLIC OF CONGO

Wood (*Croton mayumbensis*), raffia fibers, pigments, height 60 cm

Donation of R. F. O. Butaye, collected in 1932 in Bimbau, Southern Bandundu region

Royal Museum for Central Africa, Tervuren

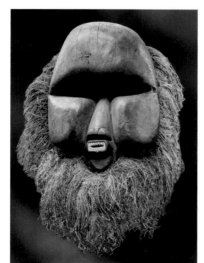

92

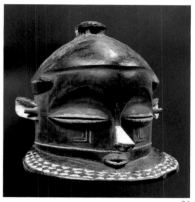

93

MASK *KAKUUNGU*
SUKU, DEMOCRATIC REPUBLIC OF CONGO

Wood, raffia fibers, pigments, height 75 cm (not including beard), 93 cm (overall)

Private collection

Among the Suku and Yaka, the imposing, carved *kakuungu* mask, along with the *m-bawa* mask (cat. 89), was considered one of the oldest and most venerable mask figures, whose power could be either benevolent or destructive. The frightening effect produced by the compact forms of the face and its imposing beard of attached raffia fibers reflect the tasks it performed during the initiation of adolescent boys (*n'khanda*). Reserved for the leader of the ritual, the mask appeared during its key phases—beginning of the seclusion period, circumcision, final leaving of the initiation camp—in order to protect initiates from harmful influences and stand by them in times of crisis, but also to instill obedience and respect in them for their elders. In addition, the mask appeared during this period in the village, as a terrifying figure that cowed the populace.

Bibliography: Biebuyck, 1985; Bourgeois, 1985, 1993, 1995; Neyt, 1981, p. 120; Petridis, 2000

94

HELMET MASK *KIPOKO*
NGOLONI OF KINDAMBA VILLAGE, EASTERN PENDE, DEMOCRATIC REPUBLIC OF CONGO

Wood (*Alstonia congensis*), pigments, height 28 cm

Royal Museum for Central Africa, Tervuren

Like the *panya ngombe* (cat. 95), the *kipoko* mask, symbolizing the power of the ancestors and embodying the ruler in its performances, belongs to the regalia of eastern Pende chiefs and is kept in their residence. *Kipoko* is considered a friendly mask figure who reflects the positive aspects of the chief. Design details illustrate his virtues and duties:

The enlarged ears, eyes and nose appeal to his watchfulness, ensuring that he knows everything that is happening in the village, while the small mouth suggests that the chief should choose his words carefully and deliberately.

Performances of the *kipoko* mask are linked with the agricultural cycle and promise the community protection, prosperity and well-being. In its dances, which are combined with pantomime scenes, it thanks the ancestors for their good deeds and entreats them to continue supporting the community.

Bibliography: Biebuyck, 1985; Neyt, 1981, pp. 131–50; Petridis, 1993a; Strother, 1993, 1995a

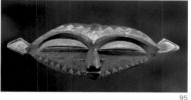

94

95

MASK *PANYA NGOMBE*
EASTERN PENDE, DEMOCRATIC REPUBLIC OF CONGO

19th/early 20th century

Wood, pigments, width 52.1 cm

The Detroit Institute of Arts; Founders Society Purchase, Eleanor Clay Ford Fund for African Art

Numerous mask types are found among the Pende. Stylistically, these can be associated with three geographic regions. In the Kasai region, inhabited by the eastern Pende, geometric and abstract mask forms tend to predominate, and are linked both with anthropomorphic and zoomorphic figures.

This broad mask, known as a *panya ngombe,* represents a buffalo, symbol of authority and dignity. Characteristic of this type are a horizontally oriented form, protruding ears, and an ornament consisting of a motif of relief triangles. With two further mask types, this one formerly belonged to the insignia of important chiefs (*mbuya jia ufumu*). Clad in a royal garment and holding a machete, the masked dancers appeared only during the *mukanda* initiation of adolescent boys after their circumcision, to gather donations to cover the cost of

the celebrations that took place after the initiation period. Since circumcision in the context of initiation was abandoned back in the 1930s, such masks have become quite rare. However, similar mask depictions are today still incorporated in the lintel of the door to the royal treasure house (*kibulu*) where royal masks and other regalia are kept.

Bibliography: Biebuyck, 1985; Kan/Sieber, 1995, pp. 144–145; Neyt, 1981, pp. 131–50; Petridis, 1993a; Phillips, 1995; Strother, 1993

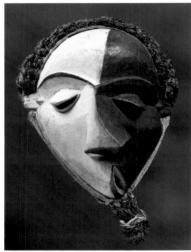

96

FOREHEAD MASK *MBANGU*

CENTRAL PENDE, DEMOCRATIC REPUBLIC OF CONGO

Wood (*Ricinodendron heudelotii*), plant fibers, pigments, height 27 cm

Royal Museum for Central Africa, Tervuren

The central Pende use a variety of carved wooden masks that represent different characters such as the chief, a bachelor, a clown, and a prostitute during the initiation of adolescent boys (*mukanda*). The *mbangu* mask represents a person who has been bewitched by a sorcerer and deformed by illness. The distorted facial features would seem to indicate a nervous disorder, the black and white painting suggests burns, and the holes in the lowered black eyelid apparently evoke pock marks.

The Pende believe that illness and misfortune can be traced to sorcerers who shoot their curses like invisible arrows at their victims. In keeping with this notion, during performances the mask figure wears a costume with a hunchback with an arrow sticking in it. In addition, he either leans on a cane to demonstrate his frailty, or carries a bow and arrows with which he symbolically threatens the evildoer who is responsible for his suffering.

Bibliography: Biebuyck, 1985; Neyt, 1981, pp. 131–50; Petridis, 1993a; Strother, 1995b

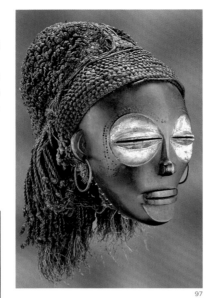

97

FOREHEAD MASK *PWO*

CHOKWE, MUZAMBA REGION, ANGOLA/DEMOCRATIC REPUBLIC OF CONGO

Early 20th century

Wood (*Alstonia*), plant fibers, metal, kaolin, colored pigments, height 39 cm

The National Museum of African Art, Washington, D.C.

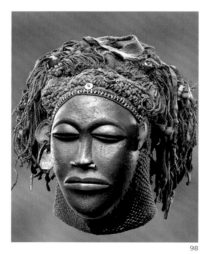

98

FOREHEAD MASK *PWO*

CHOKWE, DEMOCRATIC REPUBLIC OF CONGO

Wood (*Vitex madiensis, var. Milanjiensis*), plant fibers, metal, animal and vegetable materials, color pigments, height 21 cm

Acquired 1933–42 in Mwakahila, Kasai region, by Dr. T. Fourche

Royal Museum for Central Africa, Tervuren

99

FOREHEAD MASK *PWO*

LUCHAZI, KATUVA REGION, ZAMBIA

Wood, plant fibers, glass beads, height 17 cm

Felix collection

The Chokwe and their neighbors, including the Luchazi in Sambia, possess over one hundred different mask figures (*makishi*), which are viewed as manifestations of ancestor spirits (*afu*). They appear in the context of the initiation

(*mukanda*) in which all eight- to twelve-year-old boys spend months in camp outside the village being prepared for entry into adulthood. The masks serve to teach the initiates, protect them from evil spirits, and keep women and non-initiates away from the camp.

With their appealing features, delicate face tatooes, ear adornments and elaborate coiffure of plant fibers, based on women's hairstyles, the *pwo* masks embody an ideal of female beauty. In this mask type the Chokwe honor the social significance of women—for whom the mask is named—as nourishers and mothers. This is reflected in the performances of the male maskers, who wear a plant-fiber costume and occasionally breasts carved of wood. Their slow, precise dance steps are intended to lend the figure feminine charm, or in other dances suggestive of sexual behavior, to invoke female fertility. Frequently the dancers carry typical female requisites such as fans, fish baskets or mortars and incorporate these in their performance.

Bibliography: Bastin, 1984, 1993; Felix/Jordán, 1998, pp. 67–83, no. 66; Kubik, 1995c, 1996; Neyt, 1981, pp. 219–31; Nicholls, 1999

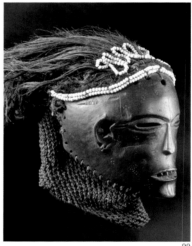

99

100

FACE MASK *CHIHONGO*

CHOKWE, ANGOLA/DEMOCRATIC REPUBLIC OF CONGO

Wood, height 20.3 cm

Private collection

Like all Chokwe mask characters, the *chihongo*, already described and drawn in the nineteenth century by the Africa travellers V. L. Cameron, and H. Capello and R. Ivens, embodies the spirit of a deceased person. It stands for prosperity and male power, forming a complementary figure to the *pwo* mask with its embodiment of female traits and beauty. Many Chokwe groups emphasize the royal qualities of this mask, which formerly was permitted to be danced and kept only by a chief or his sons. Stylistic details underscore this interpre-

tation: The narrow band with a triangular motif running over the forehead from ear to ear recalls a metal diadem (*cipenya mutwe*) reserved for high-ranking women and men, an elaborate form of which was worn by chiefs on festive occasions. In addition, for its performances the *chihongo* mask was adorned with a great feather crown like the headdress worn by chiefs and kings.

Appearing during male adolescents' initiation or at other important events, the mask was supplemented by a net costume with a white hooped skirt made of thick layers of *makintu* grass. Other of the figure's accessories included a broad axe or a bell.

Bibliography: Bastin, 1982; Felix/Jordán, 1998; Jordán, 1998, pp. 67–83, cat. 66; Kubik, 1995a, 1995b; Neyt, 1981, pp. 219–31

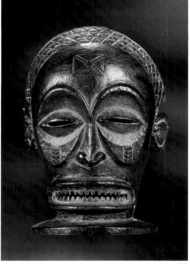

100

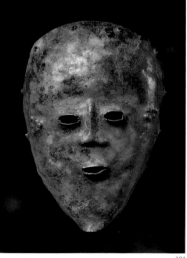

101

101

FACE MASK *NGONGO MUNENE*

KONGO-DINGA, DEMOCRATIC REPUBLIC OF CONGO/ANGOLA

Copper, height 26.4 cm

Collection of Georg Baselitz

The use of copper and other metals in the fabrication of masks is found among many peoples in western Congo and Angola. Metal applications adorn carved masks of the Kuba and Salampasu, and

the Lwalu are known to cover wooden masks entirely with sheet metal. Extremely rare, however, are the solid copper anthropomorphic masks of the Kongo-Dinga, which began to be recorded only in the 1950s. These were made by specialist craftsmen of hammered sheet metal, some of which may have derived from armlets and anklets or from imported copper crucifixes, which served as currency. Ceyssens suspects that originally a round copper breast adornment known as an *ekalanga,* reserved for chiefs and their wives, was melted down for use in masks. The Dinga associate these highly polished masks, like the breast disks themselves, with the sun. However, little is known about their use. They are said to have appeared or been performed in connection with the death or enthronment of high dignitaries, or when the community was under threat. Otherwise they were stored along with the mask costume in a basket. The responsibility for the masks lay with a secret society known, like the masks themselves, as *ngongo munene.* Beyond this, each mask had its own special name, which symbolically referred to the power of the chief.

Bibliography: Biebuyck, 1999; Ceyssens, 1993; Jordàn, 2003; Neyt, 1981, pp. 201-07

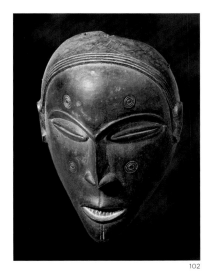

102
FACE MASK
OVIMBUNDU OR CHOKWE, ANGOLA

Early 20th century

Wood, colored pigments, height 21 cm

Formerly collection of Shesca Kotchouko, Hamburg

Collection of Arman

The art of the Ovimbundu, a people of numerous groups and chiefdoms who inhabit central Angola, comprises sculptures, staffs with figurative depictions, and masks that are viewed as embodiments of ancestors and were once indispensable features of boys' initiations (*oku lisevisa evamba*). Stylistically, these works exhibit great similarities with those of the Chokwe and other neighboring peoples.

The problem of attribution arises in the case of the present, artfully made mask as well, with its carved cord headband, open mouth with teeth, and round facial scarifications. On the one hand, its facial features correspond to the formal approach seen in Ovimbundu figures. On the other, it appears beholding to the stylistic canon of carved Chokwe masks, especially the *pwo,* which reflect an ideal of feminine beauty.

Bibliography: Felix/Jordán, 1998; Jordán, 1998; Nicolas, 1997

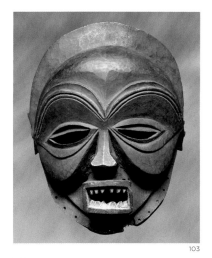

103
FACE MASK *SACHIHONGO*
MBUNDA, ZAMBIA

Wood, height 43 cm

Private collection

Like many peoples inhabiting Angola and Zambia, the Mbunda have numerous mask types that embody ancestor spirits. Most of them consist of impermanent materials. Only for the mask figure of *sachihongo* is a face carved in wood. Characterized by deeply incised forehead wrinkles and prominent cheeks, the figure represents a hunter with bow and arrow —or, according to other interpretations, a chief or soothsayer. For its performance the mask is adorned with feathers and a beard of plant fibers, which are attached to the carved crown and knotted to the mask's lower edge. A net costume, several shirts made of grass and palm leaves, and an axe and rattles round off the *sachihongo* costume.

This very expressive specimen has been identified as a work of the "old" Mbunda, whose first wave of migration in the early nineteenth century took them from their settlement area in Angola into Zambia, where they settled among the Rozi. In the course of their migration this Mbunda group abandoned the use of masks during boys' initiations (*mukanda*), but they are still found today in other Mbunda areas. Among the "old" Mbunda, such mask figures now appear only for entertainment or in honor of important guests.

Bibliography: Bassani, 2003; Felix/Jordán, 1998; Vogel, 1986, p. 135; Vrydagh, 1993

104
HELMET MASK *MUKYEEM*
KUBA, DEMOCRATIC REPUBLIC OF CONGO

Woven cane, leather, raffia cloth, vegetable fibres, cowrie shells, glass beads, height 51 cm

Völkerkundemuseum, University of Zurich

The *mukyeem* or *mukenga* mask which consists of a cane frame covered with leopard skin and cloth, is a variation of the *mmwaash amboy* type—the most important of the Kuba trinity of royal masks. It is, however, not found in the surroundings of the royal court but among one of the large ethnic groups such as the Ngeende, Keete or Shoowa, which belong to the Kuba confederation, dominated by the Bushong. In these groups, the mask, which is always borne by a notability, appears during the funeral rites of high dignitaries. This function is reflected in the white ornamentation made of uniform cowrie shells; white being the colour of mourning and also reminding one of the bleached bones of the ancestors. A characteristic element of *mukyeem* masks is the stylised elephant trunk, flanked by two small stylised tusks, protruding from the vertex and bending in the direction of the flat face. During performances, the end of the trunk is decorated with the red tail-feathers of the African grey parrot which were reserved for the ruling classes.

Bibliography: Cornet 1993; Neyt 1981, pp. 159-161; Szalay 1995, p. 178 ff.

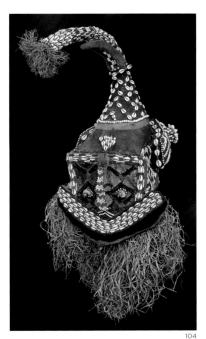

105
FACE MASK *NGAADY A MWAASH*
KUBA, DEMOCRATIC REPUBLIC OF CONGO

Wood, polychrome painting, raffia cloth, cowrie shells, glass beads, height 42 cm

Collected between 1935 and 1938

Collection of Rolf and Christina Miehler

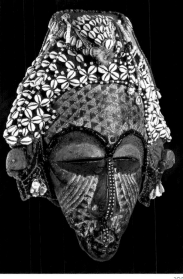

Among the more than twenty individual mask styles of the Kuba, three, connected with the royal family, take a particularly outstanding position. In this trinity of royal masks—which also includes *bwoom* (cat. 106)—the *ngaady a mwaash* mask represents Mweel, the sister and wife of Woot, the progenitor of the dominant Bushong group who is, in turn, represented by the *mwaash amboy* mask. Their appearance during initiation ceremonies or celebrations in honour of the king, bring back memories of the primeval myths of the Kuba and historical events. In this delicately-formed mask, the hood of raffia material is covered by an unusually dense ornamentation of cowrie shells. The facial ornaments are consistent with the stylistic canon of this type of mask: The forehead is covered with a triangular pattern, supposedly modelled on the scales of the pangolin, and the parallel lines under the eyes represent tears. As with most royal masks, the nose and mouth are hidden behind a cloth decorated with beads.

Bibliography: Cornet 1993; Hahner-Herzog 1997, no. 82; Neyt 1981, pp. 159-161; Roberts 1995, p. 85; Szalay 1995, p. 178

106
HELMET MASK *BWOOM*
KUBA, DEMOCRATIC REPUBLIC OF CONGO

Wood, metal, beads and colour pigments, height 32 cm

Musée Dapper, Paris

This *bwoom* mask, which is sparsely decorated with beads and metal, belongs to the trinity of the royal masks of the Kuba. It is thought that this type originated with the Cwa pygmies and was introduced by King Miko mi-Mbul in the seventeenth century. Based on this tradition, the mask is interpreted as a representation of a pygmy as indicated by the pronounced arch of the forehead. According to another interpretation, a

prince with water on the brain could have served as the model.

Depending on the occasion and context, *bwoom* can represent various characters. During the initiation of the young boys he is identified as the nature spirit *Ngeesh*. Within the framework of celebrations at the royal court, where the founding myth of the Kuba is presented through the three royal masks, he appears as the opponent of his brother Woot, the progenitor of the Kuba. The battle for power is, at the same time, a fight for the favours of Mweel, the wife and sister of Woot, represented by the *ngaady a mwash* mask (cat. 105). The rebellious character of the *bwoom* mask is reflected in the wearer's proud and aggressive dancing style.

Bibliography: Cornet 1993; Hahner-Herzog 1997, no. 83; Petridis 2000; Neyt 1981, pp. 159–163: Stepan 2001, p. 30

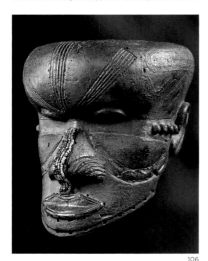

106

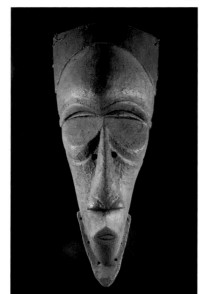

107

107
FOREHEAD MASK *NYIBITA*
NGEENDE, DEMOCRATIC REPUBLIC OF CONGO

Wood, plant fibers, height 63 cm

Willy and Marthe Mestach Collection, Brussels

One of the nineteen ethnic groups who belong to the confederation of the Kuba Kingdom, the Ngeende have developed a remarkable and diverse masking tradition. The most widespread mask types, besides the three royal masks of the ruling Bushong, include numerous local variations and creations that usually differ from the courtly masks in terms of a simpler, less adorned and at the same time more highly stylized design. This formal reduction can be observed especially in the extravagant *nyibita* or *nyimbiti* masks, which are characterized by an extremely elongated face tapering towards the chin. The eyes, as in the *bwoom* mask, are not perforated, indicating that the mask was worn on the forehead. Although information regarding this type of mask is sparing, we can gather that it was performed at the royal court on ceremonial occasions in honor of the mythical ancestors and, as part of a mask group representing various figures, embodied a young warrior chieftain.

Bibliography: Cornet, 1993; Herremann, 1993, p. 140; Maurer, 1991

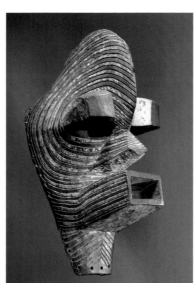

108

108
FACE MASK *KIFWEBE*
SONGYE, DEMOCRATIC REPUBLIC OF CONGO

Wood, pigments, height 63 cm

Private collection

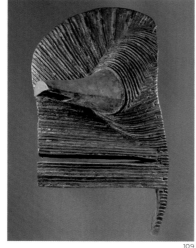

109

109
FACE MASK *KIFWEBE*
SONGYE, DEMOCRATIC REPUBLIC OF CONGO

Wood, pigments, height 75 cm

Willy and Marthe Mestach Collection, Brussels

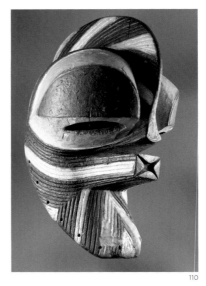

110

110
FACE MASK *KIFWEBE*
SONGYE, DEMOCRATIC REPUBLIC OF CONGO

Wood, pigments, height 50 cm

Willy and Marthe Mestach Collection, Brussels

In addition to their anthropomorphic sculptures, the Songye are famous for their expressive *kifwebe* masks, which are characterized by a design based on cubic forms and a channeled surface. The examples shown here attest to the carvers' creativity in translating symbolic content into compositions that occasionally approach the bizarre. This holds especially for the masks that are viewed as male, and are distinguished from female masks by a marked sagittal comb.

The separate facial parts of the mask and its channeled decor have been associated with various dangerous and feared wild animals, such as crocodiles, lions, zebras, antelope and porcupine, whose behavior is imitated during the mask's performance. The various colors are likewise associated with different qualities: White stands for positive traits such as purity and peace, black symbolizes darkness and evil magic, and red may stand either for courage and stamina or blood and danger. Moreover, their color schemes provide indications of the masks' origin. Broad painted bands emphasizing the geometric structure of a mask point to the Songye region east of the Lomami River, whereas the *kifwebe* masks of the western Songye area are characterized by narrow painted lines.

Not only among the Songye but among the neighboring Luba, the *kifwebe* masking tradition was originally a power instrument used by a men's association of that name, whose members were respected and feared for the magic practices they employed. They used the masks on various ritual occasions such as the death or investiture of a chief, in initiation and new moon rites, but also to maintain law and order and, in case of war, to encourge their own warriors and intimidate the enemy. Nowadays the maskers perform primarily for entertainment.

Bibliography: Hersak, 1986, 1993; Maurer, 1991, p. 121; Merriam, 1978; Mestach, 1985; Neyt, 1981, pp. 246–50

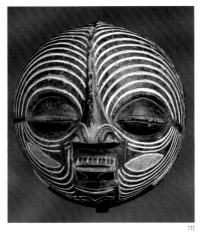

111

111
FACE MASK *KIFWEBE*
LUBA, DEMOCRATIC REPUBLIC OF CONGO

Wood, raffia fibers, bark, pigments, cord, height 92 cm

Seattle Art Museum; Gift of Katherine White and Boeing Company

Like the Songye, the Luba were familiar with the *kifwebe* masquerade tradition, which presumably originated in the border area between the two ethnic groups. Most Luba masks, with their elongated form and lacking the prominent comb running over the center of the head, bear similarities with the female-connoted Songye pieces. Comparatively rare, on the other hand, are round *kifwebe* masks, whose shape was evidently associated with the moon to which special rites were devoted. The color scheme of these grooved masks is dominated by white and black, the former recalling the realm of the ancestors and the latter covert, negative aspects. Among the Luba, these masks appeared as a male-female pair at the death or investiture of a chief or dignitaries. In addition, the meaning of the term *kifwebe*—"driving away death"—suggests a connection with the Luba *kanzanzi* secret society, which was responsible for warding off sorcery and harmful influences.

Bibliography: Hersak, 1986; Neyt, 1981, pp. 246–50, 1993, 1994; Nooter-Roberts/Roberts, 1996; Roberts, 1995a

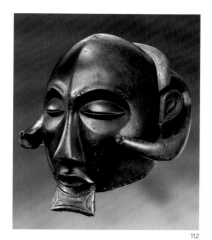

112

FACE MASK

LUBA, DEMOCRATIC REPUBLIC
OF CONGO

Wood (*Ricinodendron rautanenii*), height 39 cm

Collected in 1899 by Comm. O. Michaux in Tabora, Tanzania

Royal Museum for Central Africa, Tervuren

The origin, meaning and function of this unique anthromorphic mask, acquired at the end of the nineteenth century and attributed for stylistic reasons to the Luba, have not been determined. The form of the face recalls circular, grooved *kifwebe* masks, which suggests a lunar symbolism.

Unusual, however, is the combination of a human face with two downswept horns. These have been interpreted as reflecting the traditional hairstyle of Luba chiefs and their wives, yet they are also reminiscent of ram or buffalo depictions. These two animals are associated with Mbidi Kiluwe, a Luba culture hero and founder of the sacred kingdom, who is also figuratively known as "Black Buffalo." A small bird figure, originally mounted on the rear of the mask but now broken off, likewise points to this legendary figure. This feature may possibly have been intended to allude to a drongo (*Dicrurus adsimilis*), a bird whose deep black plumage is apparently likewise linked with Mbidi Kiluwe. This has led Roberts to conclude that the mask was apparently fabricated in honor of this mythical founder of the Luba nation.

Bibliography: Maes, 1924; Neyt, 1994; Nooter-Roberts/Roberts, 1996; Petridis, 2000; Roberts, 1996

113

FACE MASK *MWISI GWA SO'O*

HEMBA, DEMOCRATIC REPUBLIC
OF CONGO

Wood, dark patina, height 23 cm

Former L. Shone-Emoff Collection

Felix Collection

With the exception of the rare human masks which radiate gentleness and dignity, the Hemba have a familiar, zoomorphic—sometimes bizarre—mask type which was referred to as *soko-mutu*, in previous publications. Its actual Hemba name *mwisi gwa so'o* makes a connection with the humanlike chimpanzee spirit, depicted by the mask and whose traits are reflected in its decoration. The arched eyelids with the narrow eye-slits and, above all, the broadly stretched mouth, which is sometimes placed within a snout-like protruding mouth section and which, to the naïve viewer, appears to be grinning, are particular characteristics. However, for the Hemba, this mask is a memento mori: The seemingly grinning mouth foreshadows wrath and disaster and reminds of the inevitability of death. The masked dancer conjures up the chaotic, terrifying hereafter when he appears at funeral ceremonies and commemorations dressed in animal skins and bark, decorated with the black and white hair of the colobus monkey, and performs his wild, unbridled dances, causing the people to flee in horror.

Bibliography: Blakely 1987; Felix 1997, no. 63; Hahner-Herzog 1997, no. 92; Neyt 1981, pp. 280, 282, 1993; Roberts 1995, p. 141

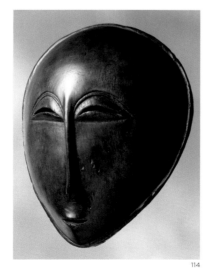

113

114

FACE MASK

HEMBA, DEMOCRATIC REPUBLIC
OF CONGO

Wood, height 34 cm

Willy and Marthe Mestach Collection, Brussels

This graceful piece is one of the few anthropomorphic masks associated with the Hemba in the eastern Congo. A few of these masks, about whose function nothing is known, come from the Niembo, a southern Hemba group. Stylistically, they exhibit similarities with the facial features of the dignified ancestor figures for which the Hemba are renowned. On the other hand, we find clear affinities with the better-known *so'o* masks of the Hemba, in which human features are combined with a snoutlike mouth reminiscent of a chimpanzee (cat. 113).

Bibliography: Maurer, 1991, p. 102; Neyt, 1981, pp. 278–82, 1993

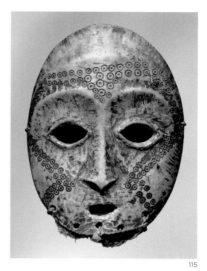

115

MASK *LUKUNGU*

LEGA, DEMOCRATIC REPUBLIC
OF CONGO

Ivory, raffia fibers, height 14 cm

Formerly collections of Jacob Epstein and
Carlo Monzino

Private collection

Masks carved of ivory, bone or copal, sometimes with a beard of raffia fibers attached to the chin, are part of the paraphernalia of the hierarchically ordered *bwami* association. This group oversees the religious and social life of the Lega and is open to women as well as men. Apart from *lukungu* masks, members of the *bwami* use four further mask types of different size, design and material in their imitation and advancement rites. The masks are viewed as emblems of certain ranks, but also as visible signs of the link between the ancestors and the living, and change hands as soon as an initiate advances in the hierarchy or passes away.

The smallest mask type, represented by the present old piece with its rich circle decor, belongs to members of the the association's highest rank, *kindi,* who have reached the utmost of moral integrity and virtue. During the days-long initiation rites, the masks are not worn but hung on fences. They form the focus of songs and dances that convey philosophical, ethical and social values, such as wisdom, beauty, harmony, fame, fortitude and prosperity.

Bibliography: Biebuyck, 1973, 1986, 1993; Petridis, 2000; Vogel, 1986, p. 183

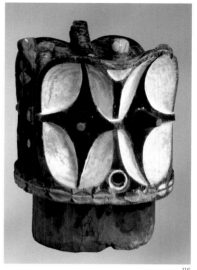

116

DOUBLE-FACED HELMET MASK *ALUNGA*

BEMBE, DEMOCRATIC REPUBLIC
OF CONGO

Wood, painted, height 48 cm

Collection of Waltraud and Udo Horstmann

The *alunga* mask belongs to the paraphernalia of an eponymous Bembe association whose power is much feared by non-initiates. With its large white eye sockets and black lozenge- or cross-shaped eyes, the mask recalls an owl, a bird with which the mask dancers in fact occasionally identify. The Bembe themselves, however, usually describe it as a mysterious being or a dangerous bush spirit. This non-human, frightening aspect is underscored by the appearance of the masked dancer, who is concealed in a voluminous fiber costume of several layers, his carved helmet adorned with a headdress of long feathers and porcupine quills. During performances in the context of initiation and hunting rites, for entertainment, or to oversee the social order, the masked dancer, a high-ranking and experienced member of the association, dances and sings in a disguised, harsh voice that conceals his identity and send shivers through the audience.

Bibliography: Biebuyck, 1972, 1993; Neyt, 1981, pp. 307–16; Strother, 2002

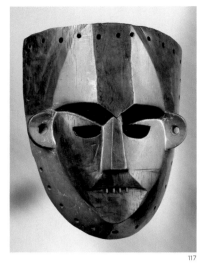

117
FACE MASK
BOA, DEMOCRATIC REPUBLIC
OF CONGO

Wood, pigments, height 25 cm

Willy and Marthe Mestach Collection, Brussels

The Boa live in the Aruwimi River region
in northeastern Congo. Only about
twenty of their masks have entered
Western collections since the end of the
nineteenth century. Their unmistakable
features include a geometric, black and
white painted design, large, round,
pierced ears, and narrow wooden teeth
inserted in an open mouth. Many of the
masks have an oval face. In the present
example, the forehead terminates in a
nearly straight line. The rows of holes
along the edges were probably intended
for the attachment of plant fibers.
Only sparing information about these
masks' use is available. Evidently they
belonged to warriors associations or
secret societies and were used in the
context of war dances. Their power was
thought to make men invincible and
weaken the enemy. Apparently this
masquerade tradition died out in the
early twentieth century, when the Boa
were defeated by troops of the Congo
Free State, revealing that the masks had
evidently lost their effectiveness.

Bibliography: Burssens, 1993, 1995; Maurer, 1991, p. 113

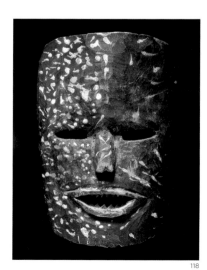

118
FACE MASK
BIRA/LESE/KOMO?, ITURI REGION,
DEMOCRATIC REPUBLIC OF CONGO

Wood, pigments, height 22.4 cm

Private collection

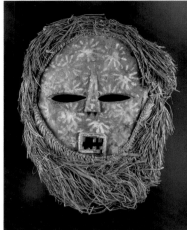

119
FACE MASK
NDAAKA/BEKE, ITURI REGION,
DEMOCRATIC REPUBLIC OF CONGO

Wood, raffia fibers, pigments, height 21 cm

Felix Collection

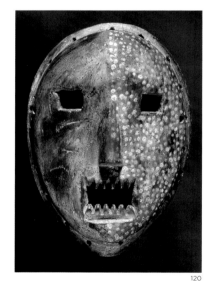

120
FACE MASK
LESE / BIRA?, ITURI REGION,
DEMOCRATIC REPUBLIC OF CONGO

Wood, pigments, height 24 cm

Private collection

The masking traditions of the numerous
small ethnic groups in the rain forest
region of northeastern Congo have yet
to be investigated in detail. Apparently
masks were used in this region princi-
pally in connection with initiation and
circumcision rites, either by the initiates
themselves or by the head of the group.
Most of the known examples are plain
face masks that combine human with
animal features and are generally painted
in white, red, black and ocher. Masks
with a dot pattern, and those with orna-

ments recalling stars or footprints, may
be read as depictions of leopards, which
are associated with leadership and author-
ity. On the other hand, such decor is
reminiscent of the patterns of the bark
textiles and face painting of the Pygmies,
the ethnic group that originally inhabited
this region. The marked horizontal division
of some masks (cat. 118, 119), as Petridis
points out, might refer to the gap
between initiates and non-initiates.
Leopard masks are found especially
among the Bodo and Ndaaka, but also
among the neighboring Lese and Bira.
Their ovoid shape, however, points to
the Komo farther south, whose masks
frequently have a rectangular mouth with
pointed teeth—if in a face that tends
more to angularity.

Bibliography: Felix, 1993, 1997, no. 92; Petridis, 1993b,
1993c; Schädler, 1992, pp. 220-24

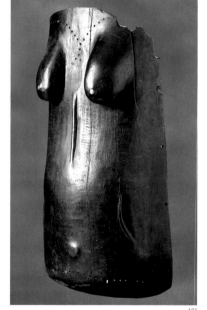

121
BODY MASK *NJOROWE*
MAKONDE, TANZANIA

Late 19th century

Wood, height 61.2 cm

Private collection, London

Among the Makonde in southern Tanzania,
masquerading is linked with the initiation
of adolescent boys and girls, to prepare
them for their future roles as husbands
and wives. In the maskerades held at the
end of the isolation period, the actors
dance and pantomime relations between
the sexes or embody various characters,
each topic being represented by a par-
ticular mask type.
In earlier periods, a body plate (*njorowe*)
with breasts, protruding navel, typical
scarifications, and a bulging belly repre-
sented a young, pregnant woman (*amwali
ndembo*). It was part of the costume of
a male dancer whose face was concealed
behind a female mask. In his performance
together with a male mask figure, he

moved sluggishly, mimed sexual inter-
course with his partner, and demonstrated
the burdens of pregnancy and giving
birth. These evocative performances can
still be observed among the Makonde
today, although the use of body masks
has since declined.

Bibliography: Blesse, 1994; Castelli, 2001; Kingdon, 1995a

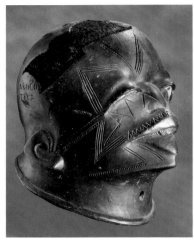

122
HELMET MASK *LIPIKO*
MAKONDE, TANZANIA/MOZAMBIQUE

Wood, skin, height 26.7 cm

Arman Collection

This type of helmet mask, called *lipiko*
or—in reference to the dance—*mapiko*
plays, in particular, a role during the
initiation ceremonies of the Makonde in
Mozambique whereas the Tanzanian
Makonde groups originally only used
face masks on similar occasions.
The realistic, but standardized, features
primarily in the formation of the eyes,
mouth and nose are typical of these
masks. In this finely-worked specimen,
the elaborately carved decoration is
indicative of the formerly-practiced scar
tattoos of the Makonde, which, on other
masks, are represented by raised, bands
of beeswax. The asymmetric hairstyle,
made out of an appliquéd piece of skin,
is similar to one of the numerous hair-
styles worn by boys at the end of the
initiation period.
In earlier times, each Makonde village
possessed three or four *lipiko* masks,
which the carver created at a secret
place in the bush, where they were also
stored after use before being destroyed
after a few years. This fact may be re-
sponsible for the first pieces not being
collected until the 1920s and 30s.

Lit.: Blesse 1994; Kan/Sieber 1995, no.85; Verswijver 1997

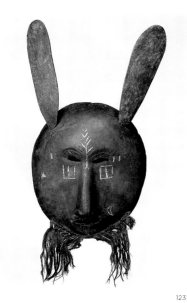

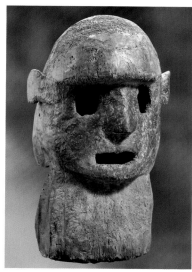

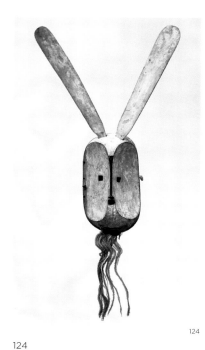

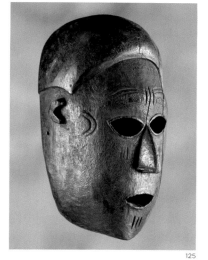

tales. In certain respects, the hare has a similarity to Reynard the fox. At the same time, the Makonde create a connection between the animal masks and Nandenga, a sinister spirit, represented during initiation ceremonies by dancers on stilts. It is possible that this has led to the denomination of "devil mask" or *sheitani* (derived from the Arabic, is the Kiswahili word for devil) used by earlier researchers for this type although there are neither Christian nor Islamic ideas underlying this.

Bibliography: Blesse 1994, Kingdon 1995c; Stepan 2001, p. 52

123

FACE MASK *NDIMU*

MAKONDE, TANZANIA

Early 20th century

Blackened wood, tin, vegetable fibres, height 71.5 cm

Linden Museum, Stuttgart

125

FACE MASK

LUNGU (RUNGU) ZAMBIA OR TANZANIA

Wood, height 32 cm

Felix collection

This thin-walled mask, which is covered with a patina from use, was purchased in 1983 in a fishing village inhabited by the Tabwa. At that time, reliable sources placed its origins with the Fipa, however, in recent publications, it has been attributed to the Lungu or Rungu. Similar to the Fipa, these groups also had close economic contacts to the Tabwa. In the same manner, both the Fipa and Lungu maintain a common descent from the Tabwa. The close intertwining of these ethnic groups is mirrored in the artistic work of this region—the southern end of Lake Tanganyika. With its eyes framed with delicate lines and open, toothless mouth, this mask reminds one of the work of the Tabwa.

We have only limited information on the mask's function. As a female mask, it is assumed that it was worn, along with its male counterpart, by members of the association at festivals celebrating the birth of twins or during fertility rites.

Bibliography: Felix 1997, p. 111, no. 72; Kingdon 1995d; Maurer/Roberts 1985, pp. 160–166, p. 251; Meur 1994; Roberts 1994

126

HELMET MASK

KWERE, TANZANIA

Early 20th century

Wood, height 50.5 cm

Private collection

Although many and diverse masking traditions have been recorded among the Makonde, only a few masks have been observed among other Tanzanian groups, and information about their dissemination, fabrication and use is sparing. Besides a few leather masks, these are principally works made of wood, usually depicting a male face. Occasionally representations of female faces or animals can also be identified. With the Kwere, makers of this striking anthropomorphic mask with its elongated neck, as with other Tanzanian peoples, masks belonged to secret societies in the pre-colonial period. The activities of these societies were suppressed by the German, and later, British colonial authorities, as well as by missionaries, and they apparently ceased to exist after the First World War. Based on the sparing information available, the societies were hierarchically ordered and performed special ceremonies when members advanced to a higher rank. Other occasions for a maskerade were initiation rites and the burial of society members. Beyond this, there are indications that masks (*piko*) were formerly used in connection with the initiation of adolescent boys and girls.

Bibliography: Felix, 1990; Kingdon, 1995b; Meur, 1994

124

FACE MASK *NDIMU*

MAKONDE, TANZANIA

Early 20th century

Wood, white colour, vegetable fibres, height 47 cm

Museum for Ethnology, Leipzig

Along with human masks, the Makonde also use animal masks during their ritual dances which are performed at the conclusion of the initiations of the boys and girls. This type combines anthropomorphic and zoomorphic elements: The face usually shows human features whereas the animal character is accented by long sticks, thought to represent antelope horns, or—as in these two pieces—through lengthened, paddle-like ears indicating the representation of a hare. These animals play an important role in the Makonde's myths and fairy

BIBLIOGRAPHY

ABIODUN, ROWLAND, HENRY JOHN DREWAL AND JOHN PEMBERTON II
1991 *Yoruba. Kunst und Ästhetik in Nigeria*, edited by Lorenz Homberger, Museum Rietberg, Zurich, Center for African Art, New York

ADAMS, MONNI
1987 "Problèmes d'identité: fêtes masquées chez les Wè (Guéré) de l'ouest ivoirien," in *Arts d'Afrique Noire 62*, pp. 37–48
1995 "Many eyed-mask," in Tom Phillips (ed.), *Africa. The Art of a Continent*, Munich/New York, p. 405

ANDERSON, MARTHA
1997 "Le Delta," in Martin, Jean Hubert et al. (ed.), *Arts du Nigeria*, Collections du Musée des Arts d'Afrique et d'Océanie, Paris, pp. 119–42

BACQUART, JEAN-BAPTISTE
1998 *The Tribal Arts of Africa*, New York

BARLEY, N1IGEL
1995 "Sculpture in the Form of a Stylised Serpent (bansonyi)," in Tom Philips (ed.), *Africa: The Art of a Continent*, Munich/New York, p. 476

BASSANI, EZIO, MICHAEL BOCKEMÜHL AND PATRICK MCNAUGHTON
2002 *The Power of Forms. African Art form the Horstmann Collection*, Milan
2003 *Africa. Capolavori da and continente*, exhib. cat. Galleria d'Arte Moderna, Florence

BASTIN, MARIE-LOUISE
1982 *La Sculpture Tshokwe*, Meudon
1984 "Ritual Masks of the Chokwe," in *African Arts* 17, pp. 40–45, 92–93, 95
1993 "The Akishi Spirits of the Chokwe," in Frank Herreman and Constantijn Petridis (eds.), *Face of the Spirits. Masks from the Zaire Basin,* Ethnographic Museum, Antwerp, pp. 79–95

BEN-AMOS, PAULA
1988 "Anhänger in Maskenform," in Werner Schmalenbach (ed.), *Afrikanische Kunst aus der Sammlung Barbier-Mueller, Genf*, Munich, p. 141

BERNS, MARLA
1997 "Mama (Kantana). Masque cimier," in *Arts du Nigéria*, Collections du Musée des Arts d'Afrique et d'Océanie, Paris, pp. 232–33

BERNS, MARLA, AND RICHARD FARDON
1997 "Le Plateau, le bassin supérieure de la Bénoué et les hautes terres," in *Arts du Nigéria*, Collections du Musée des Arts d'Afrique et d'Océanie, Paris, pp. 218–28

BIEBUYCK, DANIEL B.
1973 *Lega Culture*, Berkeley/Los Angeles
1985 *The Arts of Zaire,* vol. I: South Western Zaire, Berkeley/Los Angeles/London
1986 *The Arts of Zaire,* vol. II: Eastern Zaire, Berkeley/Los Angeles/London
1993 "Masks and Initiation among the Lega Cluster of Peoples," in Frank Herreman and Constantijn Petridis (eds.), *Face of the Spirits. Masks from the Zaire Basin*, Ethnographic Museum, Antwerp, pp. 183–96
1999 "Gesichtsmaske ngongo munene," in Koloss, Hans-Joachim (ed.), *Africa: Art and Culture. Ethnological Museum Berlin*, Munich/London/New York, p. 223, no. 146

BLAKELEY, PAMELA A. R. AND THOMAS D.
1987 "So'o Masks and Hemba Funerary Festival," in *African Arts* 21,1, pp. 30–37, 84–86

BLESSE, GISELHER
1994 "Der Südosten Tanzanias – Die Kunst der Makonde and benachbarter Völker," in Jens Jahn (ed.), *Tanzania. Meisterwerke afrikanischer Skulptur – Sanaa za mabingwa wa kiafrika*, Haus der Kulturen der Welt, Berlin, Städtische Galerie im Lenbachhaus, Munich, pp. 432–44

BOCHET, GILBERT
1988 "Waniugo-Janusmaske," in Werner Schmalenbach (ed.), *Afrikanische Kunst aus der Sammlung Barbier-Mueller, Genf*, Munich, p. 87
1993 "The Poro of the Senufo", in Jean-Paul Barbier (ed.), *Art of Côte d'Ivoire from the Collections of the Barbier-Mueller Museum*, 2 vols, Geneva, vol. I, pp. 54–85

BOLZ, INGEBORG
1966 "Zur Kunst in Gabun," in *Ethnologica* N.F.3, Cologne, pp. 85–221

BOONE, SYLVIA ARDYN
1986 *Radiance from the Waters. Ideals of Feminine Beauty in Mende Art*, New Haven/London

BOULORÉ, VINCENT
2000 "Maître de la maternité rouge," in *Sculptures Afrique, Asie, Océanie, Amériques*, Réunion des Musées Nationaux, Musée du Quai Branly, Musée du Louvre, pavillon des Sessions, Paris, pp. 90–94

BOURGEOIS, ARTHUR P.
1984 *Art of the Yaka and Suku*, Paris
1985 *The Yaka and Suku*, Leiden
1993 "Masks and Masking among the Yaka, Suku, and Related Peoples," in Frank Herreman and Constantijn Petridis (eds.), *Face of the Spirits. Masks from the Zaire Basin*, Ethnographic Museum, Antwerp, pp. 49–56
1995 "Kakuungu mask," in Gustaaf Verswijver et al. (ed.), *Treasures from the Africa-Museum, Tervuren*, Musée Royal de l'Afrique Centrale, Tervuren, p. 307

BOYER, ALAIN-MICHEL
1993 "Art of the Baule," in Jean-Paul Barbier (ed.), *Art of Côte d'Ivoire from the Collections of the Barbier-Mueller Museum*, 2 vols, Geneva, vol. I, pp. 302–67

BRAIN, ROBERT, AND ADAM POLLOCK
1971 *Bangwa Funerary Sculpture*, London

BRAVMANN, RENÉ A.
1995 "Mask," in Tom Phillips (ed.), *Africa. The Art of a Continent*, Munich/New York, p. 517

BURSSENS, HERMAN
1993 "Mask Styles and Mask Use in the North of Zaire," in Frank Herreman and Constantijn Petridis (eds.), *Face of the Spirits. Masks from the Zaire Basin*, Ethnographic Museum, Antwerp, pp. 217–33
1995 "Pongdudu face mask," in Gustaaf Verswijver et al. (ed.), *Treasures from the Africa-Museum, Tervuren*, Musée Royal de l'Afrique Centrale, Tervuren, p. 388

CASTELLI, ENRICO
2001 "Traditional Sculpture as History: A Comparative Analysis of Makonde Visual Heritage," in Manfred Ewel and Anne Outwater (ed.), *From Ritual to Modern Art. Tradition and Modernity in Tanzania Sculpture*, Dar es Salaam, pp. 79–90

CEYSSENS, RIK
1993 "Material and Formal Aspects of Copper Masks from the Upper Kasai," in Frank Herreman and Constantijn Petridis (eds.), *Face of the Spirits. Masks from the Zaire Basin,* Ethnographic Museum, Antwerp, pp. 97–113

COLLEYN, JEAN-PAUL
2001 "Ntomo and Korè," in Colleyn, Jean-Paul (ed.), *Bamana. Afrikanische Kunst aus Mali*, Museum Rietberg, Zurich, Museum for African Art, New York, Snoeck, Cucaju & Zoon, Gent, pp. 95–99
2001a "Die Geheimbünde. Kònò," in ibid., pp. 185–91
2001b "Die Geheimbünde. Ci-wara," in ibid., pp. 201–08

COLE, HERBERT
1997 "Arts Igbo," in Martin, Jean Hubert, et al. (ed.), *Arts du Nigeria*, Collections du Musée des Arts d'Afrique et d'Océanie, Paris, pp. 171–84

COLE, HERBERT, AND CHIKE C. ANIAKOR
1984 *Igbo Arts. Community and Cosmos*, Museum of Cultural History, Los Angeles

CORNET, JOSEPH
1993 "Masks among Kuba People," in Frank Herreman and Constantijn Petridis (eds.), *Face of the Spirits. Masks from the Zaire Basin,* Ethnographic Museum, Antwerp, pp. 129–42

CURTIS, MARIE-YVONNE
2000a "Haut de masque mbanchong en forme de serpent," in *Sculptures Afrique, Asie, Océanie, Amériques*, Réunion des Musées Nationaux, Musée du Quai Branly, Musée du Louvre, pavillon des Sessions, Paris, pp. 68–70
2000b "Masque d'épaules nimba," in ibid., pp. 70–72

D'ALLEVA, ANNE
1991 "Baule Mask," in Jerry L. Thomson and Susan Vogel, *Close up*, The Center for African Art, New York, pp. 92, 181

DELUZ, ARIANE
1988 "Tiermaske des Djé-Kultes," in Werner Schmalenbach (ed.), *Afrikanische Kunst aus der Sammlung Barbier-Mueller, Genf*, Munich, p. 125
1993a "The Guro," in Jean-Paul Barbier (ed.), *Art of Côte d'Ivoire from the Collections of the Barbier-Mueller Museum*, 2 vols, Geneva, vol. I, pp. 234–44
1993b "Guro mask," in ibid., p. 98

DEVISCH, RENAAT
1995 "Tsekedye mask," in Gustaaf Verswijver et al. (ed.), *Treasures from the Africa-Museum, Tervuren*, Musée Royal de l'Afrique Centrale, Tervuren, pp. 306–07

DIETERLEN, GERMAINE
1989 "Masks and Mythology of the Dogon," in *African Arts* 22, 3, pp. 34–43

DREWAL, HENRY JOHN
1978 "The Art of Egungun among the Yoruba People," in *African Arts* 11,3, pp. 18–19, 97–98
1997 "Les Cités-états et les art méridionaux et occidentaux: Ijebu, Egba, Ketu, Ohori, Egbado et Anago," in Martin, Jean Hubert, et al. (ed.), *Arts du Nigéria*, Collections du Musée des Arts d'Afrique et d'Océanie, Paris, pp. 75–83

DUPRÉ, MARIE-CLAUDE
1968 "A propos d'un masque des Téké de l'Ouest (Congo-Brazzaville)," in *Objets et Mondes. La Revue du Musée de l'Homme* 8,4, Paris, pp. 295–310
1979 "A propos du masque Téké de la Collection Barbier-Müller," in *Connaissance des Arts Tribaux,* Bulletin 2, n. p.

EISENHOFER, STEFAN
2000 "Rätselhafte Meisterwerke: Die Kunst aus Ife," in *Ife, Akan and Benin. Westafrikanische Kunst aus 2000 Jahren*, edited by Schmuckmuseum Pforzheim and Stiftung Vergessene Kulturgüter, Stuttgart, pp. 20–21

ELSAS, ELLEN AND ROBIN POYNOR
1984 *Nigerian Sculpture, Bridges to Power*, Birmingham Museum of Art

EYO, EKPO, AND FRANK WILLETT
1983 *Kunstschätze aus Alt-Nigeria*, Mainz

EZRA, KATE
1984 *African Ivories*, exhib. cat., Metropolitan Museum of Art, New York

FAGG, WILLIAM, JOHN PEMBERTON III AND BRYCE HOLCOMBE
1982 *Yoruba. Sculpture of West Africa*, New York

FALGAYRETTES-LEVEAU, CHRISTIANE (ED.)
2000 *Arts D'Afrique*, Musée Dapper, Paris

FÉAU, ETIENNE
1995a "Royal Mask of the Kah Society," in Tom Philips (ed.), *Africa: The Art of a Continent*, Munich/New York, p. 357
1995b "Buffalo mask", in ibid., pp. 354–55
1997 Verschiedene Kurzbeiträge (no. 186–93): "Région du Delta, Ijo," in Martin, Jean Hubert, et al. (ed.), *Arts du Nigéria. Collections du Musée des Arts d'Afrique et d'Océanie*, Paris, pp. 275–76

FELIX, MARC LEO
1990 *Mwana Hiti. Life and Art of the Matrilineal Bantu of Tanzania – Leben und Kunst der matrilinearen Bantu von Tansania*, Galerie Fred Jahn, Munich
1993 "The Animal in Us: The Ubiquitous Zoomorphic Masking Phenomenon of Eastern Zaire," in Frank Herreman and Constantijn Petridis (ed.), *Face of the Spirits. Masks from the Zaire Basin,* Ethnographic Museum, Antwerp, pp. 199–214
1997 *Masker. Magt og Magi – Masks. Might and Magic*, Kunsthallen Brandts Klæderfabrik, Denmark

FELIX, MARC LEO, CHARLES MEUR AND NIANGI BATULUKISI
1995 *Art & Kongos. Les Peuples kongophones et leur sculpture.* vol. I: Les Kongo du nord, Brussels

FELIX, MARC LEO AND MANUEL JORDÁN
1998 *Makishi lya Zambia*, Munich

FISCHER, EBERHARD
1999a "Gesichtsmaske," in Koloss, Hans-Joachim (ed.), *Afrika: Kunst and Kultur. Meisterwerke afrikanischer Kunst*, Museum für Völkerkunde Staatliche Museen zu Berlin, Munich/London/New York, p. 205, no. 49
1999b ibid., pp. 205, no. 52

FISCHER, EBERHARD AND HANS HIMMELHEBER
1976 *Die Kunst der Dan*, Museum Rietberg, Zurich

FISCHER, EBERHARD AND LORENZ HOMBERGER
1985a *Die Kunst der Guro, Elfenbeinküste*, Museum Rietberg, Zurich
1985b *Maskengestalten der Guro, Elfenbeinküste*, ibid.

FÖRSTER, TILL
1988 *Die Kunst der Senufo*, ibid.

FOSS, PERKINS
1988 "Mädchenmaske," in Werner Schmalenbach (ed.), *Afrikanische Kunst aus der Sammlung Barbier-Mueller, Genf*, Munich, p. 150
1997 "Les Urhobo," in Martin, Jean Hubert, et al. (ed.), *Arts du Nigeria*, Collections du Musée des Arts d'Afrique et d'Océanie, Paris, pp. 99–102
2004 *Where Gods and Mortals Meet: Continuitiy and Renewal in Urhobo Art*, Museum for African Art, New York

FREYER, BRYNA
1987 *Royal Benin Art*, National Museum of African Art, Smithonian Institution, Washington

GALLOIS-DUQUETTE, DANIELLE
1976 "Informations sur les arts plastiques des bidyogo," in *Arts d'Afrique Noire* 18, pp. 26–43
1983 *Dynamique de l'art Bidjogo (Guinée-Bissau)*, Lisbon

GARRARD, TIMOTHY F.
1993a "Diula: Mask for the do society," in Jean-Paul Barbier (ed.), *Art of Côte d'Ivoire from the Collections of the Barbier-Mueller Museum*, 2 vols, Geneva, vol. II, p. 12
1993b "Face masks from the Senufo Regions," in ibid., pp. 86–105
1995 "Pair of Helmet Mask Crests," in Tom Phillips (ed.), *Africa. The Art of a Continent*, Munich/New York, p. 454

GEBAUER, PAUL
1979 *Art of Cameroon*, Portland Art Museum and Metropolitan Museum, New York

GLAZE, ANITA
1981 *Art and Death in a Senufo Village*, Bloomington
1993a "Senufo, Janus helmet maks, wanyugo," in Jean-Paul Barbier (ed.), *Art of Côte d'Ivoire from the Collections of the Barbier-Mueller Museum*, 2 vols., Geneva, vol. II, p. 19
1993b "Senufo, Helmet mask with female figure," in ibid., p. 14

GOLDWATER, ROBERT
1964 *Senufo Sculpture from West Africa*, Museum of Primitive Art, New York

GOTTSCHALK, BURKHARD
2005 "Kunst aus Schwarzafrika: vom Gimbala zum Kongostrom," in *afrika incognita* series, Düsseldorf

GRIAULE, MARCEL
1938 *Masques Dogon*, Travaux et Mémoires de l'Institut d'Ethnologie, vol. 33, Paris

GUGGEIS, KARIN
1997 "'Wirbelwind', 'Kochbanane' and 'Menge ist Macht': Maskeraden and Masken der Igbo," in Stefan Eisenhofer (ed.), *Kulte, Künstler, Könige in Afrika – Tradition und Moderne in Südnigeria*, exhib. cat., Oberösterreichischen Landesmuseums N.F. 19, Linz, pp. 335–48

HABI BUGANZA MULINDA
n.d. "Masks as Proverbial Language," in Luc de Heusch (ed.), *Objects. Signs of Africa*, Brussels, pp. 147–59
1996 "Ndunga (mfuci ki fula) mask," in Gustaaf Verswijver, Els de Palmenaer, Viviane Baeke, Anne-Marie Bouttiaux-Ndiaye (ed.), *Masterpieces from Central Africa*, Munich, p. 145

HAHNER-HERZOG, IRIS, MARIA KECSKÉSI AND LÁSZLÓ VAJDA
1997 *African Masks: The Barbier-Mueller Collection,* Munich/New York
2000a "Helmmaske essenie / Helmmaske dugn'be," in *Mein Afrika. Die Sammlung Fritz Koenig*, edited by Stefan Eisenhofer, Iris Hahner-Herzog and Christine Stelzig. With an introduction by Peter Stepan, Munich/London/New York, p. 175
2000b "Aufsatzmaske," in ibid., p. 174

HARTER, PIERRE
1986 *Arts anciens du Cameroun*, Arnouville, Arts d'Afrique Noire
1993 "We masks," in Jean-Paul Barbier (ed.), *Art of Côte d'Ivoire from the Collections of the Barbier-Mueller Museum*, 2 vols, Geneva, vol. I, pp. 184–221

HASELBERGER, HERTA
1969 "Bemerkungen zum Kunst-handwerk in der Republik Haute-Volta: Gurunsi und Altvölker des äußersten Südwestens," in *Zeitschrift für Ethnologie* 94,2, pp. 171–246

HERREMAN, FRANK AND CONSTANTIJN PETRIDIS (EDS.)
1993 *Face of the Spirits. Masks from the Zaire Basin*, Ethnographic Museum, Antwerp

HERSAK, DUNJA
1986 *Songye Masks and Figure Sculpture*, London
1993 "The Kifwebe Masking Phenomenon," in Frank Herreman and Constantijn Petridis (ed.), *Face of the Spirits. Masks from the Zaire Basin,* Ethnographic Museum, Antwerp, pp. 145–58

HOFFMANN, RACHEL
1995 "Mask," in Tom Philips (ed.), *Africa: The Art of a Continent*, Munich/New York, p. 504

HOLAS, BOHUMIL
1968 *L'Image du monde Bété*, Paris

HOMBERGER, LORENZ
1997 *Masken der Wé and Dan, Elfenbeinküste*, Museum Rietberg, Zurich

HORTON, ROBIN
1965 *Kalabari Sculpture*, Department of Antiquities, Lagos

HOULBERG HAMMERSLEY, M.
1978 "Notes on the Egungun Masquerades among the Oyo Yoruba," in *African Arts* 11,3, pp. 56–61, 99

IMPERATO, PASCAL JAMES
1970 "The Dance of the Tyi Wara," in *African Arts* 4,1, pp. 8–13, 71–80
1981 "Sogoni koun," in *African Arts* 14,2, pp. 38–47, 72, 88

JESPERS, PHILIPPE
n.d. (1995) "Mask and Utterance: The Analysis of an 'Auditory' Mask in the Initiatory Society of the Komo Minyanka, Mali," in Luc de Heusch (ed.), *Objects, Signs of Africa*, Musée royal de l'Afrique centrale, Tervuren, pp. 37–56

JONES, G. I.
1984 *The Arts of Eastern Nigeria*, Cambridge

JORDÁN, MANUEL
1998 *Chokwe! Art and Initiation among Chokwe and Related Peoples*, Munich/London/New York
2003 "Gesichtsmaske, Maskenkostüm und Korb," in Peter Stepan (ed.), *Baselitz. Die Afrika-Sammlung*, Munich/London/New York, p. 174

JOUBERT, HÉLÈNE
1997 "Sud-est du Nigeria, Igbo Afikpo Masque," in Martin, Jean Hubert, et al. (ed.), *Arts du Nigeria*. Collections du Musée des Arts d'Afrique et d'Océanie, Paris, p. 286

JUNGE, PETER
2003 "Máscara para pôr sobre a cabeça," in *Arte da Africa. Obras primas do museu etnológico de Berlin*, Centro Cultural Banco do Brazil, Brasilia, São Paolo, Rio de Janeiro

KAN, MICHAEL, ROY SIEBER ET AL.
1995 *African Masterworks in the Detroit Institute of Arts*, Washington/London

KERCHACHE, JACQUES, JEAN-LOUIS PAUDRAT AND LUCIEN STEPHAN
1989 *Die Kunst des Schwarzen Afrika*, Freiburg

KINGDON, ZACHARY

1995 "Body mask (ndimu)," in Tom Phillips (ed.), *Africa. The Art of a Continent*, Munich/New York, p. 175

– "Mask," in ibid., pp. 155, 165

– "Face Mask (ndimu)," in ibid., p. 177

KOLOSS, HANS-JOACHIM

1987 *Zaire. Meisterwerke afrikanischer Kunst*, Staatliche Museen Preußischer Kulturbesitz, Berlin

1999 "Büffelmaske," in Koloss, Hans-Joachim (ed.), *Africa: Art and Culture. Ethnological Museum, Berlin*, Munich/London/New York, p. 210, no. 72

KOLOSS, HANS-JOACHIM AND TILL FÖRSTER

1990 *Die Kunst der Senufo, Elfenbein-küste*, Staatliche Museen Preußischer Kulturbesitz, Berlin

1999 "Kameruner Grasland," in Hans-Joachim Koloss (ed.), *Africa: Art and Culture. Ethnological Museum, Berlin*, Munich/London/New York, pp. 95–98

KUBIK, GERHARD

1995a "Cihongo mask", in Gustaaf Verswijver et al. (ed.), *Treasures from the Africa-Museum, Tervuren*, Musée Royal de l'Afrique Centrale, Tervuren, pp. 320–22

1995b "Phwò mask," in ibid., pp. 322, 162–63

LAGAMMA, ALISA

1999 "Gesichtsmaske ngil," in Hans-Joachim Koloss (ed.), *Afrika. Kunst and Kultur. Meisterwerke afrikanischer Kunst*, Museum für Völkerkunde Staatliche Museen zu Berlin, Munich/London/New York, p. 212, no. 92

LAMP, FREDERICK JOHN

1986 "The Art of the Baga," in *African Arts* 19,2, pp. 64–67, 92

1996 *The Art of the Baga*, Museum of African Art, New York

2004a "The Illusion of Lightness: a Baga/Nalu Headdress (Banda)," in Lamp, Frederick John (ed.), *See the Music, Hear the Dance. Rethinking African Art at The Baltimore Museum of Art*, Munich/Berlin/London/New York, pp. 74–76

2004b "Sun, Fire, and Variations on Womanhood: a Baga/Buluñits Mask (D'mba)," in ibid., pp. 222–25

LEHUARD, RAOUL

1977 "De l'Originge du masque tsaye," in *Arts d'Afrique Noire* 23, pp. 10–15

1993 "Masks among the Kongo People," in Frank Herreman and Constantijn Petridis (eds.), *Face of the Spirits. Masks from the Zaire Basin*, Ethnographic Museum, Antwerp, pp. 25–37

LEUZINGER, ELSY

1971 *Afrikanische Kunstwerke. Kulturen am Niger*, exhib. cat. , Villa Hügel, Essen, Recklinghausen

LINTIG, BETTINA VON

1994 *Die bildende Kunst der Bangwa. Werkstatt-Traditionen und Künstlerhand-schriften*, Munich

2004 "Mächte der Nacht. Nachtmasken der Bangwa in Kamerun," in Tobias Wendl (ed.), *Africa Screams. Das Böse in Kino, Kunst und Kult*, Wuppertal, pp. 103–13

MACGAFFEY, WYATT

1995 "Face Mask" (nos 17, 18), in Gustaaf Verswijver et al. (ed.), *Treasures from the Africa-Museum, Tervuren*, Musée Royal de l'Afrique Centrale, Tervuren, p. 289

MAES, J.

1924 *Aniota-Kifwebe*, Antwerp

MARK, PETER

1983 "Diola Masking Traditions and the History of the Casamance (Senegal)," in *Paideuma* 29, pp. 3–22

1988 "L'Ejumba du Musée Barbier-Mueller: symbolisme et fonction – The Ejumba of the Barbier-Mueller Museum: Symbolism and Function," in *Art Tribal* II, Bulletin du Musée Barbier-Mueller, Geneva, pp. 17–22

Marseille: *Petit Guide du M.A.A.O.A.*, Collections du Musée d'Arts Africains, Océaniens, Amérindiens, collection catalogue, Centre de la Vieille Charité, Marseille n.d.

MAURER, EVAN M.

1991 *The Intelligence of Forms. An Artist Collects African Art*, The Minneapolis Institute of Arts, Minneapolis

MAURER, EVAN M. AND ALLEN F. ROBERTS

1985 *Tabwa. The Rising of a New Moon*, National Museum of African Art, Washington, The University of Michigan Museum of Art, Ann Arbor, Royal Museum of Central Africa, Tervuren

MCCLUSKY, PAMELA

2002 "Beauty Stripped of Human Flaws: Sowei Masks," in McClusky, Pamela, *Art from Africa*, Seattle Art Museum

MCNAUGHTON, PATRICK

2001a "Die Geheimbünde. Einführung," in Jean-Paul Colleyn (ed.), *Bamana. Afrikanische Kunst aus Mali*, Museum Rietberg, Zurich, Museum for African Art, New York, Snoeck, Cucaju & Zoon, Gent, pp. 167–73

2001b "Die Geheimbünde: Kòmò," in ibid., pp. 175–83

2002 "Mask," in Bassani, Ezio, Michael Bockemühl and Patrick McNaughton, *The Power of Forms. African Art from the Horstmann Collection*, Milan, p. 64

MENEGHINI, MARIO

1974 "The Grebo Mask," in *African Arts* 8,1, pp. 36–39, 87

MERRIAM, ALAN P.

1978 "Kifwebe and Other Masked and Unmasked Societies among the Basongye," in *Africa-Tervuren* 24,3, pp. 57–73, 89–101

MESTACH, JEAN WILLY

1985 *Etudes Songye. Formes et symbolique. Essai d'analyse – Songye Studien. Formen and Symbolik. Analytischer Essay*, Galerie Fred Jahn, Munich

MEUR, CHARLES

1994 "Annäherung an die Masken-schnitzerei Tanzanias mit Ausnahme des Südostens," in Jens Jahn (ed.), *Tanzania. Meisterwerke afrikanischer Skulptur – Sanaa za mabingwa wa kiafrika*, Haus der Kulturen der Welt, Berlin, Städtische Galerie im Lenbachhaus, Munich, pp. 371–87

MORTON-WILLIAMS, PETER

1997 "Le Royaume et l'empire d'Oyo," in Martin, Jean Hubert, et al. (ed.), *Arts du Nigeria*, Collections du Musée des Arts d'Afrique et d'Océanie, Paris, pp. 59–68

MULLEN KREAMER, CHRISTINE

1987 "Benin Pendent Mask," in The Metropolitan Museum of Art. The Pacific Islands, Africa and the Americas, collection cat., New York, p. 84

NDIAYE, FRANCINE

1995 *L'Art du pays Dogon dans les collections du Musée de l'Homme*, Museum Rietberg, Zurich

NEWTON, DOUGLAS AND HERMINE WATERFIELD

1995 *Tribal Sculpture. Masterpieces from Africa, South Asia and the Pacific in the Barbier-Mueller Museum*, New York

NEYT, FRANÇOIS

1981 *Traditional Arts and the History of Zaire*, Brussels

1993 "South-East Zaire. Masks of the Luba, Hemba and Tabwa," in Frank Herreman and Constantijn Petridis (eds.), *Face of the Spirits. Masks from the Zaire Basin*, Ethnographic Museum, Antwerp, pp. 163–81

1994 *Luba. To the Sources of Zaire*, Musée Dapper, Paris

NICKLIN, KEITH

1974 "Nigerian Skin Covered Masks," in *African Arts* 7,3, pp. 7–15, 67–68, 92

1995 "Face Mask," in Tom Phillips (ed.), *Africa. The Art of a Continent*, Munich/New York, p. 379

1999a "Face Mask," in Hans-Joachim Koloss (ed.), *Africa. Art and Culture. Ethnological Museum, Berlin*, Munich/London/New York, p. 208, no. 62

1999b "Mask," in ibid., p. 208, no. 65

2004 "Youthful Faces: an Ogoni Mask (Elu)," in Frederick John Lamp (ed.), *See the Music, Hear the Dance. Rethinking African Art at The Baltimore Museum of Art*, Munich/Berlin/London/New York, p. 32

NICKLIN KEITH AND JILL SALMONS

1984 "Cross River Art Styles," in *African Arts* 18,1, pp. 28–43, 93–94

1997 "Les Arts du Nigeria du Sud-Est: Les Ogoni et les peuples de la Cross River," in Martin, Jean Hubert, et al. (ed.), *Arts du Nigeria*. Collections du Musée des Arts d'Afrique et d'Océanie, Paris, pp. 147–68

NICHOLLS, ANDREA

1999 "Mask (mwana pwo)," in *Selected Works from the Collection of the National Museum of African Art*, vol. 1, Smithsonian, National Museum of African Art, Washington, p. 125

NICOLAS, ALAIN ET AL.

1997 *African Faces, African Figures. The Arman Collection*, Museum for African Art, New York

NOOTER-ROBERTS, NANCY INGRAM AND ALLEN F. ROBERTS

1996 *Memory. Luba Art and the Making of History*, The Museum for African Art, New York

NORTHERN, TAMARA

1973 *Royal Art of Cameroon*, Hopkins Center Art Galleries, Dartmouth College, Hanover, New Hampshire

1984 *Art of Cameroon*, Smithonian Institute Washington

NOTUÉ, JEAN-PAUL

1993 *Batcham. Sculptures du Cameroun*, Musées de Marseille, Réunion des Musées Nationaux, Marseille

2000 "Masque royal (tukah)," in *Sculptures Afrique, Asie, Océanie, Amériques*, Réunion des Musées Nationaux, Musée du Quai Branly, Musée du Louvre, pavillon des Sessions, pp. 151–54

NSONDÉ, JEAN

2000 "L'art kôngo: une vision du monde complexe," in Christiane Falgayrettes-Leveau, *Arts d'Afrique*, Musée Dapper, Paris, pp. 255–80

OTTENBERG, SIMON

1975 *Masked Rituals of the Afikpo. The Context of an African Art*, Seattle

1997 "Le Sous-groupe Ada des Igbo," in Martin, Jean Hubert, et al. (ed.), *Arts du Nigeria*. Collections du Musée des Arts d'Afrique et d'Océanie, Paris, pp. 185–91

PAULME, DENISE

1956 "Structures sociales en pays baga," in *Bulletin de l'I.F.A.N.* XVII, Série B, 1–2, pp. 98–116

PELRINE, DIANE M.
1996 *Affinities of Form. Arts of Africa, Oceania, and the Americas from the Raymond and Laura Wielgus Collection*, Munich/New York

PEMBERTON III, JOHN
1989 "The Carvers of the North-East," in Allen Wardwell (ed.), *Yoruba. Nine Centuries of African Art and Thought*, Center for African Art, New York, pp. 189–211

PERROIS, LOUIS
1979 *Arts du Gabon*, Arnouville
1985 *Ancestral Art of Gabun from the Collection of the Barbier-Mueller-Museum*, Geneva
1988a "Tanzmaske", in Werner Schmalenbach (ed.), *Afrikanische Kunst aus der Sammlung Barbier-Mueller, Genf*, Munich, p. 218
1988b "Maske mit gebogenen Hörnern," in ibid., p. 211
1993 *Les Rois Sculpteurs. Art et pouvoir dans le Grassland camerounais. Legs Pierre Harter*, Editions de la Réunion des Musées Nationaux, Paris
2001 "Art of the Kwele of Equatorial Africa," in *Tribal Arts* 25, Spring, www.etribal.com/e/tribalarts25_p2.php3

PETRIDIS, CONSTANTIJN
1993a "Pende Mask Styles," in Frank Herreman and Constantijn Petridis (eds.), *Face of the Spirits. Masks from the Zaire Basin,* Ethnographic Museum, Antwerp, pp. 63–76
1993b "Bali," in ibid., p. 212
1993c "Ndaaka", in ibid., p. 214
2000 "Les Arts du basin du Congo," in Christiane Falgayrettes-Leveau (ed.), *Arts D'Afrique*, Musée Dapper, Paris, pp. 285–316
2003 *South of the Sahara. Selected Works of African Art,* exhib. cat., The Cleveland Museum of Art

PHILLIPS, RUTH B.
1980 "The Iconography of the Mende Sowei Mask," in Ethnologische Zeitschrift Zürich 1, pp. 113–32

PHILLIPS, TOM
1995 "Mask (Panya ngombe)," in Tom Phillips (ed.), *Africa. The Art of a Continent*, Munich/New York, p. 264

PICTON, JOHN
1995 "Helmet Mask," in Tom Phillips (ed.), *Africa. The Art of a Continent*, Munich/New York, p. 420
1997 "A l'est d'Ile-Ife", in Martin, Jean Hubert, et al. (ed.), *Arts du Nigeria. Collections du Musée des Arts d'Afrique et d'Océanie*, Paris, pp. 85–87

POYNOR, ROBIN
1995 *Spirit Eyes, Human Heads – African Art at the Harm Museum, Florida*, Gainesville

PUCCINELLI, LYDIA
1999 "Mask," in *Selected Works from the Collection of the National Museum of African Art*, vol. 1, Smithonian, National Museum of African Art, Washington, p. 89

REED, DANIEL
2004 "The Transformation into a Spirit through a 'Constellation of Arts': a Dan Mask (Tankë Ge)", in Lamp, Frederick John (ed.), *See the Music, Hear the Dance. Rethinking African Art at The Baltimore Museum of Art*, Munich/Berlin/London/New York, pp. 98–100

ROBERTS, ALLEN F.
1994 "Formenverwandtschaft: Ästhetische Berührungspunkte zwischen Völkern West-Tanzanias und Südost-Zaires," in Jens Jahn (ed.), *Tanzania. Meisterwerke afrikanischer Skulptur – Sanaa za mabingwa wa kiafrika,* Haus der Kulturen der Welt, Berlin, Städtische Galerie im Lenbachhaus, Munich, pp. 350–63
1995 *Animals in African Art. From the Familiar to the Marvelous*, Museum for African Art, New York
1995a "Kifwebe Mask", in Gustaaf Verswijver et al. (ed.), *Treasures from the Africa-Museum, Tervuren*, Musée Royal de l'Afrique Centrale, Tervuren, p. 350f.
1995b "Mask," in ibid., p. 352f.

ROOD, ARMISTEAD P.
1969 "Bété Masked Dance," in *African Arts* 2, 3, pp. 36–43, 76

ROY, CHRISTOPHER
1983 "Forme et Signification des Masques Mossi – Form and Meaning of Mossi Masks," in *Arts d'Afrique Noire* 48, pp. 9–23
1984 ibid., vol. 49, pp. 11–22
1987 *Art of the Upper Volta Rivers*, Paris
1988 "Nashornvogelmaske," in Werner Schmalenbach (ed.), *Afrikanische Kunst aus der Sammlung Barbier-Mueller, Genf,* Munich, p. 80
2002 *The Art of Burkina Faso*, website: www.uiowa.edu/~africart/

RUBIN, WILLIAM
1988 "Pablo Picasso," in Rubin, William (ed.), *Primitivism in 20th-Century Art*, Munich, pp. 248–353

SCHÄDLER, KARL-FERDINAND
1992 *Götter, Geister, Ahnen. Afrikanische Skulpturen in deutschen Privatsammlungen*, Villa Stuck Munich

SCHNEIDER, KLAUS
1999 "Tanzaufsatz magbo," in Gisela Völger (ed.), *Kunst der Welt im Rautenstrauch-Joest-Museum für Völkerkunde*, Cologne, Munich/London/New York, p. 22f.
2002 *Faszination Afrika. Schätze aus dem Rautenstrauch-Joest-Museum*, Cologne

SIEBER, ROY AND ROSLYN ADELE WALKER
1987 *African Art in the Cycle of Life*, National Museum of African Art, Washington/London

SIROTO, LEON
1954 "A Mask Style from the French Congo," in *Man* 54, pp. 148–50
1972 "Gon: A Mask Used in Competition for Leadership among the Bakwele," in Douglas Fraser (ed.), *African Art and Leadership*, Madison, pp. 57–77

STEPAN, PETER
2001 *World Art. Africa*, Munich/London/New York

STROTHER Z. S.
1993 "Eastern Pende Constructions of Secrecy," in Mary Ingram Nooter, *Secrecy. African Art that Conceals and Reveals*, Museum for African Art, New York, Munich, pp. 157–78
1995a "Kipoko Mask," in Gustaaf Verswijver et al. (ed.), *Treasures from the Africa-Museum, Tervuren*, Musée Royal de l'Afrique Centrale, Tervuren, p. 312f.
1995b "Mbangu mask," in ibid., p. 314
2002 "Mask," in Bassani, Ezio, Michael Bockemühl and Patrick McNaughton, *The Power of Forms. African Art form the Horstmann Collection*, Milan, p. 184

SZALAY, MIKLÓS
1995 *African Art from the Han Coray Collection*, 1916–1928, Munich/New York

TESSMANN, GÜNTER
1913 *Die Pangwe*, 2 vols., Berlin

THOMSON, ROBERT FARRIS
1999 "Gesichtsmaske keeko kla bwela," in Hans-Joachim Koloss (ed.), *Africa. Art and Culture. Ethnological Museum Berlin*, Munich/London/New York, p. 218, no. 120

VERGER-FÈVRE, MARIE-NOËL
1985 "Etude des masques faciaux de l'ouest de la Côte d'Ivoire," in *Arts d'Afrique Noire*, 53, pp. 17–29, 19–33, 54
1993a "The Peoples of Western Côte d'Ivoire", in Jean-Paul Barbier (ed.), *Art of Côte d'Ivoire from the Collections of the Barbier-Mueller Museum*, 2 vols, Geneva, vol. I, 128–42
1993b "Bete. Dancer mask," in ibid., p. 90, no. 148
1993c "Masks in the Dan Area of Côte d'Ivoire," in ibid., pp. 144–83

VERSWIJVER, GUSTAAF
1997 "Helmet Mask," in Frank Herreman (ed.), *African Faces, African Figures. The Arman Collection*, Museum for African Art, New York, p. 235

VOGEL, SUSAN M.
1986 *African Aesthetics. The Carlo Monzino Collection*, The Center for African Art, New York
1988 "Zwillingsmaske," in Werner Schmalenbach (ed.), *Afrikanische Kunst aus der Sammlung Barbier-Mueller, Genf*, Munich, p. 131
1997 *Baule: African Art, Western Eyes*, Museum for African Art, New York

VOLAVKA, ZDENKA
1976 "Ndunga", in *Arts d'Afrique Noire* 17, pp. 28–43

VRYDAGH, ANDRÉ P.
1993 "Un Masque Mbunda – A Mbunda Mask," in *Art tribal*, Bulletin du Musée Barbier-Mueller, Geneva, pp. 37–45

WILLETT, FRANK
1995 "Mask head," in Tom Phillips (ed.), *Africa. The Art of a Continent*, Munich/New York, p. 405

WITTMER, MARCILENE K.
1991 *Visual Diplomacy. The Art of the Cameroon Grassfields*, Horst Gallery, Cambridge, Massachusetts

ZAHAN, DOMINIQUE
1974 *The Bambara*, Leiden
1980 *Antilopes du Soleil*, Vienna

ZEITLYN, DAVID
1994 "Mambila Figurines and Masquerade. Problems of Interpretation," in *African Arts* 27,4, pp. 38–47, 94
1997 "Les Mambila," in Martin, Jean Hubert, et al. (ed.), *Arts du Nigeria. Collections du Musée des Arts d'Afrique et d'Océanie*, Paris, pp. 231–34

ZWERNEMANN, JÜRGEN
1978 "Masken der Bobo-Ule and Nuna," in *Mitteilungen aus dem Museum für Völkerkunde Hamburg* N. F. 8, pp. 45–83

Front cover: *Ngil* mask, Fang, Gabon, plate 79

Field photos
pp. 4/5: Entrance of the feather masks, Ichim, Kingdom of Oku, Cameroon
 Grasslands, 14 November 1997, photo: Hans-Joachim Koloss
pp. 6/7: Masks being "danced" by the Guro, photo: Eberhard Fischer
pp. 9: Appearance of the masks during a festival for the dead, Kingdom of Oku,
 Cameroon Grasslands, December 1977, photo: Hans Knöpfli-Zingg
pp. 10/11: Dance of the *kanaga* masks, Sangha, Dogon country, Mali, photo: Huib Blom
pp. 13: Dance of *d'mba*, Baga Sitemu, Guinea, 1990, photo: Frederick Lamp
pp. 14/15: *Mupala* mask performed at a Chokwe *mukanda* initiation, Kashonta
 Village, Northwestern Zambia, 1991, photo: Manuel Jordán

The Library of Congress Cataloguing-in-Publication data is available; British Library
Cataloguing-in-Publication Data: a catalogue record for this book is available from
the British Library; Deutsche Bibliothek holds a record of this publication in the
Deutsche Nationalbibliografie; detailed bibliographical data can be found under:
http://dnb.ddb.de

© Prestel Verlag, Munich · Berlin · London · New York, 2005

Prestel books are available worldwide. Please contact your nearest bookseller
or one of the following Prestel offices for information concerning your local
distributor:

Prestel Verlag
Königinstrasse 9, 80539 Munich
Tel. +49 (89) 38 17 09-0; Fax +49 (89) 38 17 09-35

Prestel Publishing Ltd.
4 Bloomsbury Place, London WC1A 2QA
Tel. +44 (020) 7323-5004; Fax +44 (020) 7636-8004

Prestel Publishing
900 Broadway, Suite 603, New York, NY 10003
Tel. +1 (212) 995-2720; Fax +1 (212) 995-2733

www.prestel.com

Translated from the German by John W. Gabriel, Worpswede

Map of Africa (watercolor): Laurence Sartin

Design: Liquid, Augsburg
Layout: WIGEL, Munich
Editorial assistant: Dagmar Thesing
Origination: Reproline Genceller, Munich
Printing and binding: Sellier, Freising

Printed in Germany on acid-free paper

ISBN 3-7913-3228-7

PHOTO CREDITS

Our special thanks are due to the museums and collectors mentioned in the
captions who made images available for this publication. In addition the illustrations
have been kindly provided by the photographers or were taken from the publisher's
archive:

ABM Archives Barbier-Mueller (Studio Ferrazzini Bouchet) 2,7, 15, 19, 22, 23, 26,
 28, 30, 40, 45, 47, 54, 55, 60, 69, 77, 80, 82, 89
Dick Beaulieux, Brussels 3, 5, 56, 68, 90, 99, 107, 109, 110, 113, 114, 117, 119, 125
Bildarchiv Preussischer Kulturbesitz (Ethnologisches Museum, Berlin)
 12, 66 (Dietrich Graf), 13, 59 (Claudia Obrocki), 27, 78 (Martin Franken),
 74 (Erik Hesmerg), 87 (W. Schneider-Schütz)
G. Bonnet 1, 29, 43
Courtesy The Center for African Art, New York (Mario Carrieri) 18, 63, 81, 115, 103
Igor Delmas 53
Hughes Dubois, Brussels/Paris 33
Eliot Elisofon Photographic Archives, National Museum of African Art, Washington
 61, 97
Courtesy Marc Felix, Brussels 118, 120
Courtesy Galerie Fred and Jens Jahn, Munich 126
Courtesy Burkhard Gottschalk, Düsseldorf 10
Linden Museum, Stuttgart (Anatol Dreyer) 123
Jochen Littkemann, Berlin 101
Courtesy Rolf and Christina Miehler 52, 75
Courtesy Musée Dapper, Paris 34, 84 (Mario Carrieri), 93, 106 (Hughes Dubois)
Museum for Ethnology, Leipzig (Heinrich Schneebeli) 124
Peter Nebel, Zurich 11, 104
Toni Ott, Landshut 4, 65
Rheinisches Bildarchiv, Cologne 51
Courtesy Rietberg Museum, Zurich 49
RMN, Paris 14 (Michèle Bellot), 73, 76 (Mathéus)
Royal Museum for Central Africa, Tervuren (Roger Asselberghs) 86, 91, 92, 94,
 96, 98, 112
Heini Schneebeli, London 67, 121
Courtesy André Schoeller and Larock-Granoff Gallery, Paris 38
Seattle Art Museum (Susan Dirk) 111
Sociedade de Geografia de Lisboa (Carlos Ladeira) 88
Courtesy Sotheby's London 16
John Bigelow Taylor, New York 6, 41
Malcolm Varon, New York 108
Rainer Wolfsberger (Museum Rietberg, Zurich) 17, 20, 32, 33, 36/37